Understanding Architecture

Understanding Architecture is a comprehensive introduction to architecture and architectural history and exceptional in its holistic approach. It explores the current practice of architecture in relation to its history and in relation to the issues that are significant today. This new edition looks at the implications of sustainability, at conservation, landscape, and urban regeneration. Its extended coverage includes China, the Middle East, India, Africa and other parts of the world.

Its aim is to help people make sense of the experience of architecture and the built environment by introducing some of the complexities of the subject.

Hazel Conway is a heritage consultant. She is on the London Advisory Committee and the Historic Parks and Gardens Panel of English Heritage and was a member of the Urban Parks Panel of the Heritage Lottery Fund. She lectures at a number of institutions and was principal lecturer in architectural and landscape history at Leicester Polytechnic. She was awarded her doctorate for her study of Victorian parks. Her books include *Public Parks*, Shire Publications, 1996 and *People's Parks*, Cambridge University Press, 1991.

Rowan Roenisch is a principal lecturer in architectural history at De Montfort University. She is a member of the Institute of Historic Building Conservation and a caseworker for the Victorian Society. She has contributed to the *Encyclopaedia of Vernacular Architecture of the World* and presented papers on Zimbabwean Shona and Tonga architecture at the International Association for the Study of Traditional Environments conferences held in Italy and Hong Kong.

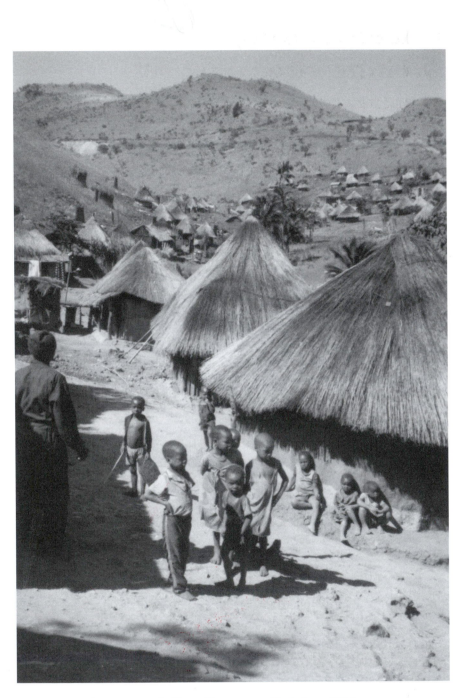

Frontispiece Malawian miners' village, Tengenenge, Zimbabwe, 1994

Understanding Architecture

An introduction to architecture and architectural history

Hazel Conway and Rowan Roenisch

Routledge
Taylor & Francis Group

LONDON AND NEW YORK

First edition published 1994

This edition published 2005
by Routledge
2 Park Square, Milton Park, Abingdon, Oxon OX14 4RN

Simultaneously published in the USA and Canada
by Routledge
270 Madison Ave, New York, NY 10016

Routledge is an imprint of the Taylor & Francis Group

© 1994, 2005 Hazel Conway and Rowan Roenisch

Typeset in Garamond by
Florence Production Ltd, Stoodleigh, Devon
Printed and bound in Great Britain by
TJ International Ltd, Padstow, Cornwall

British Library Cataloguing in Publication Data
A catalogue record for this book is available from the British Library

Library of Congress Cataloging in Publication Data
Conway, Hazel.
 Understanding architecture: an introduction to architecture and
 architectural history/Hazel Conway and Rowan Roenisch. – 2nd ed.
 p. cm.
 Includes bibliographical references and index.
 ISBN 0–415–32058–5 (hard cover: alk. paper) –
 ISBN 0–415–32059–3 (soft cover: alk. paper) –
 ISBN 0–203–23823–0 (e-book)
 1. Architecture. 2. Architecture and society. I. Roenisch, Rowan.
 II. Title.
 NA2500.C62 2004
 720–dc22 2004009647

ISBN 0–415–32059–3

For our families and friends

Contents

Illustration credits

ARS, NY and DACS: 2.11, 9.2
Bangha, Imre: 6.4
Bibliothèque Nationale: 8.5
Bower, Dave: 6.11
Branfoot, Crispin: 8.9, 8.10
Builder: 5.5, 7.2
Charles, Martin: 7.13, 8.4
Chicago Tribune: 2.10
Cole, Dominic (courtesy of Land Use
 Consultants): 6.16
Conway, Hazel: *frontispiece*, 2.3, 2.4, 2.5,
 2.6, 2.7, 2.8, 2.9, 2.12, 2.13, 2.14,
 3.2, 3.4, 3.5, 3.6 (by kind permission
 of the Chapter of Wells Cathedral),
 3.7, 3.10, 4.1, 4.3, 4.5, 4.13, 4.16 (by
 kind permission of the owners), 5.22,
 5.24, 6.5, 6.6, 6.7, 6.8, 6.13, 6.14,
 6.15, 6.17, 7.5 (courtesy of English
 Heritage), 7.7 (courtesy of the owner),
 7.8, 7.10, 7.11, 7.12, 7.15, 7.19,
 7.23, 7.24, 8.2, 8.8, 8.13, 9.2, 9.3,
 9.4, 9.6 (by kind permission of the
 National Trust), 9.7, 9.8, 9.9, 9.10,
 9.11
Country Life: 8.7
Curl, James Stevens: 4.9
Davies, Richard: 5.26
Gilbert, Dennis/VIEW: 4.17
English Heritage Photo Library: 4.4
Esto: 4.10
Etherton, David: 8.1
FLC/ADAGP, Paris and DACS, London
 2004: 8.3
Fondation Le Corbusier: 7.16

Gale, Adrian: 7.6
Hampshire Country Architects: 5.17,
 5.18, 5.19, 5.20
Hermer Verlag München: 7.9
Illustrated London News: 2.1
Insall, Donald: 4.12
London Borough of Richmond upon
 Thames, Library and Information
 Services: 5.21
McCutchion, David: 4.2
McGrath, Norman: 8.6
Ordnance Survey: 5.4
Penguin Books Ltd: 5.8
Pugin, A. W. N., *Contrasts*, (1841
 edition): 3.3
RIBA Drawings Collection: 5.11, 5.15,
 5.16, 7.18
Roenisch, Rowan: 3.8, 3.9, 4.6, 4.8, 4.14,
 4.15, 5.25, 6.1, 6.2, 6.3, 6.9, 6.10,
 6.12, 6.19, 7.1, 7.3, 7.4, 7.14
 (courtesy of the owner), 7.17 (courtesy
 of the National Trust), 7.20, 7.22,
 8.11, 8.14 (reproduced by permission
 of Nottingham City Council), 8.15,
 8.16
Rosen, Michael: 2.2
Royal Commission on the Historical
 Monuments of England: 5.1
Serlio, Sebastino, *L'Architettura, c.*1540:
 5.2
Spencer, Ian: 7.21
Tesco Stores Ltd: 8.12
Unichrome, Bath: 3.1

The authors and publishers would like to thank the above individuals and organisations for permission to reproduce material. We have made every effort to contact and acknowledge copyright holders, but if any errors or omissions have been made we would be happy to correct them at a later printing.

Foreword

Professor Peter Swallow

As the late Professor Furneaux Jordan once wrote, 'architecture is the product of a hundred circumstances' and to a newcomer the subject may appear both inaccessible and daunting. However, all that is required to make some sense of architecture, and increase one's pleasure in experiencing it is an enquiring mind and a sound introductory text to set one off on what, for many, becomes a rich life-long journey of discovery.

This book provides an impressive introduction to architecture and architectural history by presenting in a structured way clear insights into how architecture is influenced by the climate, culture, society, technology and needs of its time and place. Through carefully chosen and well-illustrated examples, taken from many parts of the world, the reader is both informed and given the means by which to analyse and understand the architecture around them.

In this thoroughly revised and updated second edition the authors have covered in a masterly way, albeit at an introductory level, such diverse issues as conservation, ethnicity, feminism, planning and urbanism, which are at the heart of many of the debates on architecture.

I warmly commend this as a book that will enable students to engage with, rationalise and understand not only the architecture of the past and the present, but also the future.

<div align="right">

Department of Product and Spatial Design
(incorporating Leicester School of Architecture)
De Montfort University

</div>

Foreword to the first edition

Sir Colin Stansfield Smith

Any book that helps in an understanding of architecture has my support. This is a difficult task, so when some of its complexities are unravelled easily, lucidly and without pretension, then I express my unfettered enthusiasm. This is a book that makes no apologies for being aimed at students and at anyone who is interested in the subject of architecture.

There is so much indifference about the nature of our built environments, how they happened, what sustains them and revitalises them and why some of them decay as they lose their sense of purpose or being. Our environments are a reflection of ourselves – we are all contributors no matter how small or modest, because we are all users of buildings. It is this last fact that becomes important in the late twentieth century. The public and semi-public realms of our urban and suburban environments have so often been dominated by agencies other than the user and the citizen. This book suggests that the balance of influence in a democratic society should be redressed. The issues of participation, civic pride, vandalism, litter, all demonstrate an attitude to the places where we live and work, whether they contribute to our well-being or whether they detract and debilitate. Some of the obvious non-caring attitudes could so easily be turned into a sense of responsibility if people knew a little more about the meaning and intention involved and understood more about why and how things happen. The aim of this book is to make these complex issues clearer.

We are faced with the problems of urban congestion, pollution and resource exhaustion. These are not peculiar to the late twentieth century. What are unique to this period are the capacity and the technology to overcome these problems in the face of vested interests, if there is the will. Architecture should express our aspirations and our sense of optimism about the future, without losing a sense of historical continuity. Architecture is only part of our environment and if this is to be life-enhancing, it has to take account of settings and the spaces between buildings. The great spaces of our cities are like the living rooms of a great house, but so many are spoiled and cluttered unnecessarily.

It goes without saying that architecture is a public art and architects should have a social responsibility. They are taught to look at environments

holistically. So often the needs and complexities of urban design go far beyond the scope and influence of any single discipline, yet arguments about our urban fabric degenerate into shallow exchanges on style and taste. They represent a superficial cosmetic, when the scale and nature of the problem demand a much more rigorous and searching analysis of not only how things should be built, but what should be built. Many of the mistakes that were made in the recent past will have to be redressed and perhaps the governmental machinery to achieve what is needed will have to undergo radical change.

These are challenging times for our urban environments, and their destinies depend on the understanding of the ordinary citizen. This book attempts to elucidate that understanding.

<div style="text-align: right">County Architect, Hampshire (1973–87)</div>

Acknowledgements

This book has evolved out of the ideas and experience of architecture that we have gained over many years and it is impossible to mention by name all the many people who have helped us in this.

While we were exploring the form that this book should take, we discussed our ideas with many people and we would particularly like to thank Peter Swallow, Crispin Branfoot, Anthea McCullough and David Saile for their constructive criticisms. We should point out, however, that the responsibility for the contents of this book rests entirely with the authors. Catherine King, Robert Hillenbrand, John Newman and Peter Howell all spent time encouraging our efforts and we would like to express our thanks to them for this. We would also like to thank Neil Jackson for his comments and help on American sources of information. In gathering together the illustrations that form an essential part of this book we have often been accompanied, in all types of weather, by tolerant friends and family who might sometimes have preferred other destinations. In particular, many discussions with Frieda Roenisch, Fred Hoffman and John Hoffman have added considerably to the book. Many individuals, organisations and institutions have gone out of their way to answer queries, provide help and lend us photographs; we would particularly like to thank Mr and Mrs J. Acton, Imre Bangha, Dominic Cole, Mr and Mrs Thomas Courtauld, James Stevens Curl, Philip Davies, English Heritage, Foster and Partners, Donald S. Gimson, Hampshire County Architects, Mr and Mrs I. Horowitz, Land Use Consultants, Michael Hopkins Architects, Donald Insall, George Michell, Michael Rosen, Rob Sheen, Joan Skinner, Ian Spencer, Colin Stansfield Smith, Mary Stewart, Michael Taylor, Tesco Stores Ltd and the owners of Downton Castle. We would also like to thank our editors and De Montfort University for their support.

1 Introduction

The experience of architecture and the built environment is something that forms part of everyday life for most of us. This book is about how to understand that environment and the form, construction and history of buildings. It is for students and all who are concerned about the architecture of today and yesterday.

It may seem that there are so many books published on the subject of architecture and architectural history that there is little need for another one. Rather than writing another history of architecture, our aim is to show that history all around us is there for us to explore and enjoy. Some buildings we may like, others we find most uncongenial. That is part of the challenge and this book is about understanding buildings, whether we like them or not. This means not just the way they look, or their construction and materials, but how they came into being, and how they were and are used. To understand the complexities of the built environment we need to know something about the decisions that led to building developments, the economic and political context of patronage, the role of developers and the social and cultural context of building use. Studying the past enables us to understand today more clearly. It frees us from becoming impotent prisoners of the present and enables us to see the possibilities of choice. This applies to any area of history, including architecture and the built environment. Architecture touches on many disciplines and this book adopts an holistic approach to the subject. It is about raising questions, rather than giving answers, and our aim is accessibility, for architecture is part of everyone's lives.

Consciously or unconsciously everyone is affected by their environment. The increasing popular interest in the subject of architecture is reflected by television programmes and articles in the daily press. Prize-winning architects and prize-winning buildings are given star treatment and major new developments across the world are the subject of keen debate. Many people now feel encouraged to join in the debate on architecture, particularly when new developments affect their own locality. Some new and important developments mark this broadening of interest. Television and the web make it possible to see examples of international architecture in our homes. In many cities there are architecture centres and museums of architecture

that present exhibitions of historic architecture, as well as architectural proposals for the future. Such centres and museums face the problem of how to present three-dimensional buildings, often of a large scale, in a confined space. Photographs, plans, models and videos are among the techniques used. Videos in particular make it possible to 'walk through' buildings and gain a sense of their spatial qualities. There is, however, a great difference between enjoying images and models and understanding something about the significance of the buildings depicted. For this a critical approach becomes important and, in order to discuss buildings in any detail, some understanding of the language of architecture is essential. This book presents a step in that direction. Some of the discussions and writing on the subject can seem daunting and impenetrable because of the technical terms used. In addition, ordinary terms may be used in a specialised way that can be quite different from our day-to-day language. While it is all very well to have a dictionary at hand, it does tend to be off-putting if one needs to use it too frequently. This book is about how to understand architecture and its history in a very practical way, so we explain the terms as we go along. They are starred with an asterisk where necessary and brief definitions appear in the glossary.

We live our lives in and around buildings, even those of us who live in the country, yet although our surroundings are familiar, their details can prove elusive. When we travel we notice how the buildings differ from those with which we are familiar. This may be due to different materials, colours, forms and scale. We can describe our homes so that a new visitor will recognise them, and perhaps we could even sketch them with a reasonable degree of accuracy. Further afield, however, even the most familiar buildings can acquire a certain fuzziness, rather like an out-of-focus photograph as the following example illustrates. First, select a small group of familiar buildings, not more than 50 metres long, such as those that form a group with the post office, those near the bus stop or station that you use regularly, or those near your home. Then try to describe that group of buildings, or sketch them, as accurately as possible. To do so you will need to remember what the roofs, windows and entrances are like, how many storeys there are, what materials are used, and their colour and texture. You will also need to remember how each building relates to its neighbour and to its wider setting. It is surprising how difficult many of us find this. If you then go on to compare these details with somewhere else where you have spent time, such as on holiday, you will be able to pinpoint some of the major differences between the two. The next step is to think about the reasons for these differences. If a new building has recently appeared in our familiar surroundings, we tend to look at it very closely. We compare it with what it has replaced and look to see how it relates to its neighbours. We often develop a clear opinion as to whether we think it is a positive addition to our environment, or a negative one. After a short while, however, it becomes virtually impossible to remember the building that it replaced.

Buildings may form the background to our lives, but most of the time we do not look at them very critically or in any detail, unless we have a particular need to do so. When moving house we think about such things as the neighbourhood, the number and disposition of rooms, the cost, the location of shops, schools and available forms of transport, but the appearance of the new house may not necessarily be very important. Yet, learning to examine buildings in a critical way can add another dimension to our daily lives, for it brings greater understanding of our environment. Our reactions to buildings depend very much on our expertise, background and interests. An architect will think about how a building was designed, why it was constructed in its particular way and how it relates to the other buildings nearby. An industrial or commercial organisation will consider how appropriate a particular building is to its business and the facilities offered by its specific location. A developer will look at the economic potential of a building and its site. Today we recognise the increasing importance of sustainability, both in new buildings and in the reuse of existing buildings.

Many of us are interested in new developments, yet feel powerless about influencing decisions concerning them. There is a well-established strategy for informing the public of new proposals, but only the broadest outlines may be given at the preliminary stage, and these may be radically altered later. Plans and models may be displayed at the town hall, city hall or in libraries, but even if people have the time to go and see them, they may not have the skills necessary to read and interpret them. A new development may take years to evolve. If people are only informed of a new proposal in its final stages, their role is often limited to the negative one of rejecting it. Their protests are then seen by planners and developers as an expensive nuisance, so the public become the 'enemy'. Many people would like their voices to be heard from the initial stages of a proposed new development, instead of at the last stages of an application. Some architects and developers see this as a threat and affront to their professional skills, rather than a two-way process, beneficial to all parties. Of course the public cannot design a building, but its involvement at an early stage adds to the information available, and replaces a confrontational 'them and us' situation by a democratic process of participation and consultation. This situation is now changing as the importance of public consultation becomes increasingly recognised. This book aims to provide those interested in the built environment and new developments with some of the skills necessary to take part in these processes.

You may wish to learn more about architecture because you feel strongly about particular buildings, or groups of buildings, but there is a great difference between appreciating or criticising architecture and understanding it. Appreciating architecture can take many forms, and many of us develop an interest in the subject because we find particular buildings or environments pleasing. The wonder of a gothic style* cathedral, the charm of rustic cottages, or the marvel of a Chinese pagoda can encourage us to find out more, and this delight can be one of the reasons why we want to take the

subject further. There may also be buildings that we detest. Appreciating architecture has a lot to do with personal attitudes and we all have our personal prejudices about most things. These prejudices can inhibit our understanding and we need to be aware of them and try to stand back from them. The ways in which people have responded to particular building forms or styles have changed from period to period and from culture to culture. These changes continue today and interpretations vary according to the taste, likes and dislikes of the period. In order to understand a building of any period, we need to be as objective as possible. We need to develop empathy with our period, so that we understand what was happening from the point of view of those who were present at the time. We examine some of the techniques that enable us to begin to do this.

Understanding buildings means what it says: going out and about and looking at buildings for oneself, not just from the outside, but inside as well. This is the only way we can begin to understand them, and the importance of first-hand experience cannot be overestimated. No photograph, film or video can reproduce the sense of form, space, light and shade, solidity and weight that is gained from a personal visit. These qualities are lost in photographs, for an external view of a building can rarely indicate how thick the walls are, or give a sense of the space around the building or inside it. Furthermore since most photographs are of single buildings, their surroundings are absent. In this book we have perforce to make do with photographs. Another advantage of visiting buildings is that a close examination may reveal how they were constructed and if they have been altered. However, with the problems of security, the number of buildings that one can visit without making prior arrangements is rather limited. Even religious buildings nowadays tend to be closed unless there is a service on, and if a service is in progress, then it is not possible to walk about. Public buildings such as railway stations, libraries, museums, stores or banks present fewer problems and provide varying opportunities for seeing a range of buildings both inside and out. Museums of building can provide excellent opportunities for seeing a range of buildings that have often been moved from their original location in order to preserve them. Archaeological sites such as the Inca town of Machu Picchu in South America, *c.*1500, or Great Zimbabwe in southern Africa, from *c.*1250, are impressive places. Such groups of buildings can be studied in their physical context, but need much interpretation owing to damage, loss and the changes brought about by tourism. Houses open to the public, such as those in the UK run by English Heritage, Historic Scotland or the National Trust, offer another excellent way of visiting buildings inside and out. There are also many amenity and specialist interest groups such as the Chicago Architecture Foundation and the Art Deco* Society of New York that arrange visits to buildings not generally accessible to members of the public. Joining these groups also provides an excellent opportunity for contributing to saving historic buildings.

The built environment consists of a wide range of building types from the earliest periods of history. Some have been considered architecture, some engineering and others have been termed building. Our understanding of the term 'architecture' is quite different today from what it was when the history of architecture first began to be studied seriously. In order to define the scope of the subject matter of this book clearly, we discuss in Chapter 2 what we mean by the terms 'architecture' and 'building' and what they include. We examine some of the broad range of buildings that have been included in the term 'architecture', and we look at traditional buildings, such as cottages or barns and other building types that have in the past been excluded. Our examples include buildings from many different periods and countries, and the captions to our illustrations indicate where they are located. Where this is not specified, then the building is in the UK. We look at the changing role of architects and at the reasons why attention has been focused so strongly on them and on monumental architecture*.

Architecture is not only about the material environment, for buildings express our aspirations, our hopes for the future and our beliefs. We look at some of the terminology used, and at what is meant by a variety of terms such as 'buildings with movement', 'buildings that speak' and 'sick buildings'. Meaning and metaphor are important parts of our subject and we look at some of the ways in which these are conveyed.

We then go on in Chapter 3 to examine what architectural history is, how the subject developed, how it has been used and how we can begin to understand it. To understand why new building types and styles developed we need to look at the social, political, philosophical, technological and economic changes that were taking place, for these provide the context of the development. We also have to try to enter into the minds of those who created and criticised the buildings at the time they were constructed. This is the only way in which we as individuals can hope to stand outside the subjective prejudices of personal likes and dislikes to which we are all prone. This is a complex task, for architectural history in its broadest sense encompasses a number of specialist areas, each of which asks different questions and applies different methods. It includes the histories of materials, of construction, and of particular building types such as public houses, temples, factories, forts, hospitals or low-cost housing. It also includes histories of building and planning legislation, archaeology and industrial building and many other areas. Each of these histories offers different insights and has enriched the subject. We look briefly at the development of architectural history as a subject and we look at some of the explanations offered to account for architectural change. Historians, writers and critics of architecture not only identified reasons for architectural change, they evaluated the architecture of their day and of the past according to their particular criteria, and we introduce some of these.

In Chapter 4 we come to the buildings themselves and their spaces and functions. Buildings may have a practical and a symbolic purpose and the

allocation of space for particular uses influences their form. The space of a building includes not only the internal space, but also the space around, under and above it: the streets, squares, plazas, landscapes, gardens and roof gardens. It also includes transitional space such as porches that link the inside and outside. We look at the size and shape of spaces and the reasons for them, at proportion and at the relationship between spaces. The allocation of living space is economically, socially and culturally determined and we include examples from many parts of the world including the Far East, India, Africa, Europe and the US. Controlling the internal environment makes it possible for us to live and work in extreme climates of great heat or cold. We examine how some of these solutions have affected building design; we look at the difference between active and passive methods of environmental control, at the spaces needed to house services such as water, electricity and sewage waste and at the implications of sustainability for buildings.

One of the ways in which architects develop their ideas and communicate them to clients and to the public is by plans*, models, photographs and computer-generated images and these are the subject of Chapter 5. We introduce the various types of plan and image and discuss some of the problems of interpreting them. Although it may be impossible to visit the inside of a building, plans and drawings enable us to see how the interior works. Models include single buildings, areas of new development, and topographical models of entire cities. Because they are three dimensional it may seem that they are easier to understand than drawings, but again there can be many issues in interpretation.

Buildings are constructed of a wide range of materials, the most common being wood and various types of stone and brick. Each material has its strengths and weaknesses and in Chapter 6 we look at some of the potential and limitations they offer. We look at the reasons for the development of particular types of material such as mathematical tiles and Wilke's Gobs – a very large brick. If buildings are to survive for any length of time they need to be well constructed and stable. We introduce the main types of construction and how to recognise them, the various means of spanning space, as well as forms of roof construction and the types of foundation that have been developed for different terrain. It is the space, function, material and construction of a building that are important in determining its form, and from this we are in a position to examine its exterior.

The exterior of a building is the part that we often see first and this forms the subject of Chapter 7. As we travel around from home to work, or out to enjoy ourselves, the exteriors that form the built environment surround us. Often these are discussed primarily in aesthetic terms, with the value of a whole building judged in terms of the aesthetics* of the façade*. Much of the debate on new developments and much of the antipathy in the West towards the architecture of the 1960s and 1970s, focuses on the subject of ornament and communication and we look at some of the issues in this debate. We respond with pleasure to many of the details on the exterior

of buildings but these often have their roots in a practical solution to a particular need. Climate, security, privacy, lighting and the expression of structure or status are just a few of the factors that influence the design of exteriors.

Many books focus on the architecture of a particular period, such as the medieval period or the 1930s, or on a particular style, such as baroque* or art nouveau*. The number of such books is indicative of the interest in this type of approach. Recognising periods and styles are important steps to becoming familiar with architecture, for they enable us to build up a vocabulary and discuss the subject with more confidence. There are many excellent books and dictionaries of architecture on the subject of particular periods and styles worldwide. Rather than providing a checklist or catalogue of the various periods and styles, in Chapter 8 we examine some of the problems of grouping buildings in this way. In many instances buildings just do not fit neatly into a particular stylistic category, nor can history be divided clearly into discrete periods and this, in turn, affects our understanding of architecture.

The location of a building is important to our understanding, for it provides the physical context. Land values, patterns of land ownership and communication networks affect decisions on building development, while the topography and orientation of the site may influence the design. The approach to buildings and their positioning in the environment, whether it is urban, suburban or in the countryside, is another important factor in our understanding of their physical context. The relationship between buildings and landscape is complex and changes from period to period. In Chapter 9 we look briefly at examples from Europe and Asia.

Environments change, cities develop, roads are built and areas change character. As a result the surroundings to buildings may alter radically and buildings may change their use or become redundant. We need to be aware of these transformations if we are to understand the physical context of buildings and we discuss some of these issues. Some environments are more attractive than others and those that we enjoy are distinctive and special. Both old and new developments may be inspiring and enjoyable but sometimes there may be a tension between the two. We look at some of the perceived conflicts between historic areas and the pressure for new development, in order to understand more clearly the relationship between the two.

In any historical subject, the facts, however they are determined, are just the starting point. The challenge comes in evaluating and ordering those facts, determining which are significant and which are not and asking questions of the material that we acquire. In Chapter 10 we indicate where to look for information, and we look at the web and at the quality of the architectural information available on it. We look at the differences between primary and secondary sources, the range of sources that are available, such as guide books, journals, title deeds, wills or company records, and the type of information that they will give us.

The aim of this book is to help as wide a range of people as possible to begin to understand architecture and all forms of building. We hope to encourage readers to look at architecture with new critical eyes and to enable them to participate in decisions affecting their own environment. Our aim is to raise questions and then indicate which paths might lead to possible answers. This book is about the subject of architecture, building and the built environment in all its forms: a vast subject that encompasses many different disciplines. It takes many years before any of us can claim to be competent architectural historians or critics, and we emphasise that here we are concerned with the first basic steps only. It is the complexity and the multiplicity of roles performed by architecture that make it such a challenge to study, for it is at the same time an art, a technology, an industry and an investment. It provides the physical framework for our lives, so it has a public role, but it is also where we live, work and play, so it has a private role. It has material form, but it also represents our ideals and aspirations. Housing, buildings for recreation, government buildings, religious buildings and town planning illustrate not only how we live, but also our aspirations for the future. Architecture is as much concerned with beauty, style and aesthetics as it is with technology, economics and politics. It is the product of architects, engineers, builders and entrepreneurs and it is used by ordinary people whose voices have until recently rarely been heard.

2 Architecture and building

This chapter looks at some of the ways in which architecture has been defined in the past and today, and at the problems of giving boundaries to the subject. It is also concerned with the reasons for studying architecture and the question of individual taste. The question 'What is architecture?' may at one level seem obvious yet there has been, and continues to be, considerable debate about what should be included in the term and we all have our own ideas and preconceptions.

According to Le Corbusier*, 'Architecture is the masterly, correct and magnificent play of masses seen in light'.[1] For him Architecture with a capital A was an emotional and aesthetic* experience, but if we restricted our definition of architecture solely to those buildings that raised our spirits, then we would end up with rather a short list. Depending on which dictionary you use, architecture is defined as the art or science of building, or as one of the fine arts. That is to say it is concerned with the aesthetic arts, as opposed to the useful or industrial arts such as engineering. When the Crystal Palace was erected in Hyde Park, London, in 1851 it was praised for its space, lightness and brilliancy and for its 'truthfulness and reality of construction', but 'the conviction has grown on us that it is not architecture: it is engineering of the highest merit and excellence, but not architecture'[2] (Figure 2.1). In some views there is a clear distinction between architecture, building and engineering, and architecture is seen as 'art', whereas building and engineering are seen as utilitarian. It is a debate that still continues. In 2002 when Wilkinson Eyre Architects won the Royal Institute of British Architects (RIBA) Stirling Prize for Architecture for the Gateshead Millennium Bridge over the River Tyne, there was considerable debate on whether it should more properly be seen as architecture or as engineering (Figure 2.2). The bridge is for pedestrians and bicycles and is the world's first rotating/tilting footbridge. Popularly known as the 'blinking eye', this design was voted for by the people of Gateshead, in a competition for a bridge to link Gateshead and Newcastle and complement the six existing bridges. This dualism between art on the one hand and utility or function on the other continues, but it is unsatisfactory for it does not address the complex interlinking of the two.

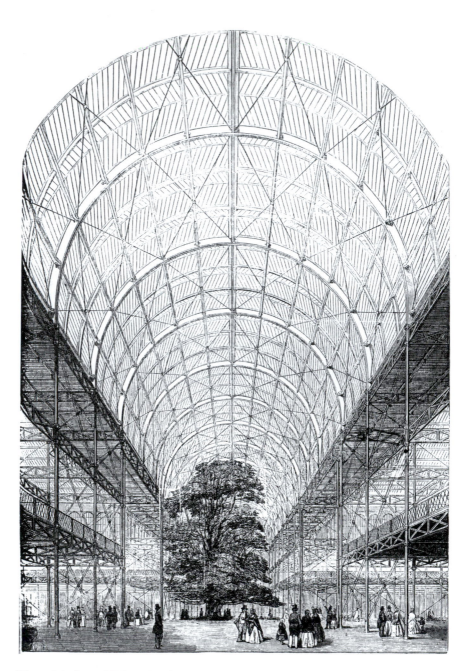

Figure 2.1 Crystal Palace, London, 1851 (Joseph Paxton)

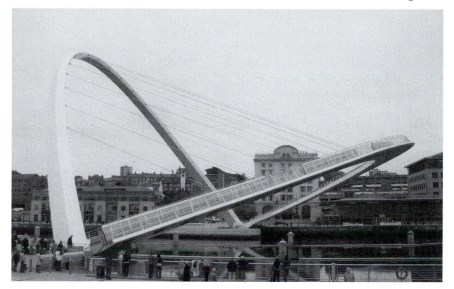

Figure 2.2 Gateshead Millennium Bridge, 2001, Wilkinson Eyre Associates

There is an enormous variety of types of building across the world, and there is still considerable debate about what should be included in the term 'architecture' and what should not. Many would agree that large, expensive and prestigious buildings representing powerful sectors of society – such as palaces, temples, cathedrals and castles, known as polite architecture – should be included, but would question the inclusion of cottages, garages or railway stations. We may enjoy the moss-covered thatched roofs and mellow walls of country cottages or admire the skill and craftwork of pole and dhaka (clay) homesteads in Africa; however because they are modest structures that professional architects did not design, some would argue that they are not architecture. Such buildings may be visually pleasing and intricately crafted, but until recently they were not deemed worth studying as architecture. These cottages and homesteads are examples of traditional or vernacular architecture*. Local builders or the occupants made them, to satisfy practical, cultural, and community needs and values. Vernacular architecture has influenced professional architects and indeed was the inspiration behind European and US arts and crafts* revivals* of the late nineteenth century. Nevertheless, it has generally been studied separately from polite or monumental architecture and has been seen as a branch of anthropology, construction history or social history. Yet, the majority of the world's population live, work and worship in vernacular buildings. In places such as the Indian sub-continent these comprise some 95 per cent of the housing stock.[3] Bernard Rudofsky's *Architecture without Architects* (New York, Museum of Modern Art, 1964) was a pioneering study of traditional architecture, and the title is revealing.

As industrialisation and urbanisation has accelerated throughout the world people have used discarded industrial materials as well as available natural materials to provide shelter. The vast shantytowns around such major cities as Rio de Janeiro or Mumbai and the 'cardboard cities' of older industrialised countries like the UK (see Figure 6.10) are also places where people live and are certainly part of the built environment. Speculatively built suburbs and mass-produced, system-built* housing estates serviced with public, retail and leisure facilities as well as the metal sheds of industrial estates are also part of the built environment. In *Learning From Las Vegas* (Cambridge, Mass., MIT Press, 1972) Robert Venturi*, Denise Scott Brown and Steven Izenour set out to show that ubiquitous commercial architecture was worthy of study by architects and urbanists. It represented a new type of urban form that needed to be understood if techniques for handling it were to evolve.

Because architecture is such a vast subject there have been many attempts to limit it, or to break it down into more manageable areas. Limiting the definition of architecture to polite or monumental works such as castles, palaces or cathedrals uses status as a way of defining the boundaries of the subject, and many of the older books adopted this stance. It has meant that those who wished to study other building types had to do so outside what was defined as architecture. Factory buildings were studied as industrial archaeology and as an aspect of labour and industrial history, railway stations as part of engineering and transport history, and steel-framed* buildings (such as skyscrapers) or iron and glass buildings (such as the Crystal Palace) as construction history. Grouping buildings according to their use, such as military, domestic, recreational, industrial or transport, is another way of subdividing the subject, as is grouping them according to the methods or materials of construction.[4]

The role of the architect

Most of us would agree that the term 'architecture' includes the great medieval cathedrals that were built in western Europe, but there has been much debate over who had responsibility for their design and the status of that person. In the past some writers argued that the monks as builders and as patrons designed these cathedrals. Others stressed the role of the master masons and emphasised the mechanics of construction, particularly of large and complicated churches, so that the architect was seen in effect as a practising engineer. Another interpretation was to see the creation of cathedrals as the achievement of collectives of craftsmen contributing their individual skills and working cooperatively. Today historians recognise the important role of the higher clergy as patrons who, in consultation with the architects, determined the form of the cathedrals. Documentary evidence from the thirteenth century provides the names of such architects as: Jean d'Orbais and Bernard de Soissons who were two of the four architects who worked

at Reims Cathedral; Henry of Reyns at Westminster Abbey, London; and William of Sens. Other evidence of the architect's role can be seen in the relief sculpture at Worcester Cathedral which shows an architect with dividers and perhaps a monk, examining what may be an architectural drawing.[5] Although the available evidence and historians' interpretations may change we still appreciate these structures as architecture, whether or not an architect was involved.

There are great variations in the architect's role. Since the late twentieth century, in some 'design and build' projects the work of the architect has declined to that of supplying outline drawings, the final detail being developed by the builder and developer during construction. Some architects may be little more than technicians or draughtspeople, while at the other end of the scale they may act as entrepreneurs and developers, particularly in the United States. A developer raises capital, acquires and assembles the site, hires a development team and when the project is complete either sells or rents the building, often at a considerable profit. Architects in this role tend to be more like business managers. The competition to design the buildings to replace the World Trade Center, New York was won in 2003 by the architect Daniel Libeskind*. However, it is by no means certain that he will retain control over what is finally built as the decisions on this rest with the developers and financiers.

The word architect derives from the Greek *archos* meaning 'chief' and *tekton* meaning 'builder'. Until quite recently – within the last 150 years – the role of the architect included surveying and building as well as military and civil engineering. Vitruvius*, the Roman architect active in the first century BC, included a whole range of examples of civil and military engineering in his influential ten-volume book, *De Architectura*. Similarly the important renaissance* architect Palladio* included designs for civil engineering as well as for churches, palaces, farms and villas in his *Quattro Libri dell' Architectura* (1570). In China there are records of named architects dating from the tenth century and the earliest surviving manual by Li Jie, *Yingzao Fashi (State Building Standards)*, was published in 1103. Li Jie worked as Superintendent for State Buildings in the Ministry of Works from 1092 and was a distinguished practising builder as well as a writer.[6] According to Hillenbrand, inscriptions on many early Islamic buildings give the date of the building, the name of the patron and that of the architect but we know little else about the architect's role until the post-medieval period.[7]

From the seventeenth century onwards in Britain, those who designed buildings were either wealthy amateurs or highly skilled building craftspeople such as masons or carpenters. By 1788 John Soane* described the architect's work as not only designing but making estimates, directing works, controlling costs, acting as agent between the patron and builders and even promoting speculative development. In the nineteenth century the work of many architectural practices included surveying, providing bills of quantities, arranging leases and assessing rents, as well as designing. With

the decline of the building trades in the nineteenth century and the rise of the general building contractor, such as Cubitts in London, architects took on the important role of supervising works on site and communicating to builders the full details of the building work required. These architects could be self-employed or salaried and working for large architectural practices, local authorities or commercial and industrial companies. Philip Hardwick* was a salaried architect working for the London and Birmingham Railway in the late 1830s. His role was to design and provide specifications for all new buildings, advertise for tenders, enter into contracts, measure buildings and superintend building work, examine and certify building accounts, direct and superintend all repairs and alterations to company buildings, collect rents and prepare plans of company property and any additional property that might be acquired, value all property being purchased or sold, attend meetings of committees and report on all business.[8]

In France the separation of civil and military engineering as disciplines distinct from architecture dates from 1747 when a school of civil engineering was set up in Paris, organised by Rudolphe Perronet. In Britain the Society of Civil Engineers began in 1771, the Surveyors' Club in 1792 and the Institution of Mechanical Engineers in 1847. Howard M. Colvin's *A Biographical Dictionary of British Architects 1600–1840* (New Haven, Yale University Press, 1995) lists over 2,000 architects. Of these only about forty were involved in building the factories that we associate with the early stages of the industrial revolution. It was the engineers who designed the machinery and it was mainly they who designed the structures to house them. The reasons for these developments relate to the changing practice of building in the mid-eighteenth century, the increasing division of labour, transformations in building technology and the emergence of new types of building. In the process, what we understand by the term 'architect' changed its meaning.

The development of the architectural profession in the UK is marked by the foundation of the Institute of British Architects, launched by T. L. Donaldson in 1834, and the setting up of chairs of architecture in the universities. Donaldson held the first chair of architecture when it was set up at University College, London, in 1841. The Royal Institute of British Architects (RIBA), as the Institute of British Architects subsequently became, was created to prevent 'the great contaminating trade element' such as builders, carpenters, cabinetmakers, ironmongers, painters and undertakers from undermining the professional status of architects. The aim of Donaldson, the Institute's first secretary, was 'To uphold in ourselves the character of Architects as men of taste, men of science and men of honour'.[9] The use of the term 'men' is significant, for women were not admitted to the architectural profession until the late nineteenth century, when Ethel Mary Charles became the first woman member of the RIBA in 1898. Women have nevertheless practised architecture throughout history although their contribution has been largely unrecognised.

Heroic architects and heroic architecture

With the professionalisation of architecture came an increased emphasis on the importance of the individual architect, an emphasis that continues today. It is in the studio that architectural students learn how to shape the spaces we live in and form our environment, and it is in the studio that the practice of architecture as a solitary creative activity is inculcated. Great architects are seen as heroes who create sculptural objects alone, often in the face of incomprehension and opposition. Alongside this focus on architects as heroes comes the disparagement from those who do not understand them, the clients, the town planners and the public. Teamwork and collaboration between architects and other disciplines, or between architect and client, are rarely emphasised and a wide range of professional architectural publications reinforces this attitude. The result of this privileging tendency is to emphasise originality and novelty, and this is also evident in current practice and in histories of architecture. It creates a predominantly aesthetic emphasis, with much less stress on the teams of people involved in the production of buildings, or the appreciation of the needs of prospective users.

The ideology of individualism and art that surrounds architecture is often in sharp contrast to the realities of practice, in which architects or builders work as part of a team. In traditional communities several family members – or local builders in liaison with community leaders – cooperate in designing and building structures. In the twenty-first century architectural practices may have offices in several continents, yet the company may be named after a single architect, or a small group of named architects. Clearly the amount of work achieved depends upon large teams in each of the offices who remain anonymous. Foster* and Partners have produced designs for buildings such as Chek Lap Kok airport in Hong Kong, the Commerzbank in Frankfurt and London's City Hall. The actual designer was not necessarily Norman Foster himself, but one of the partners, backed by a team of draughtspeople and designers. In industrialised countries architecture is often carried out within a network of political, social and economic institutions such as local authority planning, housing and environmental health departments, financial institutions such as banks and insurance companies and the changing legislation that may at one time promote development and at another seek to control it. It is necessary to be familiar with the roles of all the individuals and institutions involved in order to understand the factors that affect the built environment. If architecture is seen solely as the province of architects, whether heroic or not, then people may misunderstand their role in creating the built environment and may blame them if they do not like the results.

The nature of patronage and the relationship of architects to users are also important in understanding architecture. In vernacular architecture the men and women who design and build their own communities combine the roles of patron, designer and builder. In polite architecture, until the eighteenth

century, patrons were closely involved in the design of buildings that were usually built for their use. By the nineteenth century the clients of civic and commercial buildings could be committees of people with little knowledge of architecture. The buildings that they commissioned ranged from town halls, hospitals, workhouses and prisons to office buildings, warehouses and factories. With the rise of developers and the involvement of pensions funds and investment trusts in financing building development, many buildings are constructed speculatively. In such projects those who commission the building may be far removed from the users, and this raises particular problems for the architect who may also have little or no contact with the users. Underlying all projects is the state of the economy and the need for finance that will in many cases determine whether or not a scheme goes ahead. It can be quite difficult unravelling the contributions of all these individuals and organisations involved in the production of buildings, but it is important to do so in order to understand the final form of the building. The notion of the architect as hero and supreme artist is somewhat diminished when we consider the role of the architect in the context of these realities.

The concept of the heroic architect relates partly to the romantic view of architects as artists, partly to the ideology of individualism and partly to the perception that promoting individual architects is good for business. Indeed, several American architects, including Michael Graves* and Robert Venturi, built up reputations in the 1980s as signature architects, who were brought in after an important building had been designed inside and out, to add their recognisable signature to the façade. A number of architects have deliberately set out to cultivate the idea of the heroic architect. Major architects such as Le Corbusier and Frank Lloyd Wright* were excellent publicists and this was undoubtedly good for business.

The heroic approach to architecture reinforces the idea that it is the individual architect who makes history and so the history of architecture is the history of great architects and great buildings. Memoirs, monographs, biographies, exhibitions and films all reinforce this tendency. New research on an important but neglected building or architect remains unpublished because commercial publishers like safe, recognised subjects and do not want to risk investing in a topic hitherto unknown. The strength of this approach lies in its clearly defined subject, the individual architect. Its weakness is the tendency to isolate the architect and neglect the context within which they worked, the significant influences, the clients and patrons, the needs of the prospective users and the development of the architectural language that they used. Some architects are certainly more important and more influential than others, but it is important to recognise that individuals are products of their society and only by exploring that context fully can we begin to understand their work. There are many exemplary studies and biographies of individual architects that place their subject fully within their contexts. Among these are: A. Vidler, *Ledoux, Claude-Nicolas*, 1736–1806*, Cambridge, Mass., Ledoux MIT Press, 1983; Andrew Saint, *Richard*

Norman Shaw, Yale University Press, 1976; H. Yatsuka and D. B. Stewart, *Arata Isozaki: Architecture 1960–1990*, Los Angeles Museum of Contemporary Art, 1991; and Meryle Secrest, *Frank Lloyd Wright, A Biography*, Chicago and London, University of Chicago Press, 1992.

The counterpart to the heroic architect is the heroic building, presented as an individual star. If a sufficient number of publications focus on the same buildings then the quantity and variety of other good architecture will tend to be undervalued. The process becomes self-reinforcing and difficult to alter. With sufficient exposure to this approach there is a danger that we almost cease to see the building concerned. The Eiffel Tower is so closely linked in our minds with Paris that we cease to think about it as a structure built for a particular purpose and greeted with outrage initially. The Sydney Opera House, Australia, which was completed by Ove Arup* in 1972, six years after its architect Jørn Utzon* left the project, was voted one of the wonders of the twentieth century by readers of the London *Times Saturday Review*. It remains one of Australia's most potent symbols (Figure 2.3). Tower Bridge in London and the Taj Mahal in Agra, Central India, are other examples of cultural monuments that have become isolated from the context in which they developed (Figure 2.4). When we, the authors, visited the Taj Mahal we felt we were so familiar with its image that the reality would have little impact on us. We were quite unprepared for its striking beauty and tranquil setting. We tend to view these cultural monuments uncritically and yet accept the strength of their symbolism.

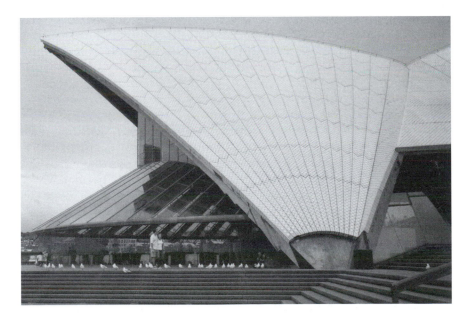

Figure 2.3 Sydney Opera House, Australia, 1972 (Jørn Utzon and Ove Arup)

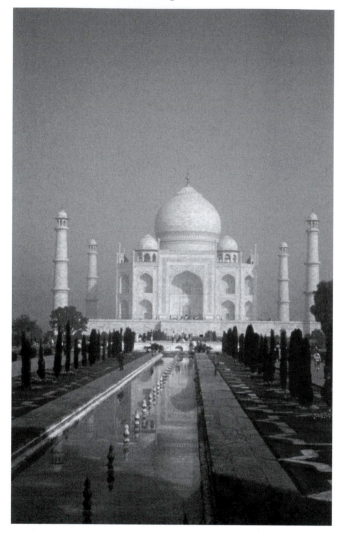

Figure 2.4
Taj Mahal, Agra,
India, 1632–47

The concept of heroic buildings has been taken a step further with the development, at the end of the twentieth century, of the iconic building as a means of cultural and economic regeneration and the promotion of tourism. So successful was Frank Gehry's* Guggenheim Museum, 1999, in the regeneration of Bilbao, Spain, that the phrase 'doing a Guggenheim' or 'doing a Bilbao' has entered the planners' language (Figure 2.5). The Guggenheim was, however, not the only new building to grace Bilbao. It was accompanied by a new airport by Santiago Calatrava* who also built a footbridge over the Nervión River and there is a new transport network with station entrances by Norman Foster and Partners. The fact that Bilbao also has an important history with buildings by major architects was for a while over-

whelmed by the emphasis on the new. The idea of heroic or notable buildings is in one sense obvious, for some buildings do stand out more than others. Lewis Mumford in his important book *The City in History* (London, Secker & Warburg, 1961) argued that cities always reflect the societies that built them. The buildings that dominated a medieval city, the church and the castle, reflected the power structure of society at that time. The major buildings in renaissance and baroque cities similarly reflected the power of church, state and royalty. Today it is commerce and banking which predominate, and the commercial skyscrapers that dominate the skyline of major cities underline this. Although heroic architecture visually reinforces the power structure in any period, this does not mean that we should concentrate our attention solely on it. To do so, or to apply a star system to architecture, would result in a very partial view of our subject, comparable in effect to restricting the study of history to that of kings and queens and the dominant hierarchy.

One of the most extensive surveys of notable buildings ever undertaken anywhere is the 46-volume *Buildings of England* series undertaken by Nikolaus Pevsner, which took 45 years to complete. Pevsner and his assistants did not restrict themselves only to obviously notable buildings such as churches and palaces, but they nevertheless had to evolve criteria to enable them to decide which buildings to include and which to omit. Bridget Cherry and her team had to make similar decisions about what to include and what to omit when resurveying UK buildings for revised editions.[10]

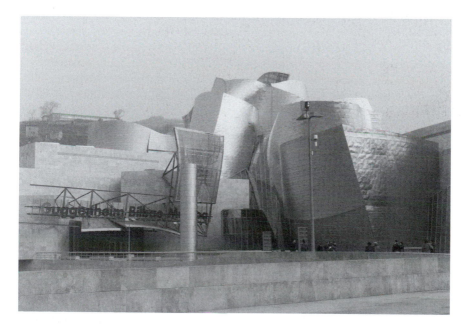

Figure 2.5 Guggenheim Museum, Bilbao, Spain, 1999 (Frank Gehry)

The key buildings that form what we call heroic architecture are only a small part of our built environment, as are the works of heroic architects. Heroic architects have not designed most of the built environment and clearly a view of architecture that ignores where the vast majority of people live, work and play would be extraordinarily limited. If we want to try to understand architecture and the built environment generally, then we need to begin to determine what is significant and what is not. For most of us, where we live is very important, yet unless we live in a palace or in a house designed by a major architect, the heroic approach would not see this as a suitable topic.

It is essential to consider the full range of buildings in any society and also, indeed, to examine those societies which at certain periods produced little architecture. In ancient Sparta there was little if any monumental architecture and the city had no city wall. Andrew Ballantyne argued that this is a most telling expression of the formidable military might of the Spartans, who required no protective architecture and lacked 'vanity and indulgence'. He contrasted this with the 'conspicuous consumption' of the contemporary ancient Athenians whose city was well known for its vast numbers of magnificent buildings for every civic function.[11] In other words the buildings that have been ignored and the everyday offer as much insight into architecture as the grand monuments. Indeed, they are essential if we are to make informed judgements about a society's priorities and achievements.

Studying any type of building is revealing whether or not an architect designed it. Every building had to be paid for, whether by a patron, the taxpayer, the builder or a commercial organisation. All buildings stand in a particular relationship to their site and to neighbouring buildings. Their form relates to their use and to the materials of which they are constructed. Their success as buildings relates to their form, construction, materials and physical context, and to how well they accommodate the functions required by those using them. They proclaim symbolic and metaphorical messages to which we respond on a variety of levels. The scope of the subject is enormous and buildings do not need to be aesthetically pleasing, intellectually stimulating or architect-designed to warrant further study.

The issue of taste

Often we are drawn into studying architecture because we have strong feelings about our environment and about what we like and dislike, but our opinions change over time as the example of the Eiffel Tower, Paris, illustrated. When the National Theatre (Denys Lasdun*) opened in London in 1975, it was thought by critics to be possibly the greatest modern building in Britain (Figure 2.6). Some fifteen years later Prince Charles thought it was 'a clever way of building a nuclear power station in the middle of London without anyone objecting'.[12]

We all have our preferences and prejudices in architecture as in anything else and our experiences determine our attitude. All of us are different, but

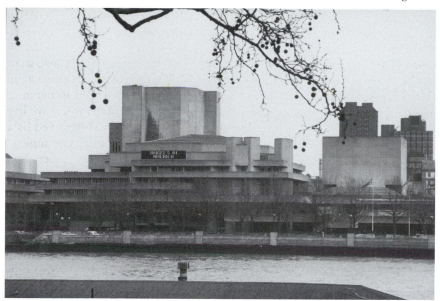

Figure 2.6 National Theatre, London, 1975 (Denys Lasdun)

it is important not to draw historical conclusions from personal likes and dislikes. Because we do not like a particular building style, it does not mean that that style was not historically important, or that the architects involved in producing such work were totally mistaken in their aims. In the mid-nineteenth century the 'Battle of the Styles' was a topic that occupied many of the foremost architects and critics of the day. It was exemplified in the UK by the debate about style for the government's new Foreign Office in London. The Liberal Prime Minister, Lord Palmerston, argued for a classical* design and rejected the winning designs of a competition held in 1856 that had been inspired by the new Louvre in Paris. The Tories, who held power briefly during 1858 when the commission for the building was still under debate, preferred gothic. The architect George Gilbert Scott*, who had come third in the original competition, promoted high Victorian gothic* through his book, *Remarks on Secular and Domestic Architecture, Present and Future*, 1857. Determined to win the commission, Scott reluctantly produced a renaissance-style design, which was built 1862–73.[13] His opportunity for high Victorian gothic soon came and at the Midland Grand Hotel (1868–74), fronting the most spectacular of the London railway termini, St Pancras, Scott designed a memorable building. More recently, in the 1960s, many architects, architectural critics, writers and historians were against historical styles and in particular any form of Victorian architecture. Their preference was for modernism*. By the 1980s taste had changed and modernism in

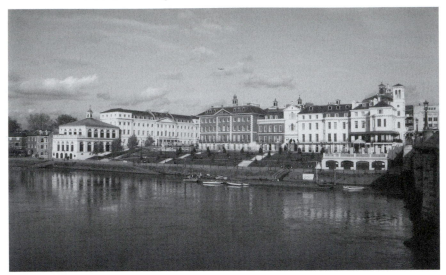

Figure 2.7 Richmond Riverside, Surrey, 1988 (Quinlan Terry)

turn had fallen out of favour. Indeed, when local citizens were given the opportunity to vote on rival plans for Richmond Riverside, west of London, Quinlan Terry's* classical design (1988) (Figure 2.7) was three times more popular than the modernist* alternative.

Trying to understand buildings in an objective way can become very difficult. If we are to try to understand the National Theatre as a building, it is no use averting our eyes and saying it is horrible. We need to look at the ideas and ideals that inspired Denys Lasdun at the time the building was being designed. We have to look at the brief of the client, at the funding, at the way crucial decisions were taken at various times during the long-drawn-out process of the building's construction. We have to look at the way the building performs, that is to say how theatregoers, actors and other staff respond to it. We also have to question the almost pathological hatred of concrete* in order to distance ourselves from today's prejudices and try to reach an understanding of the building that is as objective as possible. It is true that interpretations do change and we look at the past quite differently according to our present concerns and outlook. Different facts from the past become significant and affect our interpretations, and these in turn affect how we see and understand the present. We need to try to be as objective as possible, while recognising that our ability to be so is affected by our present assumptions and the limits of our historical period and place. Later historians may well see our interpretations quite differently, and what we find difficult to understand, or impossible to see as pleasing, may prove a delight to later generations.

Architectural terminology

If we are to understand buildings and communicate our understanding to others we need to be able to identify particular details and give them their correct name. Learning architectural terminology is like learning a new language and unfortunately there are no short cuts. In this book we introduce terms as we need them and brief definitions are given in the glossary, which is not intended to be comprehensive. There are a number of architectural dictionaries, including illustrated ones that are particularly useful for acquiring the vocabulary necessary to discuss buildings in detail. Owning your own copy is essential in order to be able to look terms up as you come across them. Acquiring an architectural vocabulary not only enables us to read about and discuss the details of buildings, it is also an essential part of acquiring the confidence to do so. One of the most direct and enjoyable ways of building up this new language is to visit buildings with a good guidebook. This will direct your attention to the most significant features to look at and, with the correct terminology, will enable you to identify them. In the UK, many of us who developed a passion for architecture acquired our architectural vocabulary largely through travelling around the country with the appropriate Pevsner *Buildings of England* in our hands. The equivalents for the United States are the volumes of *The Buildings of the United States* produced for each state by the Society of Architectural Historians USA and published by Oxford University Press. There are also guides for major cities such as the *AIA Guide to Chicago* jointly produced in 1993 by the American Institute of Architects, the Chicago Architecture Foundation, Landmarks Preservation Council of Illinois and the Commission on Chicago Landmarks.

Another aspect of architectural terminology concerns the way in which architects and architectural critics discuss architecture in books. When we hear people discussing buildings that have 'movement', that have 'masculine' or 'feminine' characteristics, buildings that are 'sick' and buildings that 'speak', we may wonder if we do indeed speak the same language. Buildings that have movement may mean that they are suffering from subsidence, or are crumbling away, but when architects and architectural writers talk about a building having movement, they could mean something quite different. If we compare a Georgian* exterior with a baroque one we see that the former has a façade that, although not flat, nevertheless presents an almost straight line to the street (Figures 2.8 and 2.9). The doors and windows are set back a little from the wall plane* and the pilasters* project slightly. Although the central three bays* are emphasised by the four columns* which project forward more boldly, we read this long symmetrical façade as a single plane modulated by the regular vertical rhythms of the shallow openings and projecting central block with its giant orders*. The rhythms or the regular spacing of openings and other features remind us of beats in music – the closer the spacing the faster the beats. In this terrace the rhythm appears

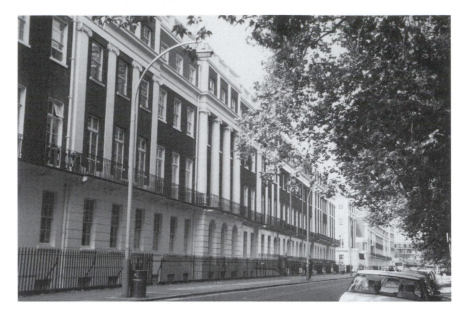

Figure 2.8
Tavistock Square,
London, *c.*1780

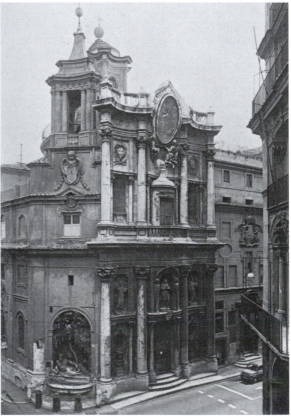

Figure 2.9
S. Carlo alle Quattro
Fontane, Rome, 1665–7
(Francesco Borromini*)

perhaps as a brisk walk. It is in this way we may speak of movement in architecture. By comparison the baroque church appears as a dynamic three-dimensional sculpture. The entrance façade almost 'swings'. Two tiers of giant orders mark the three bays. At ground level a central convex curve is framed by concave curves that are reflected, but not exactly repeated, above. Here regularity is replaced by variety and elaborate carved stonework that casts dark shadows. There are deeply carved entablatures*, sculpture, a balustrade*, and a variety of openings set within aedicules*. These varied forms and undulations give the whole façade movement. Inside, the walls undulate around the worship space, rising to an oval-shaped dome with lantern above, which we can just see on the exterior behind the parapet*.

The use of terms such as 'masculine' and 'feminine' implies that we can equate certain forms and features of buildings with a particular gender. Thus the straight lines and qualities of massiveness of a fortified castle connote masculinity, whereas curves such as those associated with the style of art nouveau connote femininity. Some see masculine and feminine attributes in a variety of architectural features: towers are phallic and masculine; domes represent breasts and are feminine. This sort of terminology and type of inter-pretation does not add very much to our understanding of architecture. Moreover, it promotes a stereotyped view of what constitutes masculinity and femininity, and is therefore something of which to be very aware.

A 'sick building' is shorthand for sick building syndrome (SBS), meaning that users become sick by being in a particular building. The indoor environ-ment causes malaise to people while they are in them and this ceases when they leave. Allergies, asthma, headaches and lethargy are the symptoms of SBS and they can result from a number of causes. Ventilation systems, the chemicals used in the building fabric, in the furnishings or in the equip-ment, dust, mould and fumes may all play a part and air-conditioned office buildings seem particularly prone.

'Buildings that speak' is another phrase that is often used about archi-tecture today. Some architectural writers argue that there is a building syntax with words, phrases and grammar, implying that buildings speak a language comparable to that which we speak.[14] Language is about communication and expression and buildings do indeed embody ideas which they express and communicate by a variety of means.

Meaning and metaphor

We experience buildings in terms of their form, their structure, their aesthetics and our use of them. This constitutes the reality of our physical experience, but buildings exist not only in reality but also metaphorically. They express meaning and give certain messages, just as the way we dress or furnish our homes gives messages about us. When Adolf Loos* entered the competition for a building to house the offices of the *Chicago Tribune* newspaper, his design took the form of a column, a pun on the idea of a

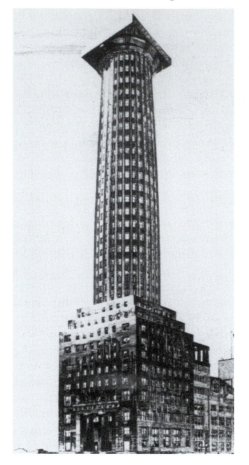

Figure 2.10
Chicago Tribune Tower,
competition entry, 1922
(Adolf Loos)

newspaper column (Figure 2.10). The dramatic rooflines of the Sydney Opera House look like seashells or sails. Its physical form, in other words, seems to refer both literally and symbolically to its maritime position and to the sailing boats in Sydney Harbour. However, the architect may have drawn upon a far wider range of experiences. Jørn Utzon had travelled widely and absorbed many influences including the ruins of the ancient Zapotec capital built on to terraced platforms on Monte Albán in Mexico, oriental temples, the structure of birds' wings and even clouds floating above the horizon. All of these may have informed his design.

Buildings are central to our need for shelter and security and they symbolise aspects of these needs in their form. A house not only provides shelter and warmth, it also symbolises home on a very deep level. A young English child drawing a house will characterise it very simply, with a pitched roof and maybe a door and windows. In the north European climate the pitched roof evolved because this was the form that shed rain and snow most

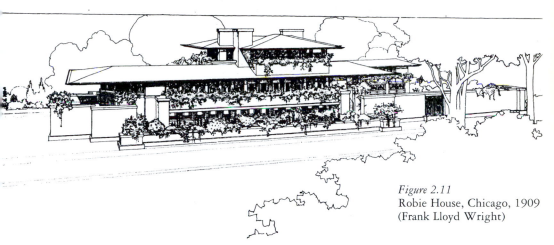

Figure 2.11
Robie House, Chicago, 1909
(Frank Lloyd Wright)

effectively. This form came to symbolise shelter, just as the chimney came to symbolise the existence of warmth. Together their message is home. Many architects have exploited this symbolism in their work, among them Frank Lloyd Wright. In his prairie houses* of the early twentieth century, the dominant features were the centrally placed hearth and chimney, symbolising the heart of the home and the dramatic roofs with large overhanging eaves* symbolising shelter (Figure 2.11).

Buildings have intrinsic meanings that result from their spatial and visible forms and extrinsic meanings that have evolved out of tradition and social use. A doorway is a means of gaining access to a building: its significance and function can be recognised from its scale and type. Thus the meaning of a door is intrinsic to it. In the housing of certain periods and places we can recognise which rooms are the most socially significant by the size of their windows. In the Georgian terrace the windows at the first-floor level are taller than the rest and indicate the importance of the reception rooms on this floor (see Figure 2.8). The exterior in this instance indicates how the interior of the building functions and this intrinsic meaning becomes part of the architectural language of the period.

The ways in which the form of particular buildings relates to their function is part of their extrinsic meaning. Because north European houses traditionally had pitched roofs, this form has come to mean home and if a flat roof was introduced it might appear alien and be disliked because of its lack of meaning and semantic content. This dislike may be rationalised in practical terms, with the argument that such roofs are inappropriate and not weatherproof, but this may not be the real reason for the antipathy.

Architecture provides the environment for our lives. Buildings are not just places of physical shelter, but places in which our social rituals are

enacted. During the nineteenth century a range of new building types evolved to house the new developments of that prodigiously inventive century. Factories, warehouses, banks, railway stations, department stores, law courts, town halls, apartment blocks and offices developed forms that were not rigidly fixed, but nevertheless became recognisable. You did not enter a theatre expecting to see the bank manager, nor did you confuse the town hall with the railway station. The overall form of these buildings communicated their purpose. Over a period of time the buildings that housed social, legal, religious and other rituals evolved into forms that we subsequently have come to recognise and associate with those buildings' function. This is a two-way process; the building provides the physical environment and setting for a particular social ritual such as travelling by train or going to the bank as well as the symbolic setting. The meaning of buildings evolves and becomes established by experience and we, in turn, read our experience into buildings. Buildings evoke an empathetic reaction in us through these projected experiences, and the strength of these reactions is determined by our culture, our beliefs and our expectations. They tell stories, for their form and spatial organisation give us hints about how they should be used, so they are a form of narrative. Their physical layout encourages some uses and inhibits others; we do not go backstage in a theatre unless especially invited. Inside a law court the precise location of those involved in the legal process is an integral part of the design and an essential part of ensuring that the law is upheld. If a building design breaks from familiar conventions we may not be able to read any message about its role and function and we could become confused or irritated. Since the late twentieth century old docks, warehouses, banks, libraries and other recognisable building types have closed down and subsequently been given new uses such as loft apartments, restaurants, bars and estate agents. Once daunting and dirty, factories and warehouses have been domesticated, with curtains at the windows and geraniums in window boxes.

Narrative architecture based on meaning and metaphor was the inspiration for Daniel Libeskind's winning design for the rebuilding of New York's World Trade Center (WTC) site. The competition for the Ground Zero design involved public consultation from the outset, and the significance of the site ensured a higher international profile than any previous architectural competition. Libeskind was chosen from a shortlist of nine and he and Rafael Vinoly of Think, the other finalist, campaigned as vigorously for their respective designs as if they were political opponents. Daniel Libeskind sprang to fame partly as a result of two completed buildings, the Jewish Museum, Berlin, 1989–98, and the Imperial War Museum North, Salford, 2002.[15] What these buildings share with his designs for the World Trade Center site is the ability to communicate: each has a narrative. The Jewish Museum is part museum and part monument. Lines connecting the points in Berlin where Jews lived and the broken Star of David are among the symbolic references that generated the fractured, zigzag forms and slit

Figure 2.12
Jewish Museum,
Berlin, 1989–98
(Daniel Libeskind)

openings in the walls (Figure 2.12). At its heart is a tall void, the Holocaust Tower, a narrow, dark grey, triangular space some three storeys high, very quiet, with no sound from the world outside, dimly lit from a vertical strip window at the top of the apex of the triangle. This powerful, frightening space dramatises and symbolises absence, evoking the memory of those millions of Jews killed in the Second World War. At the Imperial War Museum the intersecting curved fragments of the design speak just as much of a world shattered by conflict as do the military exhibits on display inside. The challenge of the WTC site was to provide a memorial for those who lost their lives on 11 September, 2001, while at the same time providing sufficient prime office, commercial and retail space for the developers. Before working on the project Libeskind visited the site in order to find its voice. His winning design showed torn, shard-like business towers rising around

the centre of remembrance, the sacred space at the heart of the design, the grave of so many who lost their lives. The design includes the tallest tower in the world, reinforcing the message of US indomitability.

At various periods a new language of forms and a new architecture were consciously evolved. One of the aims of modernism in the 1920s and 1930s was to try to evolve a new architecture fitted to the twentieth century, based on new materials, new techniques of construction and a rethinking of the design of buildings. It tried to liberate architecture from an obsession with style and its aims were universal. Modernism became an international force, but in so doing modernist buildings tended not to respond to particular cultures or to particular environments (Figure 2.13; see also Figures 7.6 and 8.3). These modernist buildings are located in the UK, the US and France and each is distinctly modernist, but there is little in their design or materials to indicate where they are located. By contrast, in the 1980s postmodernism* tried to reassert a sense of local identity. Postmodern architecture was essentially about communication. Initially postmodernism was a reaction against the high-rise apartment blocks, the commercial developments and the use of concrete that was associated with modernism in the 1960s. Such architecture alienated people, said the postmodernists, because it did not communicate, so postmodernism set out to communicate. This it did by borrowing styles from previous periods, or by 'quoting' details from adjacent buildings and the surrounding environment. New housing developments could be neo-Georgian*, or incorporate elements such as gables*, dormers* and tile hanging* which derived from traditional architecture of the pre-industrial era. Postmodern commercial buildings featured classical, gothic and many other styles on their façades as a means of communicating and as a way of attracting prestigious clients. These elements were restricted to the exterior of the building and became in effect a mask which had little or nothing to do with what went on inside. Richmond Riverside, 1988, is an office development by Quinlan Terry on the river Thames that is widely liked by the local residents of Richmond (see Figure 2.7). They liked its scale, which is in harmony with the adjacent townscape, the variety of the materials used and the traditional feel to the whole complex. This has been achieved by using a classical vocabulary that was claimed by the architect to constitute 'real architecture'. Real architecture in this particular instance meant solid brick walls and slate roofs, or roofs hidden behind parapets and classical elements which according to the architect are eternal and universal, and therefore appropriate to all periods. The complex looks like a series of eighteenth-century town houses, but Terry has applied these recognisable classical models to new buildings and a new purpose: commercial offices. He did not evolve a new classical language out of the past, as happened in the time of the renaissance, and many critics thought that the ultimate effect of his design was one of pastiche, a stage set which clashed discordantly with the clearly visible open-plan offices within. Others, including many Richmond residents, argued that Richmond Riverside is a series of 'real' neo-

Figure 2.13 Connell, Ward and Lucas, 66 Frognal, London, 1938

Georgian buildings and since Richmond is a largely eighteenth-century town, Terry's design is true to its context and appropriate, although it would not be appropriate for the modern commercial centre of, say, New York or Paris.[16]

Architecture today

The whole subject of architecture is acquiring a thorough overhaul as a result of current concerns for today and for the future. Its content and the approaches to it are being widened, as we explore in later chapters. Today we accept that it is just as valid to examine an industrial structure such as a gasholder as it is to examine castles, cathedrals and dwellings of all types (Figure 2.14). Indeed, as gasholders have become redundant they have found a range of new uses such as dwellings, art centres and scuba-diving centres. Stylistic analysis and the search for the principles of beauty are still with us and we all want to improve our environments, but we no longer seek to do this in isolation or just in terms of individual buildings, but in terms of the built environment as a whole. Greater awareness of what architecture is about is vital if we are to develop environments that mean something to us all. We need to understand how we have arrived at today and that means that we need to see today within the context and perspective of the past. Understanding history helps us to understand our development; it empowers us to work for a better future and prevents us from passively accepting what we find

Figure 2.14
Gasholder,
Battersea, London,
*c.*1880

unacceptable, whether as the users of architecture, as architects or as architectural critics. Architecture affects everyone and so we all need to take responsibility for it, but we can only do so when we understand more about it. Architecture is something to be enjoyed and shared. If it is shared more widely as more people understand it, then the chances are that the urban environment will improve and architects will no longer be seen as responsible for all that we dislike in it, but as part of a team which enables us to achieve our ideals.

3 Architectural history

Architectural history is like other histories in that it is concerned with understanding and finding explanations for the past. Where it differs is in the nature of the evidence available and in the techniques developed to evaluate that evidence. In its initial stages any historical study involves collecting facts. In order to make any sense of those facts they must be selected, ordered, evaluated, interpreted and placed in context. E. H. Carr in *What is History?* (Harmondsworth, Penguin, 1964) explains this very clearly. History begins today, but one of the main difficulties about studying the recent past is the sheer volume of information available and the problem of determining what is significant and what is not.

Architectural history is different from antiquarianism, nostalgia and the theme park industry. Antiquarians love ancient objects and buildings, and facts about them, because they are old, but they may not necessarily be interested in the reasons that lie behind their development. Nostalgia and the theme park industry are about escaping into the past in order to enter a different world, a world that may be of beauty and interest, but one that may have little to do with the realities of that past. There is nothing wrong in visiting theme parks or enjoying nostalgia so long as we are aware that we may be seeing a partial or distorted picture of the past.

History is about trying to understand the past in a critical way, its negative as well as its positive features. It is a dynamic process, not static, and the history unfolding before our eyes, the present, is part of that process and informs our understanding of the past. History is not a jigsaw puzzle that can be completed and put away. We continually come to the subject with new questions, historical interpretations are always open to reinterpretation and there will never be a time when we can claim we know all there is to know about, say, medieval architecture. Yet, studying the past can help us understand how we have arrived at today and give us insights into the production and use of built environments.

Historians use evidence in order to understand what happened and why it happened. In architectural history this evidence may take the form of the buildings themselves or their remains, and documents such as plans, drawings, descriptions, diaries or bills. Our picture of any period of history is

derived from a multitude of sources, such as the paintings, literature, deeds, buildings and other artefacts that have survived. The problem of survival lies at the root of many of the historian's problems, for what has survived may not necessarily be more significant than what has not survived. The Egyptian pyramids have survived thousands of years, but historical significance is not just a question of durability. These buildings were part of a rich and diverse culture, much of which has been lost. They are historical facts, but facts by themselves, even such massive facts as the pyramids, are just the first stage in any historical study, and until they have been evaluated, placed in context and interpreted, they tell us little. Different historians may place different values on the same facts, and the discovery of new evidence may modify or change existing theories and interpretations.

Historiography

Architectural history, like any other branch of history, is not a static subject; interpretations often change quite radically, with new evidence and as perspectives vary. Historiography is the study of the ways in which historical interpretations change. The tastes at one date may lead to once underrated architecture being completely reinterpreted. In the 1950s and 1960s Victorian architecture was despised, particularly by modernists who could see nothing to commend it. Yet, today, we enjoy its richness and complexity and seek to preserve it wherever possible. This is not a modern phenomenon. Giorgio Vasari*, the renaissance architect and painter, noted in *The Lives of the Most Eminent Painters, Sculptors and Architects*, 1550, the decline in the arts at the end of the Roman Empire. He described Byzantine* buildings as 'lacking in grace, design and judgement as far as style and proportion were concerned'. The subsequent gothic or 'German style' he thought 'barbarous . . . showing little grasp of sound architectural principles'.[1] Vasari was writing at a time when medieval feudal society and culture had disintegrated and a new rationalist, humanist, renaissance culture had developed. To sixteenth-century Italians the works of the medieval period or middle ages seemed old fashioned and even foreign (brought in by a Teutonic people or Goths), as architects sought to recover their architectural roots in Roman classical architecture. Eventually renaissance ideas spread throughout Europe, but were themselves challenged by archaeology and detailed research in the eighteenth and nineteenth centuries. This contributed to a recovery of an understanding and appreciation of medieval architecture, known as the gothic revival.

More recently the search for an alternative to the forms of modernism adopted internationally has led to a recovery of regional and historical architecture. Vibhuti Sachdev and Giles Tillotson in their book *Building Jaipur, the Making of an Indian City*, London, Reaktion Books, 2002, argued that the present revival of traditional Indian architectural forms, textures and materials lacks engagement with the theoretical system underlying the

buildings. They analysed ancient historical architectural texts as far back as the fourth and third centuries BC and studied the pre-colonial city of the early eighteenth century, Jaipur. In so doing they uncovered the evolving tradition of Indian architectural theory and built form known as *vastu vidya* (architectural knowledge). Their study challenged current interpretations of India's cultural heritage and stimulated innovative research into built form as a result of the engagement with contemporary architectural debates.

Historiography is not just an issue of changing tastes. New challenges and ideas encourage us to ask different questions, questions that had hardly been thought of previously, or if they were, only by a very few. One such example concerns the role of women in architecture. In her research, Lynne Walker argued that in the seventeenth and eighteenth centuries some women were engaged in public building projects and businesses allied to building trades, but it was mainly educated upper-class women with the money and time who practised architecture as amateurs within the family estate. They might design the country house and its decorations or, by the nineteenth century, improve estate cottages. Work in the commercial world for women was frowned upon in the nineteenth century, but it was acceptable for middle-class women to engage in philanthropic projects such as housing for the poor. The commemorative chapel for the painter G. F. Watts at Compton, Surrey, 1898–1904, designed by Mary Watts, his wife, was unusual. Discrimination and social attitudes contributed to women's marginalisation and restricted their work largely to the domestic sphere. Some contemporary women architects have responded by seeking out public and commercial projects, shunning the traditional women's sphere of domestic architecture. Others, Walker argues, deliberately accepted 'the stereotype of women having a special concern for the family and house design'.[2] Since architecture is a social art, we could argue that we need both female and male architects from every background, regardless of class, religion or ethnicity, to bring their particular insights to the whole built environment. Historical research, in other words, can explain what has happened in the past but cannot offer a simple guide to future action. It is important that we are aware and critical of the ways in which our own attitudes have been constructed.

Asking different questions about the past can lead to changes of emphasis and new interpretations. When Tim Mowl was researching Bath for his book *John Wood: Architect of Obsession* (Bath, Millstream Books, 1988), he found that John Wood* (the elder) had surveyed Stonehenge and the moon temple at Stanton Drew (Figure 3.1). The diameter of the Circus at Bath is 318 feet, the same as that of Stonehenge and this was, so Wood argued, equal to 60 Jewish cubits, that is to say the dimensions of the second temple at Jerusalem (Figure 3.2). Bath was the first Masonic city of England and John Wood was a typical member of the Society of Freemasons. He was convinced that Bath had been the principal Druid centre of Britain. He based his design of the Circus not on the Roman Colosseum, as previous writers had assumed (which in any case was elliptical) but on the most important remaining Druidic

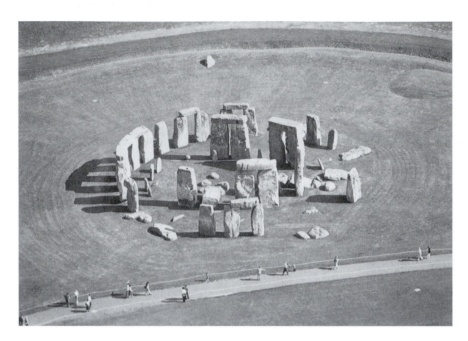

Figure 3.1 Stonehenge, Wiltshire

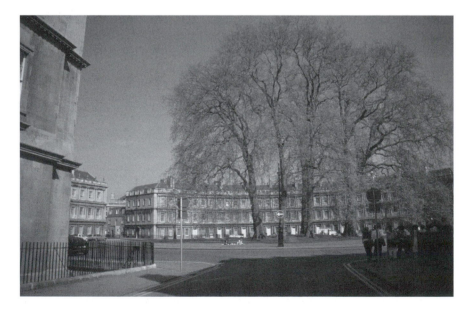

Figure 3.2 The Circus, Bath, 1754
(John Wood, the elder)

edifice in the west of England, Stonehenge. By examining and questioning the historical evidence Mowl arrived at a new interpretation of one of the most important architectural features of Bath. Yet, he was advised by other well-established figures in this field not to mention Wood's emphasis on Druids as his book might then not be treated seriously. As different facts become significant they affect our interpretation of both past and present and the process is dialectical.

Histories of architecture and their development

Architectural history is concerned with understanding all types of building and studying the built environment in its many different historical contexts. It involves a wide variety of approaches and so consists of many histories, not just one. The subject is in a sense as old as architecture itself, but in another sense it is a comparatively new one. The first Society of Architectural Historians was founded in the United States as recently as 1940. Because the separation of architectural history as a discipline distinct from that of architecture is comparatively recent, architectural histories have in the past tended to be written mainly by architects. From the period of ancient Greece and Rome until the sixteenth century, architectural critics wrote about contemporary architecture. In the sixteenth century this changed. Vasari, writing about the architecture of his day, placed it in the context of past architecture as a means of justifying the superiority of contemporary work.[3] The idea that architecture progresses and the buildings of one period are better than their predecessors is a theme that runs through much of the writings on architecture from the sixteenth century onwards and is still evident today. In their historical writings architects took a polemical stance, using the past to justify and validate the present. In many periods they have been strongly influenced by the architecture of the past, either reacting against it in order to establish a new and 'better' architecture, or by finding inspiration from it. As we have seen, the surviving remains of ancient Roman buildings in Italy provided a positive inspiration to the architects of the early renaissance there. By contrast, to A. W. N. Pugin*, intent on re-establishing gothic architecture in the UK at the beginning of the nineteenth century, classical architecture was pagan and inappropriate for Christian churches. His negative attitude was an important part of his argument for the merits of the gothic, which gave renewed vigour to the gothic revival*. In these examples the new contemporary architecture was seen as an improvement on what had immediately preceded it.

The eighteenth century was an important period for the development of architectural history. Instead of simply seeing contemporary architecture as an improvement on the past, some architects and intellectuals began to appreciate past periods and styles of architecture and differentiate between discrete phases with distinct merits. They examined earlier architecture in order to establish criteria for measuring great architecture and to support current

practice in fresh ways. As in the earlier centuries they also used past princi-
ples as the basis for new architecture. Johann Joachim Winckelmann*
(1717–68) is sometimes called the father of modern art and architectural
history. His *History of the Arts of Antiquity* was published in Dresden in 1767,
but it was not the first work of its kind. J. B. Fischer von Erlach* (1656–
1723), one of the leading baroque architects in Austria and designer of the
Karlskirche in Vienna (1716), published an earlier history, *Outline of Historical
Architecture*, in Vienna in 1721. It included Egyptian, Chinese and Islamic
buildings and was an early comparative history of world architecture. In
France the earliest group of architectural historians was associated with the
circle around the Académie Royale d'Architecture, founded in 1671. In 1687
J. F. Félibien (1658–1733), secretary of the Académie, published *The History
of the Life and Works of the Most Celebrated Architects*. Unlike Vasari, this
provided an account of past architecture that did not interpret it as a prelude
to the superior architecture of the present day.

The eighteenth-century enlightenment encouraged the development of
architectural history. During this period many intellectuals questioned the
basis of society and everything that had been taken for granted: religion,
the monarchy, aesthetics and history. It was this questioning which paved the
way for the French revolution and the industrial revolution. The enlighten-
ment examined the past in order to discover why the world was as it was and
the alternatives. Excavations of Pompeii and Herculaneum began to reveal
something of the past, as did visits to ancient classical sites and to Egypt. The
newly developing subject of architectural history tended to be encyclopaedic
in scope and to concentrate on form, styles and heroic building types. In the
United States the development of architectural history in the nineteenth
and twentieth centuries was strongly influenced by both Germany and France.
Hundreds of American students studied architecture in Paris at the École des
Beaux-Arts* and associated studios, and took that influence home with them.
The close ties between American and German scholarship in the area of archi-
tectural history persisted during the major part of both centuries.[4]

Scope

In any new and developing subject the first problem is to identify and cata-
logue the material that forms its core. Early histories of architecture identified
and differentiated between different periods and different geographical areas
primarily through an analysis of architectural form and style. One book
based on this approach is still in print after almost a century and is familiar
to generations of architectural students as 'Banister Fletcher'. *A History of
Architecture for the Student, Craftsman and Amateur, being a Comparative View
of the Historical Styles from the Earliest Period* was first published in 1896
(London, BT Batsford). Subsequently called *A History of Architecture on the
Comparative Method*, the eighteenth edition published in 1975 became simply
A History of Architecture. The comparative section was omitted from this later

edition partly in order to keep down the size of the publication. The original method adopted by the father-and-son team was to apply the techniques of comparative anatomy and comparative biology to architecture. *History of Architecture: Centenary Edition* is the title of the twentieth and most recent edition. This was published in 1996 and edited by Dan Cruikshank (London, Architectural Press).

Comparing and contrasting buildings in order to reveal similarities and differences is still a technique that is applied today by both critics and historians and it can be a useful one if the buildings being compared have something in common. For example, it can be revealing to compare a mosque in the UK or the United States today with one built in the Indian sub-continent or in the Middle East, or an ancient Roman arena with a modern football stadium, since each pair is concerned with similar functions. There would, however, be little point in comparing buildings that had nothing in common, such as a Roman arena with a Victorian church. The technique has also been used for didactic purposes. A. W. N. Pugin's *Contrasts* (1836) was a polemical blast against what he saw as the horrors of the architecture

Figure 3.3 An early Victorian town compared with an imaginary medieval town
(A. W. N. Pugin, *Contrasts*, 1841 edition)

and urban environment of the time. In the 1841 edition of this book Pugin juxtaposed illustrations contrasting the negative qualities of contemporary cities and their architecture with the positive qualities of the medieval equivalent (Figure 3.3). In so doing he celebrated the virtues of gothic architecture and at the same time drew attention to what he considered the 'barbarism' of the classical architecture of his day. The walled medieval town with church spires punctuating the skyline is surrounded by open countryside. In the nineteenth-century town, factories and factory chimneys vie with the spires. The open fields now feature a lunatic asylum, a gas works and a radially planned prison, and a classical church has replaced the medieval gothic one.

Architectural history developed in Europe, and although Fischer von Erlach included non-European architecture in his early history of the subject, the main focus of study has been European monumental or polite architecture. Often if the architecture of continents other than Europe or North America was discussed, it tended to be from a Eurocentric and colonial point of view. This is evident in the judgements made by James Fergusson, a successful Scottish businessman, amateur historian and traveller, who wrote the *History of Indian and Eastern Architecture* in 1876. His subject was enormous, covering many religions, cultures and periods. He focused on technical and aesthetic questions and praised the variety and originality of buildings in such diverse areas as India, Pakistan, Bangladesh, Burma, Cambodia, Java, China and Japan. Nevertheless he selected and saw buildings through Western eyes and constantly made a negative comparison with European traditions. Of the Indian civilisation he stated that it:

> may contain nothing so sublime as the Hall at Karnac, nothing so intellectual as the Parthenon, nor so constructively grand as a medieval cathedral; but for certain other qualities – not perhaps of the highest kind, yet very important in architectural art – the Indian buildings stand alone.[5]

Rather than recognise that different periods, countries and cultures have different priorities in their architecture, he used Western architecture as the benchmark.

The 1901 edition of Banister Fletcher included one section devoted to what Fletcher called 'the Non-Historical Styles' such as Indian, Chinese and Japanese as if there was just one style in each of these regions and there was no evolution or change. This section also referred to the 'Saracenic style'. The misleading term 'Saracenic' is one that Europeans originally used at the time of the medieval crusades to refer to Syrian and Middle Eastern Muslims. In India in the late nineteenth century British colonialists coined the term 'Indo-Saracenic'. They applied it to a style of Indian colonial architecture that borrowed eclectically from a wide range of Indian architectural traditions, Hindu, Buddhist, Jain and secular and sacred architecture of the Muslim

Figure 3.4 Great Zimbabwe ruins, thirteenth century

period in India. This is now often called Indo-Islamic architecture. The name Islamic is also a Western construct and it raises further questions. We rarely refer to Christian architecture, and if we do, we would probably mean Christian religious architecture such as cathedrals, churches and clergy houses. References to Islamic architecture, however, often apply to all building types in Islamic countries, in lands that Islam conquered, or where there are large Muslim communities, such as tropical Africa or Indonesia. It is also applied to the architecture of the Islamic diaspora in western Europe and America.[6] Until 1959 Banister Fletcher omitted any reference to African architecture. To those sharing this overwhelming European focus it was impossible to believe that a major African building such as the thirteenth-century Great Zimbabwe ruins could have been built by the local people; it was argued that early Arab or European traders and explorers must have built it (Figure 3.4). Vernacular architecture belonging to any region continues to be ignored in Banister Fletcher presumably because it is regarded as low status and the buildings are often impermanent. We need to identify the prejudices of the historian and be wary of Eurocentric value judgements that still overshadow discussions of vernacular buildings, or those of colonised people and their successors.

Theories and histories of architecture

Given the all-embracing nature of architectural history, its wide geographical spread, chronology of thousands of years and wide range of building

types, it is perhaps not surprising that it has been broken down into a myriad of specialisms. This has led to many separate societies and journals. Some take an aspect of the subject and study it in more detail; others develop new theories and approaches. The UK Construction History Society focuses on the history of structural design and the history of building practice. John Summerson wrote at the inauguration of the society and its journal in 1985 that:

> For the past thirty five years 'history of architecture' has meant history of style, patronage and theory. We now have a pretty fair command of these subjects. There is a tendency now to look more deeply into the social, economic and industrial hinterland.[7]

While such studies bring valuable new insights to the subject, the dangers of the specialist group are that their researches remain with the specialists and that they can be reductionist in focusing on a particular facet at the expense of other aspects of architectural history.

The quest for understanding why the architecture of any place or period developed as it did has led to many theories. These have helped historians to understand the production and use of the built environment and helped to define organising principles for selecting and differentiating between the wealth of information. But they have been challenged. The theories generally fall into four main groups: rational, technological and constructional; material, economic and social; religious, cultural and philosophical; and the spirit of the age. Theories of architectural change are linked to approaches to the discipline of architectural history and to value judgements in architecture. They can say as much about the historian, as identifying reasons for the emergence of particular built forms.

Technical and materialist theories

The technical and rational theory of architecture tends to seek answers either in terms of new technological or constructional developments, or as the result of applying logic to technological or practical problems. If we look at the medieval cathedral according to this theory, then the reason why gothic cathedrals evolved their complex forms was in response to the practical problems posed by building high buildings, spanning wide spaces and incorporating increasingly large glass windows. Buttresses*, for example, evolved primarily to prevent the main walls of the cathedral, with their large glass windows, from being pushed outwards by the load of the roof (Figure 3.5). Clearly many medieval buildings reveal great engineering prowess but medievalists today would question this view. There are many instances where it is difficult to distinguish the priority of construction over aesthetics. The dramatic scissor arches at Wells cathedral do carry the load of the vaulted roof to the ground, but their ornamental form is not necessarily the most

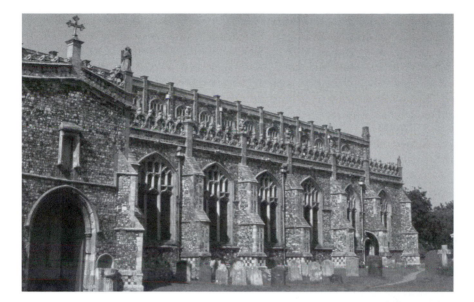

Figure 3.5
Buttresses at Holy Trinity,
Blythburgh, Suffolk,
fifteenth century

Figure 3.6
Scissor arches, Wells
Cathedral, 1338–48

direct and economic way of doing so (Figure 3.6). There is also uncertainty
as to how far medieval builders understood the behaviour of materials.
Medievalists have argued that medieval architects used older, well-tried
and practised systems of geometrical proportions and relied on good luck
as to whether the building would stand up. As for the concern for height,
this seems to have been an option but not a necessary requirement and
again raises questions about the primacy of new constructional techniques.[8]

The technical and rational explanation of architecture was an approach largely developed by French architects and theorists such as Laugier*, J.-N.-L. Durand* and Viollet-le-Duc*. Known as rationalists they also argued that merit in the architecture of their own day should come from giving priority to the logic of the essential structure or supporting elements of a building.

The second theory argues that architecture reflects the material, economic and social conditions of the time. It therefore seeks to set architecture in this context. Buildings are related to the social and economic system that has encouraged certain social relationships, methods of exchange and manufacture. These give rise to particular patterns of patronage and consumption, techniques of construction, building types and planning. This focus on the material conditions, however, denies the role of the patron and architect and fails to account for the diversity of expression at any one time.

Religious and cultural theories

The theory that architecture expresses the religious, cultural and philosophical ideas of the period implies that if we know enough, it should be possible to forecast what the architecture will be. But in a sense this begs the question, for what is sufficient knowledge? It also implies a simple and direct relationship between architecture and these ideas, rather than acknowledging that all societies and their cultural manifestations are complex organisms. For A. W. N. Pugin, all buildings reflected the society in which they were built, but the greatest influences on the various styles of architecture were religious ideas and ceremonies:

> every ornament, every detail had a mystical import. The pyramid and obelisk of Egyptian Architecture, its Lotus capitals, its gigantic sphinxes and multiplied hieroglyphics, were not mere fanciful Architectural combinations and ornaments, but emblems of the philosophy and mythology of that nation.[9]

A devout Catholic architect and theorist, Pugin had an idealised view of medieval history and architecture. He argued in *True Principles of Pointed or Christian Architecture* (1841) that gothic was not a style, but a set of building principles that were as relevant to the 1840s as to the medieval period. For example, the religious principle of truth was expressed through the principle of architectural truth. Constructional truth meant that the construction of a building was evident and not concealed; ornament was used, but it did not obscure the construction and it was appropriate in form and meaning. Truth to materials meant that all materials were chosen for their particular qualities and not painted to look like other materials. It was through architectural morality that he argued that some architecture such as classicism* was unacceptable for Victorian England, because it was pagan and symbolically inappropriate, and that some was untruthful, for example coating brick walls

with paint or stucco. Despite their religious origins, Pugin's ideas on architectural morality were developed by John Ruskin*, William Morris*, Greene and Greene* and others and provided the inspiration for such widely differing movements as the arts and crafts movement* and modernism.[10]

Structuralism* is a more recent theory that focuses on religious, cultural and philosophical ideas and derives from structural anthropology that Claude Lévi-Strauss pioneered in the 1950s and 1960s. He was influenced by the theories of Ferdinand de Saussure, a Swiss linguist, who argued that spoken language was a code that determines what messages are available and that it was a self-sufficient system with sets of rules independent of 'reality'. Structuralists have studied buildings not as isolated cultural artefacts but as part of a total system of 'constructed' knowledge involving the whole culture, its myths and rituals. They have examined individual cultures synchronically, or at one point in time, as a single system of meanings like a language. The culture was 'read' like a text revealing that buildings were inextricably interwoven with the people's ideas, social structures and ways of life.[11] This approach has been particularly effective in studying vernacular architecture. Climate, ecology, available materials, technical knowledge and the character of the local economy provided a framework of possibilities and constraints for what was constructed and a way of understanding vernacular dwellings and community buildings. However, it was clear that the diversity of solutions, whether of specific layouts or forms, indicated there was also an important social and cultural input.

The timber and clay 'hogan' or winter dwelling of the matrilineal Navajo people of the south-west of the US was a single-room dwelling with central fireplace and smoke-hole in the roof. Structural anthropological research revealed that the building was a dwelling and a sacred space, a site of rituals and an expression of the people's myths. For the Navajo the forms were a divine gift to the people from their deity, Talking God; they had cosmological meanings and required the enactment of rituals. According to Nabokov and Easton 'hogans are thought of as "alive" and require periodic purification and feeding'. The hogan was roughly circular to symbolise the cosmos. Each of four structural poles represented a cardinal point and was associated with an individual female deity. The entry always faced the rising sun in the east. Invisible boundaries within led to strict gender divisions: men and their possessions to the left or south, women to the right or north. Shamans and important visitors were seated to the west in the place of honour. People moved within the hogan in a clockwise direction representing the movement of the sun. The segmental curve of the roof represented the sky and was male, whereas the slightly hollowed out floor represented the earth and was female.[12] The theories of structuralists have added immeasurably to our understanding of buildings. Architectural historians might also wish to investigate the tension between the forms as carriers of symbolic meaning and as a product of physical and technical constraints. They would also want to undertake research into the historical sources of the design. For example,

Nabakov and Easton have pointed out that the excavation of the hogan floor derived from Pueblo practice.[13] This reminds us of the diverse origins of constructional and decorative features and the way that they can take on different meanings in different contexts.

Zeitgeist *theory*

A fourth theory sees architecture as reflecting the spirit of the age, or *Zeitgeist*. This theory came from the German philosopher Hegel and provided a conceptual framework for understanding the historical development of art and architecture for the major part of the twentieth century. Central to the concept of the *Zeitgeist* is the idea of history as a progressive process. The process of history which gave rise to each period was an evolving 'spirit', which pervaded and gave unity to every area of human endeavour – religion, law, customs, morality, technology, science, art and architecture. Every historian identifies and classifies material, and in the process common ideas and themes become apparent. Those who accepted the concept of the *Zeitgeist* argued that styles such as neo-classicism* in the mid-eighteenth century, modernism in the 1920s or deconstruction* today showed themselves across the arts. Because these styles were evident in architecture, painting, furniture, ceramics, dress and literature they were manifestations of the *Zeitgeist* and the similarities in the work of architects, painters, designers and writers were the result of living in the same period. Another interpretation of this theory argues that although many styles may coexist at any one time, only one major style truly reflects the *Zeitgeist*. The danger of this explanation is that it encourages the search for consistency in order to build a coherent picture. Anything that does not fit into this picture is ignored or undervalued, as it does not show the all-pervading *Zeitgeist* spirit.

In an attempt to establish modernism as the only true style, early twentieth-century historians such as Nikolaus Pevsner and Siegfried Giedion employed the concept of the *Zeitgeist*. Well before modernism had reached the pre-eminence that it achieved after the Second World War, they identified the main features that distinguished the modern world of the twentieth century from preceding ages. These included the mass market, new power sources, materials such as glass, steel and reinforced concrete, new forms of transport and increasing urbanisation. They saw modernism as a coherent style based on these features and thus it accorded with the spirit of the age. Many avant-garde architects and designers explored novel forms appropriate to the new materials and technology and particularly welcomed urban projects for mass housing, health centres and industrial buildings. The term machine aesthetic* summed up this new approach, which was not just concerned with style but had deeper concerns with new forms for a consciously modern, socially progressive society (see Figures 2.13, 7.6, 8.3). Between the two World Wars modernism was practised by only a small group of architects and designers, located mainly in western Europe.

It coexisted with other styles such as art deco, classicism, the domestic revival* and national romanticism*. However modernist historians did not see those styles as genuine products of the age but, rather, as the result of crass commercialism, wayward individualism or as the archaic remnants of styles belonging to previous periods. The theory presupposed a value judgement.

The concept of the *Zeitgeist* seems to have informed Dennis Sharp's approach in *A Visual History of Twentieth Century Architecture* (London, Heinemann, Secker & Warburg) which was first published in 1972. From the title we might expect a broad survey of building in the twentieth century, but this is not the case. The works that Sharp selected were those that he was able to group together as modernist. Like his predecessors, Pevsner and Giedion, Sharp found in modernism what he believed was the true and ultimately hegemonic style of the period. Few today would find it satisfactory that all the other building styles produced throughout the world in this century have been ignored and Charles Jencks in *Modern Movements in Architecture* (Harmondsworth, Penguin, 1973) has even questioned the existence of a unified theory and practice called 'modernism'.

Today the most familiar theories and approaches are being questioned. Architectural histories reflect the impact of feminist, Marxist*, structuralist, environmental, semiological* and socio-political ideas. The subject is responding to the linguistic theories of Derrida and others, just as much as it is to the social psychoanalysis of post-Freudian critics.

Discourses on history

Deconstruction evolved out of structuralism and Marxism and it was the philosopher Jacques Derrida who in effect 'established' it. Derrida challenged the existence of any necessary connection between surface structures and deep structures. He believed linguistic structures were a way of establishing hierarchical relationships between good and evil, text and speech, author and reader, men and women. A deconstructive reading meant noting the hierarchy and challenging it, but at the same time resisting the introduction of a new hierarchy. In 1983 the architect Bernard Tschumi* won the competition to design the Parc de la Villette, one of President Mitterand's series of *grands projets* for Paris. The brief was for a new type of urban park for the twenty-first century. Tschumi had been exploring the links between deconstruction and architecture and he contacted Derrida who agreed to become involved. They identified the project as 'architecture against itself'. Design was treated as an abstract system of points, lines and surfaces, mediating between the site and other ideas. Tschumi used three superimposed grids to structure the open areas. Structures came before spaces, and the *folies* came before uses. The red *folies* marked points on this grid, their uses evolving later as cafés, play centres or viewing platforms (Figure 3.7). The term 'park' was deemed exhausted and to have lost its meaning. In deconstruction

Figure 3.7 Folie at Parc de la Villette, Paris, 1983 (Bernard Tschumi)

meanings are no longer present in objects: if they are there at all they lie with the visitor and interpreter. Thus the meaning of the park depended on the visitor and their reasons for being there and did not depend on the design. Tschumi boasted that at la Villette he had created the largest discontinuous building in the world.[14]

Each of these theories and approaches has some truth and has added to the richness of the subject. Buildings may be the product of rationalist ideas, or of new technology; they are intimately linked to cultural, philosophical and religious ideas and values; and they reflect the material, economic and social context of the period. The balance of influences, however, varies in each building, and with each period and place. Searching for consistency may lead to the grouping of buildings but this may not necessarily reveal the most significant aspects of their production, form and use and does not make it any easier to explain architectural change. One of the most widespread approaches focuses on periods and style and in Chapter 8 we examine, clarify and deconstruct some of its concepts. Architectural historians need both a broad and a close focus on buildings, both singly and in groups. They need to place them in their total geographical, cultural, technological, social and economic context. They also need to characterise the function, form, the materials and construction, and examine how buildings came to be built, as well as the critical responses at the time they were constructed. Here we can only introduce the first steps in understanding architecture and its histories.

Buildings and architectural histories

Buildings themselves provide evidence of their history, but disentangling that evidence may prove very complex. Most buildings more than a few decades old have been altered, and the longer a building has been in existence, the more likely it is to have been altered a number of times. If drawings have been made, they may provide clues to some of the alterations, but if there are no drawings the evidence is restricted to the fabric of the building itself, including its foundations and drains. Some large building projects such as the great medieval castles and cathedrals were built over many years or centuries. During that time their plan and form changed as resources became available, as technology, materials, need and tastes changed, or as a result of damage by fire or from war. Evidence of these changes can be seen in the construction, and a visit to any of the larger cathedrals and churches will almost certainly reveal parts from very different periods: perhaps a Norman*-style nave*, a decorated-style transept*, and a perpendicular-style chancel*.

Throughout history people have sought to alter and convert buildings to new uses as the situation demanded. As the methods for importing and exporting goods changed, so old docks and warehouses became redundant. Rather than being demolished, they have been converted into apartments, museums, marinas, shops and restaurants. During our lives our family size changes, and if it is not convenient to move house, we may alter our houses, adding extensions and making rooms in the attic. Examining a building's fabric may reveal some of these changes. There may be variations in the ornament, changes in the brickwork, windows blocked off or of a different size, and changes in the roof pitch and form. The timber roof of a nave or aisle may have been burnt down and replaced. Churches from the twelfth century to the early fourteenth century had steeply pitched, high roofs, but by the fifteenth century the roof pitch had become shallow. If we look at the east face of the tower of St Mary de Castro, Leicester, we can see in the stonework, above the present fifteenth-century shallow-pitched roof of the south aisle, traces of an earlier, higher and steeper aisle roof, *c.*1310 (Figure 3.8). In a Victorian terraced house, the two living rooms on the ground floor may have been made into one 'through' room by knocking down the wall separating them. Where the wall used to be we may see a large beam or RSJ (rolled steel joist) spanning the opening and resting on the end walls. This would have been inserted to carry the load of the upper floors. With the advent of central heating, chimneys and chimneybreasts became redundant and in order to give more internal space, they may have been removed.

Today many churches in the UK have become redundant, as congregations have dwindled. Some have been subdivided to cater for smaller congregations and others have been converted to new uses. If the conversion makes use of the original large space, then something of the quality of the original church may have been retained, but if the whole building is divided

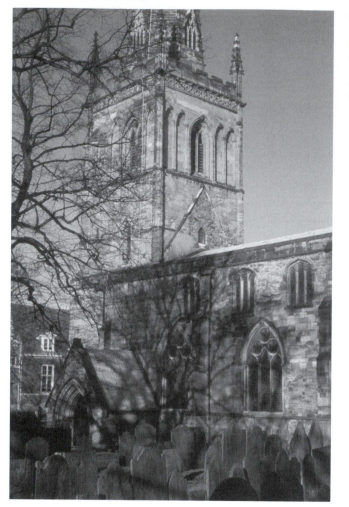

Figure 3.8
Fourteenth-century
tower of St Mary
de Castro,
Leicester, showing
evidence of an
earlier aisle roof

up into flats, then the whole significance of the church is lost, except perhaps for its exterior silhouette. The awesome space of the nave, the aisles used for processions, the stained-glass windows and the chancel with its sacred altar will all have been destroyed. The tower might provide an eccentric, if somewhat poky, living space, but the bells will no longer broadcast the presence of the church to the neighbourhood. Inside isolated floriated* capitals* and angel corbels* may end up decorating the walls of individual flats, where they will seem quite out of place. Outside, the traces of the new use will inevitably scar the exterior, with new windows for the new floor levels, skylights in the roof for the upper floors and a car park, garden and garages instead of the churchyard (Figure 3.9). Identifying the alterations and changes will place us in a better position to understand the design of the original

Figure 3.9 Converted Victorian church of St John the Divine, Leicester (1853–4)
(G. G. Scott)

buildings, but it might take a great leap of the imagination to appreciate
the character of the original spaces and forms that no longer exist. Examining
buildings for evidence of alteration and change of use provides the starting
point from which to explore the reasons for these changes. These in turn
provide the context from which we can begin to understand a building's
history.

Many buildings have been completely destroyed, but occasionally one
that has been destroyed is reconstructed. Reconstructions provide an inter-
esting problem, for although drawings of the original may be in existence
so that the reconstruction is accurate in form and measurement, there may
nevertheless be differences between the two. As part of the celebrations
for the Barcelona Olympics, 1992, it was decided to reconstruct Mies van
der Rohe's* original German Pavilion in its original location on the site of
the Barcelona International Exhibition of 1929. No detailed drawings of the
original existed and the reconstruction was worked out from photographs
and examination of the existing site. When the reconstruction was built it
was so accurate that the location of the pillars fitted exactly with those in
the original foundations. There are, however, a number of significant differ-
ences between the two. The original building did not have a basement and
was subject to flooding; the reconstruction has a basement to house the
heating. Onyx, travertine, marble and stone from the same quarries as the
original were used, but it was not possible to manufacture glass of the exact

Figure 3.10 Reconstruction of German Pavilion, Barcelona, Spain, 1992
 (Studio PER and the Mies Foundation)

greenish tint of the original, so clear glass is used in the reconstruction
(Figure 3.10).

Buildings that were designed but never built at the time have, on occa-
sion, been constructed later. Charles Rennie Mackintosh* and Margaret
Macdonald's* House of an Art Lover, 1901, won a special prize in a German
publisher's competition, and the design was published in folio form in a
series called *Meister der Innenkunst*, 1902. This promoted Mackintosh and
Macdonald's reputation in Europe. Earlier in 1896 Mackintosh had won
the competition for the design of the Glasgow School of Art, and the city
still has many of his buildings. As part of the celebrations for Glasgow's
Year of Architecture in 1999 it was decided to build the House of an Art
Lover in Bellahouston Park. However, there were significant changes between
the original design and the completed building. The original was intended
as a private house, but the building of 1999 was intended to be open to the
public and to house conferences and part of the Mackintosh archive. The
original drawings by Mackintosh had not been fully detailed and there were
conflicting dimensions. The architects, Andy Macmillan and John Cane,
sought exemplars in surviving works by Mackintosh and Macdonald and
contemporary artists and craftspeople were brought in to interpret the
interior decorations. Each exhibition room contains a print of the original
scheme and the visitor can become extremely absorbed in spotting devia-
tions from Mackintosh's interior perspectives.

Architects and architectural histories

'The study of architecture without its historical bearings would be truly frightful in its results.'[15] Since the latter part of the nineteenth century the teaching of architectural history in architectural schools in England has been seen as an essential part of the curriculum, but the way in which it has been taught has varied widely. At the beginning of the twentieth century W. R. Lethaby* at the Central School of Arts and Crafts and the School of Building, Brixton, London, argued against a concern with style and instead presented architectural history as a series of experiments in construction. He looked at the conditions and materials which gave rise to Roman vaulted* structures or to gothic cathedrals, and saw architecture as the rational solution to structural problems.

At the English universities a different approach was initiated and Reginald Blomfield* was its most strident exponent. Blomfield was an advocate of the system taught at the École des Beaux-Arts, Paris. He argued that a limited range of select masterpieces of the past should be studied in order to understand how they achieved their beauty. He analysed the principles of composition of these masterpieces, in terms of the disposition of planes, masses, form, proportion and treatment of materials. He thought that from such analyses students could learn to make pleasing forms themselves rather than by studying how buildings were constructed or why they were built.

After the Second World War the main influence on architectural schools in the US and in Europe was the approach initiated by Walter Gropius* at the Bauhaus*, set up in Weimar Germany in 1919. There, history was seen as an obstacle inhibiting the development of creativity, so it initially had no place in the curriculum. Principles of design were to evolve from the practical activity of designing and making. However, after three years, architectural history was introduced at the Bauhaus, as a means of verifying the principles that the students discovered. Gropius saw the architecture of specific periods of the past as the product of the unique social and material conditions of that period. From them students could verify what they had discovered about their own period. Thus, designing for modern needs and using modern materials would lead to the development of new appropriate forms. These approaches by Lethaby, Blomfield and Gropius offered a partial view of the architecture of the past and prejudged the architecture of the future. The past was used to confirm a particular view of how to proceed into the future, instead of being explored in as open-minded a way as possible.[16]

Recently there has been a change in how the history of architecture has been seen in relation to the training of architects. The tendency of using a selective study of the past in order to support a particular design approach, which occurred in schools influenced by the Beaux-Arts system and in post-Second World War modernist courses, is now no longer seen as valid. Today architectural history is seen as a subject in its own right, but nevertheless

attitudes towards it vary. Some see the architecture of the past as a continuum and argue that studies should concentrate on recurring ideas and themes, for similarities of approach can be found between the past and current architectural practice. Others argue the opposite: history should be interpreted as a process of continual change and it is important to emphasise the ways in which the past differs from the present. Seeing architectural history as part of a wider social process implies a rigorous historical approach that does not focus primarily on architects and their ideas. Other European architectural schools emphasise sociology and urbanism in their architectural history.[17]

A superficial interpretation of the role of architectural history in late twentieth-century architecture could be deduced from the variety of styles evident in 1980s' postmodernist buildings. Some architects, such as Charles Moore in the Piazza d'Italia, New Orleans, played with proportions in a modern version of neo-baroque (see Figure 8.6). Modern classicists such as Quinlan Terry and Robert Adam* sought to recreate classical architecture using modern materials. Others made reference to the gothic or the vernacular, while modernists such as Richard Rogers*, Norman Foster, I. M. Pei* and others have translated the principles of modernism into sleek, sophisticated buildings using modern materials and techniques.

The work of some avant-garde architects such as Frank Gehry, Daniel Libeskind, Zaha Hadid* and others involves a close analysis of the physical, social and historical context. Their work evolves from a synthesis of a wide range of information expressed in their designs as layers of meaning. Architectural history may contribute to this, but may not necessarily do so. As we have seen there is no one response to the knowledge and issues raised by history.

Architects, architectural critics, developers and planners have strong and conflicting views on the role of architectural history and the relationship of the past to the present. Today, whether or not we live in large cities with their wealth of architectural history, a wide range of architecture is accessible on the web and those in the remotest rural areas may still acquire a sense of the variety of possible architectural experiences.

4 Space and function

Most buildings were built for a particular purpose, which may not always be evident at first glance. The exterior is what we usually see first and it is easy just to concentrate on the façade. This can lead to a rather superficial understanding of buildings, particularly if the focus is on one's personal reaction to its form and decoration. We build for many reasons: shelter from the weather and protection from noise; security against theft, damage or fire; and privacy. Different activities such as work, recreation, bringing up a family and worship require different kinds of buildings, perhaps in special locations, with varying spaces, environments and forms. The functions of buildings are often complex, and not all are utilitarian, in the sense of serving a practical purpose. Many are designed to express emotions or to symbolise ideas, and this may influence the final form of the building.

The function of some ancient structures such as Stonehenge, Wiltshire, remains a mystery (see Figure 3.1). Stonehenge had a changing but carefully considered relationship to the rising and setting of the sun and moon, and it may have provided a focus for religious ceremonies and rituals. Some religious buildings embody something of the spirit of the religion. The awe-inspiring temples of ancient Egypt were designed to enhance the importance of the gods and the priesthood. The space inside medieval cathedrals was often large and of great height. This enhances the acoustics and the spatial requirements of the clergy and congregation, but it also has another more subtle function. The scale of the space creates a sense of awe in those visiting the building. Its appearance of height may be reinforced by numerous slender vertical shafts* on walls and clustered around piers* as can be seen in the church of St Maclou, Rouen, France, 1436–1531 (Figure. 4.1). Appropriately these shafts direct the eye heavenwards.

The domed* form of Indian stupas* may derive from ancient burial mounds. In practical terms their round form and encircling pathway encourage worshippers to circulate around the building, which, according to tradition, contains the cremated relics of the Buddha or his disciples (Figure 4.2). This hemispherical form is also imbued with cosmological symbolism, representing the dome of heaven, or the lotus flower that is itself

Figure 4.1
St Maclou, Rouen, France, 1436–1531

Figure 4.2
Sanchi Stupa, Central India, first
century BC

symbolic of the place of the gods. The finial at the top with its umbrella-like tiers suggests the ascending heavens of the gods or the trunk of a cosmic tree.[1]

Symbolism is not confined to the religious realm; it has its secular counterparts. In the late eighteenth century in France, some architects became particularly interested in the expressive aspect of architecture. Claude-Nicolas Ledoux's house and workshop of the coopers, *c.*1804, is composed of forms that look like double interlocking barrels.[2] The form derives from the cooper's work, the making of barrels. Often the forms of buildings are a mix of practical, expressive and symbolic functions, and we discuss these in more depth as we explore the space, interiors and forms of buildings.

Enclosing space

Most buildings shelter and contain activities and objects in spaces enclosed by floors, walls, ceilings or roofs. The space may be a cosy sitting-room, a dance floor or an open-plan* office. We tend to think of this space as being inside, but it may also be outside and include a courtyard or a walled garden. In ancient Roman houses the rooms surrounded an inner courtyard or atrium* that was open to the sky. In the Indian subcontinent, Hindu temples often stand within a walled court containing subsidiary shrines, altars, a mandapa

or hall and various domestic quarters; Mughal monumental tombs like the Taj Mahal were sited among pools and formal gardens (see Figure 2.4).

There may also be a transitional space that is neither inside nor out but flows between the two, such as a verandah, a covered terrace or an open area under the building. Frank Lloyd Wright used transitional spaces and flowing internal space in the Robie House, Chicago, 1909 (see Figure 2.11). Bands of windows, balconies, terraces and projecting eaves partially define and create transitional spaces close to the house, before it merges into the open space of the courtyard. Inside, the living and dining areas are not separately enclosed spaces but open into each other with a central fireplace between. Many of Wright's houses were in suburban locations, yet his passion for nature and for the wide, open prairies of the United States imbues his domestic architecture.

Space is created underneath tower-block flats that are on pilotis*. These enable the air to circulate under the building, provide a sheltered place for children to play in bad weather, and offer views through and past the building. Because we see through the space underneath, the building appears to float and to be lighter than it is in fact. Shelter in the form of a huge umbrella is how we might describe a railway station train shed. At St Pancras Station, London, by W. H. Barlow and R. M. Ordish*, 1863–5, the iron and glass roof spans a vast space over the lines and platforms, so that passengers waiting to board the trains are sheltered from the weather (Figure 4.3). One end of the shed is totally open so that trains can enter the terminus.

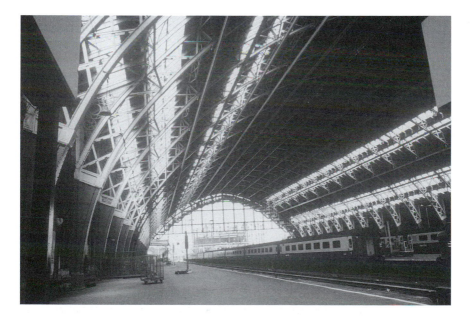

Figure 4.3 St Pancras Station train shed, London, 1863–5
(W. H. Barlow and R. M. Ordish)

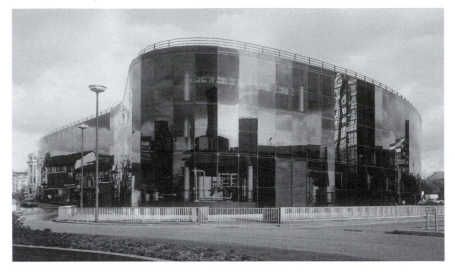

Figure 4.4 Willis Building, Ipswich, 1975 (Foster Associates)

The enormous space above passengers' heads and the open end of the shed served to disperse the smoke from the steam trains in the era before electric and diesel engines.

Walls define or subdivide space and affect the way we experience it. The transparent glass walls of iron and glass buildings like the Crystal Palace, 1851, or the Palm House at Kew do not visually define the barrier between inside and out sharply (see Figure 2.1). From the outside we can see what goes on inside and vice versa. When dark glass is used the effect is rather different. The dark glass wall in Norman Foster's Willis (formerly Willis, Faber and Dumas) building in Ipswich, 1975, acts as a mirror. On a sunny day the form of the building becomes ambiguous because of the reflections of the adjacent townscape (Figure 4.4). By contrast, at night when the lights are on inside, the walls dissolve completely and the interior is revealed. The German Pavilion was designed by Mies van der Rohe for the international exhibition in Barcelona in 1929 to be part of space rather than enclose it (see Figure 3.10). The roof defines the space below it, but the glass walls do not always meet at the corners to subdivide the space fully. Instead, there are gaps that allow people to move around the freestanding walls. The walls of glass direct the flow of visitors through the building and their transparency denies any sense of enclosure, giving a feeling of space and light throughout. In traditional Japanese domestic architecture the spaces are subdivided not by thick walls but translucent paper screens and movable partitions, some not even reaching the ceiling, so there is little sense of enclosure. We need to be aware of the way buildings define and enclose space, and how the experience of space relates to the materials used.

Space and function

Buildings often consist of several juxtaposed spaces catering for different related activities. In England, the medieval barn consisted of three parts, a central threshing floor and cartway with storage bays on each side, all under one encompassing roof. Today a night club needs a large open space for dancing and sufficient room for the band and a bar and maybe for tables and chairs around the edge so that people can sit and chat. There may also be a balcony for sitting, chatting and looking. There are separate rooms for cloak-rooms and toilets and an entrance hall to meet friends and buy tickets. Spaces for a particular function will depend on the period, the culture and the geographical context, as well as social and political attitudes, status, finances and the desire to be expressive. All of these may change over time. Early medieval houses in England consisted of one or more rectangular single-room buildings, depending on the occupants' status. The most basic was a building with one space heated by a fire and used for living and sleeping. Until the fifteenth or sixteenth century the kitchen was a separate building, largely because of fear of fire. By the fourteenth century the 'hall' was the most common residence. This consisted of a high-roofed room with central fire-place, a service or food preparation room at one end and a chamber or bed-sitting room at the other. Whole families and their guests might sleep in the chamber, which could also be used for storage. Some halls had two storeys at one end, with a bedroom upstairs and parlour below. The hall of the lord of the manor operated as a manorial court and centre for organising farming activities, as well as a residence. At the end of the sixteenth century fire-places were being enclosed and chimneys built, enabling many halls to be subdivided horizontally to provide further rooms above.[3]

Fortified walls for protection often surrounded medieval towns. A wall known as the Flodden Wall encircled Edinburgh, Scotland, in the sixteenth century. As the population grew, the density of the town increased, and it became common to build upwards. Stone tenements of up to ten storeys were constructed, with one or more families living on each storey. The families in each building or tenement shared a communal staircase and, later, lava-tories. The poor might have only one room, the slightly better off two rooms, and the wealthy had many rooms. When Sir Titus Salt, an affluent UK factory owner of the mid-nineteenth century, moved his factory out of the polluted industrial town of Bradford to a new location in Saltaire, Yorkshire, he accom-modated his employees according to their social status. Each house was well built with a yard containing a privy, and gas and water laid on. Workmen's cottages were small, with a tiny cellar, living room and small kitchen. Unlike the back-to-back* dwellings of industrial centres such as Leeds, at Saltaire there was through-ventilation with doors and windows on both the front and the rear of the building. Although housing reformers argued for three bedrooms so that boys and girls slept separately, the early workmen's houses had only two bedrooms. The houses of over-lookers had a cellar, scullery,

Figure 4.5 Saltaire, workers' housing, *c.*1860

kitchen, parlour, three to six bedrooms and a small front garden. This was a distinct improvement on urban slum accommodation, where often whole families with many children lived in one or two rooms (Figure 4.5). The managers at Saltaire lived in 'large, well appointed' houses, and, seeing himself as a new kind of feudal grandee, Salt lived in an expensive mansion 'furnished with all the elegance and luxurious taste that wealth can command'.[4]

Space and gender

Male architects, who may not necessarily have been concerned with the needs of women, have designed most buildings in Western cultures. In theatres, concert halls and even motorway service stations there are often long queues of women waiting to use the toilets and washroom. More adequate facilities are now being designed, for research has shown that women, in comparison with men, need to use them more often and they need twice the time.

In the UK in the 1930s there was a great expansion of middle-class house building. These houses were designed by men as single-family units for a nuclear family of two parents and several children. In reality, families are of varying size and type. Today an increasing number of people live alone: divorced and separated families require a home each, elderly relatives may live in a residential home or join the nuclear family, and the ethnic diversity of our cities brings many extended families. The 1930s' middle-class home was designed for a full-time housewife and perhaps domestic staff,

although these had already declined by this period. The kitchen isolated the person working there from the rest of the family. There may have been space for a study or 'den' for the man of the house, but the woman rarely had similar private space of her own. As early as 1813, Robert Owen in Scotland published plans for alternative communities that catered for the needs of working mothers. Kitchens and dining rooms were part of the communal facilities shared by the whole community, rather than rooms in each individual home. He also proposed community nurseries so that childcare took place largely out of the home. Feminists and socialists in Europe and the US, such as the American Maria Stevens Howland*, developed these ideas further during the nineteenth and twentieth centuries. Howland argued for professional childcare and domestic services, and with J. J. Deery and A. K. Owen made unrealised plans for apartment hotels, patio houses and cottages with communal kitchens, dining rooms and laundries for the experimental community of Topolobampo in Mexico in 1885.[5]

In temperate climates, rooms for different purposes are linked and sheltered under one roof, whether in an apartment or bungalow, a maisonette, a terraced or row house, or a detached dwelling. In the hot sunny climate of southern Africa rural families use the outdoor living space as well as separate buildings for sleeping, cooking or storage (Figure 4.6). The extended family unit may include grandparents and the families of several brothers. In the traditional home of a Shona family in Zimbabwe work and domestic activities such as craftwork, preparing crops and food, washing up, socialising and play take place in the central, well-swept courtyard with perhaps a tree for shade. Shelter and warmth at night, propriety, security and practicality mean that sleeping space and the areas for cooking, food storage and hygiene are inside buildings. Each is housed in its own circular or rectangular building with thatch roof. There are gender-segregated communal buildings where children sleep, individual buildings for each married couple to sleep, and granaries. Instead of one kitchen, there might be several, one for each married woman. Invisible lines subdivide the interior space of the kitchen into male and female areas and there is a platform for religious rituals. On the periphery of the homestead there are washrooms and latrines and there may be small enclosures for chickens or a goat. Visitors to the homestead have no door to knock on but will recognise they are entering a home either because there is a fence or because the space around is well swept, and they can announce their presence by calling.[6]

In the hot and humid cities of the Arabian peninsula the towns and cities of the Islamic communities have narrow lanes leading to irregular and larger public streets. These were designed for protection against dust storms, to provide shade and to channel cool breezes. Traditionally, houses in Bahrain in the Gulf were gender-segregated and designed for privacy. All rooms faced a central courtyard save the men's section that received visitors and had outward looking windows. There were two entrances: one for guests and one for the family.[7]

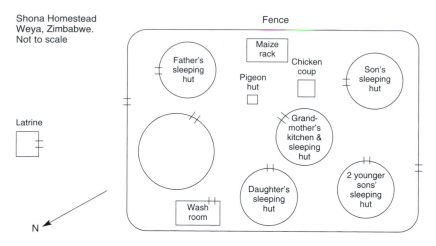

Shona Homestead
Weya, Zimbabwe.
Not to scale

Fence

Father's sleeping hut

Maize rack

Chicken coup

Pigeon hut

Son's sleeping hut

Latrine

Grand-mother's kitchen & sleeping hut

Wash room

Daughter's sleeping hut

2 younger sons' sleeping hut

N

Figure 4.6 Plan of a Shona homestead, Zimbabwe, 1991

The size of spaces

Many factors influence the size of spaces: finances, available materials, the costs involved in heating or cooling large or small spaces and the significance of the space. 'Scale' is the term we use to discuss the size of the space relative to the size of something else. A space may be physically large or small but we can only judge this by making comparisons, for its scale depends on the number of people using it, the furnishings and objects in it, the neighbouring spaces and our expectations. Small rooms in a terraced house may suggest snug comfort, but if a whole family had to live in one small room, as many people did in the nineteenth century, then the space is overcrowded and uncomfortable. Spaces for large numbers of people, such as a cathedral, sports hall, parliament or factory, need to be large. They are large scale if the height of the internal space is for more than the practical reasons of acoustics, the provision of air and the need to reduce the sense of enclosure. The earlier example of a medieval cathedral illustrated how scale can evoke a feeling of awe and grandeur.

The juxtaposition of different-sized spaces may be deliberately exaggerated to give a sense of drama or to impress the visitor. Moving from a small, confined porch or vestibule into the main, large, open space of a church or mosque emphasises the drama as well as symbolising the transition between the secular world outside and the religious world within. At the Ennis House in Los Angeles, California, 1924, Frank Lloyd Wright deliberately designed a small, dark entrance hall with a low ceiling, as a dramatic contrast from the glare of the sun outside and the spacious proportions of the rooms beyond. The priority given to some spaces over others within a building is referred to as spatial hierarchy. Andrea Palladio related the hierarchy of space to the

human body. Some parts such as the principal living and entertaining rooms were beautiful and should be exposed; others such as kitchens and cellars were not suitable for view and should be hidden.[8]

Le Corbusier in the 1920s used hierarchy in his villa designs. The largest space was the main living room with its huge floor-to-ceiling window where people relaxed or entertained. This was a double-height room that opened out onto a terrace and offered an elegant, light and airy contrast to the kitchens, bathrooms and bedrooms. These spaces were utilitarian and designed to be as small and as compact as the ship's cabins that Le Corbusier admired for their efficient use of space. Small bathrooms or bedrooms might be justified on the grounds that the basic activities of getting in or out of clothing and jumping into or out of the bath or bed require little space. A small kitchen, by contrast, suggests that the cook was a paid servant. It certainly could not form the focal point for the household and visitors. Today, many kitchens are multifunctional and are used for laundry, cooking, dining and a centre for the family. They may also be status symbols in terms of design and the latest technology.

Theatres vary in form. Those with a proscenium arch cater for a linear relationship between the audience and a rectangular stage. By contrast, theatres in the round are, as their name implies, designed so that the audience surrounds the stage. Generally the stage and the auditorium are the largest spaces within the hierarchy of space in a theatre. This is where the main action takes place both in reality and metaphorically. The high auditorium is designed to be airy, give good acoustics and to provide audiences with adequate sight lines. Above the raked seating in the auditorium there may be a number of galleries or tiers of balconies. Further seating may also be provided by boxes, which may or may not be cantilevered* one above the other along the side walls. The stage area may appear to be a small box shape to the audience, but it includes a tall rectangular space above the stage, housing the hoist mechanisms for the stage scenery. The types of performance and the facilities for the audience and the artistes determine both the relative size of the stage and auditorium and the range and size of other spaces.

The importance of the Paris Opéra, designed by Charles Garnier*, 1861–74, is reflected in its overall size as a theatre and in its elaborate deco-ration and grandeur, which emulated the magnificence of imperial Rome (Figure 4.7). The rear of the building (right) houses a complex of tiny cells used for dressing rooms, administrative activities and storage. The stage and auditorium combined are allocated a far larger space. The stage is a tall rectangular box shape. The auditorium, which is lower, is roofed over with a dome; its shallow rounded form inside pleasingly echoes the circular tiers of balconies beneath and symbolically unites the audience in a shared ambi-ence. Poor visibility of the stage, however, is offered to those not fortunate enough to be in the front row of the boxes and balconies. The Emperor Napoleon III had his own private entrance to the theatre, via a circular ramp

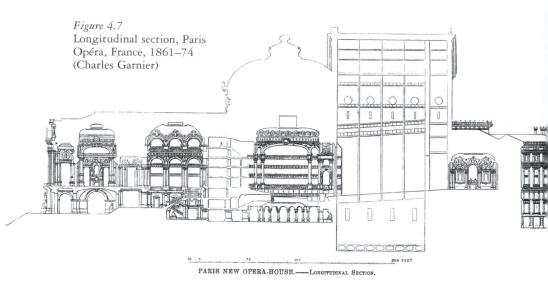

Figure 4.7
Longitudinal section, Paris
Opéra, France, 1861–74
(Charles Garnier)

PARIS NEW OPERA-HOUSE.——Longitudinal Section.

to the side of the auditorium. This leads into an elegant, small-domed circular hall that gives access to the royal box (see Figure 5.10). Spatial priority in this building is allocated to the front (left) housing the main entrance. This includes a large vestibule leading to a two-branched grand staircase overlooked by galleries within a large domed foyer adjacent to the auditorium. The grandeur and complexity of these spaces make them as significant as the auditorium and stage. These are important social and ritual spaces designed for the audience to promenade elegantly and to see and be seen during intervals and when entering or leaving the building.

Proportion

The dimensions of a building and its parts may be carefully related to create pleasing proportions, and these may have wider significance. Muslim religious buildings have used mathematical calculations, and in Japan the size of the tatami mat* became the common module for calculating the dimension of rooms in traditional houses. The harmony of parts in Buddhist, Jain and Hindu temples reflected the order of the cosmos. The measurements were based on modules derived from the dimensions of the sanctuary* or of the image of the presiding deity in the shrine as set out in the shastras or traditional treatises on architecture.[9]

Concern for proportion is associated with ancient Greek and Roman monumental architecture but its use was not straightforward. From the sixth century BC Greek temples using the Doric order* were of conventional plan yet there were differences between them. Rules of proportion evolved but could be broken as architects tackled the complex tasks of building. In early

Doric temples the length and width of the stylobate or platform on which the building rested were related, and in some early buildings the column height was one third of the width of the stylobate. Later, the width of the spaces between columns became important in determining dimensions.[10]

If a building was constructed over a long period, later parts were brought up to date. The Parthenon, for example, was built in three stages between 490 BC and 432 BC. The later building is a little longer and much wider, but the dimensions of the elements were not increased because it was practical to reuse much of the older material. Column spacing was slightly reduced, since an extra column was added to the length and two columns added to the width of the peripteral colonnade* around the building. To make the building appear up to date the entrance portico had new, more slender columns.[11]

Greek temples of the fifth century BC showed further divergence from strict proportions, regularity, straight lines and right angles. Columns were narrowed at the top and modified to achieve entasis*, columns and walls were inclined, column spacing was reduced at the corners or varied within the colonnade, and the stylobate was curved down at the edges. Various justifications have been put forward for these variations: to give vitality to designs which otherwise might appear mechanical; to counter visual distortions and perspective; to increase stability or, in the case of the stylobate, to encourage drainage.[12] In his book *De Architectura*, Vitruvius argued that proportion and symmetry were manifest in the human body. He identified the perfect numbers as six, ten and sixteen. He described how the human body with hands and feet outstretched could be inscribed in both a circle and a square if you took the navel as the centre. Vitruvius used a module based on the length of a man's foot, which is one-sixth of a man's height. This module in turn determined the diameter of the base of a column, and multiples of it gave its height and the other dimensions of a temple. The height of a Doric column should be six times the diameter of the base of the shaft. Ionic* and Corinthian* columns were more slender and reflected the proportions of the female body.[13] This was not rigidly followed in ancient Roman practice.

During the renaissance architects were inspired by antique* sources and by the beauty and harmony of the universe. The Greeks had noted the relationship between musical harmonies and the different lengths of string in tension that provided harmonious sounds. Two strings in the ratio 1:2 give an octave when plucked; strings in the ratio 2:3 give a pitch difference of a fifth and strings in the ratio of 3:4 give a fourth. In his treatise on architecture, *De Re Aedificatoria*, 1452–85, Leon Battista Alberti*, the renaissance playwright, musician, painter, scientist, architect and theorist, linked these 'harmonic ratios' to dimensions in architecture. Andrea Palladio used three different sets of ratios for the proportions of his villas and churches in Italy. These were based on arithmetic, geometric and harmonic proportions and determined the relationship between the height of rooms, their width and length and the relative sizes of different rooms.

In arithmetic proportion the size of a room could be based on the relationship between the numbers 3:6:9. This is arithmetic since $9 - 6 = 3$ and $6 - 3 = 3$. So a room that measures 6 feet by 12 feet, with a height of 9 feet, is arithmetically proportioned. In geometric proportion the first term relates to the second as the second to the third. So the relationship between the numbers 4:6:9 is geometric because $4:6 = 6:9$ and their geometric proportion is 2:3. We might then have a room measuring 4 feet by 9 feet with a height of 6 feet, because the width of the room is two-thirds of the height, and the height is two-thirds of the length. In harmonic proportion the relationship between 6:8:12 is in the proportional difference between the larger and smaller number in each pair: $8 - 6 = 2$ which is one-third of 6; $12 - 8 = 4$ which is one-third of 12. So the proportion of one-third links the width (6), length (12) and height (8) of a room.[14]

One other proportion, known as the golden section, was important during the renaissance. The division of a straight line into two parts so that the relationship of the smaller part to the larger equals that of the larger part to the whole illustrates the principle of the golden section. Unlike the previous proportions, it is not based on the relationship between whole numbers. It can be generated from a square by dividing it and so generating a spiral known as the Fibonacci series, after a twelfth-century Italian mathematician. It is this spiral that is found in nature in, for example, the way that sunflower seeds grow. In the twentieth century the French architect Le Corbusier derived a series of golden sections from the dimensions of the human body as a basis for architectural proportions. To obtain the initial dimensions, Le Corbusier used three dimensions: the length of the height of a man with his arm held aloft at 7 feet 5 inches or 226 cm; a man's height at 6 feet or 183 cm; and the height at the man's navel. These three measurements were then subdivided to create a series of golden sections, or Fibonacci ratios.[15] Called the Modulor, it was used by Le Corbusier to provide the dimensions of buildings such as the Unité d'Habitation, Marseilles, France, 1947–52.

The shape of spaces

Most Western urban buildings are predominantly rectangular, and examples such as Antonio Gaudí's* Casa Milá (now known as La Pedrera), Barcelona, 1905–10, with its curving forms and rooms are rare (see Figure 5.3). These presented a considerable challenge to furnishing the interiors. In other cultures non-rectangular forms predominate, particularly for traditional dwellings such as the ice houses of the Inuit of North America or some indigenous African housing (see *frontispiece* and Figure 4.6). The shapes of religious buildings commonly have symbolic significance. Renaissance architects used geometry to obtain ideal shapes for buildings, and Alberti preferred circular, centrally planned churches not for practical reasons but because he saw the circle as an absolute and perfect shape, common in nature and an appropriate expression of the divine.[16]

Figure 4.8
Muqarnas in the
Hall of the Two Sisters,
Alhambra, Spain,
fourteenth century

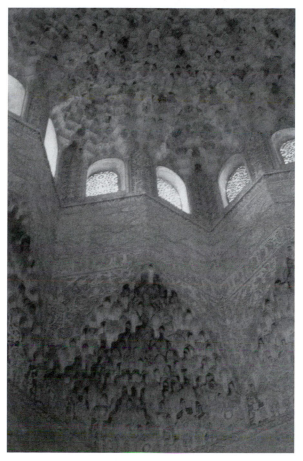

Space needs to be understood in three dimensions: to the front, sides and rear and from above. At certain periods architects have created exciting, complex spaces with sculptural roofs. The fourteenth-century Hall of the Two Sisters at the Alhambra*, Granada, Spain, has the most elaborate muqarnas* dome representing the heavens. It consists of over 5,000 cells decorating the dome (Figure 4.8). The hall belongs to the magnificent complex of Islamic palaces situated on a high plateau in south-eastern Spain. An inscription reads, 'I am a garden full of beauty, clad with every orna-ment . . . The stars would gladly descend from their zones of light, and wish they lived in this hall instead of in heaven.'[17]

Baroque and rococo* interiors of the late seventeenth and early eighteenth centuries were designed to captivate the onlooker and draw them into a world of illusion through painting, sculpture and the curving forms of architecture (Figure 4.9). Architects of the art nouveau style wanted to create a new style not based on past forms, so they explored natural forms and new materials

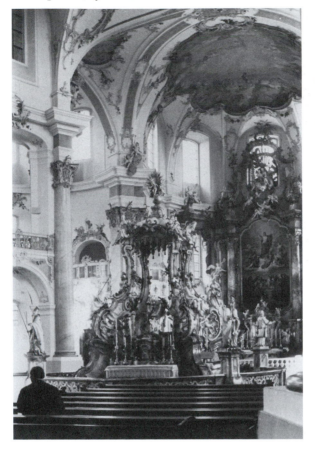

Figure 4.9
Interior of the
pilgrimage church of
Vierzehnheiligen,
Franconia, 1743–72
(plan by Balthasar
Neumann*, interior
by Küchel, Feichmayr
and Üblhör)

such as iron, glass and concrete to create curved and irregular spaces. These are best seen in the interiors of Antonio Gaudí in Spain, Victor Horta in Belgium and Hector Guimard* in France.

The expressionists* also created unusual shaped interiors such as those in the Goetheanum or temple of spiritual science, at Dornach, Switzerland, by Rudolph Steiner*, 1913–17, composed of two intersecting domed spaces (this original building was destroyed by fire in 1923).

Some building types such as libraries, sports stadia, concert halls and station booking halls offer practical opportunities for non-rectilinear forms. In the nineteenth century fine circular spaces were created in London for the British Museum Reading Room by Sydney Smirke*, 1854–7, and for the Royal Albert Hall, 1867–71, by Captain Francis Fowke and Henry Scott*. In Leeds the Corn Exchange, 1861–3, by Cuthbert Brodrick* had an oval plan. In the twentieth century the Guggenheim Museum, New York, by Frank Lloyd Wright, 1944–57, is based on a spiral, while the TWA Terminal, Kennedy Airport, New York, 1956–62, by Eero Saarinen* is a dramatic

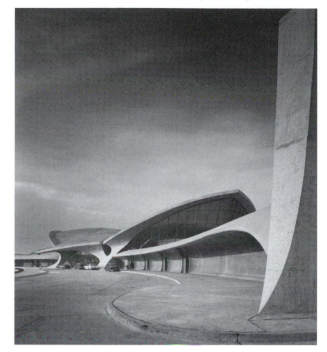

soaring organic form (Figure 4.10). The rationale for the choice of spatial configurations varies. The swirling forms of baroque churches were part of a campaign to encourage people to the Catholic Church. The organic forms of Steiner's Goetheanum were considered conducive to contemplation. Frank Lloyd Wright's spiral was designed to provide a predetermined path for visitors to walk past the works of art, and the bird-like forms of the TWA terminus were designed to suggest flight and so provide an analogy with the function of the building.

Recent developments have seen the creation of very complex forms for the exterior of buildings such as Frank Gehry's Guggenheim Museum, Bilbao, Spain, 1996. The twisted glazing and exploding, truncated, titanium-clad forms would have been impossible to engineer without the aid of sophisticated computer programmes (see Figure 2.5). Inside is a variety of spaces for displaying a wide range of modern art. Aerial bridges and walkways that give further views of the galleries interlink these spaces.

The relationship between internal spaces

Some architects design their buildings from the outside in, others design from the inside out, or place great emphasis on the circulation route. The relationship between spaces and the building as a whole depends on many factors. These include a concern with external symmetry, how the

façade reflects the function of the spaces and how rooms relate internally. Today, we think a kitchen is best located near the dining area so that food arrives warm on the table. Some large institutions such as hospitals inevitably have kitchens far from the point of consumption because it is not possible to bring patients to one large dining area. James Stirling* at the Staatsgalerie, Stuttgart, 1984, integrated the museum into the surrounding urban pedestrian network by designing it around a series of pedestrian routes, courtyards and terraces, so encouraging people to visit it. From the outside open-air sculpture is visible and glimpses can be seen of the art works within.

Architects with a classical training tend to start with a single geometrical form such as a cube, and distribute the various functional spaces within it in a symmetrical manner if this is possible. We will see this when we look at the plans of Syon House (see Figure 5.8). Modernist architects of the twentieth century, such as Walter Gropius, first identified sizes appropriate for the function of the individual rooms or spaces and then sought practical ways to link them. The results were buildings with an irregular layout such as the Bauhaus design school in Dessau, Germany, of 1925–6 (Figure 4.11).[18]

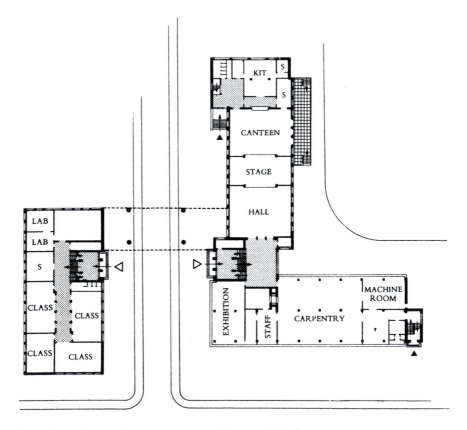

Figure 4.11 Ground floor plan, Bauhaus, Dessau, 1925–6

The plan is like a pinwheel. Projecting at right angles from a central stair-case are three pins or wings of distinct height and spread. The first is the huge, glazed, curtain-walled* block of the carpentry and weaving workshops with the preliminary course studios. The second wing contains in succession the hall, the canteen and, at the far end, the kitchen with a multi-storey students' hostel above. A third and separate wing contains the classrooms, laboratories and library. It is linked to the central staircase by a bridge over a road that carries a corridor and two storeys of administrative offices.

Communication spaces

In many buildings access from one room to another is by additional spaces or communication areas, such as corridors, passageways or halls. These provide direct access and make it unnecessary to go through a number of rooms to reach any one of them. If there is more than one floor, then there will be stairs or lifts. Careful planning is required to make circulation routes short and direct. In addition, in buildings open to the public architects need to ensure accessibility for all levels of mobility and vision. The Richard Attenborough Centre for Disability and the Arts, University of Leicester (Ian Taylor, Bennetts Associates, 1994) is a calm and enjoyable sensory and visual experience for all who use it, artists, dancers, musicians and audiences, disabled or not. Extremely robust, wheelchair accessible and with fire safety provision above normal standards, this flexible building achieves accessibility subtly through design rather than gadgets. It has a symmetrical H plan parallel to the street that is easily understood by users. There are varied levels of natural lighting including top lighting, different acoustic treatments and textured floor finishes. The strong tonal contrasts between the dark painted doors and white walls define specific spaces to help the orientation and move-ment of those who are partially sighted. The aroma of British cedar of Lebanon panelling offers further clues. This is an excellent example of inclu-sive design.[19]

In Victorian country houses the route through the house and the location of rooms were related not only to aesthetics and practicality but also to ques-tions of propriety. Corridors and stairs were either grand and very evident, to guide and impress guests, or hidden away and narrow, for servants to use (see Figure 5.5). Cragside, Northumberland, was built over a long period – 1869–85 – for Sir William Armstrong by Richard Norman Shaw. The house eventually rambled so extensively that by 1884 guests after dinner had to walk the length of the house, climb two storeys and then walk the length of the picture gallery, to reach the new drawing room!

For some architects the route through the building becomes an import-ant part of the design and, indeed, largely controls the overall layout. Le Corbusier's villas of the late 1920s such as the Villa Savoye and the double villa La Roche-Jeanneret, Paris (now the Fondation Le Corbusier), have ramps and circular stairways to achieve the *promenade architecturale*. This was

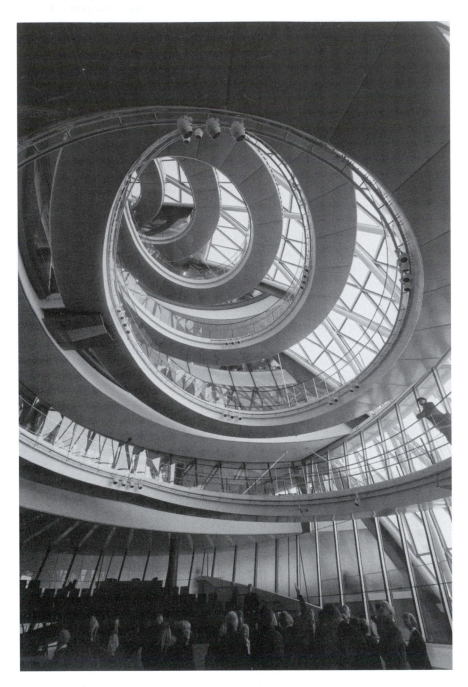

Figure 4.12 Interior, City Hall, London, 2002
 (Foster and Partners)

designed to provide a varied walk of changing visual experiences within the building. In the entrance hall of the house of Raoul La Roche, 1923, as in many of Le Corbusier's buildings, the space is exhilarating. The hall rises through the two floors and can be overlooked by people standing on balconies at each level. At the Laban Dance Centre in Lewisham, London, by Herzog and de Meuron*, 2003, a *promenade architecturale* in the form of a ramp leads from the reception down on one side to the café and out to a rear exit. To the left a circular staircase and broadening ramp lead up to the next floor where the ramp becomes an inclined plane providing access, seating and views to the café and lower area. One of the most dramatic *promenades architecturales* can be seen in London's City Hall, by Foster Associates, 2002. The assembly chamber is at the heart of the building and is encircled by a spiralling ramp reaching from the top of the building (Figure 4.12). Architects' plans are extremely valuable in helping us to understand the relative size, allocation and relationship between spaces in buildings and the communication routes.

The interior environment

So far we have discussed buildings in terms of space and the way those spaces house various activities. Buildings are also about creating a comfortable and safe environment for working, living or housing objects. The temperature, light and the transmission of noise need to be controlled, and we need warning of fire and facilities for hygiene. A building with many floor levels such as a shopping mall or a block of flats or offices will need lifts and escalators for access. Space must be found to house these services and the pipes and wires necessary for the building to function.

The materials, the design of the fabric of the building, the size of interior spaces, the nature and frequency of openings as well as the means used to heat, ventilate and control the temperature, all contribute to the quality of the interior environment. One of the most important requirements in buildings is adequate light, although buildings such as warehouses need less light than those where people live, work or spend large amounts of time. In museums light is needed to see the exhibits but it can also damage them so it has to be carefully controlled. Top lighting that avoids the direct rays of the sun and ultraviolet filters on the windows can reduce this problem. Some churches have dark interiors even though they may have large windows. The stained glass colours the shafts of light entering and adds to the sense of mystery.

The quantity of natural light used in buildings depends on the geographical location, the climate, the building materials, the constructional system, the design and the use of the internal spaces. In different parts of the world and at different times of year the amount of natural light varies. Around the tropics the hours of daylight vary little from a twelve-hour norm. In the UK we have very long hours of daylight during the summer but much less in

the winter. In the polar regions, the sun hardly sets during the short summer, but in winter the hours of daylight are minimal. Buildings need to take account of these regional variations. Medieval cathedrals in Europe were designed with large expanses of stained-glass windows to illustrate biblical stories and to dramatise God's house, but it was not until the sixteenth century that glass was widely used in domestic buildings, since it was an expensive material. In western Europe's temperate climate the advantage of unglazed openings in the wall, which let in the light, had to be weighed against the disadvantage of cold, wind and rain entering. Therefore, shutters were vital.

Buildings with load-bearing walls* tend to have relatively small windows so various methods have been adopted to obtain sufficient natural light at the centre of buildings. There may be roof lights or, if it is a multi-storey building, a light well. In Chicago, in the late nineteenth century, some architects who used load-bearing masonry walls for their office buildings introduced lots of windows and designed them in the form of projecting bays to capture as much natural light as possible. The development of metal and reinforced concrete frame buildings* offered the opportunity for complete walls of glass, but with them came the side effects of heat loss and gain affecting the internal environment.

Despite the ferocious heat in parts of southern Africa, traditional buildings with walls of wooden poles and clay, thatched grass roofs and rammed earth floors have cool interiors. The thatch and clay shield the interior from the blast of the sun. The open door and the gap between eaves and wall allow sufficient air and light without the need for windows. A building with thick walls will absorb and hold the heat from the sun during the day, reducing the rate at which the spaces within become hot. At night the heat from the walls will be slowly emitted to mediate the effects of the colder air. This effect has been well understood for thousands of years and examples of its application can be seen in the hot regions of the Near and Far East, in China and India. Vernacular buildings are excellent examples of the sustainable use of materials and passive environmental control – lessons that are still being learnt today.

In the twentieth century the modernists rejected load-bearing walls and with them their heat-absorbing properties. The frame structure* with its skin of glass poses many problems for the interior environment. Walls of glass reduce the need to provide artificial light in buildings during daylight hours, but this has to be weighed against the effects of overheating in the summer sunshine (the greenhouse effect), the temperature drop in the winter and the consequent need for high energy consumption. To shade glazed walls from the sun, Le Corbusier from the 1930s employed a thick grille of concrete called a *brise-soleil**, a device which has been employed by many other architects since (Figure 4.13). Alternative methods of reducing these effects are the use of double and triple glazing to keep out the heat and cold as in Ralph Erskine's* The Ark, Hammersmith, London, 1992, or the use of reflective

Figure 4.13
Brise-soleil at
Broadgate, London

coatings, sometimes tinted bronze or blue, which allow light, but not heat, to enter.

The danger of fire, particularly in buildings used by large numbers of people, is confronted in various ways. Spaces within buildings are often sub-divided to prevent the spread of fire; escape routes are provided and fire-resistant materials for walls, floors and doors are used to give people time to evacuate the building. At the London Ark the aim was to create an open interior space, and the nine floors of offices open on to the central atrium to encourage social interaction and a sense of community for the different companies and people using the building. This may seem to invite the spread of fire, but to compensate there are sufficient exit routes to evacuate everyone quickly and all at once. Only the highest office floor is partitioned off to enable the upper part of the central atrium to become a smoke reservoir in the event of a fire.

Active environmental control

Active methods of controlling the internal environment of buildings have changed over the centuries and vary from country to country. Artificial illumination has a long history that dates from the flickering light of fires and candles to that of oil lamps, gas lighting and electricity. In the nineteenth century, gas lighting, by gas transported in pipes to each individual building, created a stronger and more controllable light but, like candles and lamps, it had the major disadvantage of polluting the atmosphere and leaving deposits of soot within the rooms. The development of electric lighting in the late nineteenth century transformed interiors, creating a bright, even and clean source of illumination.

The most common method of heating medieval houses was by an open hearth with a fire in the centre of the floor. The high roof reduced the risk of fire and allowed the smoke to escape, filtered through the thatched roof, a louvre or gablet*. The Normans in the eleventh century introduced wall fireplaces into their castles and fortified houses in Britain and by the thirteenth and fourteenth centuries stone chimneys serviced these. Both types of fireplace coexisted during the middle ages. With the development of brick making, brick chimneys became widespread by the sixteenth century, reducing fire hazards and directing the smoke out of the building efficiently for the first time. Fireplaces and chimneybreasts constructed against external walls waste the heat, which spreads throughout the wall to the outside; so internal walls became the preferred locations for fireplaces. Often fireplaces are constructed back to back in adjacent rooms to capitalise on the heat generated. Economies are also made in the construction of chimneys, each of which may have several flues belonging to different fireplaces in different rooms. By the nineteenth century large wood-burning or coal stoves had become more common for heating domestic interiors in central Europe.

The Romans developed systems of under-floor heating known as hypocausts, but it was not until the mid-nineteenth century that commercial and public buildings were centrally heated. Boilers generated hot water or steam that was carried by pipes and radiators throughout the building. To cool the air and create a comfortable environment in hot climates fans and shutters were used. Air conditioning first became widely available in industrial and commercial buildings, cinemas and theatres early in the twentieth century, particularly in the United States. In recent years we have come to recognise that sealed interiors with air conditioning and central heating need very careful design, otherwise they may lead to sick building syndrome and encourage Legionnaire's disease and allergic reactions.

Passive environmental control

Today, environmentally conscious architects seek passive means to control the interior environment in order to reduce energy consumption and global

warming. Massive stone or brick load-bearing walls offer good thermal insulation, and many small windows, roof lights and light wells provide as much natural light as possible. Some of these techniques have been used in hot climates for thousands of years. In India and the Middle East unglazed windows with decorated, perforated screens or jalis encourage air circulation and cross-ventilation. At Mandu in the Vindhyas Mountains, near Indore, Central India, the Sultans retreated to the Champa Baoli, a labyrinth of underground, well-ventilated rooms dating from around the fifteenth century to the early sixteenth century (Figure 4.14). Wind towers were also used to cool buildings in hot dry climates. A tower on the roof catches the cooler, less dusty air above the building, which is channelled down to the rooms below. Some towers have a single opening facing one direction; others are multi-directional with openings on more than one side to catch the cool breezes. All have outlet vents to expel the hot air. Examples can be found in Cairo, parts of the Gulf, Oman, Iraq, Iran and the Sindh region of Pakistan.[20] In Hyderabad, Sind, in west Pakistan, where temperatures may exceed 50°C, the tradition for more than 500 years was to install wind scoops on roofs to channel the cool breezes into the rooms.[21] Today, environmentally conscious architects are re-exploring natural ventilation using a variety of techniques. These include the centuries-old thermo-syphonic stack effect created by openings in towers or 'chimneys' and locating windows on opposite sides of rooms to encourage cross-ventilation. The numerous computers used by the staff and students in the Queens Building, De Montfort

Figure 4.14 Underground chambers, Champa Baoli, Mandu, India, early sixteenth century

Figure 4.15 The Queens Building, De Montfort University, Leicester, 1994
(Alan Short and Associates)

University, Leicester, 1994 (Alan Short and Associates*) create tremendous
heat (Figure 4.15). In winter this can be used to reduce artificial heating. In
warm weather the excess heat generated by the computers is expelled via
vents in the roof and 'chimneys'. These 'chimneys' have a dual role of
expelling warm air and catching breezes that can be circulated around the
building to cool or ventilate it passively.

In south-west London BedZED the Beddington Zero Energy Development,
2002, is the UK's first large-scale carbon-neutral housing development.
Built on the site of a former sewage works, the energy-efficient design uses
renewable sources generated on site and all the homes are well insulated
and face south. The development by the Peabody Trust, with the architect
Bill Dunster and environmental consultants BioRegional, consists of 100
properties for sale and rent.

Space for servicing technology

Essential services such as heating, air conditioning, lighting, lifts and water-
borne sewage systems require machinery, boilers and tanks, as well as pipes
and wires, which need to be appropriately housed somewhere within the
building. Early equipment, particularly for lifts and central heating, was
often bulky and took up much valuable space. Since the late nineteenth
century in the commercial centres of cities such as London, New York and
Chicago, where land values are high, architects of speculative office buildings

have had to confront the tension between the space for services and creating as much rentable space as possible. The visual impact of such services could be minimised by hiding much of it in the basement or the attic, within the walls or under the floors and designing the central heating radiators and pipes for minimal intrusion. By contrast the traditional fireplace symbolised the heart of the home and formed a focal point around which people gathered. Inglenook* fireplaces further welcomed occupants to sit in the draught-free warm space around the fire. The two seats on either side of the fire are positioned within the chimneybreast and when seated there you can look up the chimney and see the sky above (Figure 4.16). The two original ovens are located on the left of the fireplace. With the arts and crafts revival in the late nineteenth century in both the UK and the US, the inglenook fireplace was nostalgically reintroduced into houses. Most were of modest size, allowing four people to sit close up on either side of the fire. However, the Gamble House, by Greene and Greene, 1908–9, Los Angeles, California, featured a 16-foot wide inglenook.

Chimneys were a necessary and prominent feature on many traditional buildings, particularly the elaborately decorated brick chimneys on houses in the Tudor period in England. For maintenance and hygiene reasons, sanitary waste pipes usually run down the external walls of buildings in the UK. However, in the eighteenth century, in Bath and elsewhere, such pipes were wooden and internally located, with frequent disastrous consequences. In hot climates water tanks are often placed on or under the roof, but the danger

Figure 4.16 Inglenook in Walnuts Cottage, Oxfordshire, *c.*1550

Figure 4.17 Lloyds Building, London, 1986 (Richard Rogers Partnership)

of freezing prevents this elsewhere. More recently architects have shown that placing servicing equipment on the exterior can be both visually exciting and leave more space for commercial use. At the Lloyds Building in London by Richard Rogers, 1978–86, toilet and washroom 'pods', water tanks, glass lifts and piping are on the exterior, leaving more available office space (Figure 4.17). In modern offices deep spaces between the ceilings and the

floors above are needed to house cables, ducts and pipes carrying electricity, air and water, air conditioning, fire detectors and fire-fighting sprinklers at each work station.

The creation of artificial environments, which is largely what many buildings are, is a complex task. Many factors go towards resolving the size and shape of spaces and the environmental conditions to be found within them. However, often the solution is circumscribed by the materials, the funds available, the location of the building and the nature of the site.

5 Drawings and models

Architectural drawings and models have one major function in common and that is communication. They are the means by which architects communicate with other people such as prospective clients and the public, or give detailed instructions to a builder. They also enable architects to develop their ideas. The analysis of a series of drawings of a building can reveal how an architect's ideas changed during the evolution of the design or during the course of the construction. They can also indicate the architect's approach to design and reveal their intentions at a particular moment. Architectural drawings and models are made for a variety of purposes and these determine the nature and quality of the information included. A small-scale drawing with few details may be sufficient to convince a client of the merits of a project. Finished architectural drawings to be used by a contractor on site are called working drawings and they form a legal contract between the owner and contractor. Sometimes individual drawings and models are made of particular features, such as decorative mouldings. These may be full-sized to enable craftspeople to carve the detail accurately.

Drawings include plans, elevations, sections and sketches and they give us 'access' to buildings even if they are on the other side of the world. Some buildings exist only in the form of drawings. In competitions many proposals may be submitted, but only the winner succeeds in having their building constructed. Drawings may also be the only surviving evidence of ephemeral structures, such as exhibition buildings erected for a few months and then pulled down, or buildings that have been demolished or damaged. Designs by visionary architects, such as Boullée's* design for the monument to Newton, exist only on paper but may be very influential (see Figure 8.5). More recent visionary architects include the Japanese Metabolists* and the English Archigram* group who were inspired by the technology of the early 1960s to produce utopian city schemes, many of which were influenced by space research imagery. Archigram advocated a flexible, disposable, machine-age architecture that was popular, anti-heroic and free from historical styles. Contemporary architects absorbed their imagery; indeed, it is arguable whether the Pompidou Centre in Paris (Renzo Piano* and Richard Rogers, 1974) or the Lloyds Building in London (see Figure 4.17) would have been possible without these influences.

Plans

A plan is a horizontal plane through a building, usually drawn at a level to give the maximum amount of information. This is often at chest height (that is the height at which a tape is normally held when measuring a building), so that it includes all openings such as doors and windows. As its name implies, the ground plan is the plan of the ground floor. In UK terminology this is the floor at ground level and the floors above are numbered consecutively – one, two, three. In European and American terminology the ground floor is numbered the first floor and the floors above are numbered consecutively – two, three. So a UK first floor is an American or French second floor. In this book we use the UK system of numbering. When faced with plans labelled ground floor, first floor, second floor, it is important to understand which system of numbering is used and how the floors relate to the ground level outside. The ground floor may not be the only floor with exits and entrances at ground level. A building on a steep site may offer the opportunity to design exits and entrances at ground level for several floors. Plans should give the north point to show the orientation of the building, for this determines the type of natural light that will be available, but this may be lacking in older pre-nineteenth-century plans. Plans show how the shape of the exterior relates to the interior, how the inside of a building works and the size, shape and disposition of the rooms. They also show the general structure, whether it has load-bearing walls or is a frame construction, and how the different floors relate to each other. We can also see where the windows, the fireplaces, chimney flues and other services are placed. The plans included in architectural history books are usually much simplified and show the overall form of the buildings, the spaces inside and whether the walls are load-bearing or not.

Analysing the plans we can see the circulation routes for people to move around the building, and the relationship between stairs, halls and passageways and the rooms they serve. We can also see the kinds of activity possible in a building. If the building still exists, we can compare the drawings with the building itself, but we may well find that there are differences between the two. This may be because the architect or client changed their minds during the course of construction, or changes may have taken place over many years. Additional information such as photographs, sections, elevations and models can be related to the plans, for the more information we have, the more we are able to discover.

Today, there are agreed conventions for indicating the mode of construction of a building. Figure 5.1 shows those recommended by the Royal Commission on the Historical Monuments of England (now part of English Heritage) for recording historic buildings. There are, nevertheless, still variations within these conventions adopted in different parts of the world, and in earlier periods architects developed a variety of conventions. Figure 5.2 shows Serlio's design for the ground (right) and first floors (left) of

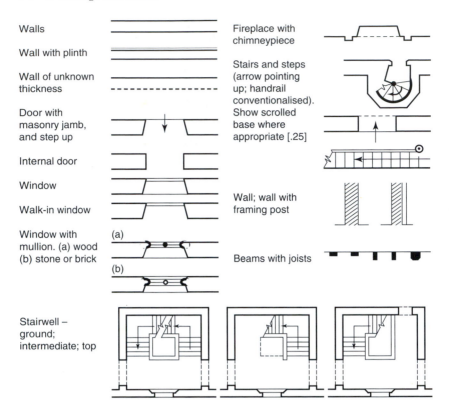

Walls	Fireplace with chimneypiece
Wall with plinth	
Wall of unknown thickness	Stairs and steps (arrow pointing up; handrail conventionalised). Show scrolled base where appropriate [.25]
Door with masonry jamb, and step up	
Internal door	
Window	Wall; wall with framing post
Walk-in window	
Window with mullion. (a) wood (b) stone or brick	Beams with joists
Stairwell – ground; intermediate; top	

Figure 5.1 Architectural drawing conventions (Royal Commission on the Historical
Monuments of England)

merchants' shops, loggia and apartments in Lyon in the mid-sixteenth
century. From this plan we can see the position of the windows on both
floors, the staircases and the spiral stairwell. On the first floor the position
of the doors, or lack of them, indicates the size of individual apartments.
Some plans are more difficult to decipher than others. Figure 5.3 shows
Antonio Gaudí's original 1906 plan for the third storey of the Casa Milá
(also known as La Pedrera) apartment block in Barcelona. The windows in
the main wall of the building can be seen as the dark spaces that appear at
intervals in the thick white line around the edge of the plan. Occasionally
a thin wavy line extends outside this boundary wall and this denotes the
balconies. The rooms have curving walls with no corners and are like a neck-
lace of bubbles threaded together. Winding passages separate these rooms
and there are also a number of internal rooms without windows, which may
perhaps be storerooms. We can see that the building has two large internal
courtyards, each with stairs, but the direction of the stairs is not indicated.
There is a curtain wall, shown by a single line around each courtyard,

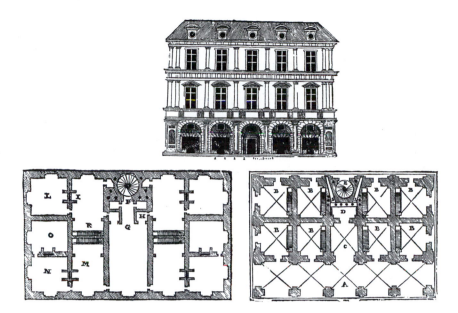

Figure 5.2 Merchants' loggia, shops and apartments, Lyon, France
(Sebastino Serlio, *L'Architettura*, *c.*1540)

Figure 5.3 Plan of third floor of Casa Milá, 1906 (Antonio Gaudí)

supported by rectangular pillars; elsewhere the white circular dots indicate columns. Between the two large courtyards are two circular spaces to which there is no access, but there are small windows facing onto them so we may conclude that they are light wells. The material of construction is not indicated but from the floor plan, the exterior walls which are of concrete, appear to be load-bearing, while columns support the floors.

In *The Bungalow*, A. D. King traces the evolution of this building type from its beginnings in India in the seventeenth century to its subsequent development in the UK, the US, Africa and Australia. Many of the plans and illustrations are from local contemporary sources and these provide an interesting insight into the conventions used in plans across four continents during more than two centuries.[1]

Figure 5.4 Street plan showing the relationship between dwellings and streets (Ordnance Survey)

Plans of single buildings generally cannot tell us how they relate to their immediate surroundings, or what the topography and character of the site are like. City plans show how the streets are laid out and where the open spaces are, but are not usually of a large enough scale to show the relationship between the houses and the streets (see Figures 9.1 and 9.5). Street plans and Ordnance Survey maps show how buildings relate to the street (Figure 5.4). At the north end of Stanley Road is a large building on the corner with the main road at the top; just to the south and within the same plot are two small rectangular buildings. Beyond are two blocks of adjoining terraced houses set back different distances from the road. The distance they are set back from the street is called the building line and this is often determined by local by-laws. Next to these terraces are what appear to be garages, since they seem too small to be dwellings. To the south of these are a detached house, then two semi-detached ones, each with gardens stretching across to the next road. At the north end of the next road are three attached dwellings, then a row of terraced houses. These seem to adjoin the building to the south, but as this is quite different in form and is set back further from the road, it is likely to have been built at a different period. Next to this are two garages and then the gardens of the houses in the next road, with what appear to be either garages or sheds at the end.

Ordnance Survey maps can provide a fund of information. The first one-inch-to-the-mile map was published in 1801 and was of Kent. The 25-inch survey was begun in 1854 and completed in 1893. Shortly after each was completed six-inch maps were published of each 25-inch one. In addition large towns were surveyed at a scale of 10 feet to the mile (1:500) between 1855 and 1894. About 400 towns were surveyed and the detail is superb, including individual trees and flowerbeds. Most local history libraries have sets of maps referring to their area, as do County Record Offices, and the British Library Map room has a complete set.

Scale

Plans and models are always to scale and the main factor governing the scale chosen is the level of information to be given. Some sketches may also be to scale, but freehand explorations of ideas will probably not be. Until 1971 all scales in the UK were in imperial measurements (e.g. a quarter of an inch to one foot represents a scale of 1:48). Since 1971 the metric scale has been used. A scale of 1 mm:1 metre represents a scale of 1:100 and this is quite sufficient to show the relationship between rooms. Figure 5.5 shows the ground-floor plan of a large Victorian country house. To understand this plan it is important to recognise how the owner's family and their servants lived within its walls. The basic rules underlying this plan concern the social dynamics of day-to-day life in an era when servants were an essential part of running the household, but their contact with the family had to be minimised. As Jill Franklin says 'the dinner route was noble, the servants

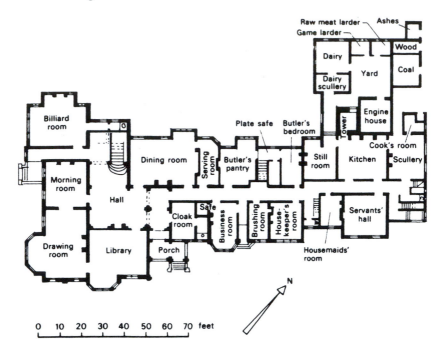

Figure 5.5 Askham Hall, Yorkshire, 1885 (Chorley & Cannon)

invisible and the boiled cabbage kept at bay'.[2] From this plan we can see that the main stairs lead off the main hall and there are several narrower stairs used by the servants. The family and the servants moved around the building by different routes. These dictated where and under what circumstances they saw each other, and how the various spaces were used at different times of the day. This plan is not symmetrical, nor is there any axial emphasis. The main family rooms are grouped around the entrance hall, while a separate private entrance provides access to the business room and the adjoining service areas and servants' quarters are completely separate.

An axial plan means that the building is designed so that it is symmetrical about either one or both axes. Axial compositions were used in many cultures. One of the most common traditional Chinese dwellings was the Han courtyard house that had roots in house designs of the Zhou dynasty of the twelfth century BC. Courtyard houses were subsequently influenced by Confucian rites and geomancy* and were of varied form; some in the south of China had multiple storeys.[3] The simplest plan consisted of a rectangular, inward looking courtyard on a north/south axis whose exact orientation depended on the birth date of the male house owner. The single entrance to the house was in the south wall, either centrally placed or to the east. The tall, main ceremonial and living hall was in the centre of the north wall

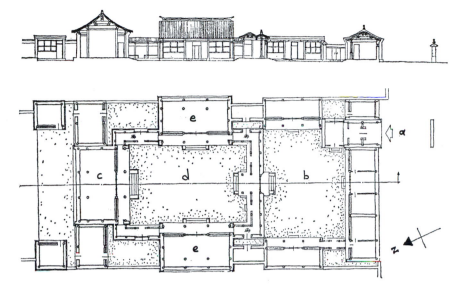

Figure 5.6 Plan of courtyard house, Beijing

flanked by the parents' bedrooms. Along the east and west walls were bedrooms for children and guest rooms. Extended families and wealthy households with servants had more than one courtyard and the service court-yard would be the first entered from the street, with service buildings along the south wall. A second gate, called the Hanging Flower Gate, located on the central axis of the north wall of the service courtyard led to the family quarters. Figure 5.6 shows one of these larger Beijing courtyard houses. The entrance (a) from the street is in the south-east corner and leads into the first courtyard (b). The main hall (c) is located centrally to the north of the second or north courtyard (d). Along the east and west sides are side halls (e) for children and guests.[4]

Larger projects, including town plans, were also symmetrically planned around a central axis and perhaps parallel and subsidiary axes. The Imperial Palace or Forbidden City, Beijing, built from the early fifteenth century onwards, is a labyrinth of courtyards containing halls, libraries, offices and living quarters for the imperial family, surrounded by a huge wall. The major palace buildings are located on an axis and ceremonial pathway that runs through the whole of the Imperial Palace from south to north (Figure 5.7).[5] Visitors entered the palace through the central Wu Men or Meridian Gate in the south. This leads to a huge rectangular courtyard with five marble bridges over a bow-shaped stream beyond which is the T'ai-ho Men or antechamber. Beyond this is a larger court that leads to three successive buildings in line, surrounded by a triple marble terrace. The first building is the public ceremonial audience hall of the Emperor, the T'ai-ho Tien or

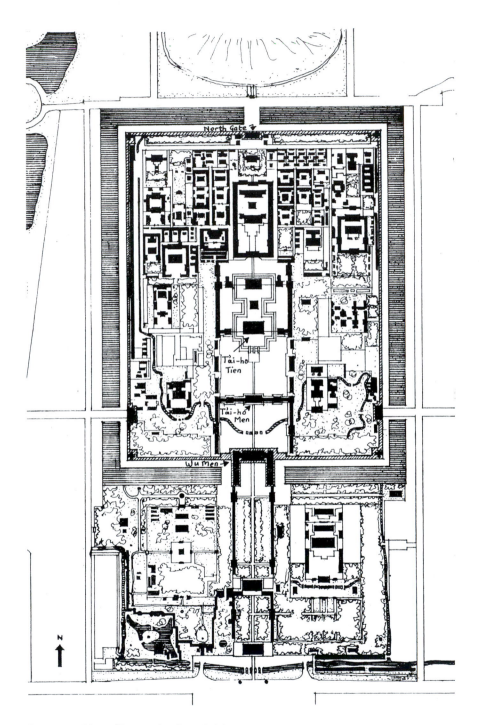

Figure 5.7 Plan of Imperial Palace, Beijing

Hall of Supreme Harmony. Smaller buildings, and a wall that subdivides this outer or formal part of the palace from the inner private complex, flank the T'ai-ho Tien. The next two buildings on the terrace are preparation rooms. Beyond these an inner courtyard contains the personal palaces of the Emperor and Empress, located one after the other on the axis with a subsidiary building between. Finally, there is a garden with minor buildings leading to the centrally located north gate in the perimeter wall. Axial plans in these Chinese compositions do not open up the space on either side of the central line or axis and often do not culminate in one element of central importance. The line passes through openings in walled enclosures and buildings. The whole length of the axis is not revealed at once so there is no vista*. There is an ordered sequence of varied spaces each blocking views of the next.

In classical architecture the example of Syon House, Robert Adam, 1772, illustrates a plan that is axial and classical (Figure 5.8). All four façades are

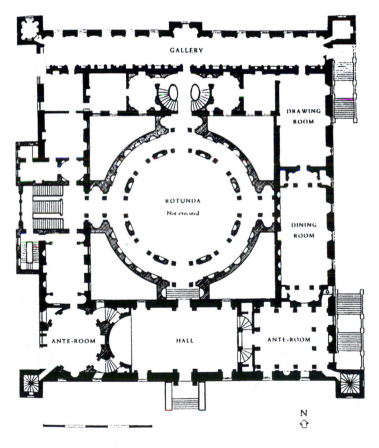

Figure 5.8 Ground floor plan of Syon House, 1772 (Robert Adam)

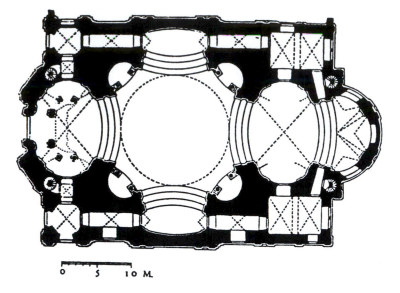

0 5 10 M

Figure 5.9 Church of Brunau, near Prague, 1708–15 (C. Dientzenhofer)

symmetrical about their centre point and the interior spaces are nearly symmetrical on either side of the north/south axis. The rooms are all geometrically shaped, and each is based on a classical prototype. The entrance hall, with an apse* at either end, leads to the domed rotunda*, or pantheon*, at the centre. Classical planning involves symmetry, the organisation of clearly defined axes, hierarchically planned rooms and, in skilled hands, the clever use of poché, which are the spaces between the main rooms. Note in this plan the insertion of winding stairs in the poché, between the hall and the anteroom to the left.[6] The classical tradition continues to the present day, but not all buildings displaying classical motifs externally have classically planned interiors, as the Richmond Riverside office development illustrates (see Figure 2.7).

The plan of Syon House shows that the spaces of each room are separate and distinct from each other. By contrast, Figure 5.9 shows how Christian Dientzenhofer created a sense of movement, in the baroque church of Brunau, 1708–15, by means of a series of ellipses. He carried this sense of movement even further in the church of St Nicholas, Prague, where the elliptical forms of the plan overlap and set up their own rhythms. The ribs that spring from the piers and support the roof and ceiling form another series of ellipses that are offset from those below. The rhythm of these elliptical forms at roof and ground level resonate in what has been called 'syncopated interpenetration'.

The Beaux-Arts system of planning which developed at the École des Beaux-Arts in Paris in the late nineteenth century was applied to major

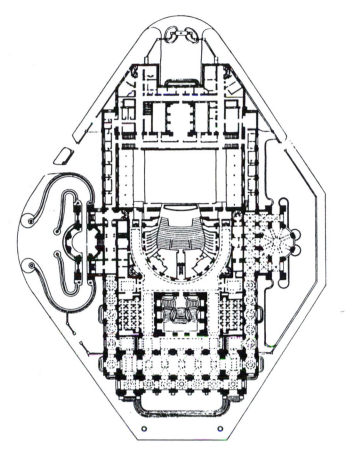

Figure 5.10 Second-level plan of the Paris Opéra, 1861–74 (Charles Garnier)

projects throughout France. Leading American architects such as H. H. Richardson* and C. F. McKim* were trained at this school and the Beaux-Arts consequently became a major influence in the US. Charles Garnier's Paris Opéra is an excellent example of Beaux-Arts planning and it was widely praised for its composition and logic (Figure 5.10). The logic derived from Viollet-le-Duc's theories of architectural change, from classical principles and from the need to create a building of national prestige which accommodated the practical requirements of staging an opera. The site of the Opéra determined the overall shape of the plan. If we look at this plan in detail, we can see that the most important space and central focus is on the horseshoe shape of the auditorium in the centre. Both axes of the plan bisect here. The next most important space is the rectangular stage. Along the major vertical axis Garnier positions a sequence of spaces: the grand foyer and staircases to the south of the auditorium and the artistes' rooms to the north of the

stage. Garnier separates the primary volumes within the plan, but relates them to each other in a composition that has both logic and harmony. Foyers separate each element from its neighbour and the circulation routes around the periphery of the plan provide a further organising framework that articulates the whole, so the overall composition has logic, harmony and a hierarchy of elements.

Elevations

An elevation is a frontal view of a building, drawn accurately to scale, with no perspectival distortions, for it is drawn as if seen from infinity. When we look at a building we see it in perspective from wherever we are standing and not in elevation. Elevations enable architects to study the geometric proportions of the façade. In Figure 5.11 Palladio offered his client two alternative solutions for the façade of this palazzo at Vicenza in Italy. On the left the ground floor is more heavily rusticated* and the windows are set forward of the wall and have a cornice*. Above, a heavy entablature and an attic storey* surmount the Ionic half* or engaged* columns. On the right, the giant order* of Corinthian pilasters runs through two storeys, the piano nobile* and the second storey, giving a lighter and more unified design. A modified version of the design on the left was built for Iseppo Porto *c.*1547–52.

Figure 5.11 Designs for the Palazzo da Porto Festa, Vicenza, *c.*1549 (Andrea Palladio)

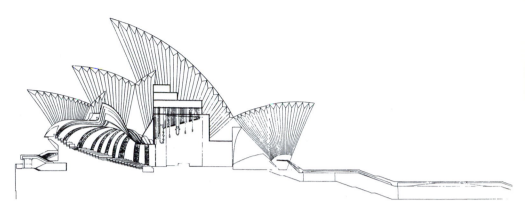

Figure 5.12 Sydney Opera House, section, 1957–65 (Jørn Utzon)

Sections

A section is a vertical plane cut straight through the building from top to bottom, showing details of interiors and the construction of walls, floors, ceilings and roofs. Like an elevation, a section cannot be seen in real life, even if a building is in the process of demolition and the exterior wall has been removed, because it is drawn with no perspective distortion. Sections enable an architect to show how the internal spaces relate to each other and they provide the opportunity for showing schemes for interior decoration. The longitudinal section of the Paris Opéra shows the spaces for the stage, auditorium, foyer and the support facilities behind the stage (see Figure 4.7). The section of Jørn Utzon's original design for the Sydney Opera House shows his proposed curving ceilings for the interior (Figure 5.12). However, after his resignation the interiors were completed to a different design. Four elevations, plans and a section (bottom right) of a village school and master's house can be seen in Figure 5.13. From the plan we can see that the school to the right of the master's house is subdivided into two spaces, one for the girls (right) and one for the boys (left). Each space has a fireplace and a door in the same wall as the fireplace. If we look at the section (bottom right) we can see these clearly, for the section is taken just in front of this wall. The boys' and girls' schoolrooms are double height with a very high roof above revealing the timber roof structure. Behind the boys' schoolroom is another classroom with a closet, and to the left is the school hallway and the master's house. There is no access from the school to the master's house. The section through the master's house is taken through the entrance and staircase hall very close indeed to the near wall of the hall, for we can see the door from the front room into the hall and a bedroom door (over the kitchen) above. The zigzag line in mid air confirms this, since it shows the upper flight of

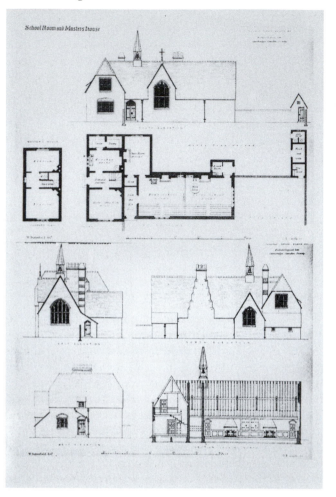

Figure 5.13
Village school
and master's
house (William
Butterfield)
(*Instrumenta
Ecclesiastica*, 1852)

the staircase. The walls at either end of the building are shown broken by openings – the door to the master's house to the left and a large window to the right – that can be seen in the two end elevations to the bottom left of the drawing. The structure of the roof of the master's house is a kingpost* construction and the two dark vertical lines are load-bearing walls, one of which forms the end wall of the master's house while the other supports the load of the flèche*.

Perspective drawings

Perspectives are the most readily understood of all architectural drawings and the technique used affects the way that we respond to them. Perspectives may emphasise the most attractive viewpoints and present the building in

a delightful setting, with colour used to highlight particular features. Indeed, one of the criticisms of drawings was that in skilled hands their beauty could captivate a client, even though the building itself was of little architectural merit. Drawings are still used today to inform and impress prospective clients. Speculative builders produce glossy brochures showing how a new housing complex will appear when completed, and the hoardings around major new developments often show artistic visions of the completed project, with the sun shining, the trees in full leaf and everyone smiling.

Plans, sections and elevations enable us to 'see' a building in three dimensions, but we can only see two of those dimensions at a time. The techniques that have been developed to show a building in three dimensions are the isometric projection and the axonometric projection.

Isometric and axonometric projections

In Alvar Aalto's* summerhouse design we can see more than one side of the building (Figure 5.14 top).[7] This is a worm's eye view isometric projection. A projection is like a perspective in that it tries to show the building in three dimensions. It brings together into one drawing the plan and elevations of more than one side of the building. In an isometric projection the plan (lower left) is rotated so that one corner of it is nearest us. The plan is then distorted so that it is no longer a rectangle; the sides of the plan are at an angle to the bottom edge of the page. The former right angles have changed. The angle of the corner of the building appearing closest to the viewer and the one diagonally opposite are 120°, the other two are 60° each. The diagonals have been distorted too, so that one is longer than the other, instead of being equal in length. In order to give a three-dimensional illustration of the building, the two nearest sides of the building have been projected or drawn in. The verticals are still vertical and they are to scale. We can see two side elevations together and can take measurements from the lengths and heights of the walls.

An axonometric projection differs from an isometric projection in that it does not distort the plan, which remains rectangular and true to shape and scale. It is very useful for creating a bird's eye view of a building. The plan is rotated again to an angle of 45° to the page to provide the third dimension, and the verticals are also drawn to the same scale. This is the most accurate and most informative method of projection, as the proportions of both the plan and the volume remain true and it is much used by architects today. Figure 5.15 shows an axonometric projection and bird's eye view of the offices of Alexander Fleming House, in south London, with a cinema in the foreground. The plans of the complex of rectangular blocks have been rotated through 45° and the vertical dimensions are all to scale. The buildings are of frame construction (note the pilotis on the far left). We can see how many floors there are in each block, we can measure the dimensions of the flat roof with its parapets, and we can see the lift service shaft with its

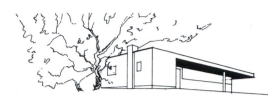

Figure 5.14
Summerhouse design 'Konsoli',
Finland. First-prize competition
entry showing isometric
projection, side elevations, plan
and section, 1927 (Alvar Aalto,
1927)

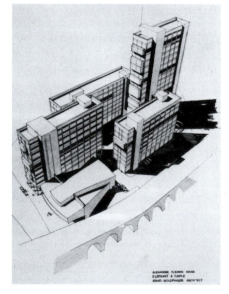

Figure 5.15
Axonometric projection of Alexander
Fleming House, 1960 (E. Goldfinger)

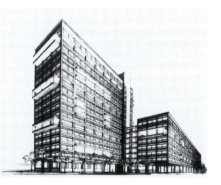

Figure 5.16
Perspective drawing of
Alexander Fleming House, 1960

housing on the roof. If we compare this projection with a perspective drawing (Figure 5.16) we can see clearly how much more information is given in the former.

Models

Like the plans, sections and projections that we have been discussing, models are another means of communicating the ideas of architects to the public and to clients. Models can be very seductive. Beautifully made of wood, crisply modelled of plaster, or carved out of polystyrene, they remind us of the doll's houses, model farms and railways that we played with as children. The seductiveness of models is not only to do with their size and the materials used, it is also to do with the clarity and cleanliness of the forms, the way they are lit and the way the shadows fall. They represent pure, ideal buildings that are removed from their context and are not subject to the wear and tear of weather and time. Models may seem more truthful than drawings because they present a three-dimensional version of a proposed building, but they may not necessarily be simpler to interpret. Problems arise when we try to move from the models to understanding what the full-sized buildings will look like. This is an ideal world we are entering and we are Gulliver looking down on Lilliput. Even if the models are finely detailed and fully coloured, and include people, trees and cars in scale with the buildings, the world that they inhabit has no litter, no graffiti, no poor or elderly, and we have no clue about where the sun might shine. No wonder most of us find it so hard to translate that model world into the full-scale built environment.

There are a number of different types of model, each serving a distinct purpose, and when we look at models of buildings we need to know why they were constructed. In the evolution of their ideas architects use design models as aids to the design process. In order to present their ideas to clients or committees, for exhibition or public criticism, they use presentation models. A third category is the working model used to guide builders in the construction work and in the internal and external details.

Figure 5.17 shows a design model of an infants' school. Here we can see how ideas of space are being explored, not only in terms of the internal spaces of the building, but also the relationship of the building to its surroundings. The main focus of the building is the large central space that in effect forms the hub of a wheel. Around this space are smaller spaces that face out, on the side nearest us, to the surrounding landscape. To the rear there appear to be no windows. We can see that the building is set on a gentle slope, with tall trees protecting it to the rear. Figure 5.18 shows a structural model of the same building, showing the structure of the roof over the central space and how this relates to the lower roofs over the smaller spaces. Structural models are a useful way of learning how a building is constructed, for once it has been completed much of the structure may be hidden (Figure 5.19).

Figure 5.17
Design model of Stoke
Park Infant School,
1989 (David White
and Steve Harte)

Figure 5.18
Structural model of
Stoke Park Infant
School (David White
and Steve Harte)

Presentation models are the means by which architects communicate their
ideas to their clients. Some presentation models show the building in great
detail, not only indicating the materials of construction but also the detailing
of doors, windows and roofs. This presentation model of the infants' school
is of wood and is of the same colour throughout (Figure 5.20). From it we
can see clearly how the central roof marks the importance of the space under-
neath and how the surrounding spaces and their roofs relate to it, but we
would need further information in order to understand what materials were
to be used on the exterior and interior.

The model of the Richmond Riverside development is in full colour and
it is possible to read from the model where brick would be used and where
stone, the materials for the roof and the details of the columns, doors,
windows and cornices (Figure 5.21). Indeed, we can see many more of the
details from this model than we can from the building itself when we are
standing on the ground. When plans were being considered for this sensitive

Figure 5.19
Stoke Park Infant
School as completed
(David White and
Steve Harte)

Figure 5.20
Presentation model
of Stoke Park Infant
School (David White
and Steve Harte)

riverside site, several proposals were put before members of the public, who were asked to indicate their preference. The vote was overwhelmingly for this group of neo-Georgian buildings. Their external appearance would lead one to think that they were houses, but these façades front open-plan offices. Indeed, the label on the model proclaims: 'Masterly conceit disguising an ordinary office building, it denies the structural logic of classicism.' The technology of today's offices demands deep spaces between ceilings and the floors above, and this has led to some rather unfortunate compromises. The round-headed and Venetian gothic windows have their heads blocked off by the floor above, so the effective window is the rectangular part only and the floors can be clearly seen crashing across (Figure 5.22). This unhappy fact could not be deduced from the model, for the windows are all painted black with white glazing bars and there is no indication of the thickness of the floors. The only way this could have been detected would have been from a comparison between a section and the model.

Figure 5.21 Presentation model of Richmond Riverside
 (Quinlan Terry)

Figure 5.22 Detail of Richmond Riverside

Figure 5.23
Clay model of Minoan
house from Arhánes
*c.*1700 BC to
1400 BC (Heraklion
Museum)

Models can also include visionary, futuristic designs that are independent
of practical considerations. Another broad group of models are those that
display groups of buildings and their interrelationship. Site models and
master plans can cover hundreds of hectares, as can topographical models
that reproduce cities or regions complete with geographical and natural
features. A further complication concerns chronology. Models may be made
before a building is constructed, during its construction or long after it has
been completed. Models of, say, classical buildings may depict them at the
time that the buildings were constructed; if the buildings no longer exist,
these models may be our only source of information. The little clay model
in Figure 5.23 is almost all we know about Minoan buildings of this kind.
Models have been made out of wood, cardboard, plastic, metal, stone, slate,
wax, cork and plaster of Paris. Plaster of Paris was found to be unsuitable
for delicately ornamented parts, particularly if the models were to be handled
frequently. This problem was solved by the invention *c.*1843 of papyrus
powder, which was a form of very fine papier mâché. Many models were only
intended to last for a short time and as they were fragile and difficult to
store, comparatively few have survived.

The use of models by architects has a long history. We know that they
were used throughout the building of St Peter's in Rome. As the renaissance
spread north through Europe, so did the use of models. In Britain their use
increased in the mid-seventeenth century, and Wren used models to demon-
strate solutions to structural problems, to instruct workmen and to impress
his clients.[8] Wren's best-known model, of St Paul's Cathedral, was a presen-
tation model of wood, designed to impress by its rich decoration, imposing
classical forms and the grandeur of its size, for it was large enough to walk
through (scale 1 inch to 1.5 feet). James Gibbs's model (1721) of St Martin-
in-the-Fields, London, is also in this tradition, with every detail of both the
exterior and the interior clearly carved in wood, and the bracing of the roof

clearly indicated. During the course of the eighteenth century the use of models declined, owing partly to the development of skill in the building trade and partly to the emergence of the architectural profession. A major exception to this trend was John Soane, who was one of the few architects working in the period 1780–1830 to use architectural models extensively. He used them not only to develop his design ideas but also to instruct masons and carpenters and to persuade clients. In 1804 Soane bought two cork models of ancient Roman buildings, the Temple of Vesta at Tivoli and the Arch of Constantine. Today these models, which are on display in the Sir John Soane's Museum, London, provide evidence of how those particular buildings appeared at the time the models were constructed in the late eighteenth century. In 1834 Soane bought twenty small plaster-of-Paris models of ancient Greek and Roman buildings by the French model maker François Fouquet. These were then called restorations, but today we would call them miniature reconstructions. Soane had been influenced by earlier French examples of architectural museums and the Model Room that he set up was, in effect, an architectural museum. In it he included the models that he had purchased, together with models of his own buildings, 108 of which survive.[9]

In the nineteenth century the use of models increased and many were displayed at the numerous international exhibitions of that period. In the first of these, the Great Exhibition of 1851, more than seventy models were shown, most of them of bridges and engineering projects. They also included a model of Decimus Burton's* and Richard Turner's* Palm Stove at Kew and a cardboard model of the Assize Courts at Cambridge (T. H. Wyatt and D. Brandon, *c.*1840). In the 1862 International Exhibition in London, there were twenty-six English models, including one of Bilbao railway station in Spain and one of the industrial village of Saltaire by H. F. Lockwood, but the number of French models was so great that a separate catalogue was issued. The Museum of Construction in London held a collection of models, and when this was disbanded, some went to the Victoria and Albert Museum, but many were lost.[10] Today, models can be uncovered in a wide variety of locations, ranging from local history museums to architectural museums and from churches to country houses. One of the grandest of all the nineteenth-century models was the 11-foot-long silver-plated Parliamentary model of the Forth Bridge, 1882, so called because it was put before Parliament in order to secure backing for the project. It is part of the collection of the Science Museum, London.

Design models are more than three-dimensional representations of plans and elevations. They provide a means of testing ideas about space, proportion, scale, massing and the relation between vertical and horizontal planes, and they can be used to test hypotheses about lighting, structure and rigidity. When Charles Garnier was evolving his ideas for the Paris Opéra in 1861, he used a model with interchangeable parts. A model of the complex Opéra can be seen in the Musée d'Orsay in Paris. If the forms envisaged are very complex, this may be the only way to test their viability. To arrive at the

complex forms of the church of Santa Coloma (Figure 5.24) Gaudí worked with an engineer and sculptor on a large wire and canvas model. They experimented with the tension forces and calculated the catenary* system by attaching small known weights to the model. These tension forces were then converted into those of compression, by inverting the structure. Only the crypt of the church was completed, but it was from the ideas that he tested here that Gaudí went on to develop his ideas for the cathedral of La Sagrada Familia in Barcelona. Today, many architects use computer modelling; indeed, without them buildings such as Gehry's Guggenheim Museum, Bilbao, would have been virtually impossible to build. Balkrishna Doshi*, one of India's foremost architects, used computer modelling to evolve forms at the Hussain–Doshi Gupa (Cave), 1994, similar to those at Santa Coloma church. This is a semi-underground gallery in Ahmedabad constructed of reinforced concrete, for the artist M. F. Hussain (Figure 5.25).

Master plans and site plans

In recent years the controversy that has raged over the development of major sites in London, Paris and elsewhere has perforce focused on models of the proposals. In Paris, when I. M. Pei's model of the glass pyramid forming the new entrance to the Louvre was unveiled, there was an outcry. The criticisms focused on the stark contrast between Pei's proposal, the architecture of the Louvre and the 'desecration' of one of France's foremost cultural monuments

Figure 5.24 Crypt of Santa Coloma, 1898, 1908–14 (Antonio Gaudí)

Figure 5.25 Hussain–Doshi Gupa (Cave), Ahmedabad, India, 1994 (Balkrishna Doshi)

that would result. Once the actual pyramid opened, opinion changed and it was greeted with general enthusiasm. This underlines the point that the relationship between models and full-scale architecture is not a simple one and the difficulties are not only to do with the problems of learning to read models. Models can simulate but rarely achieve the subtleties of architecture and its environment. If developers anxious to secure planning approval present them, detailed questions and criticism may not necessarily be encouraged. Furthermore, if criticisms of projects are made predominantly in terms of current stylistic preferences and dislikes, then the debate on issues that are just as, or even more, important may not even be voiced.

Models are one of the main methods used by developers and architects to put their ideas over to the public and to the planning authorities. In London the proposals for developments at Paternoster Square around St Paul's Cathedral, the King's Cross lands, the South Bank of the Thames and Canary Wharf in Docklands have all involved models. In the model of Foster and Partners' proposal for the King's Cross lands (Figure 5.26) the high-rise office blocks around the open park space, the low-rise housing beyond and the Victorian train sheds of King's Cross and St Pancras Stations in the foreground all appear as simple outline blocks. No detail is given of the form, colour or material of these buildings; they all appear uniformly white. The function of this model is not to show the buildings in detail but to explore the space available and show how it could be used in a commercially viable

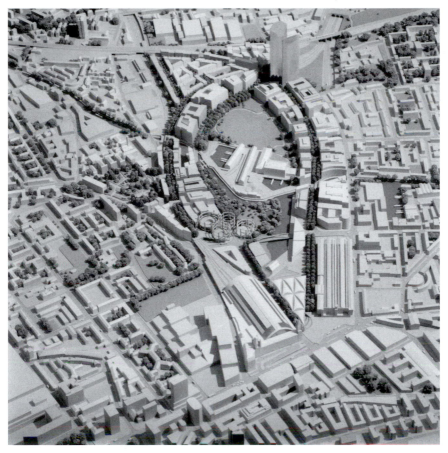

Figure 5.26 Model of King's Cross redevelopment, 1992 (Foster and Partners)

way. The model does not show how the proposed development relates to the existing environment, and the only existing buildings that are included in it are the stations and the four gasholders. The historically important Victorian buildings for storing coal and corn were omitted, as were details of the varied surface levels. When it was decided that St Pancras should become the terminus for the Channel Tunnel Rail Link, new proposals became necessary. The challenge became one of providing access for the rail link, extending the platform length and providing a canopy over it to accommodate the longer trains and also to accommodate further new rail links into King's Cross. The land behind the stations is of great historic significance. A canal crosses it and there are major Victorian buildings that received London's grain and coal supplies. New proposals will need to take all these factors on board.

Topographical models

Topographical models are rather different from the architectural models that
we have been discussing so far, for they provide detailed representations of
a city or region and include the geographical and natural features as well as
the buildings. One of the largest collections of topographical models in
Europe was the Museum of Plans and Reliefs held in L'Hôtel National des
Invalides, Paris. It comprised 140 models of French strongholds and towns
at a scale of 1:600. These date largely from the late seventeenth to the late
nineteenth centuries and for 200 years they were used for strategic purposes.
In 1986 the government decided to transfer the collection to Lille, but
because of the protests voiced by historians only 100 models were transferred
and they are now displayed in the Museum des Beaux-Arts, Lille.[11] These
models provide important evidence of the topography of particular towns
contemporary with them, and they also illustrate their use for strategic
purposes. Because of the scale and expense involved in building topograph-
ical models and because they are usually built for a specific purpose, they are
rarely updated. One major project that was subsequently partially updated
was the model of New York commissioned by Robert Moses, the chief
planner and architect in charge of city parks, housing projects and highways.
This model commemorating the 300th anniversary of the founding of New
York was exhibited at the 1964 World's Fair held in Flushing Meadow. It
featured the five boroughs of New York on a scale of 1 inch to 100 feet. Its
main significance was that Moses envisaged it as a tool to be used by archi-
tects, planners, community groups and all those involved in the development
of New York City in the future. Indeed, in the early 1980s a civic group
used it to demonstrate the inappropriate scale of Donald Trump's proposal
for Television City. Today, it is on display in Queens Museum, New York,
and although partially updated, some recent developments such as Battery
Park City and South Street Seaport have not been included.[12]

Since models may range from finely detailed urban environments with
trees, cars and people to almost abstract sculptures, what guiding principles
should we apply when we look at them? Some architects think that in order
to put across architectural ideas a certain degree of abstraction is important.
Plain wooden models and those painted white or grey not only allow archi-
tects and clients to keep their options open regarding the materials, the final
finish and colours of their buildings, they also tend to abstract the building
from its surroundings. Grey and white models tend to show form better
because the shadows are sharp and curved surfaces are therefore easier to read.
For their presentation of the Sainsbury wing extension to London's National
Gallery, Venturi and Rauch presented an all-white model that distanced and
abstracted the building from its surroundings.

If we are looking at models on display, we need to be very aware of where
our eyes are in relation to the model. Bird's eye views will give an overall
picture, but once the development has been built such a view will never be

experienced. In evaluating a model it is important to try to look at it as if from street level. Some models are displayed on high plinths for this reason, but if someone taller than average has designed the exhibition, those shorter than average may have difficulty in seeing the models at all. Models that are fully coloured and detailed also require thinking about because of the colours used. If an exact colour match of brick were used on a model, it would appear very brash. Normally we see buildings from some distance, so if the colour used on models is equivalent to the material as seen from approximately 100 metres, then the model will not appear too gaudy.

Computer-aided design

Comparing the details of a model with those of the actual building illus-trates just how difficult it is to convey such information accurately in miniature. This difficulty, combined with the great expense incurred in model making, has led some people to predict that the days of the model are numbered. With the introduction of computer-aided design (CAD), the screen is tending to replace the drawing board in the later stages of the design process. Computerised model-making builds on CAD and available software packages. These include three-dimensional modelling and visuali-sation and two-dimensional architectural and engineering drawings. Most architectural practices today employ CAD to produce accurate, speedy and detailed drawings. Nevertheless, manual drawing is still central to architec-tural design and is used largely as a problem-solving activity to sketch out and work through a series of ideas or alternatives. Once the design has evolved and detailed measured drawings and specifications are needed then CAD comes into its own. It can be used to generate various views of the proposed structure quickly so as to test out the design or produce working drawings and to enhance the original design. Revisions can be made quickly, and it has clarity, consistency and flexibility. Frank Gehry evolved the complex forms of the Guggenheim Museum, Bilbao, through sketches and drawings. Models summarising the development phases from the competition model to the verification model followed these. A computer program based on a system developed for the French aerospace industry was then used to model the architectural surfaces and volumes and to define the paths used by the milling machines in the construction process.[13]

In public consultations and architectural presentations digitally retouched photographs and animated DVD images of landscapes and streetscapes have largely replaced artists' impressions. These allow the viewer to move around, through, or over the proposed developments. These images may appear to be three-dimensional, but they appear on a two-dimensional screen and there is still the problem of evaluating them in order to under-stand what the proposed building will look like and how it will relate to its surroundings.

6 Materials and construction

The subject of materials and construction concerns not only the wide range of materials used but also their production and the nature of the building industry. The most common materials are timber, baked and unbaked clay, stone, slate, reeds, grass or straw, glass, concrete, iron and steel. The choice of materials and constructional system sets limits and creates opportunities for architects and builders. Some materials, such as brick, wood and stone, may be very familiar, but it needs careful observation to distinguish particular varieties of timber such as oak or ash, and the differences between the many varieties of stone such as sandstone, limestone and granite. One of the best ways to recognise these differences is to travel widely, look at the materials used, read guides on the local architecture which identify them and visit geological or local museums which may display local building materials.

Since the advent of the industrial age and the building of the railways in the mid-nineteenth century, manufactured materials have proliferated, yet in many parts of the world local and natural materials still predominate. To understand the social organisation, time, energy consumption and effort that went into acquiring, manufacturing or transporting materials it is important to locate their source. A quarry may be local but it may not be easy to extract the good-quality stone. The larger sandstone monoliths* that form part of the stone circle at Stonehenge, Wiltshire, constructed in 2100 BC (see Figure 3.1) were brought by late Neolithic people 18 miles (30 km) from the Marlborough Downs. The igneous bluestones in the centre came from the Preseli Mountains in south-west Wales, some 150 miles (240 km) away. These distances indicate the sophisticated social organisation of these people and the significance that they attached to this site.

Many large medieval cathedrals, castles and palaces used English lead for their roofs, windows and rainwater drainage systems. Records show that in the twelfth century lead was taken in carts across the hilly moors of Derbyshire to Boston and the Humber estuary on the east coast of England, for shipment to Europe. Rivers were also used to transport this material to the coast and until the late eighteenth and early nineteenth centuries the Derbyshire lead fields were among the richest in Europe.[1] In the nineteenth

and early twentieth centuries the UK exported cast iron building products all over the world, with the names of the ironworks emblazoned on them.

Potential and limitations of materials

Each material has its limitations and possibilities. The size of the components may be determined by natural or artificial limitations and this will affect the final dimensions and form of buildings. The height and width of a tree trunk determine the ultimate size of timber. The methods of transport may limit the weight carried and therefore the size of materials but, as we have mentioned, some early societies pushed the boundaries beyond what appeared possible, carrying huge stones very long distances.

The ability to handle modular materials such as brick, generally determines the size, but there are historical and geographical variations. Ancient Roman bricks were often large, broad and flat like tiles. Twelfth-century bricks in England could be large and flat, but in the thirteenth century Flemish influence encouraged smaller bricks. From the sixteenth century sizes were standardised. The earliest mathematical or brick tiles date from 1724 and were subject to tax. They were used to 'improve' timber-framed buildings. The tiles were nailed to timber battens on walls to give the appearance of fashionable, finely bonded brickwork. The brick tax in the UK between 1784 and 1850, imposed partly to finance the war with the American colonies, led to an increase in the size of bricks, since the duty was levied per thousand bricks. In Leicestershire Joseph Wilkes in Measham produced oversized bricks known as Wilkes's Gobs, so that fewer bricks were needed to construct a given area of walling.

The dimensions of other building components, such as beams, panels, window frames and doors may today have to conform to government or institutional standards. There is no agreed international standard although a standard size or module of 100 millimetres (4 inches) is very commonly applied. Mass production of standardised components offers great economies and flexibility within the building industry, enabling components produced by different manufacturers to be used together, or the same component to be used in many different ways. A. W. N. Pugin in 1841 pointed out the downside to this. Speaking of the repetitive use of identical castings of iron, he argued that it was 'subversive of . . . variety and imagination . . . we see the same window in a greenhouse, gatehouse, church, and room . . . although by the principles of pure design these various positions require to be treated differently'.[2]

The choice of material may be influenced by availability, cost, physical properties such as strength, fire-resistant qualities, weathering, maintenance requirements and aesthetic possibilities. Stone can withstand compression or great loads without crushing, so it is suitable for walls and columns. Timber is strong in compression, and is also one of the few natural materials strong in tension, so it can withstand forces that stretch the material. For this reason

it has been widely used in beams. Cast iron is strong in compression but brittle; wrought iron is strong in tension and malleable. Iron-framed industrial and commercial buildings such as William le Baron Jenney's Manhattan Building, Chicago, 1891, used cast iron for the columns and wrought iron for the beams and girders. Mass concrete* is strong in compression but reinforced concrete* is good in both tension and compression. The steel rods or mesh embedded in the concrete take the tension and the concrete takes the compression.

Brick and stone are generally porous and absorb rain but allow it to evaporate afterwards; other materials such as concrete are relatively impervious to moisture and this can cause problems. Many 1960s' blocks of flats made from concrete panels were designed with inadequate ventilation, so the moisture created in kitchens and bathrooms was trapped and mould grew on the walls. Some materials such as wood and metal prove hazardous if fire breaks out. Techniques to prevent or delay the buckling of the metal by fire in metal-frame buildings include cladding the frames with concrete, plaster or ceramic materials or painting them with intumescent paint that swells up and provides a barrier to the fire.

Wars and natural disasters, such as the volcanic eruption that buried Pompeii in AD 79, can lead to the loss of many buildings. Buildings may also remain unfinished due to war or economic factors. When the independent People's Republic of Mozambique was formed in 1975, the colonial Portuguese administration, professionals and business people pulled out of the country almost overnight and construction stopped. During the seventeen years of civil war, incomplete colonial buildings remained with reinforcement rods poking out of reinforced concrete walls and piers. However, at the turn of the twenty-first century plans were made to complete many of these buildings.

Maintenance problems and materials that do not weather well cause other losses. Unburnt clay walls need to be sheltered from the rain and protected from rising damp and burrowing insects, such as bees (see *frontispiece*). Thatched roofs need replacing regularly and are prone to fire damage and insect attack. Vernacular builders in any part of the world have an intimate knowledge of local materials. In Zimbabwe the inner bark of suitable trees makes a strong string and builders select timber that is straight, durable and proof against termites and insect attack. They may walk miles to find durable thatching grasses and clays. Rammed earth floors have cow dung added to deter insects. A wide variety of clays, including that from anthills, are used for floors, to infill between upright timbers, to plaster and decorate walls and to combine with small stones to build plinths. Women do much of this work. In China rammed earth, brick or stone podiums* were traditionally built to raise some timber buildings above damp earth. In important buildings stone, or even bronze, bases were placed under individual columns and the timber structure was made more durable with a lacquer coating that was very colourful.

Brick walls require repointing and stone can be damaged by frost and eroded by atmospheric pollution. Some buildings decay more quickly than others due to the poor weathering properties of the materials. In Virginia, US, the only surviving farmhouses of the seventeenth century are of brick; wooden houses were far more numerous, certainly before 1650, but the material was far less durable.[3] Many of the concrete buildings built after the Second World War now look grey and uncared for, their surfaces streaked with dirt. Yet, concrete does not have to be grey; pigments and coloured aggregates* can be added to it; chemical stains can be painted onto the surface after the concrete has been cast; and hard-wearing surfaces with fine detail can be created which are more resistant to soiling.

There was little scientific understanding of the properties of materials until the nineteenth century. As new manufactured materials were introduced it became necessary to establish these properties and the limits for their safe use. Latterly we have become aware of the health hazards posed by a wide range of materials. Reinforced concrete was largely developed and used in Europe in the nineteenth century, but concern for its fireproof qualities and structural safety led Americans to initiate systematic research in the 1870s.[4] Much of the early research into the structural properties of steel was undertaken not by those in the building industry but by railway engineers using this material. Many countries have now established research institutes specialising in the research and testing of materials.

Environmental issues

Today, the threats to the environment of pollution and global warming can influence the choice of building materials. A policy of sustainability would, if it were widely adopted, imply recycling materials and where possible finding new uses for redundant buildings, rather than pulling them down and building new ones. It would mean reducing the energy used in the production, transport and use of materials, and during the lifetime of the building. It implies the use of natural and local materials and renewable resources wherever possible. This would mean, for example, selecting other materials in place of hard woods from threatened rainforests. Instead of a curtain-walled, air-conditioned office building, the Eastgate Office Building and Shopping Centre, 1996, Harare, Zimbabwe, by the Pearce Partnership, is a long narrow building with a central atrium orientated on an east/west axis to avoid low-angle, direct solar radiation (Figure 6.1). The thermal mass of thick concrete walls clad in brick and the natural ventilation provide a comfortable working environment in the hot, tropical climate. The thick walls absorb heat from the sun slowly, so delaying the need for cooling. Deep balconies on every level shade walls, and sealed small windows with filters control the glare. Grilles beneath the windows bring air into the building through the floor and a network of vertical ducts. The glazed-roofed atrium brings natural light into the centre of the building, and rooftop vents and

Figure 6.1 Eastgate Office Building and Shopping Centre, Harare, Zimbabwe, 1996
(Pearce Partnership)

chimney-like shafts expel exhausted air. The use of passive environmental control has meant a reduction in energy use and operating costs, and expensive, imported air conditioning plant is unnecessary.

The concern for sustainability has led to a revival of interest and research into 'low tech' materials for building, such as timber, earth and bales of straw. Straw buildings have the advantage that the material is cheap, its thermal and sound insulation properties are excellent, and fuel consumption is minimised. A major disadvantage is the fire hazard posed by the material. European settlers in New England and Nebraska reputedly built straw bale structures rendered with clay or cement plaster. In the US, interest in this material revived in the 1970s and many state building codes now recognise its use. In the UK Sarah Wigglesworth experimented with alternative and recycled materials in her home and office in Islington, London, 2002. Sound insulation was essential as the building was near the railway and Wigglesworth used straw bales, recycled concrete, gabions* and railway sleepers. Bags of cement and lime, designed to decay, formed part of the load-bearing walls, and on the roof was a meadow with wild strawberries.

Modular materials

Modular materials consist of small units brought together in a variety of ways to construct walls, span spaces, infill wall frames or cover roofs. One of the most ubiquitous is stone. There are many varieties of stone, each with

its own special qualities of colour, texture, weathering properties and possibilities for carving or cutting. There are numerous ways to cut, dress and lay stone, each affecting the look of the final building. Some stone is naturally fissile* and therefore can be made into thin slabs suitable for roofing or facing walls. The majority of stone is used for walling. Many stonewalled buildings are of rubblestone. This means that the stone is of uneven shape and size and is generally relatively hard. It is common in humble buildings and is economical because every piece of stone can be used. Rubblestone can be used randomly in its rough form, to build walls that are levelled up every foot or so in height, or it may be roughly squared and placed in courses according to the size of the stone. In dry stone walling no mortar* is used, and the stability depends on the weight of the stone and the accuracy with which it is positioned. The wall tends to be battered* or slanted inwards, the two sides being constructed separately of carefully laid rubblestone, so that rainwater runs away from the centre of the wall. The centre is filled with large stones and every so often long stones are laid which run right through the wall. Dry stone walling is common in many parts of the world for low walls between fields. A monumental use of dry stone walling can be found at Great Zimbabwe, a royal palace constructed in southern Africa from the thirteenth century onwards. The hill and valley enclosures and the tall conical tower are built of huge curving walls of granite (see Figure 3.4).

Ashlar* consists of smoothly cut stone blocks that are squared so that the smooth sides make fine joints and level courses are possible. Today, thin ashlar slabs are often used to face walls built of rubblestone, brick or concrete. Limestones and sandstones make good ashlar walling, but only certain selected stone from the quarries is suitable: this is called freestone. Freestone is stone that is of sufficiently even and fine grain to allow cutting in any direction. Because of the high quality of the stone and the work involved in cutting and dressing the stone, that is, trimming and finishing the surface, ashlar was very expensive and was used in public buildings and buildings for the wealthy. Sometimes buildings may have only the front wall in ashlar, the rest being of rubblestone. Alternatively, buildings with rubblestone walls may have ashlar dressings, that is, the stonework at the quoins or corners, around openings, along the top of the wall under the eaves and perhaps the plinth*, is of ashlar masonry to give a more precise or refined finish. The dressings of stone buildings may also be of contrasting materials such as brick (Figure 6.2).

Brick

Clay is one of the most widely used materials internationally, and bricks have been used for at least 5,000 years, the earliest being sun-dried brick. Burnt brick can be traced back to 2500 BC in what is now Pakistan. Bricks are made by hand or machine and formed by pressing clay into a mould to create an appropriate shape. They are then baked in a clamp*

Figure 6.2
Cottage of granite
with brick
dressings,
Newtown Linford,
Leicestershire,
nineteenth century

or kiln (Figure 6.3). The illustration shows the hole where clay has been dug to make the bricks. There are bricks laid out on the ground to dry, before being placed in the clamp (made from old bricks) for firing. There are many varieties of fired bricks, which differ widely in colour, texture, form and use. Hand-made clamp-fired bricks can be of uneven texture and colour, some are blackened by over-firing, others pale because of the clay type or under-firing. The early tenth-century Samanid Mausoleum, Bukhara, Uzbekistan, is an excellent example of the structural and decorative use of baked brick (Figure 6.4).[5] The mausoleum is in the form of a tapered cube with central dome and four small corner domes. The exterior walls and the external circular corner piers have chequerboard patterns composed of blocks of brickwork. The bricks are in short courses, laid either horizontally or vertically. Bands and panels of decorative brickwork, some consisting of rows of circles,

Figure 6.3 Clamp firing, Mozambique, 2002

Figure 6.4 Samanid Mausoleum, Bukhara, Uzbekistan, pre AD 943

frame the central entrances on each of the four façades and run along the top of the gallery. The gallery has round arched openings framed by colonettes* composed either of zigzag or spiral brickwork. The chequerboard wall patterns have diagonally laid bricks contrasting with horizontal coursed squares. The colonettes, arches, spandrels* and jali* screens of the openings and squinches* between the upper wall and the dome are enriched with further brick patterns.

Strong, thin Roman bricks were used to create bonding courses at intervals in rubblestone walls or for facing walls with a concrete core. In Britain soft bricks suitable for carving were made from the seventeenth century onwards. Specials, or special bricks, were moulded to virtually any size or shape and used for vaulting, chimneys, string-courses*, plinths, copings* and the detailing of eaves and openings.

Today, bricks can be of very smooth texture and very hard. Powered machinery is used to mix the clay and remove impurities and large stones, so preventing a rough texture. Extremely strong bricks impervious to moisture called engineering bricks are used for foundations, manholes, damp proof courses at the bottom of walls and civil engineering projects such as viaducts.

The small end of a rectangular brick is called a header and the long side a stretcher. The many different methods for laying or bonding bricks subtly affect the appearance of the wall. The bond is the regular pattern in which the bricks are laid in courses. Two common and structurally strong bonds to look out for are the English and the Flemish: the former has alternate courses of stretchers and headers, the latter has alternating stretchers and headers in each course. Both these bonds create firm walls that are one brick length thick, with headers that run through the thickness of the wall. Stretcher bond consists of courses made up of stretchers only. The wall may be an infill wall, just half a brick thick, called a half brick wall, or it may be a cavity wall. A cavity wall is composed of three elements: separate inner and outer leaves of brickwork and an air space between for insulation and to prevent damp passing between the two leaves. Cavity walls became common in the West from the beginning of the twentieth century. In barns where ventilation is required brickwork may be laid in an openwork honeycomb pattern. If bricks are used as an infill material in a frame structure, called brick nogging, a more imaginative pattern such as herringbone* may be used.

From the seventeenth century in England craftsmanship in brick began to reach unprecedented levels. Sometimes the joints between bricks were extremely fine and the decorative aprons or panels under windows, sunken panels over windows and the columns and pilasters were also in brick. To achieve these effects, either bricks were moulded or special fine, soft bricks were used which could be cut and rubbed; this is known as gauged brickwork. Moulded brickwork and fine joints were revived in the nineteenth century for buildings in the Queen Anne revival style* (Figure 6.5).

Figure 6.5 No. 8, Palace Gate, Kensington, London, 1873–5
(J. J. Stevenson)

Mortar

Mortar is used to bed* various kinds of masonry* and has been made from
many different materials. Mud, gypsum, lime, cement and volcanic clay or
pozzolana have been used, either on their own or with additions such as sand
and/or water. Rubblestone walls require large amounts of mortar to bed
each layer of stone because of the unevenness of the material. Where stones
are very irregular and require large quantities of mortar, galleting, or small
stone wedges, are set into the mortar to counteract the rocking or movement
of the stones. This technique can be used decoratively as Antonio Gaudí did
at the Finca Güell in Barcelona where he added sparkling, coloured glass
fragments to the mortar. The character of stone or brickwork can be affected
by the colour of the mortar and its usage. Mortar may be coloured to match
the main walling material or made to contrast sharply. In the late eighteenth
century colouring the mortar with brick dust and rubbing it down disguised
thick joints and uneven-sized bricks. The joint would then be scored and a
thin strip of white lime putty inserted to suggest a fine joint. This was called
tuck-pointing. In the twentieth century Frank Lloyd Wright wished to
emphasise the horizontal in his prairie houses. He used long narrow Chicago
bricks and coloured the perpends, or vertical mortar between bricks, to match
the brick colour. Jointing may be deeply recessed, project boldly as in ribbon
pointing, or be very fine or weathered, that is, angled to throw rain from
the joints.

Wall finish

The regularity, size and shape of modular building components, together with the type of joint, determine the pattern or texture of the wall and the appearance of scale. Figure 6.6 shows the dark and shiny texture of knapped flint, called flushwork* alongside stone on the left and brick on the right.

Smooth textured walls may be made of any material if the surface is planed or finished, but this can be an expensive process and a common method is to use a render. Render may be made of wet clay, plaster, or a mix of cement, lime and sand. Generally, walls are rendered when they are made of inferior materials such as clay, rubblestone or poor-quality bricks. In Scotland harling has long been a vernacular technique to protect walls from the driving rain. Called roughcast or pebbledash in England, harling is a render in which the final coat of mortar contains pebbles that give a rough texture to the wall.

Render may be used decoratively with writing, images or patterns created by mixing clay with ash or pigments or using different coloured clays (see Figure 7.20). A particular form of render called stucco was used in Roman and renaissance classical architecture. It was introduced into England by Italian craftworkers in the seventeenth century and can be made from a variety of materials including lime, gypsum or cement, mixed with materials such as marble dust, bone ash, sand, hair and oil. It has been applied to both internal and external walls and it is sometimes pargeted, that is, decorative

Figure 6.6 Knapped flint wall, Lewes Grammar School, Sussex, 1512

Figure 6.7
Somerset House,
London,
1776–1801
(Sir William
Chambers)

designs are moulded or incised in the plaster surface. In England from the mid-eighteenth century to the mid-nineteenth century it was fashionable to render and paint the brick walls of classical-style buildings in imitation of fine ashlar stonework. The Orangery, Kew (Sir William Chambers*, 1757), for example, was built of brick stuccoed to look like ashlar stonework.

In classical buildings the plinth or basement is often made of large, roughly hewn blocks of stone called rustication. Mortar joints are deeply set so that shadows are cast, giving an appearance of massiveness or heaviness even in quite a small building. This can be seen in the basement of Somerset House that has rustication that is vermiculated* (Figure 6.7). An illusion of heavy rustication may also be achieved on a brick or stone wall by the use of sgraffito, where a plaster or stucco render is incised so that the differently

Figure 6.8
Schwarzenberg
Palace, old city of
Prague, 1545–67

coloured coat underneath shows through. At the Schwarzenberg Palace, 1545–67, in the old city of Prague, the flat walls of the whole building are covered in sgraffiti to give an appearance of heavy rustication (Figure 6.8).

In many early modernist buildings architects used cement render and paint to give a smooth finish to the walls so that they appeared to be just a lightweight protective skin, with an underlying supporting frame structure of steel or reinforced concrete (see Figure 8.3). In their search for simplicity and to break from traditional detailing, many modernists also eliminated the details that deflected rain away from wall surfaces, such as mouldings and copings. As a result walls soon became streaked and required regular maintenance. At the Unité d'Habitation, Marseilles, 1946–52, many different contractors were employed during the long period of construction. As a result Le Corbusier faced the problem of concrete finishes not matching. He was at that time becoming more interested in rough textures, so his solution was to express the wood grain finish left by the shuttering once the concrete

was struck or set. Concrete surfaces can have a wide range of textures depending on the grade of the aggregate used, the surface of the mould or shuttering into which the concrete is poured and the tooling or dressing of the surface afterwards. Much labour is entailed in tooling or bush hammering* concrete surfaces to give an appropriate texture.

Construction

After identifying the materials, the next step is to find out how the building was constructed by looking at it from both the outside and inside. This is not always easy because it may be concealed or covered by other materials. We may be able to see if a roof is tiled or slated, but not if it is hidden behind a parapet. Inside the building the roof construction is usually masked by a ceiling, so it may be difficult to find out how it is constructed. Visiting building sites or decayed buildings may reveal parts not normally visible, but such places are very dangerous, so supervision and permission are essential.

The method of construction is most important for it ensures that a building stands up, withstands the weather and accommodates the activities for which it is designed. In order to understand why buildings stand up we need to understand how load is distributed and the causes of instability. Thrusts or forces such as the loads of roofs and floors on the walls and supports, wind loads and the nature of the ground upon which the building stands are among the factors that determine its stability. Here we can only discuss some of the most basic issues.[6]

Foundations

The design of foundations depends on the nature of the subsoil and the size and load of the building. Foundations distribute the load of a building over a sufficient area of ground to prevent the subsoil spreading and to avoid unequal settlement caused by variations in the load of the building or differences in the subsoil. Some vernacular buildings have posts set directly into holes in the ground and do not have foundations. Historically, some buildings have foundations under the brick footings or courses at the bottom of the wall, and some may have piles* or rafts of timber or reinforced concrete. A tall building with an adjoining low-rise block will require two different types of foundation, with a flexible joint between the two that will accommodate the differences in settlement.

There are basically four main types of foundation – strip, pad, raft and piled – which are designed to suit a variety of loading and ground conditions. Essentially, strip foundations consist of a continuous strip running the length of load-bearing walls. Pad foundations are square or rectangular slabs placed under individual piers of brick or masonry or the columns in steel or reinforced concrete framed buildings. The load on the ground of columns

or piers of multi-storey-framed buildings can be very great, especially in locations where the subsoil is particularly unstable. Pads may therefore need to cover a large area in order to safely transmit the loads to the ground, or piles used to take loads down to a sound stratum. A raft foundation is used on weak ground where loads are modest. They float on the subsoil and support all the bearing elements* of the building, spreading the load over a larger area of ground. In parts of Chicago the depth of the Niagara limestone bedrock is over 100 feet below ground level. The soil above this consists of sand, clay and gravel, interspersed with water pockets, which created great problems for the builders of the earliest US skyscrapers.[7] Until the development of drilling techniques that enabled builders to sink firm foundations down to the underlying rock, Chicago engineers developed a reinforced concrete raft on which all the piers rested. Pile foundations are columns of wood or reinforced concrete, driven or cast into the ground in order to carry foundation loads. They may be taken down to a deep, firm subsoil or rock or, if they are friction piles, they are held up by the friction and adhesion to the soil in contact with them. The buildings of Venice, Italy, that line the canals are carried on wooden piles.

In areas subject to earthquakes the building design itself has to be sufficiently elastic to take the movement of the ground. Traditional Chinese buildings of wood used mortice and tenon* joints. In ancient Chinese buildings these joints could move and there were no deep foundations under columns, so that the whole building was able to shift during an earthquake. A building that did withstand a severe earthquake when all else succumbed was Frank Lloyd Wright's Imperial Hotel in Tokyo, 1916–22. Unable to take foundations down to rock, Wright floated the foundations on the earth. The building itself was constructed of many parts that could move independently and under the centre of each section of the hotel he built reinforced concrete posts upon which the floor slabs were cantilevered out like a waiter carrying a tray with upraised arm and fingers at the centre. The perimeter walls were supported on their own system of posts and only lightly touched the ends of the floor slabs. This allowed each part of the building to move independently during a tremor and then return to its original position.[8]

Floors

In many vernacular structures ground floors consist of soil or clay rammed until firm, and in some cases covered with flagstones or bricks. Problems of cold and damp, particularly in temperate climates, led builders to construct raised timber floors supported on low brick walls or, more cheaply, to create solid ground floors of concrete. Where necessary these latter are protected by a damp-proof membrane of bitumen, asphalt or polythene sheet on top, within or underneath the concrete. Timber floors, whether at ground level or at upper levels, are composed of joists* which span the width of

rooms and rest either on corbels, or timber or metal wall plates on or within the wall. The joists are usually boarded over. From the seventeenth century in England there is evidence of the upper floors of buildings being constructed by laying down bulrushes or fixing reeds to laths* and then covering them with plaster. This made a very durable floor. If the floor is at an upper level, a lath and plaster ceiling may cover the underside. Today, such ceilings would probably be constructed of plasterboard. In order to leave space for services such as electric wiring or pipes, false or suspended ceilings made of timber, metal or other material may be hung from the floor, to leave a gap between the boarding and the ceiling. Modern commercial buildings require very deep spaces between the floors and ceilings to accommodate all the services. One of the problems and one of the arguments used against the conversion of older buildings for commercial use is the lack of available service space.

Reinforced concrete floors span wider spaces, are more fire-resistant and can support greater loads than timber floors of similar dimensions. Their design varies from monolithic slabs to closely spaced, hollow, reinforced concrete beams covered with a layer of concrete.

Load-bearing walls

Building construction may be divided basically into two types: load-bearing wall construction and frame construction. Load-bearing walls can be of masonry, wooden logs (log cabins) or a number of other materials such as clay, or blocks of ice as in the houses of the Inuit. Even the most humble materials have been used to create buildings with load-bearing walls of great power and beauty. In New Mexico, US, seventeenth-century Spanish mission-aries encouraged the building of new churches as part of their campaign to convert the Pueblo Indians. Native Americans built the churches using their traditional material, adobe (sun-dried bricks made of a mixture of clay, straw and water). These large buildings with their clay-plastered walls are impressively austere and monumental. Today, we associate glass with windows and the thin sheets of plate glass used to clad* office buildings, but load-bearing walls have been made of glass bricks, and glass bottles were used to construct the General Store at the Silver Mine, Colorado, US.

Load-bearing walls, as their name implies, are designed to carry their own load and the load of the roof, the floors and their contents, by compression. Lateral forces such as wind are resisted by the mass of the materials forming the wall and the bracing effects of the floor and internal walls and their loads. If there are undue loads and forces, the walls may collapse by crushing, buckling or leaning. These effects can be resisted in several ways. The wall can be thickened to stiffen it, buttresses or projections from the wall can support it (see Figure 3.5), or the wall can be built with a curved or serrated plan. The first and northern section of the Monadnock Building, 1884–5, in Chicago has external load-bearing walls of stone and brick which had to be

six feet thick at the ground floor to give sufficient support and stiffness to the tapering masonry walls above, which rise to sixteen storeys. This was probably the limit for masonry load-bearing walls.

The corners of a building and the internal joists, flooring and cross-walls act as internal bracing* and help to prevent the walls from falling in. Masonry is weak in tension, so the corners and cross-walls do not prevent the walls from leaning outwards. In the eighteenth century builders wanted to put up multi-storey buildings such as mills and factories with relatively thin walls and many windows to light the interior. Rather than construct bulky buttresses to counteract the tendency for walls to lean out under the load of the roof and the machinery, they often used wrought iron tie* bars or rods at ceiling level. These acted in tension, tying together opposite walls and preventing them from leaning outwards. Lateral pressure on walls may develop later, for example if a roof has been re-covered with a heavier material, and a common remedy is then to employ tie bars. Tie rods are often visible on the exterior walls of buildings, their ends forming an X, a star or a disc. Lateral pressure can also result from other alterations. One of the authors was awakened one night by what appeared to be an explosion. A neighbour had created an open-plan house out of an Edwardian* one by removing the chimneybreasts and internal load-bearing walls which supported the upper floor. The explosion was the whole of the rear façade falling like a pack of cards into the garden.

Load-bearing panel structures

Pre-formed panel construction is like load-bearing wall construction, but each panel is relatively thin and designed to resist its own load and other specified loads. Some panels are of sandwich construction, with steel or timber as the main structural material and a facing of plywood or metal sheeting. Panels may be designed to incorporate openings such as doors and windows. 'System' building or the European heavy panel system of reinforced concrete was a totally new approach to building design and production taken up in the UK in the 1950s and 1960s. Mass-produced, prefabricated concrete components or panels were bought as a total building package, often in the form of high-rise flats for local authority estates. The postwar housing crisis and government subsidies encouraged the use of system building and it seemed to offer an economic, efficient and modern way to deal with labour shortages. Moreover, high-rise flats would, it was thought, reduce urban sprawl and improve people's lives. Some 600 concrete-panel high-rise blocks were built in the UK, but no effective code of practice was developed to control design and construction.[9] In 1968 a gas explosion caused the spectacular partial collapse of a block of flats called Ronan Point, Newham, London, and this led to the general discrediting of system building and added to the already widespread mistrust of high-rise flats in the UK.

Frame construction

In a frame construction it is the frame that carries the weight of the building. Frames may be of wood, iron, steel or reinforced concrete. In traditional timber-framed construction, the box frame system is a series of separate, prefabricated, jointed timber frames composed in such a way as to create several bays or units of space. The individual frames consist of cross-wall and truss* frames, wall frames, floor frames and roof frames, fitted together to form the skeleton of a building that might have several bays and more than one storey. Sometimes the upper-floor beams in these timber-framed buildings were cantilevered or jettied* out beyond the supports to create greater space on the upper floors. Timber-frame construction was common in Europe and the Far East but there were differences in the roof structure that we discuss later. A simpler frame structure known as the cruck frame was also used in Britain, where timber-frame buildings were constructed from the thirteenth to the nineteenth century. In the cruck frame there is no distinction between wall and roof. Pairs of curved tree trunks or crucks stood vertically on stone bases so that the curving tops of the trunks arched over and touched, and could be tied together. These carry the horizontal purlins* (including at the apex the horizontal ridge purlin) which run at right angles to the cruck. Crucks were spaced to create bays between them, and such spaces could be multiplied as necessary as in the box frame system.

The weather is kept out of a frame structure by a roof covering and infilling between the frame, or by hanging a skin of glass or other material on to it. This latter is known as a curtain wall. To withstand lateral forces such as wind, either the joints between vertical and horizontal members have to be rigid, as they are in reinforced concrete frames, or bracing or stiffening of the structure is required. This may consist of diagonal struts, or rigid panels inserted into the frame at intervals or the use of masonry walls. The Crystal Palace, London, designed by Joseph Paxton*, 1851, was a frame building infilled with glass (see Figure 2.1). The frame was largely made of cast and wrought iron, and stiffening was provided by curved braces between each stanchion* or column and by the wrought iron floor girders seen in the illustration.

Frames may be inside the building and invisible from the exterior, outside or part of the wall of the building, and the infill material will not be load bearing even if it is capable of being so. Infilling materials include reeds, straw, laths and plaster and sheet glass, which could not be load bearing, as well as clay and bricks, which could. External frames may be clad or covered by hanging clay tiles, wooden shingles*, slates, or overlapping horizontal wooden boards known as weatherboarding* in the UK and clapboard in the US. Traditional Chinese timber-framed buildings were subdivided by screens or partitions that were often not full height. A timber-framed building using panels of wire-reinforced paper can be seen in the mine manager's house and office in Kwekwe, Zimbabwe (Figure 6.9), while at a house on the campus

of Berkeley University, California, Bernard Maybeck used sackcloth dipped in concrete. Hardy, Holzman, Pfeiffer Associate's* extension to the Museum of Contemporary Art, Los Angeles, US, is a framed building where glass bricks are used as an infill to create walls, as they are at the Maison de Verre, Paris, 1928–32, by Pierre Chareau* and Bernard Bijvoet.

Temporary homes constructed by the homeless and those who live in shanty towns may consist of a nailed timber frame draped with discarded plastic or fabric and may have panels of cardboard, timber or corrugated iron on the roof or leaning against the sides to create walls (Figure 6.10).

Membrane structures

Thin membranes made of skins, fabric or plastic can be supported by tension and/or compression structures. A tent or the tipi of native Americans is such a building. The skin or canvas acts as wall and roof to keep out the weather, and the cone of tall wooden poles forms the structural support and is in compression. In other tents the poles have ropes or cables suspended from them to support the cover or membrane and further ropes attached to the poles, called guy or anchor ropes, pegged into the ground to provide resistance to wind. The poles are in compression and the ropes in tension. There are many variations in tent structures between these extremes. Such flexible, lightweight buildings make effective homes for nomadic people and similar

Figure 6.9 House and office of the mine manager, Globe and Phoenix Goldmine, Kwekwe, Zimbabwe, 1895

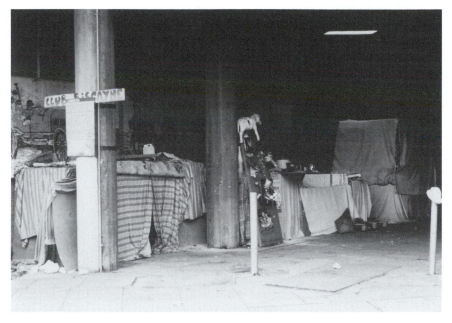

Figure 6.10 Cardboard City, London, December 1990

principles lie behind some of the most advanced architecture of today, such as the huge Munich Olympic Stadium by Behnisch & Partner with Gunther Grzimek, 1972, and the Schlumberger Petroleum Research Laboratories, Cambridge, Michael Hopkins* Architects, 1984 (Figure 6.11). Alternatively, a reinforced plastic or canvas membrane can be supported by air under pressure or in compression as in inflatable structures. In these the membrane is in tension. Today, there are many sports pavilions that use inflatable structures.

Spanning space

An important part of building construction concerns the techniques used to span space, protect buildings from the weather and provide entrances and windows. Much ancient architecture in Egypt, Greece, India and the Far East, including China and Japan, was based on the principle of the post (vertical) and the lintel (horizontal) to span spaces. Trabeated* architecture is the term for this relatively stable mode of construction. Horizontal roof or floor beams transmit their load vertically down through the posts that support them.

Another method of spanning space is to use arches, vaults and domes.[10] A masonry arch is a structure of wedge-shaped blocks of brick or stone supporting each other by mutual pressure and able to support a load from

Figure 6.11 Schlumberger Petroleum Research Laboratories, Cambridge, 1984
(Michael Hopkins Architects)

above. Arches may be openings in load-bearing walls, they may form an
arcade and be supported by columns, piers or pilasters, or they may be free-
standing as in ancient Roman aqueducts, triumphal arches or gateways. The
most common arches are flat*, semicircular, segmental* or pointed but there
are other more complex shapes such as the ogee*, the four-centred* arch,
horseshoe and engrailed* arch (see glossary, subentries under arch). By the
third millennium BC fully developed brick arches existed in Egypt and
Mesopotamia. The wedge-shaped stones or bricks used to build arches are
called voussoirs (see Figure 6.7). The voussoir at the top of the arch is called
a keystone and is sometimes larger than the other blocks. An arch transmits
its own load, and that of the wall or roof above it, vertically and laterally on
each side. This transmission of load is known as a thrust or pushing force
and in an arch these follow the curve of an inverted catenary to the ground.
The voussoirs in an arch are in compression, the lateral thrusts pushing them
against one another and against the springings* and the abutments* of the
arch. The springing is the point at which the arch rises from its support. In
Figure 6.7 the arch in the foreground springs from the string-course above
the pier. The abutment is any solid structure such as a pier or wall that
resists the thrust of an arch or vault. If the arch is an opening in a masonry
wall, then the wall on either side takes the lateral forces. During construc-
tion, arches require a supporting formwork* because until the last stone is
inserted, usually the keystone at the top, the structure is unstable.

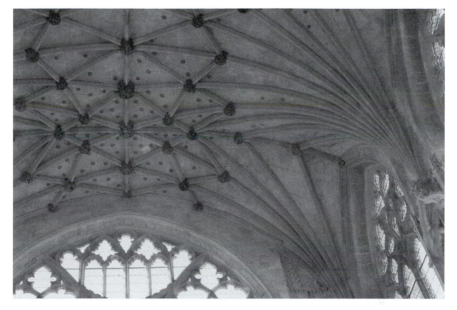

Figure 6.12 Lady Chapel, Ely Cathedral, showing fan vaults, rib vaults and liernes, 1321–49

A vault is an arched roof or ceiling. It may be tunnel shaped or it may be a groin vault that consists of two barrel- or tunnel-shaped vaults joined at right angles. The junctions between the curved vaults are called groins (see Figure 4.1). A rib vault is a framework of ribs across a compartment with a panel or web between the ribs. A fan vault consists of a series of curved semi-cones radiating out from imposts* to meet, or nearly meet at the apex of the vault. Liernes are ribs that run from rib to rib. Vaults have provided many opportunities for ingenuity and careful observation will reveal many types of vault and patterns of ribs (Figure 6.12).

A dome is a convex covering over a circular, square or polygonal space and domes may be hemispherical, semi-elliptical, pointed or onion shaped (Figure 6.13). A domical vault is a dome subdivided by groins into segments rising direct from a square, circular or polygonal base. Domes can be found in vernacular buildings such as snow houses in Arctic regions as well as more monumental structures such as ancient Buddhist stupas or burial chambers and Roman basilicas* and bathing establishments. They are also found in Byzantine churches, mosques and Islamic tombs. In Europe, Christian architecture of the middle ages exploited the vault and during the renaissance it became a challenge to revive the Roman dome for centrally planned churches. Vaults and domes historically have been constructed of stone and brick, but the Romans first used concrete in a dome. The Pantheon in Rome, *c.* AD 100–125, was the largest concrete dome of its period. In the twentieth

Figure 6.13
St Basil's Cathedral,
Red Square, Moscow,
1554–60 (Barma
and Postnik)

century domes were frequently built of reinforced concrete. Like the arch, vaults and domes produce lateral forces that need to be counteracted. The thrusts acting within the structure of a dome have a tendency to split it open at the bottom. To counteract this horizontal or outward thrust, renaissance domes constructed of stone were sometimes encircled with iron chains. In some buildings exceedingly thick walls are used to resist the lateral forces from the roof vaults or domes above. Large windows to admit plenty of light are not easily made in such thick walls; so thinner walls were built which needed buttressing to take the lateral thrust of the vaults and domes. The work of the buttresses was sometimes supplemented in medieval cathedrals by the walls of side chapels located at right angles to the nave wall. Flying buttresses carried the load of the vaulted roof laterally via an arch over side aisles, ambulatory* or chapels to the vertical part of the buttress. This enabled later churches and cathedrals to have tall naves pierced with large clerestory*

Figure 6.14
Flying buttresses,
King Henry VII
Chapel, Westminster
Abbey, 1503–*c*.1512

windows. The pinnacles on top of buttresses in gothic churches, or the statuary and balustrades encircling domed roofs, are not there for purely aesthetic reasons. The additional weight that they add to the walls and buttresses helps to stiffen the wall and deflect any lateral thrusts towards a more vertical path and safe transmission to the ground (Figure 6.14).

Space frames

Developments in steel technology and in computers have led to the application of the space frame to span very large spaces with a minimum of intervening vertical supports. Consisting of a three-dimensional truss framework of connecting bars or tubes and struts, some space frames are curved and others form an extensive horizontal platform. These complex structures are able to resist forces in any direction and so achieve the large, uninterrupted

open floor spaces now demanded in warehouses, industrial sheds, super-markets and sports halls. They were pioneered by designers such as the American R. Buckminster Fuller* who developed geodesic domes* in timber, plywood, aluminium and prestressed concrete* from the late 1940s (Figure 6.15). Recent pioneering examples include the Sainsbury Centre for the Visual Arts, Norwich, 1975–8, by Foster Associates, and the Waterloo International Railway Terminal, London, 1990–3, by Nicholas Grimshaw* and Partners which is curved in two directions. The largest curved space frame at the time of writing is at the Eden Project, Cornwall, 2001, designed by Nicholas Grimshaw and Partners (Figure 6.16). The brief, to build the largest greenhouse in the world and hide it in an existing giant pit the size of 35 football pitches, was the brainchild of Tim Smit. His aim was to encourage children to become excited about plants and horticulture and to reach all those people who were uninterested in plants and the environment. The linked biomes, located in disused china clay pits, 60 metres deep, near St Austell, Cornwall, form the largest geodesic conservatories in the world. The biomes cover a tropical zone and a warm temperate zone. The hexagonal structure is fixed to a steel superstructure that is 57 metres high at the highest point. The largest of the hexagons is 11 metres across. Glass would have been far too heavy for such a massive structure and a plastic ETFE (ethylene-tetra-fluoro-ethylene) foil is used to form transparent inflated pillows in each of the hexagons. These are 2 metres deep and have a life of 25 years. On the exterior are abseil points so that the whole building can be

Figure 6.15 Geodesic dome, Montreal, 1967 (R. Buckminster Fuller)

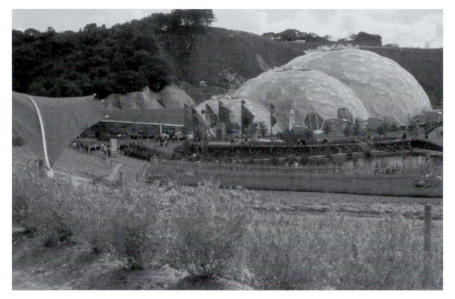

Figure 6.16 Eden Project, Cornwall, 2001 (Nicholas Grimshaw and Land Use
 Consultants)

cleaned. One of the unexpected hazards discovered on completion was that
the crows liked bouncing off the cushions!

Roofs

Roofs protect buildings from the weather and may be flat, pitched or curved.
Vaults often have a timber truss built over them to protect them from the
weather, and flat roofs may consist of a timber, metal or reinforced concrete-
framed horizontal platform. Pitched roofs are supported on a triangular frame
or truss made of wood or metal and can be of many different shapes, some
of the most common types being the mono-pitched roof, simple pitched roof,
the hipped* roof and the mansard* roof. Hipped roofs have no gable, as both
the ends and the sides slope (see Figure 7.17, left hand wing).

Roof trusses

Roof trusses, ubiquitous since the middle ages but originating in Rome, are
rigid triangular structures that span space.[11] The lower horizontal beam,
or collar, is in tension holding the ends of the diagonals of the truss or
rafters* in place. The thrust of a truss resting on walls is vertical down-
wards. However, if the collar is not located low on the truss, there is a
tendency for the diagonals or rafters to spring outwards, taking the walls
beneath with them. Trusses are usually named after particular features in

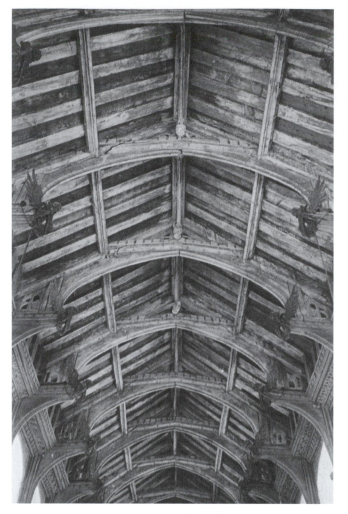

Figure 6.17
Hammerbeam
truss, St John
the Baptist,
Badingham,
Suffolk, fifteenth
century

their construction. A king post truss has a central vertical member between the apex of the roof and the centre of the tie beam (see Figure 5.13, lower right drawing). Queen posts consist of a pair of vertical timbers placed symmetrically on a tie beam. They rise to the side purlins and principal rafters. During the middle ages builders in Britain were keen to make use of the space in timber-trussed roofs, unobstructed by tie beams, and sought ingenious methods of dealing with the lateral thrusts. The hammerbeam truss* is one example but there are many other varieties of truss construction (Figure 6.17). Barns, agricultural buildings and churches, where ceilings have not been put in to hide the roof construction, offer wonderful opportunities to explore the variety of trusses. A good architectural guidebook will help in identifying the names of the different types.

The roof structure of Chinese timber-framed buildings differed from the UK triangular roof truss. In place of the single collar or horizontal beam there was a system of beams of diminishing length placed vertically above one another running between pairs of posts and separated by short vertical struts. The horizontal roof purlins rested on the struts. This offered flexibility and opportunities for curved as well as straight roof slopes, different internal roof heights and even roofs that finished with a flat top. The basic spatial bay could be varied in numerous ways. The span could be widened by increasing the number of beams and columns or by adding verandah bays, so it was possible to have multiple bays in both directions. A system of brackets or *tou-kung* made possible deep cantilevering from columns inside and out which, in turn, made possible galleries and especially deep overhanging roofs. The elaborate development of these systems was reserved for monumental buildings and the dwellings of the wealthy (Figure 6.18).[12]

The gables or end walls of a building with a simple pitched roof rise straight up and form an inverted V shape which conforms to the slope of the roof. Sometimes the roof is carried over the gable and shelters the wall (see Figure 8.15). Bargeboards* are sometimes used to protect the ends of the roof timbers and may be ornamented by carved detail, or the roof timbers may be protected at the end by taking the gable wall above the end of the roof (see Figure 6.8). The sides of such gables might be raked, shaped with curves and capped with a pediment as in Dutch gables, or the brick courses may be left uncut at the ends and staggered to provide a stepped profile as

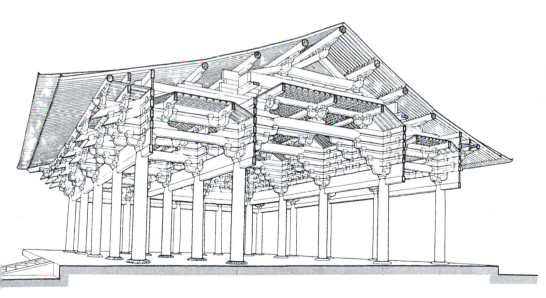

Figure 6.18 Chinese roof structure, Wutai Shan, Shanxi, Fogung Si, Tang dynasty, 857

in Scottish crow-stepped gables. Hipped roofs have no gables: the ends slope like the sides. Mansard roofs, or gambrel roofs as they are called in the US, are pitched or hipped roofs with two inclined planes, the lower slope being longer and steeper.

The construction of flat roofs, whether of timber or reinforced concrete, is similar to that of floors and they have been part of Mediterranean vernacular architecture for centuries. In the twentieth century they became fashionable with modernists, but were much criticised in the UK for poor design, inadequate materials, bad construction and the fact that they leaked. Flat roofs can be horizontal or slightly inclined for the rainwater to run off. In timber roofs the slope is generally achieved not by sloping the joists, but by nailing lengths of timber on the top of each joist. These strips or firring pieces are either tapered or vary in height on successive joists.

Roof coverings

The materials used to cover roofs greatly affect their appearance. Domes may be covered with lead, copper sheeting or tiles. Flat roofs on which water settles need materials with few joints for it to seep into, so large sheets of asphalt*, bitumen felt or non-ferrous metals such as lead, copper, zinc or aluminium are used. Pitched roofs may be covered in overlapping flat, modular materials such as slates, stone slates, or tiles of clay or concrete, which are fixed to the roof timbers using wooden pegs or nails. They may be finished at the apex or ridge with plain or decorative clay ridge tiles. In rural areas roofs may be covered in turf or, more commonly, thatch. In the present search for sustainable architecture, grass and other plants have been used on urban roofs. They have good insulation properties and in commercial buildings flat roofs can provide space for staff to relax. Indeed, the Willis Building, 1975, had a grass roof as part of its original design (see Figure 4.4). Among the most common thatching materials are sedge, reeds, heather, grass and straw. Thatch is relatively lightweight and is used where walls are not structurally strong such as cob* or clay-walled cottages. Roof pitches often depend on the type of roof covering and can vary greatly although the minimum pitch tends to be 25 degrees. To ensure the rain is thrown off quickly before it can sink in, thatch roofs are usually fairly steep. When pantiles* are used the roof pitch is sometimes gentler towards the eaves so that the rainwater does not splash uncontrollably into and over the gutter. If a very heavy covering material is used, such as stone slates common in the Cotswolds in England, then the roof support needs to be very sturdy (see Figure 8.15).

Roof texture and colour differ according to the covering materials. Handmade tiles and some slates are of irregular size and shape and can vary substantially in colour. This gives a soft rustic appearance, compared with the mechanical look of machine-made tiles or Welsh slate, which by the nineteenth century could be cut with great precision into evenly shaped and sized pieces. Some of the most beautiful slate or stone roofs use graded units

with large slates at the eaves and decreasing sizes towards the apex of the roof. In Mediterranean countries the Spanish clay tile or curved tile is common. Each course is laid with convex and concave surfaces alternately facing upwards. Clay pantiles, which are S-shaped, incorporate both concave and convex shapes, so that every tile can overlap the next. Both Spanish tiles* and pantiles create roofs of very bold texture and make a comparatively heavy roof covering. They are particularly good on shallow pitched roofs but their form is not very suitable where roofs have dormers, hips and gables because the sharp angle of the junction between adjacent roofs, for example where a dormer window breaks through a roof, is difficult to make weatherproof. The simplest solution is to cover the junction with lead or specially moulded tiles. Where flat tiles or slates are used on the main body of the roof and no time or expense is spared, small wedge-shaped flat tiles or slates can be carefully overlapped across the junction to create a gentle curve or swept valley.

Methods and processes of construction

A look at building sites today shows that an enormous amount of labour is used in construction, even with advanced technology. Figure 5.25 shows women building workers constructing an art gallery by the architect Balkrishna Doshi in India. This use of human labour is a slow process, there may be problems with quality control and in climates such as the UK's work may be held up for days by bad weather.

In prefabricated buildings the components are manufactured off site and this minimises some of these problems. In many rural American communities barns were made of prefabricated wooden frames. Barn raising was a traditional ceremony, for many strong hands were needed to position and top out the frames. Iron buildings assembled from parts manufactured in a factory included chapels, exhibition buildings, railway sheds and baths (Figure 6.19). The best known early example was the Crystal Palace, erected in Hyde Park in 1851: its iron frame, wooden glazing bars and glass were manufactured off site and the whole building was assembled in eleven weeks. The prefabricated buildings exported from the UK in the nineteenth century were initially made of cast iron columns and panels and subsequently of corrugated iron panels, which were lighter in weight and cheaper. Hospitals for the Crimea, churches and houses for prospectors in Colorado and cotton factories for Egypt were among the buildings that were exported and assembled on arrival at their destination. These were transportable buildings and temporary in that sense, but permanent in the sense that the materials were virtually indestructible.

Today, many buildings are constructed by the fast-track or design-and-build method. This means starting the construction on site before the design is complete. Waiting for the full details of the design to be completed is costly in time and money, so building starts on the basis of roughly estimated

Figure 6.19 Baths, Tenbury Wells, Worcestershire, 1862 (James Cranston)

costs and a schematic design which defines the main structural system and its materials. The architect and engineer, or the design-and-build builders, then develop the design as building proceeds.

Health and safety

All materials should be thoroughly tested before use in construction, and manufactured materials should be made in conditions where workers are protected from dangers associated with the processes or materials. This is not always the case. Knowledge of the working practices in the manufacturing and construction industries and the hazards of certain materials help one appreciate the financial, human and environmental costs involved in the production and use of buildings.

In the nineteenth century when dome-shaped, downdraught kilns were used to fire bricks, pressure on production sometimes meant that workers had to enter the kilns to empty and fill them before they had properly cooled from the previous firing. The dust from asbestos used for its fire-resistant properties has been found to be dangerous to health, as is paint with a lead base. Yet, these materials remain in many older buildings and are still being used in some countries. High alumina cement, used since 1908 because of its quick setting properties, requires very careful supervision and on-site

control. It can develop marked constructional weakness when used in humid atmospheres such as swimming pools, where the material 'converts' and loses strength. Despite the fact that it was banned in France from 1943 and the risks involved in its use were published in the UK in 1963, it continued to be used there and some roofs collapsed in the early 1970s. The construction industry in the UK today still has a very poor record in terms of industrial injuries, yet there is little attempt to deal with one of the main causes, the widespread use of casual labour.

7 The exterior

The buildings around us form a part of everyone's environment and their impact can be positive or negative. Many factors contribute to their external appearance, some of them practical, others cultural or geographic, yet much of the discussion tends to focus primarily on the aesthetics of the façade. In this chapter we look at some of the many issues involved in the design of exteriors and at some of the questions that we need to consider in order to understand them. The external form may be determined at the outset by the function of the building, the shape of the plot of land, or by a preconceived shape such as a cube, rotunda or even a car grille. Stanley Tigerman* Associates designed the Self Park Garage at 60 East Lake Street, Chicago, 1986, to communicate its function literally. The metal clad exterior of this building has skylights in the form of headlights and two black vinyl canopies that look like wheel treads; there are bumpers/fenders, and the car body has a turquoise enamel finish like a Chevrolet. The licence plate reads SELF PARK and there is car parking for 200 vehicles above two floors of retail space. Other buildings are designed from the inside out, so the exterior forms reflect the location, size and shape of the internal spaces.

In many countries we recognise domestic buildings by the scale of the front door, the chimneys and the shutters or curtains at the window. But if we are in north Africa or the Middle East, then all we might see is a blank wall facing the street and a small entrance, for all the rooms face onto an interior courtyard. In Europe we associate churches with towers and spires, and castles with turrets*, balistraria* and battlements*, but we should not assume that all buildings with these features are either churches or castles as Figure 7.1 shows. Here the turrets and battlements reinforce the impression that this maximum-security prison is an impregnable building, although the large windows, albeit with small paned lights with iron glazing bars, raise questions.

Size

The spaces inside determine the overall proportions and scale, and these relate to the type of building, its status and location. In many cultures the large

Figure 7.1 H. M. Prison, Welford Road, Leicester, 1825–8 (William Parsons*)

buildings that stand out are those that serve a military, religious, civic, community or commercial purpose. They may be large for symbolic or practical reasons, or both. The varied forms of religious buildings include pagodas in the Far East, the massive temples of ancient Egypt, the stepped forms of pre-Columbian temples in Central and South America, mosques with their minarets*, and the flying buttresses, towers, spires and domes of churches and cathedrals in Europe. Important government and civic buildings are often monumental, their size dictated partly by the numbers of people using them and partly by the need to suggest their dignity and significance. In the nineteenth century, English city administrations proudly vied with each other to create the most spectacular and impressive town halls (Figure 7.2). Today, in many places shopping has replaced religion and in Birmingham, England, the textured and bulbous shape of the Selfridges Store at the Bullring by Future Systems, 2003, looks as if an enormous sea creature has landed in the middle of the city (Figure 7.3).

Some large buildings rise above their surroundings for practical reasons. The imposing hill fort at Gwalior, Central India, dominates a huge area. The ramparts stand on a steep rocky cliff and are punctuated by tall bastions or towers capped by domed pavilions (Figure 7.4). Inside is the palace of Man Singh. Mills, factories, grain stores, power stations and gasholders need to be large in order to function efficiently (see Figure 2.14). The tall chimneys of mills and factories were designed to carry smoke and fumes up high and provide sufficient draught for the boilers. Cinemas of the 1930s

BRADFORD TOWN HALL.——Messrs. Lockwood & Mawson, Architects.

Figure 7.2 Bradford Town Hall, 1870–3 (Lockwood & Mawson*)

Figure 7.3 Selfridges
Store, Birmingham,
2003 (Future Systems)

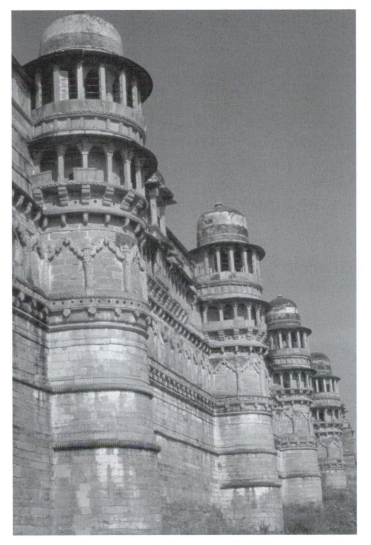

Figure 7.4 Gwalior Fort, Central India, *c.* late fifteenth century

accommodated large audiences and some had a tower and neon-lit signs to attract attention. Today, the largest buildings are often office blocks, but in cities such as Paris tall buildings have mainly been confined to outlying areas such as La Défense, in order to maintain the character of the historic centre. By contrast the ban on high buildings was lifted in London in the 1950s and the city witnessed an outcrop of commercial skyscrapers positioned at the intersections of major roads. The idea was to terminate vistas, but it led to a scattered effect and the new buildings dwarfed their neighbours.

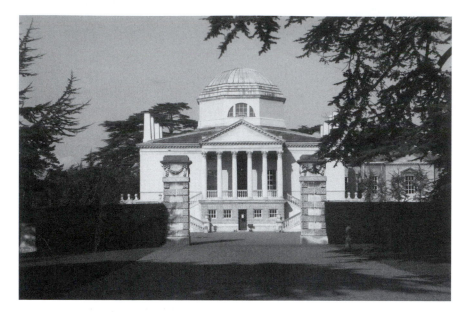

Figure 7.5 Chiswick House, London, 1723–9
(Lord Burlington)

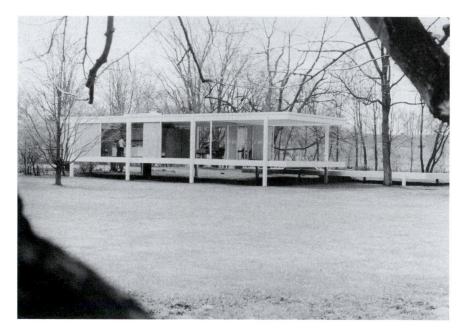

Figure 7.6 Dr Edith Farnsworth House,
Plano, Illinois, US, 1946–50
(Mies van der Rohe)

A building may be a large or small example of its type. The main branch of a bank in the town centre will probably be larger and grander than a suburban subsidiary branch. The home of an important landowner may be a grand mansion on a prominent site, while a rural worker's cottage will be small with a comparatively modest garden. While the size and complexity of a building may be a sign of wealth, this is not necessarily so. Chiswick House is set in spacious grounds to the west of London and seems quite elaborate at first glance, although it is comparatively small (Figure 7.5). Indeed, according to Horace Walpole* it was too small to live in and too large to hang upon one's watch chain. He thought that in order to enjoy it, it would be better to live opposite rather than in it. Lord Burlington* built Chiswick House to house his collection of paintings, and he lived in the house next door. Mies van der Rohe's Farnsworth House, Fox River, Illinois, 1946–50, is the antithesis of elaboration, yet it was so expensive to build that it led to the most acrimonious court case between the patron, Dr Edith Farnsworth, and her architect (Figure 7.6).

Scale

Sometimes the scale of a building is designed to deceive us. A large building may be detailed so as to look smaller or larger. Barningham Hall, Norfolk, designed for Sir Edward Paston, is a very large building but it appears smaller because it is divided vertically into a number of different elements (Figure 7.7). Terry Farrell's* dramatic Embankment Place built over Charing

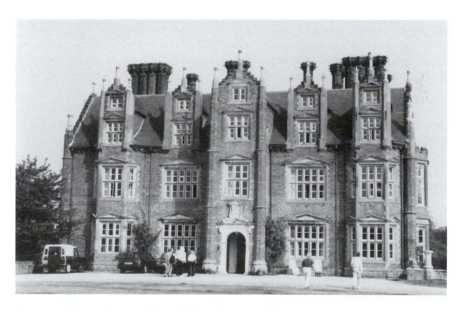

Figure 7.7 Barningham Hall, Norfolk, 1612, west façade

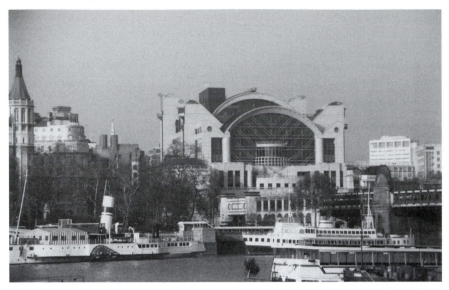

Figure 7.8 Embankment Place, London, 1991 (Terry Farrell)

Cross Station and overlooking the river Thames is not much taller than other buildings alongside it, but its horizontal scale and bulk make it appear considerably bigger than its neighbours (Figure 7.8). Groundscrapers is the term used for such buildings. The height of a tall building may be minimised by the horizontal emphasis of ribbon or long windows, balconies or a flat roof. By contrast, tall chimneys, a steeply pitched roof and tall, narrow windows will give a vertical emphasis. The height of Louis Sullivan's* multi-storey office building, the Guaranty Building, Buffalo, 1894–5, is exaggerated by increasing the number of vertical piers of the façade. Sullivan introduced extra non-structural piers between the structural ones with internal steel supporting columns. Instead of subordinating and clearly differentiating the non-structural from the structural piers, he treated both equally.

Scale can be used to emphasise certain features. A large entrance commands attention and reinforces the significance of the building; or the size may relate to the large numbers of users. At Amiens cathedral, the doorways in the west front appear larger and more impressive than they really are (Figure 7.9). The huge buttresses between each doorway are united with the architrave* to create great cave-like porches, lined with multiple tiers of elaborately carved sculptural decoration. Similarly, the use of rusticated stonework on the ground floor, or basement of palaces and banks is designed to give a sense of monumentality. The rustication at Somerset House, built to house the Navy Office, the Tax Office and a number of other ministries,

reinforces its massiveness and dignity (see Figure 6.7). Sometimes relatively small features are exaggerated to lend unexpected drama to a façade. A common example is the use of an enlarged keystone over an opening, a feature that was developed in mannerist* architecture of the sixteenth century in Italy.

Figure 7.9 West Front, Amiens Cathedral, Amiens, France, begun *c.*1220

Figure 7.10 Vishvanath Temple, Khajuraho, India, 1002

Figure 7.11 Sultan Ahmed Mosque, Istanbul, Turkey, 1610–16

Massing

Many architects create sculptural and dramatic effects by the massing of their buildings. In India, the huge curving forms in Hindu temples are piled up to create a series of peaks. The highest is placed over the most sacred part of the temple, the garbhagriha or sanctuary, to symbolise cosmic mountains or the sacred place of the gods (Figure 7.10).[1] The dome of the Sultan Ahmed Mosque, Istanbul, Turkey, indicates the central praying space and from the tall minarets the muezzin (or crier) calls the faithful to prayer (Figure 7.11). Buildings in the baroque style in Europe with their bold sculptural façades and varied rooflines with chimneys, lanterns, domes, balustrades and sculptures were so named because they were originally considered to be of odd and extravagant shape (see Figure 2.9).[2] The word 'baroque' was originally a jeweller's term applied to a rough pearl.[3]

In England the picturesque* taste of the late eighteenth century was inspired by seventeenth-century paintings of the Italian countryside by artists such as Nicolas Poussin and Claude Lorrain. These showed buildings set harmoniously in the landscape. Picturesque architects sought to make their buildings more sympathetic to the natural features of the site. They looked back to the sculptural forms of the baroque but broke with classical symmetry to create buildings of irregular form. Robert Adam wrote in 1773 of 'the rise and fall, the advance and recess' of the mass of the building to create 'movement' sympathetic with 'hill and dale, foreground and distance, swelling and sinking . . . in the landscape' and so 'produce an agreeable and diversified contour, that groups and contrasts like a picture . . .'.[4] Theorists such as Uvedale Price* thought large chimneys, with urns, vases and obelisks* on the roofs would make the roofline more interesting and varied. The small irregular cottages by John Nash* and John Adey Repton* at Blaise Hamlet and the irregular skyline of John Soane's Dulwich Art Gallery with its lantern, urns and sarcophagi illustrate some of the different interpretations of the picturesque (Figures 7.12 and 7.13). Downton Castle's asymmetrical and castellated* forms, designed by the picturesque theorist and architect Richard Payne Knight*, were picturesque in massing as well as being symbolic. The house crowned a rugged hill and to Knight it represented a crown on the head of Mother Nature (Figure 7.14).[5]

To provide variety and interest to high-rise buildings, some architects created gothic profiles such as the Chicago Tribune Tower, Chicago, by Raymond Hood and John Mead Howells*, in 1922, which has gothic pinnacles and flying buttresses. The housing for the lift mechanism and other servicing equipment offered opportunities for more complex shapes, as we noted in the Lloyd's Building, London. Generally, the commercial office blocks erected in the major world centres towards the end of the twentieth century sought to offer maximum floor space, but made little contribution to the urban scene at either street or roof level. There are, however, some notable exceptions such as the wit and elegance of Philip Johnson and

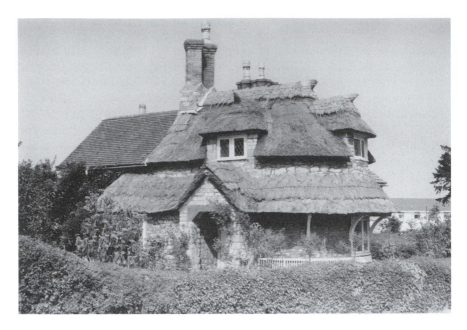

Figure 7.12 Blaise Hamlet, Bristol, 1810–11
(John Nash and John Adey Repton)

Figure 7.13
Dulwich College
Art Gallery and
Mausoleum,
London, 1811–14
(Sir John Soane)

Figure 7.14
Downton Castle,
Herefordshire, 1772–8
(Richard Payne Knight)

Figure 7.15
885 Third Avenue
(Lipstick Building),
New York, 1983–6
(Philip Johnson and
John Burgee)

John Burgee's* 'lipstick' building at 885 Third Avenue, New York, US, in 1983–6 (Figure 7.15). The beginning of the twenty-first century indicates that the next generation of skyscrapers may recapture the distinctive and pioneering forms associated with some of their 1930s' forbears. Norman Foster and Partners Swiss Re Building, at 30 St Mary Axe in the City of London has a helical structure, a distinctive aerodynamic profile and both natural and mechanical ventilation.

Design and the climate

The exterior is designed to keep out the heat, cold, wind and rain. Small windows with louvred shutters are common where there is strong sunlight, for they allow the air to circulate, but keep out the hot sun. Bungalows in India and other UK colonies featured large verandahs to shade the sunny sides of the building. Large overhanging roofs with deep eaves serve a similar function shading the building and shedding heavy tropical rains. The gutters and drainpipes on such buildings are very large compared to those of temperate climates. When Le Corbusier designed the government buildings in Chandigarh, the capital of the Punjab, India, he created huge, overpowering sculptural roofs. These shielded the buildings from the monsoon rains and the blast of the sun and gave them a monumentality fitting to their function (Figure 7.16). He also used a huge overpowering sculptural roof on

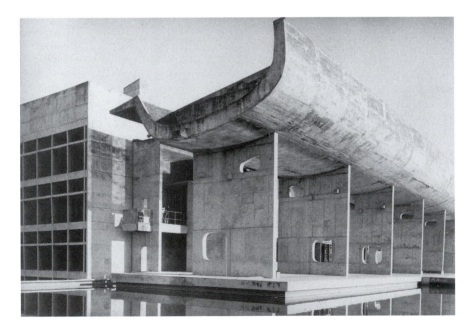

Figure 7.16 Palace of Assembly, Chandigarh, India, 1956–62 (Le Corbusier)

that little jewel, the chapel at Ronchamp in France, where the climate is temperate and not the dominating factor. The positioning of gutters and drainpipes also provides clues to how the rain is kept out.

If buildings are to be weatherproof it is important to keep the rain off the walls, doors and windows as much as possible. The coping of walls and parapets, projecting cornices, drip moulds* over openings and sills beneath windows are all designed to throw the rain clear. String-courses are also designed to deflect the rain. In India chajja or thin sloping stone projections were distinctive features that threw off the heavy monsoon rains. In wet climates windows are often set back from the face of the wall to protect them, but before the Great Fire of London in 1666 they tended to be built flush with the wall plane. After the fire the London Building Act of 1709 introduced fire precautions, to reduce the risk of the flames licking across the façade and setting adjacent areas alight. The Act required all openings to be set back four inches from the face of a wall. Wooden cornices at eaves level had also been forbidden in an earlier Act of 1707 for similar reasons. In other words, many of the details that we think add character to a building had practical origins.

The elements that protect a building from the weather may be hidden, or their visual impact minimised. In classical buildings where clarity of form is given precedence, it is often difficult to see how the rain is dispersed. The drainpipes or rainwater goods are hidden within walls or relegated to the rear, and parapets hide the pitched roof and gutters. In Edwin Lutyens'* lodges at Victoria Park, Leicester, 1930, the gutters are set into the sloping roof and can only be detected by a break in the slates two or three courses from the eaves. To create crisp, geometric, undecorated forms early modernists designed buildings with minimal or no mouldings*, windows were flush with the wall with no sills or weather coping to disperse the rain. Consequently the rain streaked the concrete walls.

Where there is little rainfall roof gardens and solariums can be built on flat roofs. Modernist architects in the 1920s and 1930s used flat roofs and roof gardens for ideological reasons, regardless of the weather. Central to the modernist use of the flat roof were Le Corbusier's 'Five Points of Architecture' ('Five points towards a New Architecture' in *Almanach de l'architecture moderne*, Paris, 1926) in which he argued the merits of the frame structure in an urban context, where space is at a premium. If a building was raised on pilotis or piers, there would be no damp basement, and gardens and pedestrian routes could be placed under it. Both the flat roof and the space beneath the building could then be used to bring nature back to the city, instead of losing the land to buildings. In the reaction against modernism at the end of the twentieth century flat roofs were criticised for leaking and considered alien to cultural traditions in countries such as Germany and the UK. For the post-modernists the flat roof became synonymous with the evils of modernism and, to make buildings homely to look at and weatherproof, a pitched roof became obligatory for a while. As the emphasis on sustainability and greening

the city has grown, so greater significance is given to roofs planted with a variety of plants.

Security and privacy

Some buildings have exteriors that are open and welcoming to strangers, others are deliberately forbidding. Forts, castles and prisons are inward-looking, with few openings, and their defensive purpose lends a bleak monumentality to their external form. At the Bank of England, London, 1792–1826, John Soane ensured that natural light only entered at roof level through lanterns and clerestory windows set high in the walls. Gated residential communities are being built throughout the world, and in many dwellings ground-floor windows are fitted with burglar bars, entrances are made unobtrusive and properties are surrounded by high walls and fences with alarms, CCTV cameras, 'fierce dog' and 'armed response' notices. Such defensive measures are witness to the gap between rich and poor.

Privacy is a factor in window design, so bathroom and toilet windows are often small with textured or patterned glazing. Some early modernist architects were so keen to express all the internal spaces of the building that they designed glazed staircases as a prominent external feature (see Figure 2.13). Perhaps they forgot that at night residents could be seen moving about in their night attire, or not as the case may be, unless the windows were well draped by curtains.[6]

Lighting

The exterior of a late eighteenth-century Georgian terrace has windows vertically aligned one above the other and repeated rhythmically along the row. At regular intervals, at ground-floor level, a door substitutes for the window opening (see Figure 2.8). The strong vertical accent of the façade reflects the alignment of living spaces within and the location and height of the windows tell us of the hierarchy of rooms. Below street level are the small square windows of the cellar or kitchen in the basement; on the ground floor the rectangular windows light the dining or sitting room. The taller windows of the first floor or piano nobile express the greater floor-to-ceiling height of the drawing room, and above that square windows light the family bedrooms. The smallest windows are for the servants' rooms in the attic. Since the Second World War some Georgian terraces have been converted into open-plan offices, by knocking down internal walls on each floor. The vertical emphasis of the exterior then no longer reflects the internal layout.

During the eighteenth and early nineteenth centuries in the UK many classical buildings, including terraced houses, had blocked-in windows. This was not necessarily due to the Window Tax, 1696–1851, which was levied on the number of windows in a property. Because the size, layout, air and light requirements of the interior did not match the regular layout of open-

ings required by classical design, many buildings had blocked-in windows. By the mid-nineteenth century there was an increase in window size in the UK for a number of reasons: the duty on glass ended in 1845; the Window Tax was repealed in 1851; and sheet glass became cheaper and available in larger sizes from the mid-1840s. As a result larger panes and fewer glazing bars were used, encouraging a fashion for four-paned sash windows and bay windows. This contributed to the move away from classically proportioned façades.

A large building with many regularly spaced large windows and a chimney may be a nineteenth-century mill or factory. If there is no chimney and the windows are small, it may be a warehouse, but in Manchester cotton warehouses needed large windows so that the cloth could be examined. In the late nineteenth century arts and crafts architects designed well-proportioned, asymmetrical buildings with varied rooflines and irregularly spaced and sized windows to reflect the layout of the internal spaces. These can be seen in Philip Webb's* Red House, 1859–60, built for William Morris and inspired by designs by G. E. Street and William Butterfield (Figure 7.17). Red House has an L-shaped plan. The inner corner, visible in the photograph, shows a discrete block with pyramidal roof for the main staircase. Two rectangular windows, at different heights on each face, light the two flights of stairs. Corridors run from this staircase at ground-floor and first-floor levels to left and right. They are lit by rows of regular windows, rectangular on the ground

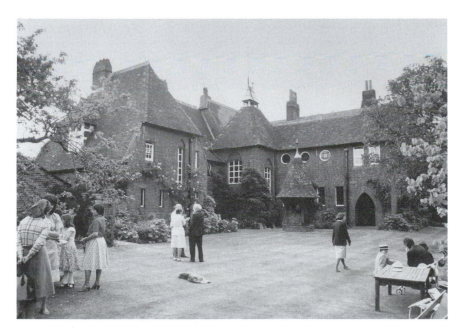

Figure 7.17 Red House, Bexley Heath, Kent, 1859 (P. Webb)

floor with circular windows above. On the right-hand side or east wing we can just see two of the ground-floor corridor windows and three oculi above. An arched porch next to these provides an entry from the garden. Above, a large L-shaped studio runs across the end of this east wing, and to provide sufficient light for working, there are two generous sash windows. Within the large, hipped-roofed block at the end of the south wing on the left are the servants' quarters and domestic offices with servants' bedrooms above. The small windows of the servant's bedroom upstairs and the pantry and larder below contrast with the two large studio windows. A tall, narrow window symbolically suggests vertical access and lights the servants' stairs. This photograph of Red House does not show the windows of any of the main living rooms, kitchen or bedrooms because they line the outer face of the building, but we can glimpse a distinct high roof sheltering two important rooms behind the staircase block. Here, located centrally beneath this roof, is the drawing room set above the dining room.

A glass, curtain-walled office building suggests an open-plan interior on each floor, but in practice the floors may be subdivided. In his search for the perfect form, Mies van der Rohe offered in his buildings open, flexible space suitable for different uses. Although each was for a particular purpose, often the final form is a neutral-looking box that expresses nothing of the particular function. So there was nothing to differentiate commercial office blocks from residential apartments other than the curtains in the latter. So keen was Mies to preserve the pristine rhythms of his façades that at Lake Shore Drive apartments, Chicago, 1950, he tried to prevent residents from putting up curtains!

Expression of structure

Another way to think about the exterior form of buildings is in terms of the structural elements that make them stand up. Some buildings openly express their structure; in others it is given little prominence. The huge, defensive

Figure 7.18 Perrycroft, Colwall, near Malvern, 1893–4 (C. F. A. Voysey)

walls of forts and castles are openly expressed, as are the buttresses supporting the vaults or domes of medieval churches and mosques. The arts and crafts architect C. F. A. Voysey* built buttresses to support the walls of the houses of his middle-class clients (Figure 7.18). These gave variety to the austere, undecorated exteriors and provided sheltered bays with benches for the occupants.

In the late eighteenth and early nineteenth centuries in the UK it became fashionable to use stucco to suggest ashlar and disguise brick, which was considered a mean material. With the introduction of ethical principles to architectural design later in the nineteenth century, architects moved away from stucco and exposed the brick in all its glory. Timber-framed buildings, when they are not covered in plaster, clearly show the structural framework of posts and beams. In the eighteenth century, rationalist* theorists and architects in France such as the Abbé Laugier sought an architecture based in nature in contrast to the preceding sculptural baroque and ornate rococo styles. Laugier believed that buildings should be stripped to their essentials and that their most significant characteristics were the supporting elements. His idealised 'primitive hut' was a simple structure without walls, but with vertical tree trunks supporting branches that arched overhead to provide shelter. Translated into architectural practice, this meant reducing extraneous ornament and expressing the supporting elements of the building honestly, especially the columns or piers in trabeated structures. These were principles that twentieth-century modernists praised, along with the austere, undecorated forms of much industrial architecture. The skeletal frame structures of Mies van der Rohe's designs appear to be a good illustration of this principle, but owing to fire regulations, the structural frames of his buildings were usually clad and not quite as openly expressed as we might think. At the Lake Shore Drive apartments non-structural I beams are attached to the façade at regular intervals almost like decoration to give a bold vertical rhythm. Mies spent many hours studying their profile in order to achieve the precise effect he wanted.

Façades

Although buildings are three-dimensional and may be viewed from four sides, or from above, we generally only see one or two sides at a time. Usually it is the main façade that makes the initial impression. Many buildings front on to a street and are designed so that this façade is more important than the others. This usually features the main entrance, which may include sculpture and other decoration. Often the most important rooms overlook the street. The rear and sides of the building are not seen so often and may be of cheaper materials and relatively plain.

Some buildings, such as the first-century BC Sanchi Stupa (see Figure 4.2), are designed to be seen from all sides and, in this case, walked around by devotees. In the twentieth century some architects designed their buildings

like discrete sculptural objects to be viewed from any side. They rejected giving special attention to one façade as 'façadism', so no one façade was given prominence, and the quality of materials and design was maintained all around. This was certainly the case with Le Corbusier's Villa Savoye (see Figure 8.3). The Hong Kong and Shanghai Bank Headquarters, 1986, Foster and Partners, is recognised by its main front facing Statue Square but the architects defied the usual approach to access. The building faces three streets and is suspended over a plaza that runs directly beneath the whole building. Visitors and workers enter the building from underneath where escalators take them from the gloomy plaza to the main banking hall. At the National Glass Museum in Sunderland, 1998, Andy Gollifer designed the building's main entrance to cut into what appears to be a continuation of the pavement that gradually rises to form the single sloping or mono-pitched roof of the museum. The visitor can walk onto this partially glazed roof and look down on the museum galleries below. Visitors arriving from the port side, however, are confronted with a tall, glazed façade. We need to look at buildings all the way round to find where the main emphasis is and whether there is a principal façade.

Aesthetics

Façades may be symmetrical or asymmetrical and some features may be more prominent than others. If there are few small openings, then the stress is on large areas of wall. If there are many large windows, these will break up the wall plane, emphasising the voids. The façade may appear simple or complex, and it may appear quite different at different times of day according to how the light falls on it. Façades can be subdivided into vertical sections or bays marked by arches, columns, pilasters, buttresses or windows as Figure 7.7 shows. A plinth, windowsills and lintels that have been aligned, string-courses, a cornice or a flat roof mark the horizontal divisions of a façade. The repetition of elements and their arrangement creates a rhythm within the façade. Many varied but repeated elements may suggest a restless rhythm; simple elements widely spaced may create a gentle rhythm and many large, bold elements a vigorous rhythm. The spacing and size of elements not only create rhythms but express emotions. For example, widely spaced columns suggest a 'stately, serene, and meditative' feeling, while closely spaced columns appear 'tense and forbidding'.[7]

Harmony and proportion

Different cultures employ different aesthetic criteria, and many buildings have been designed according to carefully calculated ratios and proportions (see Chapter 4). The façade of Santa Maria Novella, Florence, Italy, by the renaissance architect Alberti can be analysed in terms of arithmetic proportions that are quartered, halved, doubled or tripled (Figure 7.19). It can

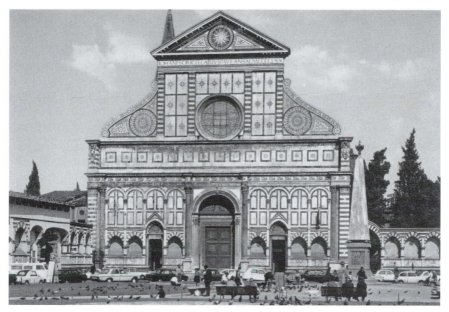

Figure 7.19 Santa Maria Novella, Florence, Italy, 1456–70 (Leone Battista Alberti)

be circumscribed by three large and equal squares, two side by side at the base and one centrally placed above. If these squares are subdivided into quarters we have the dimensions of the scrolls that flank the upper storey. The entrance bay is composed of six squares that are a quarter of the size of the squares used to give the dimensions of the scrolls; the height of the entrance bay is one and a half times its width. Further subdivisions reflect the same ratios and nothing can be added to or taken away from the façade without destroying its harmony.[8]

Many simple buildings give pleasure because of the careful use of proportions. The clarity of design and harmony of Georgian classical façades is determined by the proportions of an order, real or imaginary, and the brick or stucco façades with undecorated openings rhythmically disposed are very pleasing. If there is no order we call such buildings astylar. The pilasters between the windows with their base, shaft and capital, determine the horizontal divisions of the façade. The dimensions of this order also provide the module for the dimensions of windows and doors and their horizontal spacing. The best of modernist design also reveals a concern for proportion. Le Corbusier had his own methods for ensuring pleasing proportions in the undecorated forms of his buildings. He analysed both gothic and classical buildings to determine the principles of the composition of their façades. Eventually he developed his own proportional grids or 'regulating lines' and a proportional system, called the Modulor, which we discussed in Chapter 4.

The Hungarian modernist, Erno Goldfinger, who worked chiefly in England, greatly admired buildings of the classical tradition. The stark drama and austerity of the boldly expressed frame of Alexander Fleming House, Elephant and Castle, London, 1959, is combined with careful geometry and proportions (see Figures 5.15 and 5.16).

In the work of some contemporary architects complex sculptural forms have replaced the rhythm and proportion that we have been discussing (see Figure 2.5). To understand the forms of such buildings we need to develop new ways of 'reading' them.

Decoration

Decorative effects may be achieved in a variety of ways. During the middle ages in Europe glass in church windows was subdivided by branching curved mullions* carved in stone called tracery*. There were diaper patterns in brickwork using burnt headers and structural timber framing could be used ornamentally in secular buildings. In Italy during the renaissance church façades such as that of Santa Maria Novella were decorated with coloured marble facings. With the development of the railways architects of high Victorian gothic buildings had many more materials available to them. Their buildings were designed to use stone and brick of many different colours to give richness to the façades in structural polychromy. Because of the dirty, smog-laden air in this period, coloured terracotta was also widely used as it withstood the pollution.

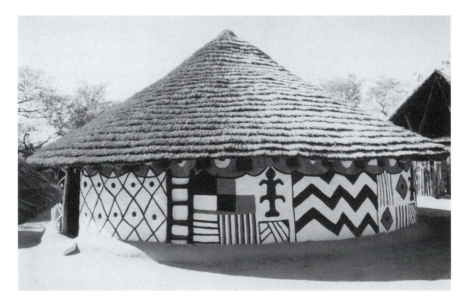

Figure 7.20 Hut of a Venda chief, Victoria Falls Craft Village, Zimbabwe

Many African clay-plastered buildings are painted with coloured clays and ashes; the most elaborately decorated indicating the status of a tribal chief (Figure 7.20). In India, Hindu temples are strikingly decorated with carved stone figures representing divinities, maidens, embracing couples symbolising fecundity, dancers, musicians and foliage. In some buildings these sculptures are set in sheltering niches or recesses in the wall; elsewhere intricate carvings cover the walls regardless of any need for protection from the elements (Figure 7.21). In medieval cathedrals the sculptural decoration is part of a symbolic programme, designed both to educate and impress the congregation. At Amiens the sculptural decoration reaches a crescendo in the west front (see Figure 7.9). Tiers of statues representing the Last Judgement flank the deeply projecting portals, the tympana* contain relief sculpture, a row of kings fills the gallery below the huge round, rose window, and stone water spouts or gargoyles are carved to represent people and animals.

In the 1930s the decorative façades of art deco factories and cinemas were intended to make them up to date and glamorous (Figure 7.22). Architects

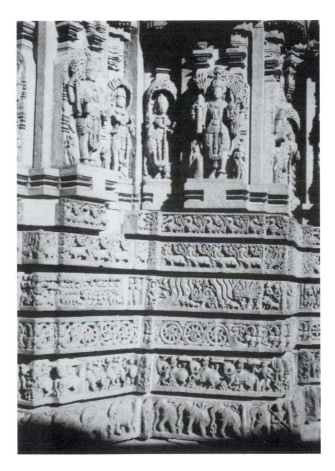

Figure 7.21
Sculptural decoration,
Keshava Temple,
Somnathpur, *c.*1268

Figure 7.22 Hoover Factory, London, 1931–2 (Wallis, Gilbert & Partners)

looked for something modern and exotic that was different from the tired gothic or classical motifs. The Chrysler Building in New York by William van Alen* is appropriately decorated with motorcar motifs and has a stainless steel dome. Other buildings eclectically drew motifs from ancient Egypt, Aztec culture, pleated shapes from expressionism*, and modernist geometric forms. This colourful and jazzy decoration was applied to tiles, used in stained and leaded glass, carved in stone and made out of enamel or terracotta, and it was very photogenic. Indeed, there are so many books published on art deco that they tend to distort the full picture of the period. Contemporary with art deco, other architects and designers in Europe and the US sought simplicity, in reaction to what they saw as the over-decorated forms of nineteenth-century architecture and the commercialised excesses of art deco. Some of them were modernists; others were working in a classical style. Classicists reduced or stripped the decorative details of their buildings to the minimum. Modernists employed *Zeitgeist* theory to justify reduced or no ornament. They believed that their buildings should reflect and symbolise a new period of efficiency and industrialisation, and that beauty lay in geometry and clean-cut forms.

Architects such as Le Corbusier were deeply concerned with aesthetics and Western cultural traditions. The roots of his architecture lay in the geometry and proportions of ancient Greek temples and the vernacular architecture of the eastern Mediterranean. Far from being a mere 'functionalist'*, narrowly focused on the practicalities of planning and construction, Le Corbusier

wrote in his book *Vers une Architecture* that architecture is 'a thing of art, a phenomenon of the emotions [. . .] The purpose of [. . .] architecture [is] to move us'.[9] In buildings such as the Villa Savoye at Poissy of 1928–9, the sculptural forms have beauty because of their proportions, clarity and simplicity (see Figure 8.3). Le Corbusier felt that these geometric forms were appropriate to the modern world because they reflected the forms of so many contemporary, mass-produced products, such as bottles and aeroplanes. In this sense he believed his buildings were not only beautiful, but also expressive of the age in which he lived.

There are many approaches to aesthetics and decoration. Postmodernists in the 1970s and 1980s thought modernist buildings with little or no decoration were alienating and neither expressive nor pleasing. In a development of affordable housing for sale with state-subsidised mortgages at Noisy-le-Grand, France, the architects Ricardo Bofill* and the Taller de Arquitectura, argued that symbols such as theatres, temples and triumphal arches could form habitable spaces and would bring the vocabulary and elements of the architecture of the past within the reach of the whole society.[10] The Théâtre and Palacio d'Abraxas, 1978–82, offered a range of apartments within these recognisable forms. The horseshoe-shaped Théâtre d'Abraxas features hollow concrete columns on the external façade which housed the emergency stairs and living spaces. On the internal façade glazed columns form bay windows for the apartments (Figure 7.23). When Venturi, Rauch and Scott Brown designed the extension to the National Gallery in London they addressed the

Figure 7.23 Théâtre and Palacio d'Abraxas, Noisy-le-Grand, France 1978–82 (Ricardo Bofill and the Taller de Arquitectura)

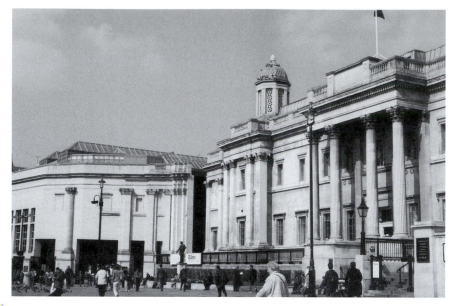

Figure 7.24 National Gallery Extension, London, 1991 (Venturi, Rauch and
 Scott Brown)

need for a new building that was sympathetic to its context. The result
combines old and new elements reworked in a way that is recognisably a
modern building (Figure 7.24). The theme of the columns and pilasters of
the main building is taken up on the right side of the extension, in the form
of pilasters. These are much more closely spaced, as if they are accelerating.
As the corner turns towards the new main entrance the pilasters become
more spread out and calm.

 The emphasis on decoration and allusion so prominent in much post-
modernism is no longer so evident in deconstruction. Many avant-garde
architects of the early twenty-first century share a concern to rethink form
and to organise it in a way that has little to do with decoration. Inspired by
complexity/chaos theory, irregular geometries, biological organisms, post-
structuralism, the writings of Jacques Derrida and the use of computers, their
work ranges from disturbing our assumptions about architectural form, to
the creation of heterogeneous and complex forms that appear as blobs, defy
gravity, or look like fractured landscapes.

8 Styles and periods

Identifying styles by common characteristics is an important part of looking at buildings, but there is much more to styles than this. In his book *The Classical Language of Architecture*, John Summerson said that it was a mistake to try to define classicism. Classicism was not just about the use of particular forms, it was also about the classical spirit and philosophy which informed their use. Consequently the term had different meanings in different contexts. Here we explore what we mean by styles and examine some of the ways in which architectural history is divided into periods. The concept of a period is drawn from different disciplines and this influences our perception of our subject.

Styles

Styles take their name from many sources. The name of an exhibition gave us art deco and that of a shop gave us art nouveau. Style names may in effect be value judgements such as classical, or derive from the names of tribes or cultures such as gothic. Historical periods such as Queen Anne*, Jacobean* or Ming dynasty* may signify particular styles, whereas the term Indo-Islamic refers to both a geographical area and a mix of cultures. Some styles such as modernism were identified before they came into being, while others such as art deco acquired their name after they achieved their greatest popularity. The concept of style is used in all the visual arts, not only by historians, but also by archaeologists, anthropologists, sociologists and philosophers. In order to date and identify architectural remains and other finds, archaeologists often use stylistic analysis together with an investigation of materials and techniques. Architectural historians use stylistic analysis as a tool for identification, but recently this emphasis on style has been increasingly questioned. There are many books that focus on particular styles, and the history of architecture has often been presented as a series of styles that follow one another chronologically. This was the method applied by Banister Fletcher and his son in the first edition of *A History of Architecture on the Comparative Method* published in 1896 (London, BT Batsford). They looked at styles chronologically, comparing and contrasting them in order

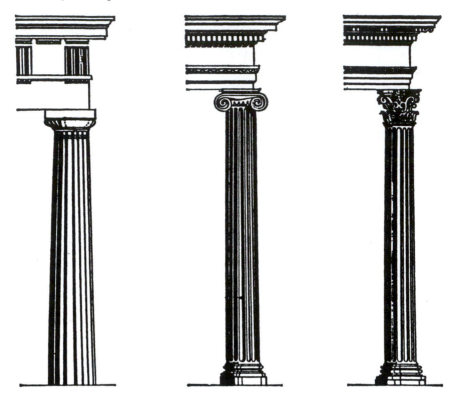

Figure 8.1 The orders: (a) Greek Doric, Ionic, Corinthian (J. Fleming, H. Honour,
 N. Pevsner, *Penguin Dictionary of Architecture*, Harmondsworth, Penguin,
 third edition, 1980)

to identify their specific characteristics. They compared the decorative mould-
ings of ancient Greek with Roman architecture and the round-headed
openings of English medieval Norman-style cathedrals with the various
types of pointed-arched openings of the gothic style in order to identify and
date their particular characteristics. There is, however, a great difference in
later editions, which from the 1970s have attempted a world survey with
descriptions of major buildings and building types.

Styles are not homogeneous or static but complex and changing amalgams
of old and new forms. If we say a building is in a particular style, we are
referring to its visual and physical characteristics. This implies that other
buildings or artefacts share similar features. All the buildings in the style
will not necessarily have identical characteristics, for the number of shared
features may vary, but most will have a large number of them. Gothic cathe-
drals often have vaults, buttresses and openings with pointed arches. Some
windows are simple lancets* with no tracery, others have plate tracery*, and
yet others curvilinear tracery*. Often, there is no single physical attribute

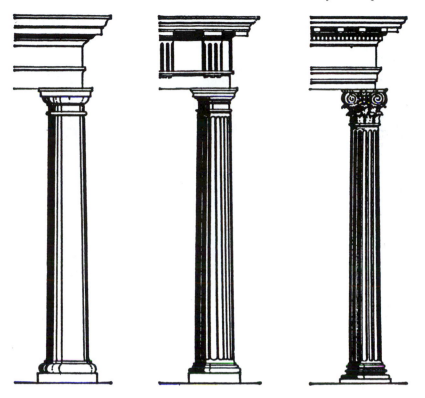

Figure 8.1 (b) Tuscan, Roman Doric, composite

that is both necessary and sufficient for membership of a style. In other words, we cannot say that a building is not gothic just because it does not have buttresses, nor that every building that has buttresses is gothic. C. F. A. Voysey used buttresses in his domestic architecture, but his work is not gothic (see Figure 7.18). The physical and visual characteristics of a style may include the use of particular materials, structural elements such as columns, spatial characteristics, protective elements such as hood moulds and decorative features such as carving on a moulding.

The classical style is one of the most pervasive, and new interpretations of it continue to be made. It originated in the temple architecture of ancient Greece, which was based on a post and lintel system of construction using columns. The Greeks created three types of column: Doric, Ionic and Corinthian. The ancient Romans developed this mode of construction further in their religious, military, civil and engineering structures, adding two further types of column, the Tuscan* and the composite*, as well as the arch, the dome and the vault to their repertoire of forms (Figure 8.1(a) and (b)).

Columns are used structurally to support a lintel and decoratively to enliven façades or walls. Each type of column is associated with a superstructure or an entablature of a particular design and this, together with the column, is called an order. Each order is also associated with an identifiable standard treatment of the windows, doors, openings, mouldings and ornament of the building. The classical style is also associated with principles of symmetry, proportion and a harmonious relationship between the elements of the building. Some classical buildings employ one order, others such as the Roman Colosseum, AD *c.*75–82, or the Farnese Palace, Rome, built between 1534 and 1589, employ several orders. In both these buildings a sturdy Tuscan or Doric order controls the design at basement or ground-floor level. Above, the orders become progressively more slender and elaborately decorated, with an Ionic order at first-floor level and a Corinthian order on the second. This was a common feature of many renaissance buildings.

So far, we have identified the classical style in terms of the orders, symmetry, proportion and harmony, but there have been many interpretations of the classical orders and a building does not have to use the orders to qualify as classical in style. The proportions and layout of Georgian classical terraces derived from an order, but many were astylar and did not actually employ one. Other buildings that are not classical may nevertheless suggest the character and proportions of a classical building. The Villa Savoye, 1928–9, by Le Corbusier, is a reinforced concrete frame structure, the forms of which echo the post and lintel structure of a Greek temple with

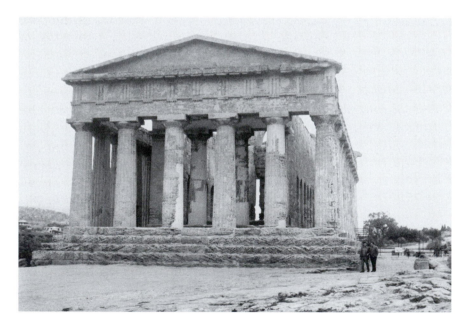

Figure 8.2 Temple of Concordia, Agrigento, Sicily, *c.*440 BC

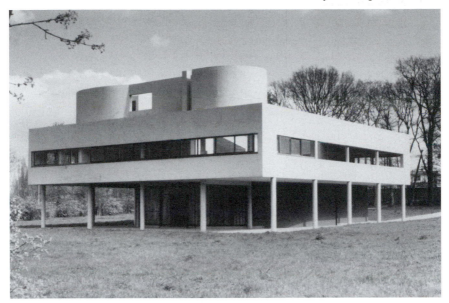

Figure 8.3 Villa Savoye, Poissy, France, 1928–9 (Le Corbusier)

its peripteral colonnade (Figures 8.2, 8.3). The outer pilotis of the supporting frame of the villa are visible all the way round the building at ground level. At first-floor level the walls hide them. The parallel with the Greek temple is emphasised by the spacing of the pilotis in a strong regular rhythm, and the ribbon windows at first-floor level give a horizontal stress reminiscent of an entablature or frieze. Although this is a modernist building in style we recognise the classical influence.

Variation within styles

Travel, trade, colonialism or war may lead to the introduction of new building types and styles which local architects or builders will tend to modify to suit the new circumstances. In the vast Indian subcontinent there is cultural and stylistic diversity. The great Buddhist, Jain and Hindu religions introduced major stylistic traditions that were tempered by many regional and local influences. Muslim invasions of the Indian subcontinent occurred from the twelfth century and culminated in the establishment of the Mughal empire in northern India between 1526 and 1858. This saw the introduction of Persian/Islamic influences by rulers who commanded wealth unparalleled in Indian history. Building types and elements new to India, such as the mosque, minaret, Islamic tombs and chattris* were introduced and a style developed that synthesised Islamic with indigenous traditions. The 'style' of buildings of this period is complex, and to understand it

adequately involves looking at patronage, regional materials, styles and traditions of craftwork.

Revival styles

From time to time architects become interested in reviving styles from the past. These differed from the original for a number of reasons: the building type, materials, or technologies were different; the social and philosophical outlooks had changed; or the style was being used in a different part of the world. During the period of neo-classicism in the nineteenth century the revived ancient Greek and Roman styles were modified in many different ways. John Nash's Carlton House Terrace, London, 1827–9, has cast iron columns, a material unknown to the ancient Greeks. Similarly, railway stations did not exist, yet P. and P. C. Hardwick's Euston Station, London, 1835–9, was in a Greek revival style. Some neo-classical buildings are an eclectic mix of different classical prototypes. William and Henry William Inwood's* St Pancras Parish Church, London, 1819–22 features elements from several ancient Greek buildings: the Tower of the Winds (top right), the Choragic Monument of Lysicrates (middle right), and caryatids* from the Erechtheum (centre) (Figure 8.4). Benjamin Latrobe had nationalist reasons for modifying the columns of the Capitol, Washington, DC, 1815–17. He replaced the acanthus leaf decoration of the capitals with an American motif, the ear of corn, and for the fluting of the shaft he substituted stalks of corn.

Using style as the common factor linking buildings does not help us to understand anything very significant about the revivals of classicism in different countries, or under different political and economic conditions. In the eighteenth century classicism was revived in France as part of the enlightenment. Inspired by the rationalism and intellectual ferment of the period, architects such as E. L. Boullée and C. N. Ledoux questioned the baroque and rococo architecture of the early eighteenth century in a search to understand the essence of the classical tradition. In their new classical designs they did not copy antique originals, but took the spirit of ancient architecture with its simplicity, symmetry, order and proportion to create novel buildings. Boullée's project for a monument to Newton is composed of a sphere encircled by cypress trees, without the use of orders (Figure 8.5). In the United States the passion for the Greek revival in the early nineteenth century was part of the search for a national identity. Parallels were perceived between America's earlier fight for independence and the contemporary Greek Wars of Independence, and also between ancient Greek democracy and the formation of the American democratic system. These encouraged the design of government buildings, churches, houses and even stores in the form of Greek temples that symbolised cultural and political independence.[1] Between the two World Wars, by contrast, the neo-classical architecture of the National Socialists in Germany and the fascists in Italy was designed to give stature

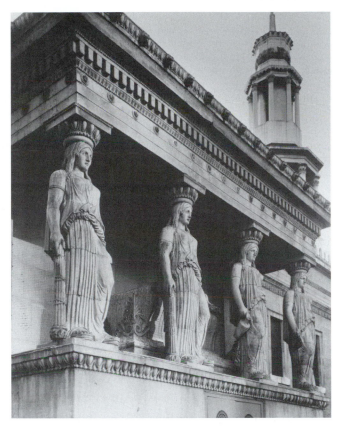

Figure 8.4
St Pancras Parish
Church, London,
1819–22 (W. and
H. W. Inwood)

Figure 8.5
Monument to
Newton, project,
1784 (E. L. Boullée)

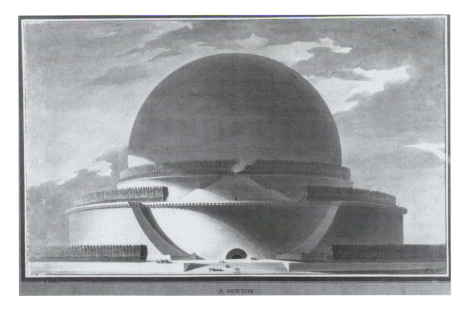

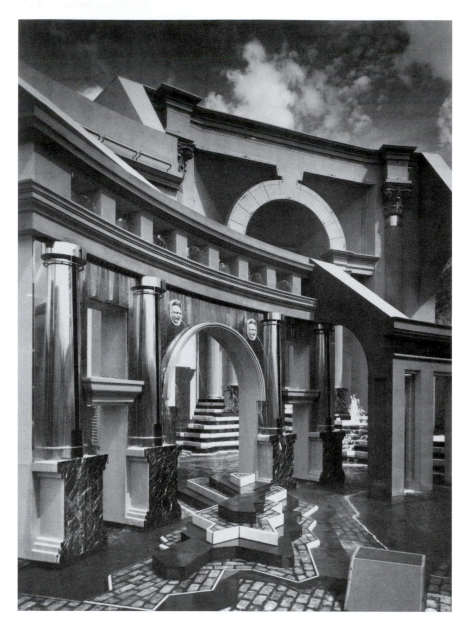

Figure 8.6 Piazza d'Italia, New Orleans, Louisiana,
US, 1975–80 (Charles Moore,
Perez Associates Inc., Urban Innovations
Group, and Ron Filson)

and legitimacy to authoritarian regimes. The colossal scale of their classical buildings symbolised the domination of the state over the individual, and were designed to impress and overwhelm spectators. Some postmodern architects used classicism eclectically and irreverently to brighten up the surroundings in a light-hearted manner. Charles Moore* *et al.*'s Piazza d'Italia, New Orleans, 1975–80, used classical elements to give a sense of place and familiarity to an area used by an Italian community (Figure 8.6). To understand any form of classicism, we need to know the reasons for the revival at that time and in that place. We also need to discuss the 'message' given by these buildings at the time that they were built.

In the early nineteenth century A. W. N. Pugin passionately committed himself to reviving the medieval gothic style in England, as the only style suitable for a Catholic architect living in that period. Pugin did not initiate this revival, for from the mid-eighteenth century Horace Walpole and others had taken great delight in the medieval gothic style and the associations with chivalry that it conjured up. Strawberry Hill, Twickenham, Horace Walpole's gothick home, created from 1748 onwards, was an exercise in the free and romantic use of gothic details to create the desired effect (Figure 8.7). The 'k' at the end of the word 'gothick' indicated that there was little intention of recreating precise medieval forms, or indeed of using those forms in the way that they were used originally. Carved stone details from tombs and canopied niches from churches were used to create decorative timber

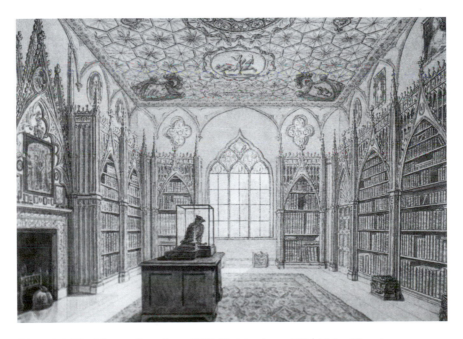

Figure 8.7 The Library, Strawberry Hill, Twickenham, 1754 (John Chute)

fireplace surrounds and bookshelves. By contrast Pugin pioneered a more authentic and rational approach to the gothic revival. He coupled his religious zeal with a great archaeological understanding of the original medieval structures. These two examples, the gothick and Pugin's use of the gothic in the gothic revival, show how styles may be used for very different reasons and with very different results.

Identifying an appropriate style for buildings offered serious challenges for colonial powers in their subject countries. With the establishment of the East India Company in London in 1600, trade expanded and initially the British used European styles such as classical and gothic for their precolonial buildings. By the mid-nineteenth century some new building types were designed in the then fashionable high Victorian gothic style. The Victoria Railway Terminus in Mumbai, 1878–87, by F. W. Stevens, eclectically combined Italian gothic revival detailing, stained glass and polychromatic stonework with domes and engrailed arches* (Figure 8.8). There are also open arcades, staircases and galleries to provide air and shade, and much of the carved ornament was by local craftsmen and depicted local flora and fauna.[2] After Queen Victoria was made Empress of India in 1876, the debate about style became more intense. Should they adapt a European style or should they turn to indigenous traditions for modern buildings? In 1909 Henry Irwin sought a precise Indian prototype for the main façade of the Victoria Memorial Hall (now the National Art Gallery) in Madras (Figure 8.10). He ignored local and more recent Indian architectural developments and instead chose one of the finest Mughal buildings, the Gateway of Victory or Buland Darwaza at Fatehpur Sikri. The gateway with Quranic inscriptions commemorated Akbar's conquest in Gujarat in 1573 (Figure 8.9). It was built on a high ridge during the reign of Jala-ud-Din Akbar, 1556–1605, the third and greatest Mughal emperor, and was part of the royal palace and administrative centre of a new city. The Gateway of Victory, built of red sandstone, was the southern gateway that opened into the courtyard of the Friday mosque.[3] It is approached by a great flight of steps and consists of an overpowering arched gateway capped by a series of domed chattris. Many of these features are directly reflected in Irwin's design for the Memorial Hall in Madras. It seems that Irwin ignored the original context and meaning of the gateway, and the fact that Akbar had never ruled in southern India where Madras is located.[4]

One further example illustrates how buildings sharing common stylistic features arise out of very different circumstances. The development of the modernist style in architecture occurred in Europe between the two World Wars. The characteristics associated with modernism are the use of new materials such as steel or reinforced concrete, a frame structure, a flat roof, smooth undifferentiated wall surfaces with little weather coping such as sills and mouldings around openings, and lack of ornament. When Nikolaus Pevsner traced the origins of modernism back to the nineteenth century in his book *Pioneers of Modern Design* he considered technological developments,

Figure 8.8
Victoria Terminus,
Mumbai, India,
1878–87
(F. W. Stevens)

social and moral ideas and visual criteria. One of the architects that he iden-
tified with the early stirrings of modernism in Britain was the arts and crafts
architect C. F. A. Voysey, who employed little or no decoration in his build-
ings (see Figure 7.18). Many of the houses Voysey designed had white-
painted, roughcast walls and no historicist decoration, and he made drawings
to ensure that no standard builders' mouldings were included in window,
door and other joinery detailing. Pevsner suggested these forms presaged
modernism, but Voysey, later in life, expressed vehement opposition to mod-
ernism and its dogmatic use of new materials and techniques.[5] Voysey's work
developed from British vernacular architecture and he disliked the way some
modernists rejected traditional materials and past architectural forms such as
pitched roofs. Some early twentieth-century modernist architects may have
been influenced by Voysey's principles of honesty and integrity, and may have

Figure 8.9
Buland Darwaza (Gateway
of Victory), Fatehpur Sikri,
Gujurat, India, 1573

Figure 8.10
Victoria Memorial
Hall (now National
Art Gallery), Madras,
India, 1909 (Henry
Irwin)

admired the lack of ornament in his work, but Voysey should not be seen as a pioneering modernist, because his aims were quite different. We should be wary of classifying buildings purely by stylistic criteria, for they may have little or nothing in common philosophically with that style.

Vernacular styles

Vernacular architecture covers a wide range of building types, from dwellings, granaries and animal enclosures to religious buildings of various kinds. Vernacular buildings provide environments for much of the world's population to live, work and worship. For these communities construction is not a professional activity and the methods are passed down from mother to daughter and from father to son. The forms of vernacular buildings derive from the practical and cultural needs of the community and are a product of available resources and natural materials, so they vary from region to region. Such architecture is often seen as conservative, yet closer examination reveals complexity and variation.

Vernacular buildings belong largely to pre-industrial societies, but vernacular traditions continue in societies undergoing economic and political change as they move towards market and industrial economies. This was true in the West from the fourteenth to the nineteenth centuries and it is also true of many other regions of the world today. In Zimbabwe, despite nearly a century of colonial rule, followed by independence in 1980, there are still many examples of vernacular architecture. These belong to the two major indigenous peoples, the Shona and Ndebele, and other groups living in the country such as the Venda, the Tonga of the north-east and Malawians who first came as migrant labourers (see *frontispiece*). The generic Shona and Tonga homestead consists of several separate circular or rectangular sleeping, cooking and storage buildings, built of pole and dhaka (clay) with thatched roofs and located within a swept space (see Figure 4.6). There are variations from village to village and each home expresses individual needs, preferences and experience in planning, materials, forms and decoration. Homestead size and the number of buildings are flexible, reflecting changing family size. As needs change, buildings are readily converted from one purpose to another. Light and air enter through a gap between the walls and the eaves of the building and there is one door. Buildings are located around and face a central courtyard where crop preparation, craft activities and play take place. This gives a symbolic unity to the home. The precise location and orientation of each building type has to be juggled against a number of factors and can be in tension with this generic symbolic requirement. In locating buildings, residents consider issues such as surveillance of the homestead entry, hygiene, security, privacy, propriety, and try to avoid the spread of smoke or fire from the kitchen. In orientating buildings they may wish to admit light through the door but avoid wind or rain. This leads to a variety of arrangements and requires a creative response.

The Shona and Tonga kitchen is a distinct building used for ritual activities as much as cooking. The Shona kitchen plan conforms to a norm with central fireplace, ritual bench opposite the door and male seating bench to one side. The Shona granary is a separate building within the courtyard. This is different from nineteenth-century practice. Then men slept in the kitchen rather than having their own sleeping building, calves and important animals were kept in the kitchen and granaries were located within the fields. Tonga design is different. Within the Tonga kitchen there is flexibility in the location of the fireplace, clay seating benches, ritual clay platforms and the grain silos, which are also kept in the kitchen for security. Tonga male sleeping huts have porches and verandahs, and often there are small gardens outside, all of individual design. In both communities each woman has her own personal recipes for the materials used in the construction and maintenance of clay floors, and women develop their own designs for decorating clay-rendered walls. Individuality and social difference may be expressed through materials, construction, form and decoration, and a chief's home is sometimes larger and more elaborate than the others. It may use imported materials or be built by specially trained builders.

Today, some Shona and Tonga homes built near to roads have an encircling fence and gate to prevent animals roaming into the home and to provide security. The sale of crops and the employment of some family members on large farms, or in the city, has enabled them to buy more permanent, manufactured materials such as bricks, concrete and corrugated iron that do not require constant repairs. The well-off can afford to build a bungalow, but often a separate, traditional circular kitchen and separate storage buildings are built around a paved courtyard with the bungalow and its garage. It can be seen that many factors influence the design of these vernacular buildings, including creative responses to the modern world, and that vernacular buildings are not 'just traditional'. Their forms evolve: they are as consciously designed as buildings in advanced market economies and can exhibit marked complexities of style.

Style and content

Style is usually discussed in terms of form, rarely in terms of content. When Sanderson Miller*, the amateur gentleman architect of Warwickshire, built a sham gothick ruin in the grounds of his estate at Edgehill in 1746 it was visited by Horace Walpole. Afterwards Walpole wrote that the 'ruined castle built by Miller, . . . would get him his freedom even of Strawberry: it has the true rust of the Barons' wars'.[6] Any ruin could inspire melancholy, but to the mid-eighteenth-century mind gothick ruins conjured up images of heroism in the age of chivalry. The addition of small buildings to the eighteenth-century landscape was not just about providing places for shelter from the rain, or for picnicking, nor were they solely to close a vista, or to provide aesthetic delight. They were intended above all to inspire

associations. Imitation classical Greek buildings such as the Tower of the Winds at Shugborough, Staffordshire, 1764, evoked Greek political philosophy and expressed the political ideal of liberty.[7] The garden buildings at Stowe had a clear political agenda, while the pagoda at Kew and the Indian bridge at Sezincote provided architectural variety and inspired romantic visions of other climes and other cultures. Although these buildings do not inspire the same associations today, we need to recognise that form and style are also about meaning and content. They express ideas and values, and similar forms have been used to express both reactionary and progressive ideas, as the example of neo-classicism illustrated.

Another aspect of this can be seen in the adoption of the Greek temple form for museums and banks in the nineteenth century. The 'museon' was originally a shrine of the muses of literature and the arts. It then became a repository for gifts and subsequently a temple of the arts.[8] The use of the temple form for museums in the nineteenth century made that reference explicit to those with a classical education. The 'message' of the temple form used for banks was rather different. Since Greek temples based on this form had existed for thousands of years, it gave the message of trustworthiness. It was also a form associated with power and dignity, but in this instance transferred by association from a Greek god or goddess to the particular financial house. The message of power is still important: the architecture, scale and style of large and expensive office blocks are intended to convey their commercial power.

Modernist architects were also interested in the 'meaning' of their buildings. They rejected the dark, claustrophobic interiors, the dirty, cramped and polluted cities and what they considered the dishonesty of borrowed styles that proliferated in the architecture of the nineteenth century. A new century, the twentieth century, required a new style of architecture appropriate to the new technology, new constructional systems, materials and way of life that was emerging. Crisp geometric forms, light structures, clean smooth surfaces; airy, uncluttered, open-plan interiors and large windows symbolised their bright new healthy and efficient vision for the future, which new technology and mass production would make available to everyone. It was both a radical and democratic view that, in rejecting traditional forms and materials, sometimes 'threw out the baby with the bathwater' and irritated those who prefer to cling to convention. It was a style seen by many to match the spirit of the period immediately following the Second World War when people in the West wanted to start afresh. However, political and economic pressures and inadequate research resulted in many failures, notably in the field of mass housing and flat roofs. It became fashionable to condemn modernist buildings, but we need to understand their design in the context of the period in which they were built and the motivation of patrons and architects. History will judge whether the twenty-first century has similarly inspired new forms of architecture for a new age.

Figure 8.11
Houses in Regent
Road, Leicester, 1881
(Goddard & Paget)

Figure 8.12
Tesco supermarket at
night, Amersham,
Buckinghamshire, 1993

Figure 8.13 Wheat barn, Cressing Temple, Essex, *c.*1255

The debate on style and meaning was very much part of postmodern architecture. In the UK, domestic bliss is associated with the vernacular revival* and is characterised by features eclectically drawn from British vernacular architecture: tiled pitched roofs, dormers and gables, and the use of brick, half timbering, tile hanging and render for walls (Figure 8.11). These vernacular revival elements were not limited to domestic architecture, but towards the end of the twentieth century they were applied to large buildings such as supermarkets and stores (Figure 8.12). This was partly to give them a domestic and friendly feel, partly to relate them to their domestic surroundings, and partly to make reference to the medieval barns that stored agricultural produce in the past (Figure 8.13). Tesco developed a particularly recognisable signature in this area, but it was not alone, and maybe tradition has been stretched to its limit here.

Styles and dating

Architecture in different periods and places tends to vary in style and reflect the different social, economic and cultural contexts. It was thought that if changes in style could be linked with changes in society, whether technological, economic, ideological or social, we might understand the reasons for stylistic change. Furthermore, since style relates to society in a particular place and at a particular time, it could also be used as a tool for dating. Stylistic evidence could be used either on its own, or with such other evidence

as surviving documents, a patron's brief for a building or scientific evidence such as radiocarbon dating. If no other evidence was available, then style alone could be used to date buildings.

It is a complex task to use styles as a method of dating buildings, for as we have seen, they are rarely 'pure'; each draws upon a variety of cultural resources and is constantly reinvented. In Europe, the renaissance style developed in Italy in the fifteenth century. It is associated with the reuse of the ancient Roman classical orders and principles of architectural design. The style subsequently spread through Germany, the Low Countries and France, becoming fashionable in England later, in the second half of the sixteenth century. In each country the style was modified by local stylistic idioms. In the Netherlands the renaissance style was combined with decorative tall gables, strapwork* and obelisks, and the orders themselves were banded*. Its early use in Britain combined all these influences with medieval, Elizabethan and Jacobean forms. Robert Smythson's Wollaton Hall, Nottinghamshire, 1580–8 has Flemish strapwork and shaped gables, renaissance pilasters, pediments and niches, a great medieval hall, Tudor mullioned and transomed* windows and Egyptian obelisks (Figure 8.14).

Generally several styles coexist at the same time and in the same place, each evolving and developing at their own pace, or even borrowing elements from one another. The waxing and waning of styles does not necessarily happen with clearly defined beginnings and endings. There may be buildings that prefigure a developing style, or a style may be employed in the regions long after it has ceased to be used in a fashionable metropolitan context. Styles may have life cycles in which they are born, grow, mature and decline. The identification of early, middle and late phases in a style may be a matter of its chronological development, or there may be a moral judgement involved, for the word 'decline' is negative, implying lack of creativity. Some styles may represent avant-garde and radical approaches; others are seen as archaic survivors of an outmoded tradition. However, what was seen as archaic and unfashionable yesterday may be reappraised today. Many longstanding styles, such as gothic, vernacular and classical, continue to be revived and creatively reworked in the twenty-first century. They could be criticised as revivalist and irrelevant to the modern world, but each generation injects new vigour and finds new reasons for revivals.

Non-styles and movements

Although buildings may share characteristics and can be grouped visually and stylistically, there are some significant attributes that are not visual. The visual characteristics of the Crystal Palace (see Figure 2.1), for example, are not nearly as important as its method of construction. Rather than trying to classify the Crystal Palace stylistically, it is more useful either to group it with similar prefabricated buildings of iron and glass or to group it in terms of its function with other exhibition buildings.

Figure 8.14 Wollaton Hall, Nottinghamshire, 1580–8 (Robert Smythson)

Figure 8.15 Stoneywell Cottage, Leicestershire, 1899 (E. Gimson)

Buildings may be classified according to the ideas and approaches of the architects or builders. Some groups of architects such as the futurists* and the expressionists published manifestos declaring their aims. In classifying groups and movements according to their ideas and aims we find similar problems to those encountered with style. Although there may be a manifesto, the buildings designed by its members may not always fulfil all of the aims. Some movements, such as the arts and crafts movement, encouraged individual creativity as part of their aim. The architects of this group may be linked together because of their belief in the unity of the arts, their view that humble vernacular buildings could be both practical and delightful and their support of the principles of honesty in design and use of materials. The application of these aims, however, resulted in very different buildings, depending on which vernacular tradition the architects chose to develop and their personal interpretation of the principles (Figure 8.15, and see Figures 2.11 and 7.18).

Buildings may also be classified in terms of religion, particularly in areas where a number of religions coexist. The buildings associated with the Hindu, Buddhist, Jain and Muslim religions embrace a variety of building types including buildings for worship, religious schools, tombs, monuments and shrines. The form of these buildings and attitudes towards them may have changed over periods of time. In some parts of India today shrines or monuments are revered by both Muslims and Hindus; in other parts they are

a focus for dissention. Focusing on buildings associated with a particular religion can be a useful way in which to understand the evolution of a building type within the context of a region and its society. In the UK the problem of redundant churches can be seen as an aspect of this type of study. By contrast, the study of Islamic architecture is not just concerned with religious buildings. The study of Islamic arts is a Western and colonial construct of the nineteenth century. In the West there are centres for the study of Islamic arts, for example the Aga Khan Programme for Islamic Architecture at Harvard and MIT set up in 1979, but in Egypt or Iran it is Egyptian or Iranian art and architecture that is studied. Islamic architecture does not refer to only one style, only one region or only religious buildings. It covers both secular and religious buildings in the geographical areas where Muslims have lived, worked and worshipped since the seventh century. So it includes buildings in places as far apart as Spain, the Middle East, Central Asia, India and Indonesia as well as buildings produced by converts to Islam or the Muslim diasporas in western Europe and the US. Such vast geographical coverage, chronology and range of building types suggest not a single universal Islamic architecture but a multiplicity of architectures.

One further example illustrates the diversity of architectural classification that is not stylistically based. It also shows how the particular concerns of those studying the architecture of the past can lead to emphases that we would perhaps dispute today. The Chicago school of architects working in the US in the 1880s and 1890s included Burnham and Root*, Holabird and Roche* and Louis Sullivan. The school is associated predominantly with the development of a new building type, the skyscraper or high-rise office building. Modernist historians writing in the 1930s, such as Siegfried Giedion, H. R. Hitchcock and Nikolaus Pevsner, focused on the Chicago school, which seemed to them significant for: the development of a new structural system, the frame structure; the use of a new material, steel; and the reduction of ornament and historical elements in their buildings. The modernist storyline was that the Chicago school architects and engineers pioneered the 'skin and bones' style of the modernist office block. To modernists this confirmed the link between technological and aesthetic change in architectural production. Today, we look at these buildings less selectively and recognise that the commission, design, construction and use of these buildings involved complex issues, which led to a variety of solutions. Daniel Bluestone has shown that these Chicago architects were concerned to provide distinctive and up-to-date working environments for office workers with shops, restaurants, hairdressing salons and well-appointed washrooms.[9] Many architects used ornament, especially in the entrance halls, to impress business clients and the public. The hallway of the Reliance Building, 1894–5, Burnham and Company, had elaborate elevator casings and tessellated floor tiles, and the exterior walls were clad in polished red granite with grey terracotta panels with gothic detailing above. The entrance hall of the Marquette Building by Holabird and Roche, 1893–5, illustrated

Figure 8.16 Entrance arch, Stock Exchange, Chicago, 1893
(Dankmar Adler and Louis Sullivan)

the history of the Northwest Territory in bronze bas-reliefs and panels of Tiffany and Company mother of pearl and favrile glass. The work of Louis Sullivan is of particular interest because he developed his own personal style of ornament that was evident in Adler* and Sullivan's Chicago Stock Exchange, 1893, and the Auditorium Building, 1886–90. The Stock Exchange was demolished in 1972 and today only some interiors and the entrance arch survive (Figure 8.16). The Chicago school is still a useful concept because it focuses on a location and period important in the technical development of skyscraper office design and it raises questions about the development of styles and their interpretation.

Periodisation

There are many ways to subdivide historical time. They include arbitrary subdivisions into decades or centuries, periods derived from style developments, from other branches of history such as the reigns of kings and queens, or more complex subdivisions defined by economics or technology. The question of periods and styles is by no means straightforward for it is not always possible to discuss them independently. Sometimes periods are given the names of styles and vice versa. In order to understand change in the built environment, the origins of a development or its influences, we need to focus on chronology and periodisation as a useful way of structuring our ideas.

Defining periods in terms of decades or centuries seems in a sense 'natural', for we often think of our own lives in terms of decades. To differentiate one period from another we look for evidence of change and growth marking the beginning of a new period or its end. These changes rarely take place in exact decades or centuries. Books that focus on '1930s' architecture' or 'the architecture of the eighteenth century' might appear to subdivide the subject neatly but not necessarily most appropriately, and there may be a tendency to impose arbitrary storylines in order to make the material fit the period.

Periods and style

When we refer to the art and architecture of ancient Greece and Rome we often talk about antiquity, meaning ancient times. The antique period lasted some 1,200 years, from the eighth century BC to the fourth century AD. During the course of this period geographical boundaries changed and expanded. The Roman Empire eventually extended as far west as the Spanish peninsula, north to the Black Sea, the Netherlands and England, south to the north African coastline and Egypt, and east to Asia Minor. A prodigious number of buildings were produced over a long time span and in a wide geographical area. Given the diversity of work produced, the concept of antiquity is only useful in isolating for research the two cultures that

were seminal in the development of Western arts. Because of the Eurocentric emphasis of so much architectural history the cultures that predate those of Greece and Rome, such as those of China and Egypt, do not form part of what has been understood in the West as 'antiquity'. Yet, evidence of Egyptian architecture dates from 2600 BC and that of China, India and Pakistan from 2000 BC and over the centuries there has been interaction between all of these centres.

The word 'classic' derives from the Latin and means 'of the highest class or rank'. It referred to the superior tax-paying class of Roman citizens, but in architectural history the term has taken on several meanings. As we discussed earlier, the term 'classical' is often used to refer to the style of architecture that developed during antiquity. 'Classical' is also used as a name for buildings constructed in ancient Greece between c.490 BC and 323 BC when the Parthenon and the Erechtheum were built, as they represented a peak of perfection. In this case the term is being used as a name for a particular period in Greek architecture and also implies a value judgement. Classicism is another related term that is used to mean a revival, or return to the principles of ancient Greek and Roman architecture, as in neo-classicism.

The use of a style name to denote a period encourages us to think that only that style existed during that period, and that if other styles existed, they were inferior and unworthy of attention. For example, the architecture of the medieval period in Britain is often subdivided chronologically into Anglo-Saxon, Norman and gothic styles. The gothic style is then further subdivided chronologically into the early English style* (see gothic style in glossary), the decorated style and the perpendicular style. The identification of these latter three styles derived initially from the changing style of vaults, piers, arches and windows in churches, cathedrals, castles and palaces. These features rarely appeared in cottages, mills, barns, farmhouses or vernacular buildings made of timber, clay or stone and so these styles are not applicable to them. They are applicable only to polite architecture, because they are usually only found in those building types. If we are looking at a range of building types in the medieval period, subdividing that period chronologically using style names is inappropriate. There is a similar problem with the architecture of colonial and ex-colonial countries where a tendency to focus on colonial-style buildings has meant ignoring those of the indigenous population. So when we are using the names of styles we should be careful not to assume that they can be used to name periods.

Periodisation and other disciplines

The example of the renaissance shows it is important to identify the criteria used to define the chronological boundaries of a period. Dynasties, empires or the reigns of kings and queens may define periods. It might be assumed that in this form of periodisation there is a direct relationship between those

holding the reins of political power and the built environment. In some cases royal or state patronage may be a significant motor of change, but it is rarely so for every building type. If we look at the architecture of the Victorian period, we can see some of the pitfalls that can arise. The Victorian period acquires its name from the reign of Queen Victoria (1837–1901). Certain buildings were constructed through the patronage of Queen Victoria or Prince Albert, such as Osborne House, Isle of Wight, and the Crystal Palace, but the most significant characteristics of the architecture of her sixty-four-year reign do not relate to this, nor are they confined by the boundaries of her reign. This period saw the development of new building types such as railway stations, the use of new materials such as iron and glass, new technologies such as prefabrication, and a proliferation of architectural styles. These changes did not occur solely within the period 1837–1901, for their roots lay in the changing economy and the new technological and architectural developments of the eighteenth century. Strictly speaking, the term 'Victorian architecture' should be applied only to work produced in the UK, or those areas of the world that were part of the British Empire, such as India, yet it is often used to describe nineteenth-century North American architecture. The death of Queen Victoria in 1901 and the accession of Edward VII brought the end of the Victorian and the beginning of the Edwardian period, with the implication that Edwardian architecture was significantly different from that of the Victorian era. Yet, no sudden architectural changes had taken place.

The modern and postmodern periods illustrate different criteria used to define them. The modern period in Western culture can be defined in a number of ways. From an economic or historical perspective it dates from the end of feudalism and the beginnings of a market economy in the fifteenth century, when the roots of the Western social system were emerging that affected all the arts. From a technological perspective the beginning of the modern period relates to the fundamental changes taking place at the time of the industrial revolution. The development of urbanisation, industrial technology and new manufactured materials took place towards the end of the eighteenth century and during the early nineteenth century. If we are only concerned with stylistic changes in architecture and design, we might identify the early years of the twentieth century as the period when modernism as a style in architecture and design emerged.

Postmodernism is a term that is applied to such diverse areas as philosophy, politics, economics, culture in general and architecture. To some it denotes a style or a period; to others it implies a whole new philosophical and critical approach to the world. Most critics agree that postmodernism developed after modernism from the late 1960s. Postmodern philosophers are opposed to all-encompassing theories and stress the diversity of interpretations. The question of similarities or links between the many postmodern disciplines is complex. Postmodernist architecture of the late twentieth century featured a plurality of styles including high-tech, free-style

classicism, neo-vernacular, classicism and deconstruction. In many periods and places several styles have coexisted so whether late twentieth-century architectural pluralism is postmodern is debateable.

Some economists have used the term 'post-Fordism', rather than 'postmodernism', to describe the global market economy in the present period. This includes the move away from the welfare state and state-owned industries, diversification of production and the transfer of manufacturing to economies where labour is cheap. It also includes the rapid growth of the finance sector and international stock market, the impact of global communications and increased consumption in wealthier countries. In this context identifying postmodern architecture as simply a concern with stylistic plurality and eclecticism seems rather narrow and ignores the many ways in which leading contemporary architects work in a global economy.

9 Site and place

So far we have concentrated on individual buildings, but buildings rarely exist singly. Even the polite architecture that we have discussed – the castles, palaces, temples and mansions – seldom appear alone, but have subsidiary buildings close by, where those associated with the main building live and work. Here we look at the location, site and physical context of individual and groups of buildings, to see how they relate. We look at local distinctiveness and what we understand by sense of place. Sense of place relates to many factors, and we will look at topography, townscape, streetscape and skyline.

If we visit a building, then we are aware of its physical context. If we have only a photograph, a drawing, or a description, then we need to know about its geographical location, how it relates to open spaces such as streets, squares, parking lots and gardens and to the neighbouring buildings, and what sort of access there is to it. A street map, or an Ordnance Survey map, of the district may help us to build up a picture of the location. There are always good reasons for the location of buildings although they may not always be apparent. Buildings have been grouped together for defence, for commercial reasons as in a market town or a seaport, for religious reasons as in the great medieval monastic centre at Vézelay in France, and for leisure purposes as in the eighteenth-century spa towns of Baden-Baden in Germany, or Bath in England. They may reflect the power of the king, the religion, the government or the local landowner, and they may be planned or may just have evolved.

Planned and unplanned developments

If the initial grouping of buildings was for strategic, commercial, religious, industrial, governmental or leisure purposes, the layout of a town may still reflect that original purpose. Versailles outside Paris was built to testify to the power of King Louis XIV, while the layout of Washington reflected the power of the newly independent United States (Figure 9.1). In Bath the Royal Crescent and the Circus were created in the early eighteenth century in order to attract upper- and middle-class patrons to take the waters.

Figure 9.1 Plan of Washington, 1800 (Pierre L'Enfant)

Bath became the fashionable place to visit and to be seen, although some criticised the new layout and thought that after the completion of the Circus and the Crescent 'we shall probably have a Star; and [. . .] all the signs of the Zodiac exhibited in architecture'.[1]

Planned cities have existed from *c.*2500 BC. City planning is about the relationship between buildings, open space and their use. A common feature of Western city planning from the ancient Greeks and Romans to today has been the city square. Ancient Greek and Roman towns featured an agora*, a central open space where people met and markets were held. Such squares had a democratic basis and symbolised the civil rights of people to meet and exchange ideas. There was no equivalent to the agora in Chinese city planning. In the feudalistic society of China, city planning was, until the nineteenth century, dominated to a large extent by the Zhou Ritual. This emphasised the power of the emperor as Son of Heaven, with the walled palace city placed at the centre of the larger, imperial city, also walled, facing the sun to the south. In Beijing the power of the emperor in the palace city was reinforced by the mass of the palace buildings and the use of colour, with roofs of yellow glazed tiles and the surrounding palace city walls in deep red. Outside these walls people's houses were restricted to grey roof tiles and walls. In addition the central location of the palace meant restricted communication between the east and west sides of the city which inhibited both physical contact and the spread of ideas.[2]

Most settlements, however, were not planned. A group of buildings by a crossroads may have started with an inn, which provided a resting place for travellers. In southern California the missions set up by the Spanish at the end of the eighteenth century were strategically placed a day's journey apart on horseback. With the industrial revolution, industrial centres grew up initially near appropriate water supplies to power the mills and subsequently near supplies of coal and iron. Only with the development of the railways and the gradual introduction of mass transport did people gain a measure of choice on where they lived. Before then most people walked to work and so had to live nearby. What we think of as the picturesque huddle of medieval buildings grouped around a church or market place had a practical basis that related directly to the distance between home and place of work. The crowded housing around a port such as London in the Roman and medieval periods continued into the mid-twentieth century and was due directly to the need to be near work in the docks that was casual and available on a first-come, first-served basis. Similarly, the crowded shanty towns or informal housing around Mumbai or Rio relate not only to the extreme poverty of the residents but also to the need to be near wealthier areas in order to survive.

Location and site

Land that has been built on, or for which there is permission to build, is more valuable than agricultural land, and city-centre land is generally more valuable than land in the suburbs or on the outskirts of cities. The cost of land has a direct bearing on the types of building that it is economic to build. The pattern of land ownership, the controls imposed by local authorities and the availability and cost of land may encourage or discourage the architect or builder. If landowners are concerned to maintain property values when leasing out the land, they may impose controls on the building quality, which will affect the design. Indeed, this occurred on many of the large London estates when they were opened up to building development in the eighteenth and nineteenth centuries. Other factors may also affect the quality and type of building. In the late nineteenth and early twentieth centuries the transport network of London expanded. With the new train and underground facilities came the opportunity to develop suburban housing ever more distant from the centre of London. The type of housing built depended not only on the cost of land but also on the fare structure available on the different lines. Areas of working-class housing developed in an arc to the north-west and north-east of London due to the fact that cheaper workmen's fares were available on the lines serving those areas.[3]

During the last fifty years commercial buildings were built on inner-city sites and housing was rarely provided, not because it was not needed but because the return on the capital investment was too low. Today, the need for inner city affordable housing is increasingly recognised, as it has become apparent that key workers such as teachers and nurses can neither afford to

live in city centres, nor afford the fares to travel in to work. When we look at the location of buildings we need to consider what the commercial opportunities and limitations were, for towns and cities are not static, they change and evolve. Houses built for individual families may be broken up into apartments and bedsitters, and a once-prosperous residential district may then offer accommodation that poorer members of the community can afford. The location of particular types of buildings also needs to be considered, for city centres change their character. Churches were built originally in the centre of towns to be accessible to the population. When these centres were taken over by shops, offices and other commercial ventures, the population moved to the suburbs. The churches became redundant, and new ones were needed to serve the new suburban communities. Today, the changing ethnic mix in residential areas has led to a new range of religious buildings, temples, gurdwara*, mosques and madrassas. These may be new buildings, or conversions of warehouses or other redundant buildings.

Another recent major change has been in the location of the shopping centre. New shopping centres and hypermarkets are increasingly located on the outskirts of town, with good parking facilities and often motorway links with other urban centres. These attract shoppers, and consequently city-centre shops suffer and close down, unless provision is made, as it is in France, to encourage entrepreneurs there. These shopping centres then become the focus of further developments such as out-of-town leisure parks, hotels, industrial estates and housing. Such edge cities* can become thriving industrial and commercial centres but lack viable public transport systems. They are therefore dependent on the car and those without access to cars are excluded.

The location of particular types of building may be due to zoning. As cities expanded and became more complex, their problems appeared more intractable, so various solutions were put forward. Zoning was a solution that was widely adopted after the Second World War. This meant physically separating industrial areas, commercial centres, cultural centres (with their theatres, concert halls and cinemas) and residential districts. Zoning seemed at the time to be a way of solving the complexity and chaos of cities, but it has subsequently been recognised that it led to other problems. Jane Jacobs in her seminal book *The Death and Life of Great American Cities*, 1965 was one of the first to point out the negative results of zoning.[4]

The dimensions of the site and the desire for maximum profit may determine the form of buildings. As the city of Leeds expanded, towards the end of the eighteenth century, long narrow plots of land became available for building on one by one, as they were in individual ownership. Each owner was concerned to develop their plot to the maximum, regardless of how their development related to those on adjoining plots. The result was a warren of housing with no properly planned streets, and the development of a housing type that subsequently became associated with some of the worst slum features of the nineteenth century, the back-to-back dwelling. Built in terraces or rows with doors and windows on the front only, there was no

through ventilation and they had limited light. Moreover, the only running water was a standpipe which served a large number of houses and people had to share communal privies. The poverty and overcrowding and the consequent mortality rate became notorious.

The dimensions and features of a site are important in other ways. Some sites are an awkward shape and this may determine the form of the building. The Maison du Peuple in Brussels, 1896–9, was located on a circular *place* and its curved façade was designed by Victor Horta* to reflect this. The design of some buildings may be determined by the footprint* of buildings from a previous era. In Lucca, Italy, for example, the houses lining the elliptical Piazza Anfiteatro were built on the footprint of a Roman arena.

Topography and orientation

If a building is situated at the top of a hill, or against a hill, or on level ground, or by a river, lake, or the sea, this information will enable us to determine whether its position is exposed or sheltered, dominating or hidden. Topography is an important factor in our understanding of buildings and with recognising where we are. Hilly cities provide views unattainable from the ground on flat sites. We associate San Francisco with its hills and the prospects from them. London has hills to the north and the south of the Thames and views from them show how it is still a predominately low-rise city. The high-rise buildings are clustered in the main around St Paul's Cathedral in the City, and in Docklands. Designated strategic views protect not only St Paul's, but also the Tower of London and the Houses of Parliament from becoming obscured by new high-rise developments.

The topography of a site and such features as a rocky outcrop, a stream or trees can prove inspiring. At Falling Water, Pennsylvania, Frank Lloyd Wright designed the house around the natural features of the rock and waterfall (Figure 9.2). Ernest Gimson's* Stoneywell Cottage at Ulverscroft, Leicestershire, was inspired by the rocky outcrop which merges with the cottage (see Figure 8.15). Built of local rough field stones of granite, Gimson and his mason, Detmar Blow*, designed the irregular forms of the cottage and varying floor levels within to follow the rock formation. The use of local materials was another way of relating a building to its surroundings and was adopted by such arts and crafts architects as Edward Prior* and by Greene and Greene in the US. Le Corbusier's Dominican Monastery de la Tourette (now Convent), 1957–60 at Eveux in France was built around a courtyard, on a steep hillside with views over the surrounding countryside. The hillside provides ground-level access to many floors (Figure 9.3).

The orientation of a building may be concerned with the best view, or with climatic conditions. The early eighteenth century saw a new approach to town development in London, Edinburgh and elsewhere. Instead of building single houses, or rows of housing, developments were focused around a square. James Craig's plan for the New Town of Edinburgh dates

Figure 9.2 Falling Water, Bear Run, Pennsylvania, US, 1936 (Frank Lloyd Wright)

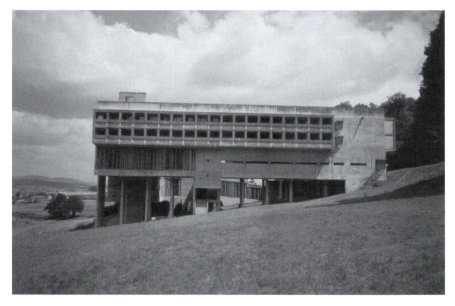

Figure 9.3 Monastery (now Convent) de la Tourette, 1957–60 (Le Corbusier)

from 1767, and his plan for Bedford Square in London from 1775. The largest houses, often three or four storeys high, faced the square, which was accessible to the residents only. Behind were rows of smaller, two-storey buildings laid out in cobbled mews*, which accommodated the horses, carriages and people who looked after them. Major buildings can often be found in favoured positions along rivers, by a lake or overlooking a delightful view. Orientation is also important in relation to climate. If the main façade faces north, south, east or west, we can deduce whether it was designed to take advantage of the sun, to catch any likely breezes, or to be sheltered from the sun and wind.

In some cultures orientation has a deeper significance than the practical response to climate. Geomancy is an important aspect of Chinese culture and whenever a new construction is proposed the *feng shui* expert is consulted on the most auspicious orientation and siting of the building. In *feng shui* the universe is in a state of continual change and the flow of vital energy, or 'cosmic breath' coursing through the earth is known as *Qi*. These strongly influence the fortunes of individuals and their descendants, according to how they place their houses and the graves of their ancestors. Similarly, they influence the occupants of, say, commercial offices, according to the building's orientation in relation to the winds (*feng*), the waters (*shui*), the hills and the valleys.[5] *Feng shui* advice was sought on the siting and orientation of the Hongkong and Shanghai Bank in Hong Kong, and on such internal features as the angle of the escalators, in order to bring maximum fortune to the enterprise.

Air rights and subterranean buildings

So far we have been talking about buildings on sites on the ground. Above a building is open space that belongs to the building, up to a ceiling determined by the aviation authorities. In Chicago that ceiling is 2,000 feet. Air rights buildings are those built over other buildings, or over structures such as roads or railways. They are a comparatively new phenomenon resulting from new technology, and the desire of landowners and developers to exploit the potential of expensive inner city land as fully as possible. In London there are air rights buildings over existing railway termini at Charing Cross on the Thames (Embankment Place, see Figure 7.8), at Liverpool Street Station and elsewhere. In Paris the Jardin Atlantique is a new air rights park built over the railway station of Montparnasse. Although these projects do not occupy a site on the ground we still need to relate them to their surroundings.

Subterranean buildings are another group to be considered. In extreme climates, living underground can make life tolerable, as it is cooler in summer and warmer in winter. In Coober Pedy in the South Australian outback daytime temperatures reach 50°C in the summer and freezing in the winter. To withstand this climate half the residents of this opal-mining town live

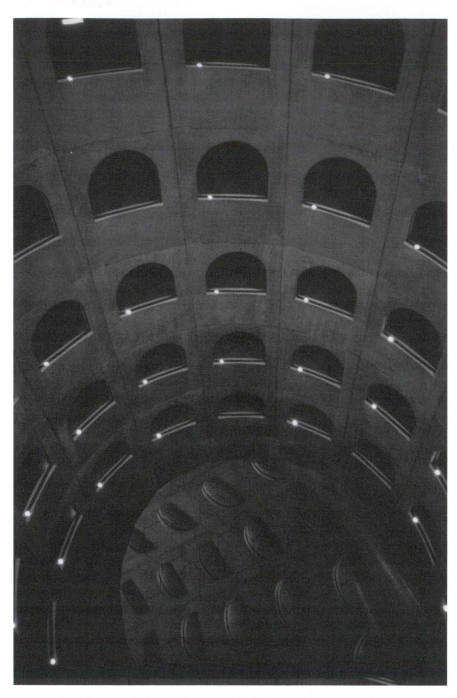

Figure 9.4 Underground car park, Lyon, 1994 (Architects Jean Michel Wilmotte and Michel Targe; sculptor Daniel Buren)

in dugouts. Subterranean buildings also include subways, underground stations and car parks. Some underground stations such as those in Moscow and Paris have been successfully designed to enliven and enhance the experience of travelling. Underground car parks are a useful method of off-street parking, but they are usually designed so that no one would want to linger there. An exception to this is an underground car park in Lyon, France, the Parc Celestins in the Place de Celestins, designed by the architects Jean Michel Wilmotte and Michel Targe, with the sculptor Daniel Buren, 1994. The illuminated windows of the inverted cylindrical parking tower are reflected in a circular inclined mirror at the base of the tower which moves continually, sweeping the field of vision. The sculpture is called 'Sens dessus, dessous' (Sense of above, below) and in the centre of the square above, a periscope provides a kaleidoscopic view of the changing scene below (Figure 9.4).

Approaches

The approach to a building can tell us many things. The path to the main entrance may be short and just wide enough for one or two people; if so, it is probably for a private house. It may be very long, lined with trees, large enough for cars and carriages and lead to a house, but a much more imposing one. The approach may take us to an underground car park from which we enter the building and the main entrance may not be immediately visible from the street. The route to the main entrance determines how we approach the building and in a sense sets the scene for it. It may be a direct route or a circuitous one, it may be grand and imposing, friendly, mysterious, or menacing, and its design will affect how we first see our destination.

At Chiswick House the approach via the entrance gates directs our attention increasingly on the house in front of us (see Figure 7.5). It is a processional route, part of the design to reinforce the significance of the house and to focus our attention on it. A processional route is one of the ways in which the significance of a major building such as a palace, cathedral or monument is reinforced. The Champs-Elysées in Paris is a processional route terminated at one end by the Arc de Triomphe in the Place de l'Etoile. In New Delhi, India, Edwin Lutyens designed the Viceroy's House to terminate the processional route leading to it. Unfortunately the gradient between it and Herbert Baker's* Secretariat Building is such that the Viceroy's House is almost hidden until you reach it. The Indian Government refused to alter the gradient to the gentler slope that Lutyens needed and he complained bitterly about having met his Bakerloo.[6]

The emphasis of classical town planning involved positioning a major building, such as a palace or a cathedral, to close a vista, but not all major buildings were designed to terminate vistas. St Paul's Cathedral in London was designed by Sir Christopher Wren* to be glimpsed between the buildings around it. Wren's initial plan for the City of London after the Great

Fire in 1666 was based on the principle of churches, including the new St Paul's, terminating lengthy vistas. This plan was rejected and his revised plan recognised the earlier arrangement and the fact that rebuilding around the cathedral after the fire was already taking place.

In baroque planning, the most important building became the focus not just of the immediate surroundings but of the whole urban environment and surrounding landscape. The seventeenth-century palace of Versailles designed for King Louis XIV was the focus of a series of avenues that radiated from it over the landscape beyond. Versailles provided the model for Potsdam and Karlsruhe in Germany and St Petersburg in Russia. At Karlsruhe (1715) thirty-two avenues converge upon the palace. Pierre L'Enfant's* plan for Washington was based on similar baroque ideas, but instead of a palace, the focal points are the Capitol and the White House. From them streets radiate and cross each other. It is an interesting contradiction that a form of town planning associated with an absolutist monarchy should be applied to the capital city of a democracy opposed to virtually all the principles for which Versailles stood.

The development of picturesque sensibilities towards the end of the eighteenth century had a direct influence on the approach to and setting of buildings. The landscape architect Humphry Repton* thought that a direct approach to a country house lacked the element of surprise and showed no imagination. Instead, he recommended to his landed and middle-class clients that the approach should wind through their property, thereby enhancing its apparent extent. The first view of the house should be carefully chosen so that it presented the best first impression.[7] John Nash adopted the picturesque approach to town planning when he laid out the route from Regents Park, London south via Regent Street to Piccadilly from 1811. The bends in this route retained the element of surprise, while at the same time they accommodated the problem of landowners unwilling to sell particular properties, which prevented a straight route in any case.

There is immense variety not only in the approach routes to buildings, but also in the materials used for them. The scale, colour and texture of the materials may have been chosen to relate to the fabric of the building and its surroundings in a particular way. Large paving stones will give a very different feel from gravel, small-scale bricks, cobbles or granite setts. If a fine-grained material is used, the approach route will look like a continuous ribbon. The use of large paving stones with wide grouting*, or roughly cut setts, will break up this continuity and this could, in effect, foreshorten the approach route.

The setting

The approach to a building may be along a street, across a square or through a garden, park or landscape. These provide its setting, which may be urban, suburban or in the countryside. They also determine how the buildings relate

to each other and to open space and how they contribute to the urban density. The ways in which buildings relate to the street or square affect how we see them individually and as a group, and streets form an important part of how we experience our environment.

Density and grain

An aspect of the physical context of buildings concerns urban density. Urban density is the relationship between the solid elements, the buildings and the spaces – such as streets, squares, gardens, parks, sports fields, rivers and lakes – around them. It can be measured in terms of population density (people per hectare or per square mile), the number of houses per hectare, the square metres of office space, the factory units per hectare and in many other ways.

Urban density and urban grain are related, and it is primarily the width, pattern and plan of the streets that determine them. The grid system of laying out streets so that they intersect at right angles has been known since Kahun in Egypt some 5,000 years ago. It was used by the Greeks and Romans, and it has been the preferred way of planning new settlements ever since. Narrow streets and small-scale buildings give a fine grain; wide streets and large buildings give a coarse grain; and there are many variations in between. A coarse grain tends to be associated with large areas of flat land. If large areas are set aside for a widespread infrastructure of sewerage, water and roads, it suggests that the land was cheap and resources plentiful. Los Angeles and new colonial towns such as Harare, Zimbabwe, are examples of coarse grain.

Most settlements were not planned systematically, but evolved and developed over decades and centuries, often along narrow winding streets and footpaths. This resulted in a fine grain of streets lined by small-scale building. It is associated in Europe predominantly with the medieval period and is still evident today in many European cities. The plan of Barcelona shows clearly the contrast between the fine grain of the medieval centre, the Barrio Gotico, and the coarse-grained grid plan of the nineteenth-century Eixample (Figure 9.5). The City of London still retains the fine grain of its medieval streets, but these are now lined by modern buildings, so although the grain has been retained, the scale of the buildings has changed radically.

Urban grain is part of a town's identity, and buildings need to be seen in the context of their particular urban grain and whether or not they respect it. If developments do not respect the grain, it can gradually become eroded and with it the character of that area of town. The recent trend of replacing a group of buildings, each with its frontage on the street, by one building that takes up a whole block has the effect of coarsening the grain of an area. We may wish to preserve the grain because it is part of the historic character of a particular environment, or for aesthetic reasons, and we need to balance this against the recognition that societies develop and change, as do people's needs.

Figure 9.5 Barcelona, plan (Spanish Tourist Office)

A coarse urban grain is associated with wide streets. How we experience the urban grain will depend on whether we are walking, stationary, or travelling by bus or car. A long, straight road, whether it was designed to focus on a major building or to promote traffic flow, can present a daunting prospect to even the keenest walker. We may enjoy the pavement cafés and watching the people going by on the Parisian boulevards far more than trying to walk along them from one end to the other. In a city such as Los Angeles, which was largely designed for the motor car, few would consider walking the whole length of Wilshire Boulevard, which stretches for some 16 miles. When we walk around a town, or sit relaxing in a square, our views are restricted to a few hundred metres. This range increases to thousands of metres when we travel by car or bus. Some buildings were specifically designed to be seen at speed by people driving by. The Hoover Factory to the west of London was designed by Wallis, Gilbert & Partners* in the 1930s to be seen by people travelling by at a speed of 30 mph (see Figure 7.22).

Landscape and gardens

Buildings may be designed to dominate the landscape, to blend in with it, to form eye-catchers* on the skyline, to provide a focal point, close a vista, stimulate the imagination and many other functions. In some analyses buildings are seen as the star performers and the garden, or landscape the background. Often the garden near to the house is designed with a formal or geometric structure to give architectonic* support to the house. In examining the setting of buildings within the landscape, it is important to understand the relationship between the two, for both are important. Gardens have been seen as a form of earthly paradise, places for meditation and contemplation, places where the imagination is inspired and places to relax and enjoy the surroundings. They may, or may not, feature plants, they may include a variety of buildings, and they embody important ideas of the society of the time. The major civilisations of the Middle East, China, India, Japan, Europe and the Americas have developed particular forms of garden and the function of buildings within each is very different.

In the baroque period the house was the focus of a formal, designed landscape that stretched for miles, as the example of Versailles illustrates. Kip and Knyff's* late seventeenth-century and early eighteenth-century engravings showed the extent of such landscapes in some 82 palaces and country seats in the UK. With the development of the English landscape movement in the eighteenth century the emphasis was on 'natural' landscapes, which were nevertheless just as much designed as their formal predecessors. Small buildings punctuated these 'natural' landscapes, making classical, literary, philosophical and political statements. They included temples, ruins, hermitages and castles, as well as exotic buildings such as pagodas and Turkish tents. Some were set on circuit walks illustrating classical or political themes, or providing allegories of life. At Kew, London, the buildings were designed and laid out on a circuit by Sir William Chambers for the Dowager Princess Augusta between 1757 and 1763. They included temples, a ruined arch and a ten-storey pagoda.[8]

Among the most visited of these landscapes was Stowe, Buckinghamshire, which also produced the first garden guidebook. All the key landscape architects – Bridgeman*, Vanbrugh*, Kent* and Brown* – worked there, and under Lord Cobham it became a centre for the ideals of the Whig aristocracy, of liberty and de-centralised power. On one side of the Elysian Fields, with the river Styx running through it, stands the Temple of Ancient Virtue (William Kent, 1734), a domed Ionic peripteral-columned building, with statues of famous Greek philosophers, poets and law givers. Facing it across the valley is the Temple of British Worthies (William Kent, 1735), with busts of Shakespeare, Locke and other noted British writers and philosophers (Figure 9.6). Visitors were invited to compare ancient virtue with the modern British counterparts and note the political significance of the British Worthies. Much of the significance of these buildings is no longer apparent, yet it was an integral feature at the time they were built.

The English landscape garden movement became popular throughout Europe. In Germany Prince Franz of Anhalt-Dessau created the Garden Kingdom of Wörlitz, near Dessau, and an island garden at Oranienbaum. He had been inspired by the Grand Tour, by his four visits to England between 1763 and 1785, and he knew Sir William Chambers personally.[9] The Prince's Anglo-Chinese garden at Oranienbaum (1785–95) featured a five-storey pagoda, a Chinese tea house and several Chinese bridges spanning the canals, on which were gondolas (Figure 9.7). These buildings gave an exotic touch of the orient, but their deeper significance remained largely unexplored. Chinese buildings in Chinese gardens played a very different and much more complex role that related to religious and philosophical beliefs.

There are three distinct types of Chinese garden: the gardens of temples, pagodas and ancestral halls; large imperial gardens; and the private, urban gardens built by scholar officials. These urban gardens date from the twelfth to the thirteenth century, the period of the southern Song dynasty, their golden age was in the eighteenth century and they have been rebuilt and restored many times since.[10] Yangzhou and Suzhou became important centres for their development and Suzhou had the added advantage that it was near Lake Tai Hu, which was the main source for the water-worn limestone rocks that became such a feature. The earliest manual on Chinese gardens, *The Craft of Gardens*, was written by Ji Cheng in the early seventeenth century.[11]

Figure 9.6 Temple of British Worthies, Stowe, 1735 (William Kent)

Figure 9.7 Chinese bridges, Oranienbaum, *c*.1785

Space was at a premium in the city so it was important to take full advantage of the topography of the site. These gardens were built, rather than planted, and featured pools and rocks, pavilions linked by covered walkways and zigzag bridges influenced by Daoist and Buddhist principles. They were seen as places of seclusion and contemplation where flowing forms contrasted with angular built elements – ying and yang – open areas contrasted with enclosed, and light contrasted with dark. In the Daoist view of nature, mountains were the earth's skeleton, water its arteries and the mountains of the Himalayas were the home of the Immortals. This mountain symbolism underlies the significance of the standing stones and rock formations that are such a feature of Chinese gardens. The rocks are skilfully composed with paths leading up, down, in and around them and a viewing platform or pavilion on top (Figure 9.8). There are no axes, no monumentality and views are limited to small spaces at a time, so the relationship between spaces is not evident.

The pavilions, or *tings*, provide shade and shelter, and frame particular views. Each pavilion has a carefully chosen name – the Pavilion of the Dark Blue Waves, The Distant Fragrance Pavilion, the Lotus Pavilion – to inspire reflection and poetic thoughts, which are enhanced by tablets inscribed with poems and inscriptions elsewhere in the garden. Larger gardens could include reception halls, studies and studios, or a *fang*, a stone boat. Galleries link the pavilions, divide the space and frame and provide vantage points for views. Like the zigzag bridges they do not go in straight lines. In *feng shui*

Figure 9.8 He Yuan, Yangzhou, China, *c.*1880

dragons embody the spirit of the mountains, are good transmitters of *Qi* and protect their devotees. Curves that evoke dragon mythology, such as an undulating dragon wall or water curving along a bank, symbolise this vital flow of energy, as do winding lines, zigzag bridges and paths. The walls are punctuated by a wide variety of doors, gates and windows, each with its own symbolism. The circular moongate is a symbol of heaven and of perfection. It frames a view and each visitor has to pause to step over the sill; only one person at a time can do so, so each experience is unique (Figure 9.9). Each gate shape has a significance; a jar-shaped gate, for example, symbolises Daoist emptiness. Windows lend themselves to further decorative and symbolic shapes. These gardens were designed by individuals for their own use and for the use of their friends and families; it takes a great effort of imagination for the large numbers of tourists who now visit them to understand their meaning.

Changes in the setting

The surroundings, approach, garden and landscape around a building may have changed radically since it was first built. A once isolated country mansion or farmhouse may, with the expansion of a neighbouring town, be surrounded by more recent buildings; or the building of a new road may cut off part of the garden. Infill development may have taken place in the garden or in the spaces between buildings. Cramant Cottages are a surviving one-

Figure 9.9 Moongate, Yihe Yuan, China, rebuilt 1888

up, one-down, single-aspect terrace built in the nineteenth century as infill between the surrounding industrial and commercial buildings of central Leicester. These buildings were replaced in the twentieth century, and it is astonishing that the cheaply built terrace has survived (Figure 9.10). This row of houses has now been glazed over and converted into a wine bar. If we are not familiar with the original site, we cannot understand the intentions of the architect, builder or patron, nor the way that a building was designed to respond to various features.

Similarly, towns and villages do not stand still. If the original reasons behind their development disappear, they will need to respond to this in order to survive. Today we enjoy towns and districts untouched by time, such as Bruges in Belgium whose fortunes reached a peak in the fourteenth and fifteenth centuries. Since then, time passed Bruges by, until it was rediscovered by the tourist industry. If no new use can be found for them, then buildings, villages and towns may go into decline and ultimately disappear. They may also disappear for other reasons. Famine, flood, plague and war have resulted in whole settlements being wiped out, and it may be centuries before their existence is revealed by excavation or by aerial photography. Changes in the policy of land ownership or the whim of patrons may also result in the wholesale removal of groups of buildings. In the mid-eighteenth century when English landowners were expanding their estates and enclosing common land, the view from the country house became all-important. If a village or hamlet happened to be in the way, it was removed and perhaps

Figure 9.10 Cramant Cottages, Leicester, *c.*1850

rebuilt as a model village elsewhere. Milton Abbas in Dorset, designed by William Chambers (1773–86), and Nuneham Courtenay in Oxfordshire are just two examples. Indeed, the destruction of Nuneham Courtenay was the subject of Oliver Goldsmith's poem, *The Deserted Village*.

The planning of new roads, rail links, or the expansion of airport runways can mean the destruction of whole areas. Changes in technology have meant that docks, warehouses, factories and markets became redundant and were pulled down to make way for new developments. Recently, there has been growing awareness of the value of retaining such buildings in urban regeneration schemes. Retaining and reusing buildings can be cheaper than razing them to the ground and building anew. It is also a sustainable use of existing materials and reinforces the sense of place and local distinctiveness that characterise an area. With regeneration, such areas become places that we enjoy visiting. Covent Garden (Charles Fowler, 1830) in the centre of London was formerly a large fruit and vegetable market. After the market moved out, the whole area was threatened with development, and the battle to save it became a cause célèbre. Its successful outcome has resulted in an enormously popular area with shops and restaurants housed in the old market buildings. On the south bank of the Thames the success of the Tate Modern art gallery, created out of the redundant Bankside power station has exceeded all expectations.

If historic buildings are threatened by development, they may, if they are sufficiently important, be saved by moving and reconstructing them in museums. These provide excellent opportunities for seeing both the exteriors and interiors of a range of buildings. There are, however, a number of points to bear in mind on such visits. First, since the buildings have been moved, their setting is not the original one, even though the museum may have made a good attempt to recreate it. Second, such museums have to follow safety regulations to protect visitors. Few of the historic buildings on display were designed with any form of fire regulations, yet if numbers of visitors are to enter them, the museum must ensure that they can leave quickly and safely. This may result in alterations to the building, or in restrictions in the areas which visitors can visit.

If redundant buildings are to survive, then new uses must be found for them. This may also mean changes to their setting, or even a completely new use for that setting. Lofts in New York, which were formerly warehouse space, have been converted into prestigious apartments. If many such transformations occur, then an area will ultimately become gentrified and change from a commercial to a desirable residential district. When the redundant Albert Docks in Liverpool found new uses as museums, shops, restaurants and housing, new uses also had to be found for the dock basins. These now flourish as marinas. Whole towns have changed their use; for example, colonial Williamsburg in Virginia is now a complete museum. Whole districts have also changed. In north Germany the Ruhr was the centre of the coal and steel industry, but it is so no longer. New uses have had to be found for large areas and huge building complexes. One of the most successful transformations has taken place at Emscher Park, Duisberg, where the former Thyssen steelworks have been laid out by the landscape architect Peter Latz as a leisure park. There is scuba diving in the gasometer, areas for practising rock climbing, play facilities for children, a concert hall and a variety of gardens set among the increasingly rusty and decaying furnaces and steelworks buildings (Figure 9.11).

At the other end of the scale changes in setting also include those that occur underfoot. The Victorian towns and suburbs laid out in the nineteenth century had pavements laid mainly with large paving stones. A recent trend has seen these being replaced by much smaller ones, by brick in a variety of shades, or by tarmac. This is due partly to the many services such as telephone, cable TV and water that are laid under pavements and need to be accessible, and partly to problems of general maintenance and the need to keep costs down. Large paving slabs crack, subside and are damaged by tree roots more frequently than small ones, and uneven surfaces can lead to accidents. The rhythm and colour of the replacement surface may differ substantially from the original and in its relationship to the surroundings.

In the determination not to let the car dominate all aspects of urban life many areas have been pedestrianised. This can mean changes in the materials, colour and texture of the surface, the removal of kerbstones and a reduction

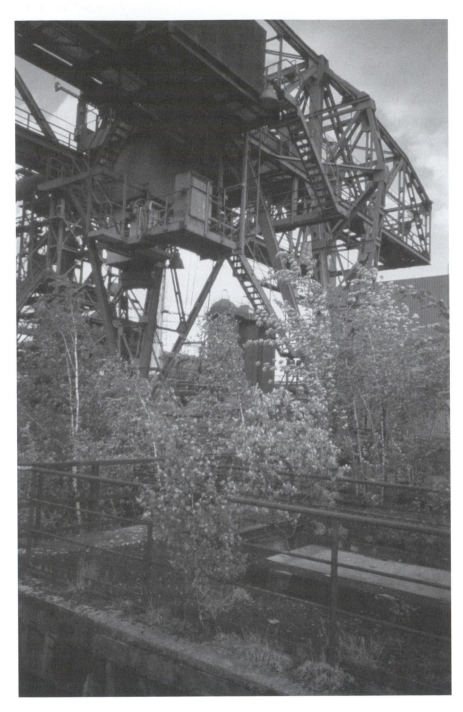

Figure 9.11 Emscher Park, Duisberg, Germany

in the level of the pavements. All these changes affect the setting of the buildings and the approaches to them, and the streetscape may, as a result, be very different from how it appeared originally.

Space and enclosure

How we see buildings depends not only on whether we are walking or travelling at speed but on their size and the space around them. Scale and site are closely interrelated, for they relate not only to our own size, but also to the building's position and the relative sizes of neighbouring buildings and spaces. If buildings are very tall, we need to be able to stand well back in order to see them. Many of the major cathedrals face open space, so their main façades can be seen as a whole, but it is often difficult to gain more than occasional glimpses of the other sides. The skyscrapers of the commercial districts are often set on comparatively narrow streets, making it impossible to step back far enough to see them properly. The best views tend to be from the tops of adjacent high buildings, or from a plane.

The feeling of space and light around buildings depends on the relationship between their height, the width of the street or size of the open space and how the shadows fall. A group of tall buildings lining a street can create a very dramatic environment, but if the street is always in shadow, the feeling of enclosure can become oppressive and it can seem like a canyon. In a square the feeling of enclosure depends on the dimensions of the open space, the heights of the surrounding buildings and the location of the streets leading into and out of the open space. The Circus in Bath gives a satisfying feeling of enclosure due to the height of the buildings, the distance across the open space and the fact that the three streets that provide access are not positioned directly opposite one another (see Figure 3.2). The Place de la Concorde in Paris, by contrast, generates no feeling of enclosure since it is very wide in comparison with the height of the surrounding buildings. Where streets intersect, the placing of buildings at the corners has an important effect on our perceptions of the spaciousness of the junction. If the buildings form right angles, maximising the use of building land, there will be a strong sense of enclosure at the crossroads. If they are angled around the intersection, this encourages a feeling of openness, as well as giving greater visibility.

The relationship between buildings and the street line also affects our sense of enclosure. Buildings may stand directly on the street, be set back from it or turn their backs to it. The building line determines how far forward towards the street buildings can come, and local by-laws often dictate this. A straight building line means that all the buildings will be the same distance from the street, whether this is curved or straight, and whether the buildings are terraced or row houses, detached or semi-detached. This may result in the feeling that the buildings form a wall along the street, particularly if the street is not very wide and the buildings are closely spaced or terraced.

If the buildings are different distances from the street, they have varied setbacks. This encourages a feeling of spaciousness and variety, even though the street itself may be narrow and the buildings closely spaced. In Beijing, China, the traditional form of housing was the *hutong*. This featured a courtyard surrounded by single-storey housing. In the courtyard people could keep chickens and grow vegetables. The *hutong* generally presents a plain wall to the street, with a narrow doorway to provide access. These line the streets. With increasing pressure on space Mao Tse Tung decreed that the courtyards should be built on, so increasing the density of the towns. In the recent fervour of modernisation in China many of these *hutongs* have been destroyed and replaced by modern expensive apartments, unaffordable to the former residents.

Streets affect our everyday lives. Straight streets enable us to see clearly what is ahead, unless there is a dip in the ground. Curved streets encourage traffic to go more slowly and may also promote a sense of mystery and variety, for we do not know what lies around the corner. In today's urban environment the unexpected may also become the unwelcome and in the design of pedestrian areas and subways it is most important to be able to see what lies ahead, for reasons of personal safety.

Safety

The question of safety is an important one if we are looking at urban buildings. We now understand more about the organisation of cities and the functions of different kinds of space and their role in promoting or inhibiting safety. As part of post-Second World War planning and reconstruction many cities were zoned and separate areas allotted to housing, commerce, industry and entertainment. It is now recognised that while zoning may have brought some form of order to cities, it has also had other effects that are of direct concern to the question of personal safety. With zoning, cultural districts come alive in the evenings but are deserted for the rest of the day; commercial districts are used during weekdays, but are deserted in the evenings and at weekends; and residential districts tend to become dormitories inhabited during the daytime by the very young, older people and the unemployed. If there are few people around, then an area becomes potentially dangerous, for cities are full of strangers. It is people who make cities safe places to be in. We tend to think that the function of streets is to carry traffic, but streets also relate directly to the question of safety in the city. Their function is to accommodate strangers and the more a street is used, the more safely it can accommodate them. People like to watch others and they will not use streets unless they have a reason to do so. Streets with shops, newsagents, bars and restaurants in them are used day and evening, and if there are a lot of different activities in an area, then it will be used by a variety of people, for a variety of purposes and at different times. The area will then be a lively and safe one to be in.[12]

Another aspect of personal safety in the urban environment concerns the question of accessibility. This, in turn, relates to the identification and differentiation between public space, private space and semi-public space. Public spaces include the streets, squares, parks and plazas which people are free to use and congregate in, if they wish to do so. Private space, as its name suggests, is space where use is restricted to a small number of people. The garden of a private house is private space for the use of the residents and their guests. We know immediately if there is an intruder in our private space, because we can distinguish between those who have a right to be there and those who do not. With semi-public space this distinction is not so clear. Semi-public space includes a range of different types of space that the public can use on certain conditions. The front gardens of houses and apartments are semi-public space for they mark the transition between the street, which is public space, and the house or apartment, which is private space. This type of semi-public space may be used by those who have a proper reason to do so, such as the families that live there and their friends. A whole range of people who have an intermittent need to be there may also use it, such as the postman, the people who come to read the gas and electricity meters and those who come to do repairs. Those who have no right to be there, such as thieves, muggers and burglars, can also use it. It is when it is impossible to differentiate between legitimate and illegitimate users of semi-public space that problems arise. It is now recognised that many of the design failures associated with 1960s' and 1970s' mass-produced housing are directly linked to this problem of differentiating between people who have a right to be there and those who have not.[13] If people do not know who their neighbours are, they cannot distinguish between those entitled and those not entitled to be there. Furthermore, shared areas, such as the corridors, lifts, hallways and the immediate surroundings to these buildings, are places where anyone can lurk, and the links between buildings make ideal getaway routes for illegitimate users. Design disadvantagement was the term used to pinpoint such negative design features of housing estates, and much work has been undertaken to rectify them.[14]

Sense of place

From experience we know we respond positively to some environments and negatively to others. We may enjoy the small scale and variety of a winding street of buildings that has developed over centuries, and we may, for completely different reasons, enjoy the drama and scale of the skyscrapers of Manhattan Island, or those of La Défense to the west of Paris. Although very different, these environments have a sense of place that makes them individual and memorable. Gertrude Stein summed up the absence of these qualities succinctly when she was asked, after a visit to Oakland, California, how she liked it there. 'There?' she replied. 'There was no there, there!' Whether we are visiting an historic town, an industrial district, a residential

area or one that is a mixture of uses and periods, we can recognise the presence or absence of a sense of place. We can probably go further and identify the particular characteristics that we find appealing in particular environments, but the difficulty comes when we try to establish broad, generally applicable criteria.

We may admire the regularity of eighteenth-century Georgian classical terraces and the mid-nineteenth-century Parisian boulevards that were developed under Napoleon III and Baron Haussmann*, with their strictly controlled rooflines, but our reactions to the regularity of 1930s' ribbon development* or to 1960s' mass-produced housing may be rather different. In order to understand such reactions we need to consider when regularity stops being harmonious and becomes monotonous, and we need to ask when variety stops being pleasing and becomes a mess. We also need to think about how much our attitudes are conditioned by current prejudices. Much of the architecture of the 1960s and 1970s is viewed so negatively that it is still almost impossible to be objective about it. Postmodernism in the 1980s encouraged us to concentrate on the exterior of buildings, but the urban environment is not a stage set, and buildings occupy three dimensions, not two. The groups of buildings that comprise our cities have functions and form and occupy space. If we look critically at buildings from any period, we need to look at how they came to be where they are, the pattern of land ownership, their functions as well as their form, and we need to differentiate between constructional problems and social problems. Much of the mass-produced housing of the 1960s and 1970s shows signs of both problems, but many of the solutions to the social deprivation evident in the graffiti and vandalism in various parts of cities lie in the political arena, rather than in the realm of architecture.

Sense of place may result from the use of particular materials or the styles of the buildings; it may be to do with the history or geography of an area, and it can be found in any part of the world. Until the advent of powered transportation and the mass manufacture of materials, most buildings were constructed out of local materials, unless the patron commanded considerable wealth. The use of local materials and the variations in the ways in which they were used led to wide differences in the colour and texture of buildings in each region. In England we can still enjoy the special sense of place that results. The weatherboarded and tile-hung houses of East Sussex can readily be distinguished from the red brick houses of north-west Leicestershire; the mellow, golden stone walls and the grey stone roofs of buildings in the Cotswolds contrast with the whitewashed and thatched cottages of Devon and Cornwall. The flint walls and red pantiled roofs found along the coast of north Norfolk are very different from the timber-framed buildings common in Shropshire. Today, because materials are readily transported nationally and internationally, the local character that resulted from the use of local materials is being eroded.

The qualities that give a place its particular identity are so varied that it is impossible to list them all, but the one factor that all such places have in common is that people recognise its individuality and unique identity. It is the recognition of this unique identity and the desire to retain it that led a number of cities and regions to issue design guides. The aim of many design guides is to try to ensure that a particular sense of place is preserved, but there are many problems. Our identification of what is significant changes, and a design guide written a decade ago would be subject to severe criticisms today, yet the decisions taken about planning and development today may be based on it. These decisions, in turn, affect the future. The rigid application of design guides, or the insistence on the preservation of particular historic characteristics to the exclusion of all else, could mean that nothing new was ever built. A measure of flexibility is needed so that the merits of new features and developments can be weighed up, for there is much more to architecture than front elevations and the fashionable style of the moment.

Skyline

Tall buildings have their own contribution to make to sense of place. Although they can seem to have little relevance to people at street level, they affect our sense of enclosure and can create adverse microclimates and high winds. In 1916 the zoning laws in New York meant that skyscrapers had to be stepped back to allow sufficient light and air to reach adjacent, closely packed buildings and the streets. This created the distinctive staggered profiles of New York's tall buildings and the 'sky-piercing' elegance of the Chrysler Building and the Empire State Building.

The profiles of skyscrapers give distinction to many cities such as New York, Hong Kong, Melbourne and Shanghai. The new commercial district of Shanghai, the Pudong, features an amazing variety of skyscrapers as well as the world's tallest building for the moment, the 492-metre World Trade Center due to open in 2007. In the quest to develop valuable inner city land, many cities, including London, are seeking to build an increasing number of tall buildings. This raises many questions concerning whether or not they should be grouped in clusters, how they affect the immediate area and its infrastructure and what impact they will have on the historic environment and on strategic views.

Conservation

Many countries have now introduced measures to protect their historic buildings and areas. France was one of the first to do so, producing lists of historic buildings from the 1840s. From 1882 ancient monuments have been scheduled in the UK, but it was not until 1944 that official lists of historic buildings were drawn up under the Town and Country Planning Act. Today,

structures as diverse as telephone boxes, grave stones, terraced housing, piers, stables, power stations, football stadia and churches are listed. The designation of whole areas as worthy of preservation, whether or not they contained listed buildings, came in England in 1967. The Civic Amenities Act 1967 made it possible to designate as Conservation Areas 'areas of special architectural or historic interest, whose appearance it was desirable to preserve or enhance'. Conservation areas include industrial areas such as Nottingham's Lace Market, workers' housing, wealthy suburbs such as Holland Park, London, and medieval villages such as Chipping Campden in the Cotswolds.

Over the whole of the UK two per cent of buildings are listed, and many historic districts are designated conservation areas. This means that a wide variety of vernacular, industrial, monumental, civic and religious buildings and environments are protected, many of them privately owned. To make viable environments for today, new uses may have to be found and these may require sensitive alterations. There is little government grant aid to repair and enhance, so much is dependent on private owners or local authorities and whether they can attract or qualify for funding. By contrast, in France fewer buildings and areas are protected, but their financing and control comes from central government.

Protection at international level is proceeding. In 1972 UNESCO adopted a convention for the protection of the world's cultural and natural heritage and established a World Heritage List of sites of universal significance to all humanity. By 2003 some 750 sites had been listed. A review in 1994 found that there were imbalances in the number and types of sites within individual countries. France had twenty sites on the list, but fifty countries had none. Of the listed sites internationally, only four were vernacular, few were industrial or twentieth-century and most religious sites were Christian. This situation is being rectified. The well-preserved feudal villages Xidi and Hongcun in Southern Anhui Province, China, with their water systems, street plan and housing have been added to the list. In Wales the Blaenavon Industrial Landscape was the world's major producer of iron and coal in the nineteenth century and this has been added. In Germany the Zwecke Zollverein Coal Mine Industrial Complex in Essen was an example of an outstanding modernist design applied to a heavy industry, and this has also been added. It is now also possible to include cultural landscapes, that is, natural landscapes that have no historic buildings but have been significant to the lives of people for a variety of reasons, such as having spiritual significance. For example, in 2003 the Matobo Hills in Zimbabwe were added to the list, because of their longstanding focus for the Mwari religious tradition and their rock art. The interests of native peoples can clash with government and industrial interests and this can threaten attempts at preservation. At the geologically unique Zuni Salt Lake, New Mexico, the volcanic crater with a salt spring is considered the enchanted home of the Salt Mother by the Zuni Pueblo. They have traditionally lived in the area and used the

salt for healing, ceremonies and trade. The proposal for a coal mine nearby would mean drawing water from the underground aquifers which could disturb the pilgrimage trails and burial sites. This conflict between conservation and pressure for development has yet to be resolved.[15]

Although many people agree on the importance of conserving historic architecture, views vary as to what should be preserved and why. The criteria for conservation initially focused on what were perceived as old and 'beautiful' buildings and areas. Today, social and historic significance, technological innovation, the major works of architects important in their day and threats of alteration or demolition to important modern buildings are among the factors considered. Our tastes and concerns change and what was seen as an unimportant building, building type or area a decade ago may be considered much more significant today. The preservation of historic buildings raises further issues, for an appropriate use then needs to be found for them. Today, the serious threats to the planet posed by global warming can make sensitive reuse of old buildings and the preservation of natural areas both economic and sustainable.

10 Sources

First-hand study of built form is the essential basis for many studies of archi-
tecture as earlier chapters have shown, but there is a wide variety of other
sources, both published and unpublished. If buildings do not survive in whole
or part, then we have to rely solely on documentary evidence. Some projects
may involve oral history and the use of the web. In this chapter we suggest
major sources to look out for, indicate where they might be found and discuss
their significance and uses. Where we begin and what we can discover
depends on our aims and on the type of evidence available.

Basic questions

At the outset of most studies it is important to identify a number of basic
questions.

Checklist

1 What was the date of the building?
2 Who was the patron or client?
3 What was the brief for the commission?
4 Who was the architect and/or builder?
5 What was the cost of the building and what have been the costs of use
 and maintenance?
6 What was its original function?
7 Which parts are original and which are alterations?
8 What are the materials and methods of construction?
9 What is the form and style and what was its meaning?
10 What was the location? Has the character of the original site and
 surroundings changed?
11 What were the responses to the building at the time of its construction?
 What have been subsequent responses?
12 What was the social, cultural, technological, economic and political
 context in which the building was constructed?

On its own the answer to any one of these questions will not take us far. The more answers, and the fuller they are, the more the researcher can begin to build up a picture of why the building came to be constructed in a particular form, the characteristics and significance of the building and the context in which it was produced, used and critically evaluated.

Approaches to answering these questions

Documents and written records offer insights into buildings, but in practice much research involves a mixture of reading, searching in documents, analysing plans and illustrations and surveying the built fabric. The range of sources available depends on the building type, the date, the location and the chance survival of information. Generally there is a better chance of tracing the home of an important local dignitary, a government building or an important religious building than a vernacular building or a row of workers' cottages. Often, the older the buildings the fewer the surviving records. However, if we are examining contemporary vernacular architecture in communal lands in southern Africa, the major sources will be direct observation and oral evidence. This is because such buildings are built by the occupants and do not require written permission. Historical examples of such architecture were not of permanent materials, so study may have to rely on such documents as travellers' observations. In addition, archaeological excavations may reveal postholes and depressions in the ground. There is no one path of research for every building and situation.

In trying to find the answers to these basic questions we need to be methodical, critical and always cross-check information. For example, oral evidence may be imprecise and memories fickle, so if possible, other supporting evidence should be sought. It is important to keep a record of all the sources used and helpful to record any negative searches. Often, material which at first seems irrelevant may at a future date become significant, and if a careful record is kept it will be easier to retrace. Accuracy is most important because subsequent interpretation will be based on this information.

Dating

Dating is most important since it will focus the rest of our research and determine the types of extant documents and the historical and material context of the building. If a building has been altered over the years, or built over a long construction period, as many medieval cathedrals were, dating can be complex. The use of documents to help with dating is fraught with pitfalls and depends on the chance survival of relevant information. There is no one method to search for the date and no one document will provide it. A building plan, for example, may often be dated, but this does not tell us when construction started or finished. At the outset it is important to try to

identify the period, if not the precise date when the building was constructed, and if there is no date inscribed on the building itself, the first step is to use secondary sources.

Secondary sources

There are two categories of source material: primary and secondary. In general, primary sources are contemporary with the building or period being examined. They may include the building itself, a client's brief, bill of quantities, surveyor's report, plan, press coverage of the opening of the building, a description in a diary, or legislation affecting buildings in a particular period and place. Secondary sources are interpretations of a building or period by later historians, critics or writers. In practice, there is no rigid boundary between the two, for it depends on the aims of the research. A history of architecture written today and concerned primarily with architecture since the Second World War would generally be considered a secondary source. However, in an historiographical study of architectural history in the later twentieth and early twenty-first centuries, then such a book would be considered a primary source.

To avoid duplication it is sensible to see if someone else has already researched and published on the same or similar subject. As the research progresses we may wish to return to secondary sources, such as periodical literature, general histories, architectural and building studies, in order to place the topic in a broader context. Local libraries may order from other libraries and will have computer terminals enabling access to more specialised libraries. Many of the major national and international institutions such as universities, specialist architectural libraries, and national libraries such as the British Library, London, and Bibliothèque Nationale, Paris, publish on-line catalogues of their holdings.

Local buildings

If the building is local, a local website or reference library, council, museum or records office may have information. If a building has a specialist function, such as a mosque or a town hall, then the institution or organisation associated with it may provide information, have its own website or have produced its own leaflet or brief account that can save a lot of legwork. For many large towns and cities there are books published on the local historic architecture; for example, in the US, C. D. Kousoula and G. W. Kousoulas, *Contemporary Architecture in Washington, D.C.*, Washington, DC, The Preservation Press, 1995, and D. M. Reynolds, *The Architecture of New York City: Histories and Views of Important Structures, Sites and Symbols*, New York, John Wiley & Sons, Inc. 1994. Local chapters of the American Institute of Architects also publish guides to cities, such as the *AIA Guide to Chicago*, San Diego, Harcourt Brace & Company, 1993, which lists the principal

buildings. Broader surveys are very useful if one is attempting to look at buildings in more than one area. An example is the Society of Architectural Historians, *The Buildings of the United States*, published from 1993 by Oxford University Press, Oxford; this aims to cover the whole nation in a state-by-state series. In 1951 Nikolaus Pevsner published the first county volumes of *The Buildings of England*, Harmondsworth, Penguin. Since then other authors have contributed and the series has expanded to include *The Buildings of Wales* and *The Buildings of Scotland*; earlier volumes have also been updated. Each volume identifies and describes a wide range of building types. Another useful series is *The Victoria County History of England*, London, Oxford University Press. This series was published by Constable (London) from 1900 and is still being updated today.

At a vernacular level there are increasing numbers of publications devoted to national and regional styles, for example: D. Philippidis (ed.), *Greek Traditional Architecture*, Athens, Melissa Publishing House, 1989; S. Denyer, *African Traditional Architecture*, London, Heinemann, 1978; and M. Heard, *French Quarter Manual: An Architectural Guide to New Orleans' Vieux Carré*, New Orleans, Tulane School of Architecture, 2000. For a broad overview of the vernacular in each region of the world P. Oliver (ed.), *Encyclopaedia of Vernacular Architecture of the World*, Cambridge, Cambridge University Press, 1997, is unparalleled.

Websites and well-known buildings

Many well-known buildings, especially those designed by significant architects, feature on websites. Such images may be accompanied by a variety of information. Many architectural practices also have websites, and this is a useful way of getting an overview of architects' work, and checking the latest information on new projects. Major buildings can be found in general architectural histories, monographs and period and style studies. Examples are: William H. Jordy's series, *American Architects and Their Buildings* in five volumes published by New York, Doubleday & Company Inc., 1970; N. C. Steinhardt, *Chinese Architecture*, New Haven, Yale University Press, 2002; Christopher Tadgell, *The History of Indian Architecture*, London, Phaidon, 1994; the volumes of the Pelican History of Art on *The Art and Architecture of Islam*, 1987, 1994; D. Watkin, *A History of Western Architecture*, London, Lawrence King, 1992 and W. J. R. Curtis, *Modern Architecture Since 1900*, London, Phaidon, 1996. Others can be found by consulting specialist architectural bookshops, libraries or bibliographies on the web. It can be necessary to learn another language in order to read works by significant scholars who have worked on the architecture of some parts of the world. Most scholars of Islamic architecture are Westerners. For example, the architecture of Persia (now Iran), spread to Turkey, Iraq, Central Asia, Pakistan and India. The gazetteers are in Persian and Turkish, and scholars include English, German, French, Russian and Italian.[1]

If a particular building is not mentioned, such sources may still enable one to understand its characteristics and identify an approximate period for its construction. They can also give general guidelines to building types, the approach to planning, structure, style and the geographical location of similar buildings. Social histories, or histories of particular organisations and institutions, are also useful for understanding the design and function of such building types as schools, workhouses, prisons, hospitals, religious and industrial buildings.

With any history or published study of buildings it is useful to look at the author's bibliography and footnotes, which identify the primary and secondary sources used. These can then be followed up to cross-check the information, or to see if there is further material. In all sources it is important to be aware of the stance taken by the authors towards their material, and it is useful to approach secondary sources by asking who wrote the text and when it was first published. The date of publication can provide an indication of the author's viewpoint, which may be very different from that of today, and the context in which the study was undertaken. Reading around a topic will reveal many inconsistencies and even contradictions from one source to another. A critical evaluation of texts and information helps to build up an understanding of a period and the approaches to buildings.

Unfortunately many websites do not indicate the author and, like picture books, coffee-table books and some very general books, they lack bibliographies and footnotes so it makes it impossible to check the author's sources and their accuracy. It is therefore important to verify information from these sources against other more traditionally referenced works.

Primary sources

Primary sources may be used in many different ways and may also present challenges to the researcher. Very early documents often require specialist language knowledge. For example, medieval documents in Britain may be written in Latin or Anglo-Norman. It may also be difficult to identify particular buildings in documents because this depends on knowing the names of the occupants or owners of the building. Few buildings had street numbers or names before the twentieth century, and street and road names can change, as can street numbering.

Primary sources, like secondary sources, should be approached critically. To do so we should ask what the purpose of any written source or document was. Most contemporary accounts of buildings, documents and records classed as primary sources represent a selection of information for a particular purpose. Understanding that purpose helps us to interpret the information. Often the most accessible building plans are those submitted to local authorities to control building design and prevent the construction of insanitary dwellings. We can use them to discover the name of the architect or patron, as well as to examine the proposed building design. Nineteenth-century trade

directories, useful for identifying when a commercial building was first opened, also carried business advertisements to attract customers. There is no guarantee that the business occupied a particular building, only that it operated at a particular address at a particular date. Further research is needed to confirm the details of the building.

Early sources

Because there are few documentary sources available of any value before the sixteenth century it is largely through excavation and archaeological research that we understand ancient buildings. Plans survive of buildings in ancient Mesopotamia and Egypt, and in the Louvre, Paris, is a statue of Gudea of Lagash, Mesopotamia, *c.*2200 BC with an engraved plan on a drawing table on his knees. More common plans of this period are on clay tablets, limestone flakes, or papyrus. In ancient Greece no plans or elevations of buildings have survived; however, inscriptions still survive of specifications, contracts, accounts and lists of donors.[2] It is interesting and perhaps reflects on the differing circumstances of ancient Greek and Roman architecture that we know the names of over a hundred Greek architects of *c.*650 BC to 50 BC but hardly a single Roman architect.[3]

The writings of ancient authors gave only scant information about contemporary buildings. The guidebook of Pausanius describes what were considered the chief cities and sanctuaries of ancient Greece in the second century AD, but no writings of ancient Greek architects or art historians survive. However, there are summaries of Greek texts in the Roman writings of the elder Pliny, *Historia Naturalis, c.* AD 77, and references to Greek buildings and methods before 27 BC in Marcus Vitruvius Pollio. This was a major source for renaissance architects, but since it and Pliny's writings were written from a Roman viewpoint they are not very reliable sources for Greek architecture.[4] As a practising Roman architect, however, Vitruvius' writings do offer valuable insight into the architecture of his day.

There is little mention in medieval texts of Islamic monuments although there were some craft and technical manuals and observations of significant buildings by travellers in the tenth century such as al-Muqaddasi who came from Jerusalem. Hillenbrand mentions records of endowments or *waqfiya* for the upkeep of buildings that linked the financing of buildings to individuals and groups within a town or area such as shopkeepers.[5] He also refers to inscriptions on Islamic buildings giving the building's date and the names of the patron and architect, but points out that if we only know the dates and names, the information is of little value. It was only in Ottoman Turkey that some biographical information on major architects became available.

In England some medieval building accounts, drawings and manuscripts referring to major works such as castles, mills, bridges, monasteries and colleges survive. After the sixteenth century the range of documentary sources for buildings widens, but various factors determine the types of document

available, such as the type of tenure of the property: freehold, leasehold or copyhold. Leasehold properties, for example, did not have title deeds. Local archive and public record offices hold many documents, as do private owners or government, religious, corporate or institutional bodies. If the property is leased, then relevant documents will be found in the estate records of the landowner or the institution. The records of some building types may have changed hands and it will be necessary to trace such changes of ownership. For example, many early nineteenth-century parish schools in England were founded by voluntary societies or by private charities. Some of these records are now to be found among parish records.[6] National registers of archives, local record and archive offices and libraries will often help in locating such source material.

Published documents

Documents considered important are sometimes published to make them more widely accessible. An example is G. Necipoglu, *The Topkapi Scroll: Geometry and Ornament in Islamic Architecture*, Santa Monica, California, 1995. This consists of an early set of Islamic architectural drawings in Istanbul that date from the fifteenth century.[7] Another example is H. M. Colvin, *Building Accounts of King Henry III*, Oxford, Clarendon Press, 1971. Many books of published documents are either extracts, or compilations of many documents covering particular topics, periods and geographical areas, such as L. F. Salzman, *Building in England down to 1540*, Oxford, Oxford University Press, 1992, and L. Roth (ed.), *America Builds: Source Documents in American Architecture and Planning*, New York, Harper & Row, 1983. These include contemporary descriptions of works of art and architecture, or theoretical treatises, as well as building accounts or patrons' briefs. Local museums and record offices publish widely used documents in their collections, such as local hearth tax returns, and it is worth looking out for these. Such publications are very convenient, but need to be used with caution, particularly where only partial extracts are included, or the document has been translated from another language. It is advisable to read any commentaries accompanying them because they may include helpful remarks concerning their context and purpose. Innumerable scholars have worked on many well-known original documents and it is also advisable to check what has been published concerning their interpretation.

Architectural publications

Architectural publications include treatises, pattern books and rules of design as well as studies of contemporary buildings. Underlying the forms of pre-colonial architecture and planning in India were theories of design derived from ancient treatises or *vastu shastra* such as the Manasara and the Mayamata. The Manasara probably dates back to the Gupta period in India during the

fourth to sixth centuries AD. These texts provided concepts or principles for the layout of different types of city and building and were in use until the nineteenth century. They included proportions, orientation and location of elements, and many mandalas* of varying complexity that offered patterns for the subdivisions of space.[8]

During the renaissance in Europe the works of ancient authors were studied, and the first printed edition of the writings of Vitruvius appeared in 1486, followed by many further editions and commentaries. The writing of treatises became popular; Leone Battista Alberti's *De Re Aedificatoria*, 1452 (Florence, Nicholas Laurentii, Almanus, 1485) is an example. There were books setting out the rules for the design and use of the classical orders such as Sebastiano Serlio's *Regole generali di Architetura sopre le cinque maniere de gli edifice*, Venetia, 1537. Architects began to publish books on their own buildings such as the *Quattro Libri*, Venice, 1570, by Andrea Palladio. There were also studies of contemporary buildings such as the Frenchman J.-A. du Cerceau the Elder's *Plus Excellents Bâtiments de France*, Paris, 1576–9. With the setting up of schools of architecture such as the French Royal Academy in the seventeenth century, information on architectural education may be gleaned from published accounts of courses. The most widely read architectural handbook in France in the eighteenth century was François Blondel's *Cours d'Architecture*, Ivry, Phénix Éditions, 1771.

Engravings and pattern books were published from the renaissance onwards. Jan Vredeman de Vries of the Low Countries published *Architectura*, Anvers, 1577, which helped to spread architectural ideas throughout Europe. In Britain from the sixteenth century architects were exposed to imported architectural treatises and pattern books from Italy, France and the Low Countries, followed by translations of such works. It was not long before indigenous treatises were published and John Shute's *First and Chief Groundes of Architecture* was published in London by Thomas Marshe in 1563. The eighteenth century saw a broadening of the range of books on architecture. The ambitious and perhaps most comprehensive English discourse on architecture was Sir William Chambers' *A Treatise on Civil Architecture*, first edition, London, J. Haberkorn, 1759; second edition, London, J. Dixwell, 1768; third edition, London, Joseph Smeeton, 1791. Books advising builders on the design and construction of even the simplest buildings began to proliferate – Batty Langley's *The Builder's Compleat Assistant*, London, Richard Ware, 1738, is an example – and UK architectural handbooks were also widely used in the colonies.[9]

With the development of trade and travel and the rise of revivalism in Europe and the US in the eighteenth century, European interest in oriental architecture as well as archaeological studies of ancient European sites became increasingly popular. The many English publications included Sir William Chambers, *Designs of Chinese Buildings*, London, printed for the author, 1757. William Hodges, *Select Views of India*, 1785–8 and *Travels in India*, London, printed for the author, 1793, and Thomas and William Daniell, *Oriental*

Scenery, six volumes published between 1795 and 1808 (London, Robert Bowyer, 1795, 1797; London, Thomas Daniell, 1801, 1807, 1808), were used as manuals for the Georgian Indian style.[10] The antiquarian Thomas Rickman invented the labels early English, decorated and perpendicular for the styles of English medieval architecture and published *An Attempt to Discriminate the Styles of English Architecture*, London, Longman, Hurst, Rees, Orme & Brown, 1817. Early measured studies of ancient Greek architecture included James Stuart and Nicholas Revett's *Antiquities of Athens* (London, John Haberkorn, 1762; London, John Nichols, 1787, 1816; London, T. Bensley for J. Taylor; London, Priestly, 1830).

By the nineteenth century in the US indigenous builders' and architectural handbooks such as Asher Benjamin, *The American Builder's Companion* (Boston, Etheridge & Bliss, 1806) and J. Haviland, *The Builder's Assistant* (three volumes, Philadelphia, John Bioren, John Haviland & Hugh Bridport, 1818–21) were widely available. The latter was the first of many to illustrate the Greek orders, and revived Grecian forms became widely popular in North American domestic architecture until as late as the Civil War of 1861–5.[11] With improved methods of printing in the nineteenth century, and the expansion of the building industry and architectural profession as a result of industrialisation and urbanisation, publications in the field of architecture proliferated.

Newspapers, journals

Newspapers and journals are a major source of information on contemporary responses to buildings, although the focus tends to be on more prominent public and commercial examples. From the nineteenth century onwards local papers often comment on new building proposals, the opening of new religious buildings, cinemas, sports halls or shopping centres, large planning proposals, and prominent industrial and commercial buildings. At a national and international level professional architecture and building journals cover the work of individual architectural practices, engineers or particular building companies, and discuss important new projects. From time to time they may survey the works of a particular architect, examine in detail a building type or look at buildings in a particular locality. Articles may illuminate the general social and economic context of contemporary architecture, as well as advise on available materials, processes and methods of construction in a period. The advertising in professional and technical journals may also be valuable in supplementing information on building professions, trades, materials and technology.

From the eighteenth century onwards local and national newspaper and magazine advertisements give details of properties for sale. Some may refer to whole estates offered for sale or broken up, others to individual buildings. They may also include details of houses, estate farms and cottages. There may be plans, engravings or, in the twentieth and twenty-first centuries,

photographs illustrating the property, details of the number of rooms, their sizes and descriptions of fixtures and fittings.

Descriptions, paintings and drawings

For many reasons large numbers of buildings fail to survive, and some are deliberately destroyed. In 1993, Bosnian Croat forces blew up the sixteenth-century bridge at Mostar because this Ottoman structure symbolised the local Muslim community. It has now been reconstructed. If buildings are lost before any studies have been made, we have to interpret their form from plans, oral or written description, illustrations or photographs. The value of written descriptions and visual records of buildings varies, depending on when they were made, their accuracy and coverage of the building. Some of the early descriptions and drawings, although often partial, are valuable in giving information concerning buildings or parts of buildings that no longer exist. For example, the French draughtsman Jacques Carrey made drawings of the Parthenon sculptures *in situ* in 1674. In 1687 an explosion in the centre of the building destroyed large parts of the side walls. However, since Carrey's drawings recorded the full design of the frieze, it was possible to identify the location of surviving fragments.

Topographical engravings and paintings showing views of towns and paintings of country houses and landscapes have been a popular subject for artists from at least the seventeenth century. In the eighteenth century picturesque taste in England encouraged an interest in rural cottages and farmhouses which led architects to design small rural dwellings or the *cottage orné* on country estates. Topographical views can often be found in local and national museums, art galleries, stately homes or private collections. Engravings and paintings should be checked for accuracy against other sources, for a certain amount of artistic licence may have crept in, in order to produce a 'satisfactory' work of art. In the early eighteenth century Jan Griffier painted Syon House with its formal garden, on the bend of the river Thames to the west of London. On the opposite bank was the red-brick Richmond Palace, which he moved nearer to the river so that it could be included in the painting.

From the eighteenth century many architects hired perspectivists to 'sell' their buildings to commissioning bodies and juries. Unfortunately few of these have survived. One of the most important architectural competitions of the Victorian period was that for the Law Courts, London, in 1868. While photographs survive of the entries invited from eleven eminent architects, none of the original, and in some cases dramatic, drawings survive.

The most accessible architects' drawings are those reproduced in nine-teenth-, twentieth- and twenty-first-century architectural journals, and the plans and drawings of buildings submitted to local authorities from the late nineteenth century for purposes of building control. Some drawings and plans may be found in collections held by architects' professional bodies, museums

and libraries, the archives of architectural firms and institutions and private owners who have commissioned buildings.

Photographs

Where they exist photographs provide invaluable records. Aerial photographs can be helpful in identifying archaeological sites visible in the disruption to the natural contours of the land, the layout of towns or groups of buildings, roofs and garden layouts. Photographs of buildings may be found in public and private collections, local museums and libraries, and both local and national newspapers often have photographic collections. Since 1955 the Royal Commission on Historical Monuments in the UK has recorded buildings of architectural and historic interest threatened with destruction. The archives of the Commission contain a large number of drawings, photographs and written accounts of buildings from all over the country, from small rural dwellings to more substantial structures. Their photographic collection was founded in 1941. The Commission publishes inventories and lists of buildings recorded as well as studies or surveys of particular types of building, or the buildings of a town or region. In the US the Historic American Building Survey (HABS) and the Historic American Engineering Record (HAER) similarly record buildings and engineering structures respectively.

Like the other means of communication, photographs can provide documentary evidence for studying architecture, provided we can interpret their evidence. Even the most amateur photographer knows how to achieve different effects according to the presence or absence of the sun, the angle at which the photograph is taken, the grain of film used and the variety of techniques that can be used in printing. Exploring the way that shadows fall at different times of the day helps us to train our eyes to see more perceptively. In the hands of a skilled photographer a building, or part of it, may become an almost unrecognisable essay in light and shade. Indeed, in the 1920s and 1930s the work of some photographers was inspired by the clarity of the form of modernist buildings. In turn, their photographs of these buildings helped to promote modernist images, and the black-and-white photographs encouraged the belief that these buildings were white-walled, whereas many were painted in pastel colours. Add to these factors the presence or absence of people, a photographer's wish to record a specific building for a specific reason, or to achieve a particular effect, or create a certain mood, and it becomes clear that the use of photographs as documentary evidence is by no means straightforward. Since we are concerned with interpreting the evidence presented by photographs, we will concentrate on some of the problems they present.

The photographs of buildings that appear in books or on the web are one of our major sources of information, yet they tend to reinforce a particular notion of what architecture is about. In most professional architectural

photographs people tend to be absent, even though they provide a clear measure of the scale of a building. The photographs are usually of single buildings, whereas we tend to experience buildings in groups. A photograph of a single building gives it significance just by virtue of isolating it from its surroundings. This privileging tendency is accompanied by the tendency to see all photographs in terms of their aesthetic qualities. Both black-and-white photography and colour photography, by their very nature, emphasise the surface qualities, form and ornamental details of their subjects. They therefore tend to reinforce the attitude that architecture is predominantly about aesthetics and style. This is further reinforced by the tendency of most architectural photographs to show only the front of a building. With no further information about the rest of the building, such as its rear, how it was constructed, its interior organisation or what it is used for, the erroneous notion that the study of architecture is about the study of façades (façadism) is reinforced. If these photographs are read in conjunction with plans and models of buildings, then a much fuller evaluation becomes possible.

Photographs range from amateur snaps to details of construction in progress. These latter can provide valuable evidence of methods of working in the building industry, the existence or lack of safety measures, as well as information on how particular buildings were constructed. Similarly, photographs of slum clearance or of buildings in the process of destruction or refurbishment can also reveal structural details. Photographs of street scenes can provide evidence of the physical context of a building at that period, but we may need to develop skills in dating such evidence. The style of the cars, buses, horse-drawn vehicles or street furniture and how people are dressed may provide clues that will help us to date them. Photographs of interiors can provide valuable information on the design of fireplaces and materials used for floors and walls, how much natural lighting there was and what forms of artificial lighting were used. Interiors can either be changed very rapidly owing to the influence of fashion, or remain unchanged for long periods, so their date may not help in dating the building.

Maps

Maps can provide evidence of the age and changing shape of a building and its surroundings. They are invaluable for helping to understand the original site that the architect or builder had to contend with. However, there can be problems of identifying buildings on old maps. The buildings may have changed shape over the years with extensions or demolitions, the site and its neighbouring features may have altered, with the construction of new roads or buildings, and in some cases the map may not be accurate. It is often useful to begin tracing an old building by starting with recent large-scale maps that show the streets and, if it still survives, the building, and then work backwards in time to older maps. The more useful larger-scale maps tend to be of recent origin (see Chapter 5).

The range of maps and plans available depends on the region and period. From the sixteenth to the nineteenth centuries engraved maps of towns and regions were often produced, although many are inaccurate and most are of small scale. They can sometimes be of value in locating isolated buildings. In Britain plans of individual parishes were made under the Enclosure Awards between *c.*1760 and *c.*1870 and the Tithe Commutation Act of 1836. However, not all parishes were subject to these. The awards give the names of newly allotted land, the act identifies landholdings and their buildings.

Plans drawn up for legal or administrative purposes that relate to small plots of land, estates or whole parishes were produced to identify landholdings or property units and can be useful. During the eighteenth and nineteenth centuries detailed plans of housing to be erected on estates were often prepared for developers. Urban landowners often had plans made and some exist from as early as the sixteenth century. It is possible to find plans of the construction and improvement of ports, docks and coastal architecture such as piers, quays and promenades as well as works by public utilities such as gas, sewerage, drainage, water and lighting from as early as the late eighteenth century. Libraries with local studies collections, local authorities and local record or archives offices usually keep maps of the neighbouring areas. At a national level there may be a variety of map collections held by different institutions.

Building legislation

Building legislation can help to explain some aspects of construction and building form, and may be helpful in dating. Usually legislation is the result of a concern to safeguard buildings against fire, and to ensure the health, safety and the convenience of people living in towns. In some cases legislation made a tremendous impact on the form of new building, for example, the regulation under Charles I in 1625 that controlled brick sizes in England. From the nineteenth century onwards much legislation related to architecture has been enacted. This includes the Zoning Law in New York in 1916, which led to the stepped-back profile of skyscrapers, and in the UK the Tudor Walters Report, 1918, and the Parker Morris Standards, 1961, both of which recommended design standards for local authority housing.

Government surveys and reports could form the basis for subsequent legislation. The Report on the Sanitary Condition of the Labouring Population, 1842, provides useful information on housing conditions and the perceived priorities at the time. It surveyed urban areas in the UK in order to discover the links between disease, poverty, bad housing and other environmental factors. Reports such as this contained information on overcrowding, dirt, disease, the size, condition and types of housing and led to the Public Health Act of 1848 and eventually to the development of building controls.

Building controls

In traditional African communities physical territory was not about owner-ship, or determined by lines on a map. It was defined by spiritual require-ments and clan relationships. A family might live on a portion of land, but they did not own it: there was an important distinction between 'possession' and 'ownership'. A Nigerian chief stated to the West African Lands Com-mittee in 1912, 'I conceive that land belongs to a vast family of which many are dead, few are living, and vast numbers are unborn.'[12] From the nine-teenth century on, land in the colonies was assigned for settler towns, taxes imposed on indigenous communities and 'native locations' established. Traditional patterns of life were disrupted for the economic benefit and secu-rity of the settler, and communal notions of land gave way to municipal and private ownership. Thus, land and the structures built on it were controlled. In 1907 in Harare, Zimbabwe, corrugated iron huts were built, numbered, located in strict rows within a 'native reserve' and let out to Africans on a monthly rental. There were no churches or shops allowed until 1939, and the site was supervised from the superintendent's cottage.[13]

With the massive growth of urban areas in nineteenth-century European and North American cities, building control became essential. By the 1860s most provincial centres in England had issued building regulations. In some cases these were independently worded local Acts; in others the regulations were based on the guidelines for local by-laws suggested in the 1858 Local Government Act. The 1875 Public Health Act rationalised sanitary control, extended it to all areas and in 1877 introduced a set of Model By-laws that were widely adopted. These controls aimed to regulate the design of build-ings to reduce the risk of fire, ensure structural stability, and to provide proper drainage and sanitary facilities. They determined the level, width and construction of new streets, the space around buildings to ensure circulation of air and required the provision of sewers. Despite widespread adoption there were still local variations in the regulations, their interpretation and implementation. Thus, for example, back-to-back houses continued to be built in the West Riding, Yorkshire, well into the twentieth century.

By-laws and building regulations are not only valuable in understanding aspects of building design; they are important because architects and builders had to supply copies of all their plans of buildings to the local authority for inspection. These provide one of the most important sources of material for studying buildings from the late nineteenth century onwards. It is here that we may be able to find the names of patrons and architects, confirm the date of the design of a building and examine original measured plans and elevations. These are also quarries for alterations and extensions to any building, including buildings originally constructed in a period before the introduction of building controls.

In the UK these building plans are deposited with the local borough, urban and district councils or record office. The registers to these plans are

chronological and are rarely indexed, so a long search is usually necessary unless one knows the date of the building. For newer buildings questions of security may require that researchers obtain permission of the architect to inspect the plans.[14]

Title deeds

The character of land ownership has varied historically and across the world. When Hong Kong Island was ceded to the British in 1841 the land policy in the new colony consisted of no freehold land: all land was Crown Land and private property consisted of leases of greater or lesser duration.[15] Freehold land is land privately owned by an individual or organisation. Deeds are documents recording the transfer of rights of freehold property from one person or body to another and require an understanding of legal terminology. The owner's solicitor, bank or building society usually keeps them, although in the UK local record offices keep many old deeds. The value of deeds in researching buildings is that they record change of ownership; in addition, properties with a special function are usually named, for example, a windmill or warehouse, and the size of the site and its boundaries are given. These are usually defined with reference to the local geography or neighbouring landowners.

Since the transfer of property might take place as a result of a sale, through marriage or inheritance, deeds are somewhat random records of properties, occurring only when they change hands. Moreover, when an individual building belonging to a group, say a barn on a farm, is sold, the deeds are not divided but remain with the larger unit, that is, the rest of the farm. Title deeds for individual properties are rarely relevant to religious institutions, municipal corporations or large landed estates. Here, either the property rarely changes hands in the ways indicated or, if it does, it passes as a whole to the next owner or heir. In the UK many great estates were sold at the end of the nineteenth century and during the twentieth century, and deeds of individual properties may be found from this period.

Taxation and rating records

Taxation records may help to determine aspects of building form and even the nature of settlements, provided the question of evasion and under-taxation are taken into account. These records will vary in character and value from country to country. The English Hearth Tax was levied from 1662 to 1689 to replenish impoverished government coffers during the reign of Charles II. Many of the records relating to this tax are lost and it has been estimated that possibly some 40 per cent of households were not recorded in the Hearth Tax, not least because several categories of people were exempt, including some of the very poor. Those records that survive, however, may indicate the size of houses or the number of rooms that were heated.[16]

The Land Tax was an English property tax levied from the late seventeenth century into the nineteenth century. Most records survive for the period 1780–1832 when they were used for electoral purposes. These records rarely give a description of the property or its location, but simply list owners and occupiers, so over a long period we can reconstruct the ownership and occupancy pattern of every house in a town or village by comparing returns for each year.

Fire insurance records

The records of some fire insurance companies may still survive. They may consist of maps detailing the building materials of properties, or other documents that give details of the function, valuation and building materials of the insured property. Insurance records can be found in record offices and the head offices of insurance companies. From the early eighteenth century property in the UK could be insured against fire and often a small metal or ceramic plaque was attached to insured buildings giving the name of the insurance company and policy number.

Inscriptions on buildings and makers' marks on building materials

Buildings themselves may reveal written information helpful in identifying dates and the names of patrons and makers of materials. Initials of the architect or patron and dates may be carved on plaques set into walls, or may form part of the casting of a lead rainwater head. Building workers sometimes inscribed dates and initials on to timber components or masonry. The names represented by initials may be identified in directories, parish registers or wills. However, care should be taken in interpreting any inscriptions or embossing of materials. Weathering and the use of Roman numerals and letters may cause confusion, and it may not always be clear to what part of the building an inscription refers. It is also important to check that the component inscribed is an authentic element of the original structure and not a later addition or transferred from other buildings.

Archives of professional bodies and the building trades

Architects, engineers and surveyors often belong to a professional body and details of their membership and career may be traced through such bodies or institutions. Local branches of national institutions may also have information on local members. A general knowledge of these institutions and bodies is useful in understanding the nature of the profession and the way it was controlled at a particular date. In the US architects belong to the American Institute of Architects (AIA), in the UK to the Royal Institute of British Architects (RIBA). Most architects who are or were fellows or associates of the RIBA will be recorded at the British Architectural Library in London.

The records date back to the founding of the RIBA in 1834 and are continually being updated. The library aims to collate the addresses, dates, education and training, professional career, bibliographical references and obituaries of each architect. In each area of the country there are also local branches of the RIBA that organise meetings, lectures and events for members and may publish a local journal or newsletter.

Books published on the history of particular crafts and trades can help to contextualise the materials and methods used in the building industry in particular periods. Primary source material may be found in the archives of the relevant guilds, trade unions and other organisations. Christopher Powell's valuable booklet, *Writing Histories of Construction Firms*, Englemere, The Chartered Institute of Building, 1992, gives a wide range of sources for the history of firms engaged in building in the UK.

Company archives

Company archives may contain letters, business diaries, accounts, briefs, reports, architects' drawings and plans. Whether we are looking for information concerning an architectural practice, a building firm, auctioneers, estate agents or surveyors, or trying to find out about the construction of an industrial or commercial building, company archives can be useful. In the UK the National Register of Archives of the Historical Manuscripts Commission includes company archives.

Estate and manorial records

The records of landowners, whether individual families or institutions, may include surveys and valuations of the land in their ownership. These can consist of: written descriptions of buildings and land, sometimes accompanied by maps and plans; lists of leases and properties rented; the names of tenants and the annual value or rental; covenants for repair; accounts and correspondence relating to new buildings and to repairs.

Inventories which accompany wills are detailed lists of the personal possessions of the deceased. Particularly relevant to domestic architecture in the UK are those from the sixteenth to the eighteenth centuries that itemise the contents of houses room by room. They provide an indication of the wealth, lifestyle and use of the rooms. However, it is rarely possible to relate early inventories to particular houses. Wills and inventories of the personal possessions of the deceased are usually kept in local record offices.

Trade directories, census returns and electoral registers

To find information on a patron, architect, builder or occupant living within an area the major sources are directories, census returns and electoral registers. People in trade or business can usually be found listed in trade directories.

Trade or commercial directories, which proliferated from the second half of the nineteenth century but can be found as early as the late eighteenth century, give names of trades people and principal inhabitants of towns and villages. Often published annually, the directories contain alphabetical lists of names, trades and streets. They can be useful in tracing the existence of firms or individuals at particular dates. A rough date for the initial occupation of a building can be deduced from the appearance in the directory of the street number of a dwelling, or trade name of a business. However, as we have mentioned earlier, there is no guarantee that an individual or business occupied a particular building – only that the person or business operated from that particular address at that particular date. Armed with this date it is possible to focus the search for the plans of a building, through building control plan registers, to within a few months or years. It is important to remember, however, that not all inhabitants are listed, and that street numbers and names change.

Genealogical information may be traced through registers that give the names of those born, married or buried in an area. Census returns compiled from the mid-nineteenth century may help in identifying the names, occupations and numbers living in houses. They record the names of individuals within households in a street, their relationship to one another, ages, occupations and birthplace. As the franchise extended in the late nineteenth and early twentieth centuries, electoral registers became useful records of adults occupying addresses in each locality. Local record offices and libraries can advise on the location and availability of such records, and there are websites helpful in tracing family histories. In the UK the government website http://www.familyrecords.gov.uk provides data on births, marriages and deaths as well as census and migration information.

Oral history

An important area of historical evidence that is not based on documents is oral history. By this we mean live interviews and discussions with architects, patrons or users of a building. Some universities, such as the University of California, run oral history programmes and there are oral history groups in many localities. There are limitations on oral history, as we have already mentioned and the accuracy of memory cannot be assumed. Myths may arise in relation to particular buildings and the individuals associated with them, which could result in misleading anecdotes. It is always wise to cross-check information by interviewing more than one individual and to use documentary evidence.

The most telling responses to buildings come not from the patron, architect, builder or even journalists and professional critics but from those who have to live or work in them. The users' views are rarely sought or made available in written form unless, perhaps, for sociological or other reasons a survey has been made. Tape and video-recording equipment are widely

available and offer excellent opportunities for recording people's responses to contemporary buildings. Interviews may also be conducted with patrons and professionals involved with architecture, particularly those of an older generation who may remember buildings that no longer exist or for which there are limited written records.

There are professional tape recordings of radio, film and television interviews with those connected with the patronage, design or use of buildings, and radio, film and television company archives may prove fruitful quarries. In the 1930s in the UK, Europe and the US there was much debate on good design and the built environment that was promoted not only in books and journals but also on the radio.

During the past half-century there has been an increasing interest in architecture both generally and in the media. Local and international news reports ensure that new developments at home and abroad are discussed. Millions throughout the world learn about the listing of World Heritage sites or damage and loss of historic architectural sites and monuments in earthquakes such as Bam in Iran in 2003. Whether positive or negative, such news can engender greater interest in a broader range of international architecture. The series *Restoration* featured by the BBC in 2003–4 was the first to focus on historic buildings at risk across the UK and, indeed, some examples seemed to be in terminal decline. The buildings ranged from a croft and a castle to a chapel and a swimming pool; viewers were invited to vote for one building to be saved, and voted in the first series for the Victoria Swimming Baths in Manchester. Some three million people watched the series. The programmes were important for highlighting the plight of a small fraction of the UK's historic buildings, and above all for showing how much people care for their local environment and the contribution historic buildings make to local distinctiveness and sense of place. With the accessibility of email and the web this has meant that many more people can join in the debate and become involved.

Glossary

Aalto, Alvar (1898–1976): individualistic and expressive Finnish architect and furniture designer. Sensitive to the landscape, he blended modernism with nature and the Finnish vernacular. Major projects include: the Tuberculosis Sanatorium, Paimio, 1928–33; Villa Mairea, Noomarkku, 1937–9; Säynätsälo Town Hall, 1949–52; and Vuoksenniska Church at Imatra, 1956–9.

abutment: a solid structure that resists the thrust of an arch or vault.

Adam, Robert (1728–92): highly acclaimed Scottish-born architect, decorator and furniture designer who worked in an original, light neo-classical style largely inspired by ancient Roman architecture. Some of his notable works are the interior designs for Kedleston Hall, Derbyshire, 1760–5, Osterley Park, London, 1763–80 and the planning and decoration of Syon House, London, 1762–9.

Adler, Dankmar (1844–1900): see Sullivan, Louis.

aedicule: a shrine in a temple usually containing a statue, framed by two columns which support an entablature and pediment; also used more loosely to describe the framing in a similar manner of a door, window or other opening.

aesthetic: relating to the principles and perception of beauty in the visual arts.

aesthetics: the study of the principles of taste which form the basis of criticism in the arts.

aggregate: broken stone, gravel or sand which is added to cement to make concrete.

agora: open space in a Greek or Roman town used as a market or meeting place, often surrounded by colonnades.

Alan Short and Associates: a firm of English architects, originally Peake, Short and Partners, who made their reputation by specialising in ecologically sound designs. One of their early buildings was the Simonds Farsons Cisk Ltd Brewery in Malta, 1988–90; subsequently they have built The Contact Theatre, Manchester, and the Lanchester Library, Coventry University, 1998–2000.

Alberti, Leon Battista (1404–72): influential Italian architect and theorist who produced *De Re Aedificatoria*, 1452 (not fully published until after his death), the first architectural treatise of the Renaissance period that focused on proportion, the orders and town planning. His few buildings were remodellings of earlier ones, with the exception of the churches of S. Sebastiano, 1460, and S. Andrea, 1470, both in Mantua, which he designed.

Alen, William van: see van Alen, William.

Alhambra: royal residence and fortress dating from the mid-thirteenth century, located on a plateau to the east of Granada, Spain, with magnificent Islamic gardens covering some 10 hectares.

ambulatory: space for walking round the east end of a church, behind the altar.

antique: pertaining to the ancient Greek and Roman civilisations.

apse: polygonal or semi-circular chancel or recess.

arch: an alternative to the lintel for spanning an opening or space; composed of wedge-shaped blocks or voussoirs that support each other by mutual pressure and are able to support a load from above. Usually arcuated or bow shaped.

> *engrailed*: an arch with cusped, serrated, indented or foliated edge.

> *flat*: a horizontal arch with a straight or slightly cambered soffit or underside. Sometimes composed of bricks on edge, or a soldier course; otherwise, the voussoirs radiate from one centre as in a true arch.

> *four-centred*: an arch of four arcs, associated with the late medieval period.

> *ogee*: a pointed arch with double curved sides, one concave, the other convex. It was much used in decorated and perpendicular gothic architecture and in Indian architecture of the sixteenth to eighteenth centuries.

> *segmental*: an arch in the form of a segment of a circle, drawn from a centre that is below the springing line.

Archigram: a group of avant-garde English architects which included Peter Cook, Warren Chalk and Ron Herron. Consumerism, disposable products, space capsules and 'clip-on' technology inspired the founding pamphlet, *Archigram I*, 1961. Their projects, such as 'Plug-in City', 1964, remained largely on paper.

architectonic: pertaining to architecture in the broadest sense. A formal garden with a geometric layout, clipped hedges and straight paths suggests the forms of architecture and thus gives architectonic support to, for example, an adjacent classical building.

architrave: the lowest part of an entablature; also the lintels, jambs and mouldings surrounding an opening.

art deco: an eclectic style fashionable in the 1920s and 1930s in Europe, the US and European-influenced parts of the world. It originated at the Paris exhibition of 1925 and was inspired by avant-garde art such as

fauvism, cubism, futurism* and expressionism. Its sources also included motifs from ancient Egypt, the Russian ballet, Aztec temples, classicism and contemporary machinery.

art nouveau: a style which evolved in Europe and the US in the 1890s and reached a peak at the turn of the century. Its leading motif is a sinuous, sometimes vegetal, often tense line, which was particularly suited to ironwork, columns and railings. In architecture it led to asymmetry and novel curving plans.

arts and crafts: see arts and crafts movement.

arts and crafts movement: a revival of traditional crafts and vernacular architecture in the second half of the nineteenth century in the UK, Europe and the US. Inspired by the gothic revival and particularly the ideas of A. W. N. Pugin, John Ruskin and William Morris, architects and designers created individual and evocative works through a return to traditional materials and techniques, honesty in design and joy in making.

Arup, Ove Sir (1895–1988): UK engineer who trained in Denmark and was senior partner in Ove Arup Partners from 1949 and Arup Associates from 1963. The firm has offices all round the world. Significant buildings associated with Arup include the Penguin Pool, London Zoo, 1939, Sydney Opera House, 1973, the Pompidou Centre, Paris, 1977, and Stansted Airport, 1981–91.

ashlar: cut stone worked to even faces and right-angled edges laid in horizontal courses with vertical joints, as opposed to rubble or uncut stone.

asphalt: black or dark brown bituminous substance derived from oil, used as a waterproof roofing material when mixed with rock chippings or other material.

atrium: an open-air court at the centre of a Roman house; in contemporary architecture a central, glazed light well in multi-storey buildings, sometimes used as communal space.

attic storey: a low storey over the main entablature, with ceilings square with the side walls and quite distinct from the roof space.

back-to-back house: a house sharing party walls to the rear and sides so that there can only be openings at the front; sometimes called a 'single-aspect' house.

Baker, Sir Herbert (1862–1946): English architect best known for his work for the South African and Indian governments. He designed the Union Administrative Buildings in Pretoria, South Africa, 1905–13, and the Secretariat and Legislature Buildings in New Delhi, India, from 1912.

balistraria: narrow openings or arrow slits in fortified walls from which arrows were fired.

balustrade: a parapet consisting of balusters or small pillars or posts supporting a coping or rail.

banded order: a column broken by plain or rusticated rectangular blocks of stone.

bargeboards: boards placed at the gable of a building to cover and protect the ends of the purlins and ridge or horizontal roof timbers.

Barlow, William Henry (1812–1902) and Ordish, Roland M. (1824–86): Barlow was a civil engineer who worked on railway projects and the Clifton Suspension Bridge, 1860–4. Ordish worked in an engineering office, assisted in the design of the Crystal Palace and worked with architects who included Owen Jones and George Gilbert Scott.

baroque: a classical style of architecture which developed in Italy in the seventeenth century and spread to other parts of Europe. It is characterised by exuberant sculptural forms, complex spatial relationships and illusionistic effects.

basilica: a Roman hall; a building with a nave, two aisles and an apse at one end.

batter: a wall that is thicker at the base and slopes inwards towards the top.

battlement: an indented parapet.

Bauhaus: German design school (1919–33) which promoted modernist architecture and design. The Nazis closed it in 1933. The New Bauhaus opened in Chicago in 1937.

bay: a vertical division of a building marked by buttresses, an order, openings, or the main divisions of the roof such as units of vaulting or rafters.

bearing element: part of a building that carries a load or is load-bearing.

bed: the horizontal surface on which stones, bricks and other forms of masonry lie.

Blomfield, Professor Sir Reginald Theodore (1856–1942): English architect and architectural historian much influenced by R. N. Shaw and English and French renaissance styles. He promoted the neo-Georgian revival in the early twentieth century in England. Among his buildings are the United Universities Club, Pall Mall East, London, 1907–8, and the Talbot Building at Lady Margaret Hall, Oxford, 1910–15. His books include *A History of Renaissance Architecture in England 1500–1800* (1897) and *A History of French Architecture 1494–1661 and 1661–1774* (1911–21).

Blow, Detmar (1867–1939): English arts and crafts architect and mason inspired by John Ruskin, William Morris and Philip Webb. His works include construction, historic building repair work, and designs such as Government House, Harare, Zimbabwe, 1910, with his partner from 1906, Fernand Billeray.

Bofill, Ricardo (1939–): Spanish architect who founded the Taller de Arquitectura in Barcelona in 1960 and designed many residential complexes in Spain and France that feature a distinctive, expressive and monumental form of postmodernism. The group has used revived gothic, classical and Egyptian forms.

Borromini, Francesco (1599–1667): important Italian architect who worked in Rome in the baroque style. S. Carlo alle Quattro Fontane (1637–41) displays his radical spatial ingenuity.

Boullée, Etienne-Louis (1728–99): influential French neo-classical architect and teacher, known for his expressive projects of monumental scale, which utilised simple geometric forms and repetitive columns.

bracing: in framed structures a subsidiary member located near or across the angle of two main members in order to stiffen the joint.

Bridgeman, Charles (d. 1738): English landscape architect who in the early eighteenth century played an important role in the transition from formality to the more informal designs developed by William Kent and Lancelot Capability Brown.

brise-soleil: horizontal and/or vertical elements on the outside of a building, designed to shade windows and large areas of glass from the sun.

Brodrick, Cuthbert (1822–1905): Yorkshire architect best known for the design of Leeds Town Hall, 1853–8, and Corn Exchange, 1861–3, and the French renaissance-inspired Grand Hotel at Scarborough, 1863–7.

Brown, Lancelot (Capability) (1716–83): architect and landscape designer whose landscapes were created out of 'natural' elements such as the contours of the land, lakes, rivers and extensive tree planting, rather than the introduction of buildings or formal planting.

Burgee, John: see Johnson, Philip and Burgee, John.

Burlington, Lord (1694–1753): the widespread fashion for English Palladianism* was largely due to Lord Burlington. Chiswick House, *c.*1723–9, his best-known work, was based on Andrea Palladio's Villa Rotunda. With William Kent, his protégé, Burlington dominated English architecture for thirty years and in 1730 he published Palladio's drawings of the Roman baths.

Burnham and Root: Daniel Burnham (1846–1912) and John Wellborn Root (1850–91) formed a partnership in Chicago and played an important part in the development of the Chicago School in the 1880s and early1890s. Their best-known surviving building is the Monadnock Building, 1889–91.

Burton, Decimus (1800–81): son of a successful London builder, he became involved in the development of Regent's Park, London. His Hyde Park improvements include the screen at Hyde Park Corner, 1824–5. He was involved with Paxton in the design of the Great Conservatory at Chatsworth (1836). The Palm House, Kew, 1844–8, the largest iron and glass building of its day, combined the ideas of both Burton and Richard Turner, ironmaster of the Hammersmith Ironworks, Dublin.

bush hammering: a technique to create a regular finish on concrete using a powered hammer that chips away the rough surface.

buttress: masonry projecting from a wall to give additional strength particularly against lateral thrust.

Byzantine: refers to the style of early Christian architecture developed in Constantinople (now Istanbul) by the Emperor Constantine who in AD 330 established it as the capital of the Roman Empire.

Calatrava, Santiago (1951–): Spanish engineer and architect famous for his skeletal, curvilinear reinforced concrete bridges and buildings. Among his works are the Campo Volantin bridge, 1998, and the Sondica Airport, 1999, both in Bilbao, the City of Arts and Sciences, Valencia, 1991–2002 and the Olympic Stadium, Athens, 2004.

cantilever: a horizontal projection that appears to be self-supporting but which is supported by downward forces on the other side of a fulcrum. Balconies and canopies are often cantilevered.

capital: the head of a column or pilaster.

caryatids: female figures used instead of columns to support an entablature or similar feature. Male figures are known as atlantes.

castellated: a battlemented parapet.

catenary: a curve formed when a heavy chain or rope hangs freely from two supports.

Chambers, Sir William (1723–96): the most important official architect of his day; Somerset House, London, 1775–1801 is one of his best-known works. In his youth he made voyages to India and China and through his writing he advocated Chinese landscape design at a time when Brown's landscapes were in vogue. The Pagoda in Kew Gardens, London, is Chambers' only extant Chinese building.

chancel: the east end of a church reserved for the choir and clergy, in which the main altar is placed.

Chareau, Pierre (1883–1950): French architect and furniture designer who, with Bernard Bijvoet, designed the modernist Maison de Verre, Paris, 1928–32. This featured glass bricks in the façade and other mass-produced components in the interior.

chattri: a small domed pavilion characteristic of Indo-Islamic architecture.

cladding: external covering or skin applied to a building for protection or for aesthetic purposes.

clamp: a stack for firing bricks. Dried unburnt bricks are stacked over a fire with spaces between to allow fire gases to circulate or with fuel, such as bundles of brushwood, between. The stack is covered with turf, earth and old bricks and then set alight from the base.

classical: pertaining to the monumental architecture of ancient Greece and Rome, in particular, the principles such as a concern with proportion and harmony and the use of the orders.

classicism: a revival or return to the principles of classical architecture of ancient Greece and Rome.

clerestory: windows or openings in the upper part of a building. Usually applied to the windows in the upper part of the walls of a church, above the triforium* or aisle roofs.

cob: a mixture of clay, straw, chalk or gravel and water used to build walls.

colonette: a small column.

column: a free-standing, slender upright pillar, circular in section. In classical architecture it consists of a base, shaft and capital except in the Greek Doric order.

engaged column: a column which is attached to a wall. Engaged columns may just touch the wall, so that they are still circular in cross-section or they may be half columns, or any variation between these.

composite column: see order, composite

concrete: a mixture of water, sand, stones or broken stone and a binder which hardens to form a hard mass like stone that is strong in compression. Binders may be of varying type: the ancient Romans used volcanic dust and lime; today, Portland cement is commonly used.

prestressed: stretched steel reinforcing cables inserted into the concrete either before or after casting. These place in compression those areas of the concrete that will be subject to tension when building loads are introduced.

reinforced: concrete with steel rods or mesh embedded. The two materials have complementary roles, the concrete withstanding compressive forces, the steel tensile ones.

coping: covering to a wall to throw off water.

corbel: projecting block supporting a beam or other horizontal element. A vault or arch can be constructed from a series of projecting corbels.

Corinthian column: see order, Corinthian.

cornice: the top projecting section of an entablature, or any projecting moulding along the top of a wall, arch or building.

curtain wall: in medieval architecture the straight wall of a castle or fortification constructed between towers, buttresses or piers. Today, a thin, non-load-bearing cladding, skin or wall, partly or wholly glazed, suspended from the frame or structure of a multi-storey building.

deconstruction: an analytical approach to architectural design linked since the 1980s to the theories of Jacques Derrida. It is associated with the work of architects such as Bernard Tschumi, Peter Eisenman, Daniel Libeskind, Zaha Hadid and Coop Himmelblau. Abstraction, complexity, disjunction, warped surfaces, tilted planes and space determined by vectors, tangents and diagonals rather than axes and focal points characterise works such as Coop Himmelblau's Cinema Centre, Dresden, 1993–8, and Daniel Libeskind's proposed Spiral extension to the Victoria and Albert Museum, London.

dome: a convex covering over a circular, square or polygonal space. Domes may be hemispherical, semi-elliptical, pointed or onion-shaped.

domestic revival: refers to creative developments in middle-class domestic architecture in Britain, northern Europe and the US in the second half of the nineteenth century. Inspired by A. W. N. Pugin, John Ruskin and vernacular architecture, it is sometimes known as the vernacular revival. In England it encompasses the architecture of Philip Webb, the Queen Anne Revival, the Old English style of Norman Shaw and William Eden Nesfield and the arts and crafts movement.

Doric column: see order, Doric

dormer: a vertical window with its own roof, placed in a sloping roof.

Doshi, Balkrishna Vithaldas (1927–): trained in Poona and Bombay. Worked with Le Corbusier in Paris and India (1951–7) and with Louis Kahn in India (1962–72). Since 1977 senior architect with Joseph Allan Stein and Jai Rattan Bhalla in New Delhi and Ahmedabad, designing major commercial, institutional and town planning projects and housing combining traditional Indian themes with contemporary ideas and materials. Major works include the Indian Institute of Management, Bangalore, 1977–83, Gandhi Labour Institute, Ahmedabad, 1980–4, and, with the Vastu-Shilpa Foundation, Aranya Township Low-Cost Housing Project near Indore, from 1988.

drip mould: any projecting moulding to throw off rainwater.

Durand, Jean-Nicholas-Louis (1760–1834): influential French neo-classical architect, theorist and professor at the École Polytechnique, widely known for his publication *Recueil et parallèle des édifices de tout genre*, 1800.

eaves: the lower overhanging edge of a sloping roof.

École des Beaux-Arts: school in Paris providing academic architectural training from 1816 and open to students of any nationality. It promoted a form of rational classicism. It attracted many architects from the US in the nineteenth and early twentieth centuries.

edge cities: urban development that has been stimulated by transport links, particularly motorways, typically growing up around out-of-town shopping centres and leisure parks.

Edwardian: strictly the period in UK history between 1901 and 1910 during Edward VII's reign, but often extended to include the beginning of George V's reign to the outbreak of the First World War, 1914.

engaged column: see column, engaged.

entablature: the upper part of an order or the elements carried by columns and pilasters. These include the architrave or lintel, the frieze and the cornice.

entasis: a slight convex curve used on classical column shafts to prevent them appearing concave.

Erskine, Ralph (1914–): English architect who settled in Sweden in 1939. His international reputation came with the Byker housing project in Newcastle-upon-Tyne (1969–80) in which the residents were consulted throughout the design process. Other works include the Ark in west London, 1992, a commercial office with communal spaces on a difficult site.

expressionism: an architecture movement in northern Europe just prior to the First World War that lasted until *c.*1925. It includes the housing estates of the Amsterdam School (Michel de Klerk and Piet Kramer) and Rudolph Steiner's Goetheanum, Dornach in Switzerland, 1924–8, for the Anthroposophical Society. Among works in Germany are: Bruno Taut's projects for utopian cities and landscape architecture using coloured glass; the biomorphic, semi-automatic architectural sketches of Hermann Finsterlin; and Hans Poelzig's Grosses Schauspielhaus for

Max Reinhardt's theatre, 1918–19. The early work of modernist architects, such as Walter Gropius and Mies van der Rohe, was influenced by it.

expressionist: see expressionism

eye-catcher: a decorative feature or building associated with landscaped parks, designed to terminate a view, or form a feature on the skyline. One of the best known is the eye-catcher designed by William Kent, outside the boundary of Rousham, Oxfordshire that 'called in' the distant undulating landscape.

façade: an external elevation or face of a building, often the most important one.

Farrell, Sir Terry (1938–): English architect whose extensive developments in London include Embankment Place, 1991, and the MI6 Building, Vauxhall Cross, 1993.

Fischer von Erlach, J. B. (1656–1723): leading Austrian baroque architect, appointed court architect of Vienna in 1704. His major work, built for the Emperor Joseph I, is the Karlskirche, Vienna, from 1716. It has a dramatic façade with central dome and two huge Roman imperial columns flanked by twin towers; the plan blends an oval with a Greek cross.

fissile: material that is easily split.

flèche: a slender spire often of wood, which rises from the ridge of a roof.

floriated: carving representing leaves or flowers.

flushwork: decorative use of flint in walling. The flints are split or knapped to expose the black core and to give a fairly flat surface. They may also be chipped to give a square end and laid to give pleasing patterns.

footprint: literally the outline of the space on the ground occupied by a building.

formwork: a wooden or metal structure which forms the mould for wet concrete.

Foster, Norman (1935–): leading English late modernist architect. Among his well-known works are the Willis Building in Ipswich, 1975, the Hongkong and Shanghai Bank Headquarters in Hong Kong, 1986, the Mediathèque in Nîmes, France, 1993, Chek Lap Kok Airport, Hong Kong, 1992–8 and 30 St Mary Axe, (Swiss Re Building), London, 2004.

Fowke, Captain Francis (1823–65) and Scott, Henry (1822–83): both were Royal Engineers. Fowke's work included the National Gallery in Dublin, 1860, the Royal Scottish Museum in Edinburgh, 1861, the Victoria and Albert Museum quadrangle from 1859, and, with Scott, the Royal Albert Hall in London, 1867–71.

frame building: see frame structure.

frame structure: any building carried on a frame as distinct from load-bearing walls.

Fuller, R. Buckminster (1895–1983): American architect and teacher. His works include the project for the low-cost, mass-produced Dymaxion House, 1927, and, post 1945, various geodesic domes, including one exhibited at the Montreal Exhibition, 1967. His writings are collected in *The Buckminster Fuller Reader*, edited by J. Meller (London, 1970).

functionalism: a misnomer applied to modernist architecture to suggest that the spare forms were simply the product of utility and had no aesthetic or symbolic dimension.

functionalist: see functionalism.

futurism: a movement dating from 1909 to the First World War in Italy comprising all the arts, including architecture. The futurists stressed the importance of new technology, sought to break the bonds of history and were an important influence on modernism.

futurist: see futurism.

gabion: a wire container filled with earth or stones.

gable: upper part of the end wall of a building with a pitched roof that rises straight up to conform to the slope of the roof, so forming an inverted V. In some cases, the gable wall may rise above the end of the roof to protect the ends of the horizontal roof timbers, and the sides of the gable form a sloping parapet that may be shaped in various ways.

gablet: a small gable beneath the ridge of a hipped roof.

Garnier, Charles (1825–98): French architect who trained at the École des Beaux-Arts, Paris, and the French Academy in Rome, 1842–54. He made his name with his design for the Paris Opéra, 1861–74, that crystallised the aspirations of the Second Empire.

Gaudí y Cornet, Antonio (1852–1926): a deeply religious architect within the Catalan economic and artistic revival. He explored spiral, parabolic and catenary curved structures and used wrought iron, brick and ceramics to produce inventive, colourful and sculptural work with a Moorish influence. Backed by his patron Count Eusebio Güell, Gaudí's key works in Barcelona include the Parque Güell, 1914, the Palacio Güell, 1890 and the cathedral of La Sagrada Familia from 1883.

Gehry, Frank (1929–): California-based architect best known for his design of the Guggenheim Museum, Bilbao, Spain, 1995. His work includes his own house, Santa Monica, 1978, the Vitra International Design Museum and Furniture Factory at Weil am Rhein, Germany, 1989, and the Walt Disney Concert Hall, Los Angeles 1997.

geodesic dome: lightweight hemispherical dome constructed of a grid of straight line geometrical elements, e.g. triangles and hexagons.

geomancy: divination from the configuration of a handful of earth; also the art of siting buildings auspiciously. *Feng shui* is sometimes known as a Chinese version of geomancy, although it is very different.

Georgian: pertaining to the reigns of George I, II, III and IV (1714–1830).

giant order: an order where the columns or pilasters rise through more than one storey.

Gimson, Ernest (1864–1919): English arts and crafts architect and furniture designer who moved to the Cotswolds in 1893 to work with the Barnsley brothers. His work includes Inglewood, Leicester, 1892, Bedales School hall, 1910, and library, built after his death in 1920, and Long Orchard, Budleigh Salterton, Devon, 1912.

gothic revival: a movement in the eighteenth and nineteenth centuries that revived the gothic style. It began in England and spread to Europe, the US and British colonies.

gothic style: a style of architecture that developed in Europe from the twelfth to the sixteenth centuries. The style is characterised by soaring effects, pointed arches, ribbed vaults, clustered shafts and walls pierced by large windows and supported by buttresses. In each country the style had its own development. In England it is often subdivided into three consecutive sub-styles: early English, decorated and perpendicular gothic; in France the sub-styles are called early, high and flamboyant or late gothic.

> *decorated*: a sub-style of English gothic architecture of the period *c.*1250–1360, characterised by decorated surfaces, curvilinear tracery and ornamental foliage which became naturalistic.

> *early English*: the earliest phase of the gothic style from the end of the twelfth century to *c.*1250. Characterised by lancet windows, later with platetracery, and stylised stiff-leaf ornament.

> *perpendicular*: a sub-style of English gothic architecture, it is characterised by flattened or four-centred arches, window tracery with straight mullions and transoms (horizontal bars), blind panelling on walls and complex vaulting, often fan vaulting. It developed during the fourteenth century and continued until the sixteenth century.

Graves, Michael (1934–): American postmodern architect whose Portland Building, Portland, Oregon, 1980, and Humana Headquarters, Louisville, Kentucky, 1982–6, illustrated his free and colourful adaptation of classicism.

Greene and Greene: Charles Greene (1868–1957), Henry Greene (1870–1954); southern Californian architects whose work was mainly domestic and influenced by both the arts and crafts movement and by Japanese timber construction. The Gamble House in Pasadena, California, 1908–9, has been preserved with its original furnishings and is open to the public.

Grimshaw, Sir Nicholas (1939–): English architect associated with late modernism. Major works include Waterloo International Railway Terminal, 1990–3, the Western Morning News Building, Plymouth, 1990–3 and the Space Centre, Leicester, 2001.

Gropius, Walter (1883–1969): architect, educator and director of the Bauhaus at Weimar and Dessau, Germany, 1919–28, where he introduced a new approach to the training of artists, designers and architects. The influence of the Bauhaus teaching methods and philosophy spread to schools and colleges throughout Europe and the US, persisting until the 1970s, and was a central influence on the development of modernism.

With the rise of National Socialism, Gropius left Germany in 1934, going first to Britain and subsequently to Harvard University, US, where he continued teaching and also set up his own company, The Architects Collaborative.

grouting: a thin mortar used to infill between paving stones, setts or tiles in order to keep them firmly in place.

Guimard, Hector (1867–1942): French art nouveau architect whose Metro station entrances 1900–1 are still a feature of Paris.

gurdwara: Sikh place of worship meaning gateway of the guru.

Hadid, Zaha (1950–): Iraqi born architect who studied at the Architectural Association, London and taught there with Rem Koolhaas and Elia Zanghelis. Important for her innovative designs such as the Fire Station at the Vitra Factory, Weil-am-Rhein, Germany, 1994, the winning but unbuilt project for the Cardiff Opera House, 1994, and the Contemporary Arts Centre, Cincinnati, 1998–2003.

half column: see column, engaged.

hammerbeam truss: a complex roof structure which avoids the use of a low tie beam. It is named after two short projecting horizontal beams (hammerbeams) on opposite sides of the wall, which do not meet. Each supports a vertical post (hammer post) and/or an arched beam (brace), which in turn supports a horizontal beam or collar, which ties in the rafters. The hammerbeams are themselves supported on curved braces rising from corbels.

Hardwick, Philip: Philip Hardwick (1792–1870) and Philip Charles Hardwick (1820–90); father-and-son team of architects. Euston Station in London, 1835–9, with its huge Greek Doric propylaea (now demolished), is probably their most famous building.

Hardy, Holzman, Pfeiffer Associates: US architectural company with headquarters in New York.

Haussmann, Baron Georges-Eugène (1809–91): entrusted by Napoleon III to make sweeping improvements to Paris, where he introduced long boulevards which meet at *ronds points*, and vistas terminated by major buildings such as the Opéra, in a baroque form of town planning. It is largely owing to Haussmann that building heights were controlled.

herringbone brickwork: has the bricks laid diagonally instead of horizontally, so that they form a zigzag pattern.

Herzog, Jacques (1950–) and de Meuron, Pierre (1950–): Swiss architects with offices in the US and Europe, who transformed the former Bankside power station on the south side of the Thames into the popular Tate Modern Art Gallery, 2000. Their Laban Dance Centre, London, 2003 is the largest purpose-built dance centre in the world and was the winner of the RIBA Sterling Prize, 2003.

high Victorian gothic: a sub-style of the gothic revival popular *c.*1850–70. Inspired by the writings of John Ruskin and George Edmund Street, architects looked to the medieval architecture of northern Italy, France

and Germany. Structural or permanent polychromy or the use of materials of different colour was common at the outset; latterly French sources became important. The style was applied to both religious and secular buildings. Key examples are William Butterfield, All Saints Church, Margaret Street, London, 1849–59, Sir George Gilbert Scott, Midland Grand Hotel, St Pancras Station, London, 1868–74, and Alfred Waterhouse, Manchester Town Hall, 1868–77.

hipped roof: a roof with four inclined planes, so there are no gables.

Holabird and Roche: William Holabird (1854–1923), Martin Roche (1855–1927); architects important in the development of the skyscraper in Chicago. The Old Colony Building, 1894, and the McClurg Building, 1899, exemplify their contribution.

Hood, Raymond (1881–1934) and Howells, John Mead (1868–1959): winners of the *Chicago Tribune* building competition in 1922, with a gothic-style skyscraper. Later work by the partnership includes the art deco Daily News Building, New York, 1929–30.

Hopkins, Sir Michael (1935–): late modernist architect whose practice, Michael Hopkins Architects, with his wife Patricia Hopkins, (1942–) exploits the potential of modern technology and tent structures as at the Schlumberger Research Laboratories, Cambridge, 1984.

Horta, Baron Victor (1861–1947): Belgian art nouveau architect whose structural use of iron enabled him to make innovations in the planning of buildings. He achieved stunning decorative effects at the Solvay House, Brussels, 1894–1903, for the industrialist Armand Solvay.

Howells, John Mead: see Hood, Raymond and Howells, John Mead.

Howland, Maria Stevens (1836–?): American feminist and socialist who believed in economic independence for women, free love, cooperative housekeeping and scientific child care. She visited the Familistère at Guise in France, which inspired her attempts to set up similar industrial cooperative communities in the US and Mexico.

impost: the member or point in a wall from which an arch springs.

inglenook: a recess on either side of a fireplace for a bench or seat, often within the chimney breast.

Inwood, William (1771–1843) and Henry William (1794–1843): father and son; architects of one of the key Greek revival buildings in England, St Pancras Parish Church, London, 1819–22.

Ionic column: see order, Ionic.

Jacobean: the period of James I of England, 1603–25, when there was a mix of Flemish, French and Italian renaissance influences in architecture.

jali: lattice or pierced ornamental screen.

jetty/jettie: a projecting or overhanging storey in a timber-framed building.

Johnson, Philip (1906–) and Burgee, John (1933–): Philip Johnson was in the vanguard of modernism, postmodernism and deconstruction in America. He and Henry-Russell Hitchcock coined the phrase 'international style' for modernist architecture. Johnson was initially a devotee

of Mies van der Rohe's architecture and his own house in New Canaan, 1949, was built in homage to Mies's Farnsworth House. In partnership with John Burgee from 1967, their AT & T Building in New York, 1978–83, with its broken pediment roofline, was hailed as postmodernism's first major monument.

joists: horizontal timbers on which flooring is laid and to which ceilings are fixed.

Kent, William (1685–1748): painter, furniture designer, architect and landscape gardener, whose patron was the third earl of Burlington. Among his key works are the house and garden at Holkham Hall, Norfolk, and the gardens of Chiswick House, Rousham, Claremont, and Stowe.

kingpost: in a truss or pitched roof a vertical post located centrally on the tie beam and supporting the ridge piece or horizontal timber at the apex of the roof.

Kip and Knyff: Kip, Johannes (1653–1722) and Knyff Leonard (1650–1721); Dutch engravers, painters and draughtsmen chiefly known for their topographical views of palaces and country seats. These were published in *Britannia Illustrata*, Vol. 1, 1707 and *Le Nouveau Théâtre de la Grande Bretagne*, Vol. 1, Part 1, 1715.

Knight, Richard Payne (1750–1824): English landscape gardening theorist and champion of the picturesque. His poem *The Landscape* (1794) attacked 'Capability' Brown's style of landscape gardening.

lancet window: a narrow window with a sharply pointed head, associated with the early English gothic style.

Lasdun, Denys (1914–2001): leading English post-Second World War architect. His main buildings in London are the Royal College of Physicians, 1961–4, and the National Theatre, 1967–76.

lath: a thin strip of wood.

Laugier, Abbé Marc-Antoine (1713–69): French priest and neo-classical theorist, famous for his *Essai sur l'Architecture*, 1753. A rationalist, he argued that classical architects of his day should return to the principles of nature, as expressed in the truth, simplicity and logic of the 'primitive hut'. These principles could be found in Greek temple architecture where, he argued, architectural form is governed by essential structural elements, such as columns, beams and rafters. He condemned pilasters and excessive ornament. Laugier praised Jacques-Germain Soufflot's Ste Geneviève, Paris, 1756–90 as exemplifying his principles.

Le Corbusier (1887–1966): extremely influential French/Swiss modernist architect who used a rich language of forms derived from historical precedents, the vernacular and the modern industrial world. He was a key member of the International Congress of Modern Architecture (CIAM) founded 1928. His publications included *Vers une Architecture*, 1923 and *The Radiant City*, 1935. Among his key buildings in France were the Villa Savoye at Poissy, 1928–9, the Unité d'Habitation, Marseille, 1946–52, the pilgrimage church of Notre Dame-du-Haut at

Ronchamp, 1950–5, and the monastery of Ste Maria de la Tourette, Eveux-sur-l'Arbresle, 1956–9. He designed the Centrosoyus Building, Moscow, 1929–33, and from 1950 planned the new Punjab capital city, Chandigarh, and designed its major public buildings.

Ledoux, Claude-Nicolas (1736–1806): French neo-classical architect of great imagination. The powerful geometry and symbolism of his work can be seen in his toll-houses, 1784–9, such as the Barrière de la Villette in Paris, and in his Salt Works at Arc-et-Senans, 1775–80, that formed the basis of his utopian industrial town of Chaux.

L'Enfant, Pierre (1754–1825): French painter and sculptor who fought in the American War of Independence. His plan for the new federal capital of Washington, DC, 1789, with its network of diagonal streets radiating from circular points was partially realised.

Lethaby, William Richard (1857–1931): English architect, surveyor and educator of great importance to the arts and crafts movement. He became the first principal of the Central School of Arts and Crafts, London, that based its principles on those of William Morris. His publications include *Architecture, Mysticism and Myth*, 1891, and *Westminster Abbey and the King's Craftsmen*, 1906. He explored mass concrete vaults and evocative forms, and his few buildings include Melsetter House and a chapel in Orkney, 1898, and the highly original All Saints Church, Brockhampton, Ross-on-Wye, Herefordshire, 1901–2.

Libeskind, Daniel (1946–): Polish-American architect, writer and architectural theorist who has created a number of dramatic and emotionally charged buildings. These include the Jewish Museum, Berlin, 2001, and the Imperial War Museum North, Trafford, Manchester, 2002 which is based on a shattered globe and fractured time zones.

load-bearing walls: walls that carry their own weight and that of the floors and roof.

Lockwood & Mawson: Henry Francis Lockwood (1811–78), Richard Mawson (1834–1904) and William Mawson (1828–89); a firm which practised in Bradford and subsequently in London. Works by the firm include Bradford Town Hall, 1869–73, and the layout and design of buildings at Saltaire, Yorkshire, a philanthropic project for the industrialist Sir Titus Salt.

Loos, Adolf (1870–1933): a Moravian architect who worked for three years in Chicago and then moved to Vienna. He entered the *Chicago Tribune* competition (1922), but did not win it. Loos favoured a stripped classical style and in his writing, such as *Ornament and Crime*, Vienna, 1908, was abusive in attacking the use of ornamentation.

Lutyens, Sir Edwin (1869–1944): a leading English architect. Many of his arts-and-crafts-influenced country houses were designed in conjunction with Gertrude Jekyll, the garden designer, including her own house, Munstead Wood, Surrey, 1896–9. He also designed in the classical style and was involved in the planning of New Delhi where he built

the Viceroy's House, 1912–31. He designed many war memorials in northern France and the Cenotaph in London, 1919–20.

Macdonald, Margaret (1865–1933): a Staffordshire-born artist-craftswoman who attended the Glasgow School of Art from 1891. With her sister Frances, Herbert MacNair and Charles Rennie Mackintosh formed The Four and contributed to the Glasgow artistic revival at the turn of the twentieth century. After her marriage to Mackintosh in 1900 she produced many designs in metal, gesso and embroidery for the interiors of his buildings.

machine aesthetic: an early twentieth-century modernist approach to architectural form inspired by industrially produced artefacts, new materials and technology. It consisted of smooth surfaces, simple geometric forms and elements taken from industrial architecture, machinery and transport. See also modernism.

McKim, Charles Follen (1847–1909): studied engineering at Harvard and architecture at the École des Beaux-Arts, Paris. From 1879 a partner in McKim, Mead and White, one of the largest and most successful firms in the US and worldwide. Inspired by the renaissance, the firm's projects were admired for their classical restraint, a major work being the Boston Public Library, 1895.

Mackintosh, Charles Rennie (1868–1928): Scots architect, designer and painter, a key figure in the Glasgow artistic revival. Influences included nature, the castles and manor houses of Scotland and later, the Vienna Secession. His concern with a distinct image for his designs over ethical principles earned him disapproval from the English arts and crafts fraternity. His work was exhibited in Vienna in 1900 and thenceforth became a stronger influence in Europe than in Britain. His major works include Glasgow School of Art, 1896–1909, Hill House, Helensburgh, 1902–3, Scotland Street School, 1906, and a number of tea rooms for Mrs Cranston in Glasgow.

mandala: geometric diagram symbolising the structure of the universe and often used as the basis for Buddhist, Hindu and Jain temple plans.

mannerism: associated with Italian architecture from Michelangelo to the early seventeenth century. It is characterised by the free application of classical motifs that is distinct from their hitherto normal usage.

mannerist: see mannerism.

mansard: a hipped roof with a double slope, the upper being less steep than the lower. Called a gambrel roof in the US.

Marxist: pertaining to the economic and political theories of Karl Marx, 1818–83.

masonry: work produced by a mason using stone although sometimes used to refer to brickwork.

mass concrete: see concrete.

Mawson, Richard: see Lockwood & Mawson.

Mawson, William: see Lockwood & Mawson.

Metabolists: a group of Japanese architects set up in Tokyo in 1960, who advocated the use of advanced technology to create changeable, flexible architecture. It included Kiyonori Kikutake and Kisho Noria Kurokawa.

mews: originally a row of stables with living quarters above, built at the rear of a town house, especially in London. Today, often converted into houses and apartments.

Michael Hopkins Associates: see Hopkins, Sir Michael.

Mies van der Rohe, Ludwig (1886–1969): German architect of central importance to the development of modernism. Mies was director of the Bauhaus (1930–3). In 1938 he became Professor of Architecture at the Illinois Institute of Technology, Chicago, and designed a variety of buildings based on his philosophy of 'less is more'. Key works include the Tugendhat House, Brno, Czech Republic, 1928–30, Lake Shore Drive Apartments, Chicago, 1948–51, and the Seagram Building, New York, 1954–8. In less talented hands his sophisticated detailing and massing resulted in the 'glass box' commercial architecture in the 1960s and 1970s that contributed to the reaction against modernism.

Miller, Sanderson (1716–80): contributed to the early phase of the gothic revival in England with the design of sham castles.

minaret: slender tower or turret near or connected to a mosque from which the muezzin calls people to prayer.

Ming dynasty (1368–1644): period of Chinese history when China pursued isolationist policies and the Great Wall was completed.

modernism: sometimes called the modern movement. A movement that emerged in the early twentieth century in western Europe among individuals and small groups of avant-garde architects and designers. Modernists shared a commitment to urbanism, new technology and materials, a rejection of historical ornament, and a desire to create solutions in planning, architecture and design symbolically appropriate to the modern world. After the Second World War modernism achieved worldwide dominance, particularly for post-war reconstruction, mass housing, commercial and public projects. Some architects moved beyond the machine aesthetic of earlier works, for example the expressive work of Eero Saarinen and the use of rough or brut concrete by Le Corbusier. The modernist faith in new materials and technology continues in the work of such contemporary architects as Norman Foster, Richard Rogers and Santiago Calatrava and is termed late modernist or high-tech. From the 1970s postmodernists attacked modernism for what they perceived as its lack of sensitivity to locale, its banal, repetitive and undecorated forms, lack of communication and the rigid application of zoning to planning.

modernist: see modernism.

monolith: a single stone of large dimensions.

monumental architecture: synonymous with polite architecture and applied to examples of high status architecture: public buildings,

churches, cathedrals, temples and mosques, palaces, castles and houses of the nobility. Monumental buildings may not necessarily be large in scale.

Moore, Charles (1925–94): studied at Michigan and Princeton universities. His reaction against modernism took the form of historicism and symbolism. This can be seen in the Piazza d'Italia, New Orleans, 1975–80, where he collaborated with the Urban Innovations Group (UIG) of Los Angeles, Perez Associates of New Orleans and Ron Filson.

Morris, William (1834–96): influential poet, writer, designer, theorist and, from the 1880s, a socialist. Influenced by John Ruskin and A. W. N. Pugin, Morris with friends set up a decorative arts firm in 1861. He became the principal theorist and inspiration behind the arts and crafts movement, espousing a democratic view of the arts, 'joy in labour' and ethical design principles. In lectures he attacked division of labour and showed the lessons of vernacular architecture, 'a truly popular art form'. Morris founded the Society for the Protection of Ancient Buildings in 1877 and his interests extended to conservation of the landscape, pollution and town planning. His publications include *The Earthly Paradise*, 1868–70, *Hopes and Fears for Art*, 1882 and *News from Nowhere*, 1890. His widespread influence continues today.

mortar: used as a bond between bricks or stone and made from cement or lime, sand and water.

mortice and tenon: joint between two pieces of timber at right angles to each other. A mortice is a slot in one member into which a tenon, or projection from the other member, is inserted and pinned or glued.

moulding: contour given to projecting or indented features of a building.

mullion: vertical post dividing a window into two or more lights.

muqarnas: in Islamic architecture multiple, closely packed, small concave niches in vaults, domes and arched recesses.

Nash, John (1752–1835): favourite architect of the Prince Regent (later George IV) for whom he designed Brighton Pavilion, 1802–21, Nash was a prolific architect, happy to work in a variety of styles. These ranged from picturesque thatched cottages to buildings in the Indian, Chinese, classical, Italianate and castellated gothic styles. His greatest work was the laying out of Regent's Park and Regent Street in London.

national romanticism: the turn towards national architectural traditions as part of a desire for national or regional identity. This took place at the end of the nineteenth and beginning of the twentieth centuries in Scandinavia, Catalonia, the UK, and the US and was linked to arts and crafts revivals. Major examples include Martin Nyrop, Copenhagen Town Hall, 1892–1902, Lars Sonck, Tampere Cathedral, Finland, 1899–1907, and Ragnar Ostberg, City Hall, Stockholm, 1909–23.

nave: western part of a church, where the congregation sits. It may or may not be flanked by side aisles.

neo-classicism: from the mid-eighteenth century in Europe and the US, a move away from the baroque and the rococo towards a revival of the

principles and spirit of ancient Greek and Roman architecture. The Grand Tour and the French Academy in Rome offered architects first-hand experience of ancient buildings, while other architects drew inspiration from the imaginative etchings of the Italian engraver Giovanni Battista Piranesi or from measured drawings such as those of the British architects James Stuart and Nicholas Revett. Not simply a sterile copying, but often a creative reworking of ancient forms and principles, neo-classical buildings vary from the rationalism of Jacques-Germain Soufflot's St Geneviève (later renamed the Pantheon), Paris, 1756–90, to the megalomania and geometry of Boullée's Monument to Newton, 1784, and the elegant, decorative buildings and interiors of Robert Adam in the UK.

neo-Georgian: a twentieth-century revival of architecture from the reigns of George I to IV in the UK and US. In practice mainly a restrained classical domestic architecture was revived through the use of brick, symmetry, proportions and sash windows. Since the Second World War there has been a debased version popular in some speculative housing where original classical features are adapted to suit new materials and taste, for example, miniaturised fanlights in the upper part of the door instead of above the door opening, or ill-proportioned columns. This is not to be confused with the New or Real Classicism of Quinlan Terry and Leon Krier who aimed to reassert scholarly classicism.

Neumann, Johann Balthasar (1687–1753): outstanding German baroque and rococo architect and engineer recognised for his dramatic use of space. Widely acclaimed is his planning of the Pilgrimage Church of Fourteen Saints (Wallfahrtskirche Vierzehnheiligen), Franconia, Germany, 1742–72.

Nicholas Grimshaw and Partners: see Grimshaw, Sir Nicholas.

Norman: style of architecture introduced to Britain after the Norman Conquest in 1066. It lasted until the end of the twelfth century and is characterised by massive piers and walls, and semicircular arches. Elsewhere in western Europe it is called romanesque.

obelisk: a tapering shaft of stone, often square in section, with a pyramidal top. Introduced to Europe under the Roman Empire from Egypt, it subsequently became associated with funerary and commemorative architecture.

open plan: an interior space which is unimpeded by subdividing walls, although it may have moveable partitions. Much favoured by modernists, the open plan in theory allowed space to be organised as the users wished. In practice it meant that it was impossible for the various members of a household or office to pursue different activities within the space without conflict.

order: in classical architecture each column (Doric, Tuscan, Ionic, Corinthian and composite) and its entablature (the lintel or architrave, frieze and cornice) with their distinct characteristics. Known as the classical orders.

Although authorities have sought to codify the precise features of each order, including dimensions and decoration, architects during antiquity and since have often developed or tailored the forms and even created new orders.

composite: Roman order; the capital of the column combines Ionic volutes and Corinthian acanthus leaves. The entablature is very ornate.

Corinthian: the most elaborate of the classical orders. It first appeared in Greece in the late fifth century BC and was developed by the Romans. The tall, slender shaft of the column is fluted and the capital ornamented with foliage, usually the acanthus leaf. Initially the entablature was similar to the Ionic order but later it became very ornate.

Doric: classical order originating in the early seventh century BC. The Greek Doric column shaft is fluted and has no base, whereas the Roman Doric column has a base. The curved capital or echinus is capped by a thin square slab or abacus. The entablature has a frieze consisting of alternating blocks with vertical grooves called triglyphs and either plain or decorated panels known as metopes.

Ionic: originated in the seventh century BC in Asia Minor (Turkey) and developed by both the Greeks and the Romans. The characteristic feature of the column is a capital with spiral projections or volutes. There may be two volutes on each face, or rolled cushions on either side of the capital, showing as volutes only on the rear and front face. Treatment of the entablature varies: often the architrave or lintel has three overlapping flat bands and the cornice includes a dentil course – a series of regularly spaced small blocks.

Tuscan: the simplest of the orders. It has a plain frieze. The column has a base, plain shaft and capital. It is believed to be derived from Etruscan temples.

Ordish, R. M.: see Barlow, William Henry and Ordish, Roland M.

Palladianism: strict classical style deriving from the ideas and work of Andrea Palladio. Palladian architecture involved rules of proportion, the temple front, and the Venetian window (window with triple openings, the central one arched and taller). In Britain it was introduced first by Inigo Jones and subsequently in the early eighteenth century by Colen Campbell at Wanstead House, Essex, *c.*1713–20 and Mereworth Castle, Kent, 1722–5, and Lord Burlington at Chiswick House, London, *c.*1723–9.

Palladio, Andrea (1508–80): the most influential of Italian renaissance architects, Palladio sought to revive Roman ideas of planning and harmonic proportion. He introduced the idea of temple front porticoes on his villas, and his influential villa La Rotonda, Vicenza, (1567) featured porticoes on all four façades. In 1570 he published his *Quattro Libri dell'Architettura* in which he set out his theories of architecture and his achievements as an architect.

pantheon: literally a temple to all the gods. The Pantheon in Rome, AD 118 to *c.* AD 128, featured the largest concrete dome of the period. It was visited on the Grand Tour and inspired many owners of land-scaped gardens to include smaller copies in their gardens.

pantile: S-shaped roof tile.

parapet: a low wall placed for protection where there is a sudden drop, such as on a rooftop, or the edges of a bridge.

Parsons, William (1796–1857): early nineteenth-century architect who worked mainly in Leicester.

Paxton, Sir Joseph (1803–65): head gardener to the Duke of Devonshire at Chatsworth, where he initiated a new system of iron and glass construction for greenhouses. This provided the experience and inspiration for his design of the Crystal Palace, 1851, the first large-scale prefabricated building.

Pei, Ieoh Ming (1917–): born in China, emigrated to the US in 1935. Head of a prolific architectural practice and acclaimed for the glass pyramid, 1983–93, which forms the new entrance to the Louvre in Paris. Other work includes the Bank of China, Hong Kong, 1982–90.

peripteral colonnade: a single row of columns surrounding a building.

Piano, Renzo (1937–): Italian architect best known for his work with Richard Rogers on the Pompidou Centre in Paris, 1971–7, a key late modernist building, and independently, the Olympic Stadium, Ban, Italy, 1989. Subsequent works include the Kansai Airport Terminal, Osaka, Japan, 1994, and the Basilica of San Giovanni Rotondo, Puglia, Italy, begun 1995.

piano nobile: the main floor of a house containing the reception rooms, usually at first-floor level. Often the height from floor to ceiling was greater than the other storeys and characterised by taller windows on the main façade.

picturesque: an influential English taste for association of ideas, eclecticism, asymmetry, intricacy, variety and surprise. Meaning 'scenes in nature well suited to representation in pictures', it derived from the seventeenth-century Italianate landscape paintings of Claude Lorrain and Nicholas Poussin and initially influenced landscape design in the early eighteenth century. In architecture it was much in evidence in the work of John Nash and was popularised by pattern books published in the late eighteenth and early nineteenth centuries.

piers: a solid masonry support, more bulky than a column, from which arches spring as in an arcade in Norman architecture or between openings in buildings.

pilaster: a rectangular column projecting slightly from a wall. In classical architecture it conforms to the order used.

pile: a concrete or timber pole driven into the ground to provide a foundation.

pilotis: stilts or pillars which raise a building off the ground.

plan: horizontal section of a building, or a drawing or diagram depicting this.

plane: flat two-dimensional surface, such as that of a wall or floor.

plinth: projecting base of a wall; pedestal.

podium: a continuous base supporting a monumental structure with columns high above the ground, such as a Roman temple.

postmodernism: an international movement in many artistic and academic fields, including architecture, that addresses major changes in advanced capitalist society and culture since the late 1960s. Advocates criticise the Enlightenment and the modernist narrative of universality, progress and science, seen as authoritarian and insensitive to world cultures and individual needs. They support pluralism, relativism, fragmentation, and, in architecture, the use of historical, cultural and local references, often eclectic, to encourage communication with different communities.

prairie house: associated with the early domestic work of Frank Lloyd Wright from 1901, but linked to a broader group of architects including George Maher, Myron Hunt and others called the Prairie School. Their small town buildings and houses symbolised the ethos of the mid-western states of the US and were influenced by the climate and open prairies featuring low, horizontal lines with lengthy projecting roofs and open plans.

Price, Uvedale (1747–1829): landscape garden theorist and friend of Richard Payne Knight, Price defined the picturesque in a three-volume *Essay on the Picturesque*, which was his reply to Knight's poem *The Landscape*.

Prior, Edward (1852–1932): English arts and crafts architect whose butterfly-plan houses took advantage of the views. He used local materials to link his houses physically with their immediate environment.

Pugin, Augustus Welby Northmore (1812–52): extremely influential English architect, designer, theorist, critic and draughtsman with an extensive knowledge of medieval architecture. He converted to Catholicism in 1835 and through his many publications, such as *Contrasts*, 1836, and *The True Principles of Pointed or Christian Architecture*, 1841, severely attacked classical architecture as pagan. He campaigned for an archaeologically correct, revived gothic architecture based on rational and moral principles rather than copying medieval works. He was a prolific designer of churches and their contents, and assisted in the design of the Houses of Parliament, 1835–68. His buildings include St Giles, Cheadle, in Staffordshire, 1841–6, St Barnabas Cathedral, Nottingham 1842–4, and at Ramsgate, his own house, the Grange, 1843, and church, St Augustine's, 1846–51.

purlins: horizontal timbers that carry the common rafters of a roof. The purlins are supported on the roof trusses.

Queen Anne: pertaining to the reign of Queen Anne, 1702–14.

Queen Anne revival style: an eclectic and flexible style in England in the late 1860s and 1870s associated with the work of Richard Norman Shaw, William Eden Nesfield, John James Stevenson and Edward Robert Robson. Fashionable in artistic circles for houses and studios, it was also used for school buildings and known as the architecture of 'sweetness and light'. With sources in English seventeenth-century and early eighteenth-century urban vernacular architecture, the picturesque and gothic revival, it featured red brick, steeply pitched roofs, shaped and Dutch gables, tall chimneys, asymmetrical compositions, tall sash windows, classical pilasters and mouldings, and aesthetic movement motifs such as sunflowers. Craftwork such as gauged and cut brickwork, moulded terracotta, wrought iron, carved and turned wood and leaded glass were much in evidence.

rafter: inclined timber which forms the side of a roof, which supports the roof covering.

rationalism: a view of architecture as a science that can be understood logically. It is also applied to the work and ideas of neo-classical and gothic revival architects and theorists of the eighteenth and nineteenth centuries, such as Marc-Antoine Laugier and Eugène-Emmanuel Viollet-le-Duc, who emphasised the skeleton or essential load-bearing structure of a building as the primary visible element in architectural design. This metaphorical approach to rationalism in design is exemplified in the 'skin and bones' architecture of Mies van der Rohe. Sometimes called structural rationalism.

rationalist: see rationalism.

renaissance: a style which developed in Italy in the fifteenth century and spread throughout Europe. It represented a return to Roman standards and motifs but in France, Germany, the Low Countries and Britain it developed regional variations.

Repton, Humphry (1752–1818): leading English landscape gardener of the generation succeeding 'Capability' Brown and prolific writer on the theory and practice of the subject.

Repton, John Adey (1775–1860): architect and son of Humphry, John Adey worked in the office of John Nash, but was not always given credit for his work.

revival: return to the forms of an earlier style.

ribbon development: the development of buildings alongside newly built main roads.

Richardson, Henry Hobson (1838–86): studied both in the US and the École des Beaux-Arts, Paris. Inspired by romanesque architecture, his public and commercial projects have monumental masonry forms and round-arched openings. Major projects include Trinity Church, Boston, 1873–7, and Marshall Field Wholesale Warehouse, Chicago, 1885–7.

Roche, Martin: see Holabird and Roche.

rococo: the last phase of the baroque in the early eighteenth century in France, Austria and south Germany. Characterised by decoration that is light in colour and form, even frivolous, asymmetrical and employing shell-like C and S curves. The rococo style is rare in England, but is sometimes associated with the use of Chinese and early gothic revival forms (gothick).

Rogers, Richard (1933–): Italian-born UK late modernist architect well known for the design of the Pompidou Centre, Paris, 1971–7, with Renzo Piano, and, as the Richard Rogers Partnership, the Lloyds Building in London, 1978–86, and Channel Four Television Headquarters, London, 1990–4.

Root, John Wellborn: see Burnham and Root.

rotunda: a circular building, often with an encircling colonnade and a dome.

Ruskin, John (1819–1900): English writer and critic who had an immense influence on both the gothic revival and the arts and crafts movement. His major writings include *The Seven Lamps of Architecture*, 1849, and *The Stones of Venice*, 1851–3, where he pleaded for inventiveness, craftwork and pleasure in labour, stressed honesty, structural polychromy and vigorous naturalistic ornament, and promoted Italian, particularly Venetian, gothic architecture.

rusticated: refers to rustication, that is, masonry composed of large blocks of stone with deep joints, generally reserved for the lower part of the wall. There are several variations in the treatment of the stone from rock-faced (roughly cut) to vermiculated (appearing to be worm-eaten) and the jointing from chamfered (V-shaped joints) to banded (emphasis on the horizontal joints). Sometimes rendered walls are incised or grooved to appear like rustication.

Saarinen, Eero (1910–61): Finnish-born American architect much influenced by Mies van der Rohe in his early career. Saarinen was among the leaders of the reaction against modernist minimalist architecture and the search for more expressive forms. This can be seen in his TWA Building, Kennedy Airport, New York, 1956–62, with its sculptural forms expressing flight.

sanctuary: a sacred cell within a church or temple, often containing a statue of a deity.

Scott, Sir George Gilbert (1811–78): prolific English restorer and architect who built workhouses, churches and many public buildings. He was in partnership with William Boynton Moffatt, 1838–45. He moved on from the influence of A. W. N. Pugin to espouse high Victorian gothic, publishing *Remarks on Secular and Domestic Architecture*, 1857. His most important works are St Nikolaus, Hamburg, 1844 and in London, the Foreign and War Office in Whitehall, 1862–73 (which he was forced by Lord Palmerston to design in renaissance style), the Albert Memorial, 1862–72, and The Midland Grand Hotel, St Pancras Station, 1868–74.

Scott, Henry: see Fowke, Captain Francis, and Scott, Henry.

semiological: pertaining to the study of signs and symbols.

shaft: the trunk of a column between the capital and the base.

shingles: wooden tiles used for covering roofs and walls.

Short, Alan and Associates: see Alan Short and Associates.

Smirke, Sydney (1798–1877): English architect mainly known for the Carlton Club, London, 1854–6, and for the Reading Room at the British Museum, London, 1854–7.

Soane, John (1753–1837): outstanding English neo-classical architect who developed his own personal style influenced by the picturesque, M.-A. Laugier, G. B. Piranesi and Greek, Roman and Egyptian sources. His varied works are characterised by the use of different height spaces, segmental arches and domes, top lighting and the reduction of extraneous ornament. As surveyor to the Bank of England from 1788 he designed several banking halls and offices. He was Professor of Architecture at the Royal Academy from 1806. Among his extant works are his own house, No. 13 Lincoln's Inn Fields, London, 1812–13, now Sir John Soane's Museum, and Dulwich College Art Gallery and Mausoleum, 1811–14.

spandrel: the triangular space either side of the apex of an arch. Also applied to the panel between windows on successive floors of a framed building.

Spanish tile: roofing tile of half cylinder shape, but wider at one end.

springing: impost or the point at which an arch meets its support.

squinch: in buildings where a polygonal or circular superstructure, e.g. dome, is placed onto a square building, squinches are placed to make the transition between the square and the polygonal or circular form. A squinch is an arch or series of arches of increasing size and projection.

stanchion: a vertical supporting member usually of steel.

Stanley Tigerman Associates: see Tigerman, Stanley.

steel frame: steel structure which carries the load of a building instead of load-bearing walls.

Steiner, Rudolph (1861–1925): German scientist, mathematician, artist, writer and founder of the Anthroposophical Society. The buildings erected for this society in Dornach, Switzerland, from 1913 are attributed to him, but several architects were involved.

Stirling, James (1926–92): key English architect whose reputation was established with the Engineering Building, University of Leicester, 1959–63, with James Gowan. The architects reworked modernism, designing a contextually sensitive red-tile clad concrete tower and laboratories with glazed industrial angular roof-lights. The internal exposed structure and pipes adumbrated high tech. Stirling, with Michael Wilford, won further acclaim with the postmodern Stuttgart Staatsgalerie Extension, completed 1984.

strapwork: sixteenth-century and seventeenth-century decoration in northern Europe, particularly Flanders, France and England, in the form of interlaced bands.

string-course: a thin horizontal band of moulding on the exterior of a building.

structural rationalism: see rationalism.

structuralism: developed in the 1950s by the linguist Ferdinand de Saussure and the cultural anthropologist Claude Lévi-Strauss. It is a study of all social and cultural practices within a particular culture, including language, to uncover the relationships or codes, rules and meaning. In the 1970s post-structuralism replaced structuralism with a variety of approaches that challenge assumptions, identify fault lines in language or cultural systems and assert multiple relationships and meanings. Theorists in this field include Jacques Derrida, Michael Foucault, Jacques Lacan and Roland Barthes.

stupa: a hemispherical Buddhist funerary mound.

Sullivan, Louis (1856–1924): American architect and theorist who joined Dankmar Adler in Chicago to form Adler & Sullivan, 1881–1895. Major works include the Auditorium, 1886–90, and the Transportation Building, 1893, in Chicago, the Wainwright Building, St Louis, 1890–91, and the National Farmers' Bank, Minnesota, 1907–8. Sullivan is famous for his vigorous spiky ornament and the slogan 'form follows function'. His writings include *The Tall Office Building Artistically Considered*, 1896, and *Kindergarten Chats*, 1901.

system-building: architecture based on assemblies of prefabricated components.

tatami mat: a Japanese floor mat, made from rice stalks and to a standard size.

tenon: see mortice and tenon.

Terry, Quinlan (1937–): English architect and keen advocate of revived classical architecture. His works include Waverton House, Gloucestershire, 1979–80 and the Maitland Robinson Library, Cambridge, 1989–93.

tie rods/beams/bars: used to tie together two members, such as walls that are in danger of falling outward.

Tigerman, Stanley (1930–): American architect who became interested in postmodernism, eclecticism and metaphor.

tile hanging: the cladding of walls with tiles.

timber frame: a frame structure made of timber.

trabeated: construction using vertical posts and horizontal beams or lintels.

tracery: decorative work subdividing screens, panels or more generally the upper part of windows.

 curvilinear: ornamental intersecting work composed of moulded mullions, stone bars or ribs of compound or ogee curves found in the upper part of windows. Associated with the English decorated gothic style.

 plate: decorative pierced stonework in a window head to create geometrical openings often in the form of a roundel or quatrefoil, found in

late twelfth-century and early thirteenth-century English gothic architecture.

transept: the transverse arm of a cruciform church.

transom: cross bar or beam.

triforium: gallery or arcaded wall passage facing onto the nave, at a level below the clerestory and above the arcade.

truss: rigid triangular framework of timbers that carry the common rafters and the roof covering.

Tschumi, Bernard (1944–): Swiss architect and theorist based in Paris and New York and associated with deconstruction.

Turner, Richard (1798–1881): ironmaster of the Hammersmith Ironworks, Dublin, and expert in hothouses, palm houses and heating systems. He established his reputation with the Palm House at Belfast Botanic Gardens where he constructed the curvilinear wings, 1839, and with the curvilinear range at the National Botanic Gardens, Glasnevin, Ireland, which he designed and built, 1843. The Palm House at Kew (1844–8) combined both his and Decimus Burton's ideas.

turret: a small tower.

Tuscan column: see order, Tuscan.

tympanum: the area above the lintel of a doorway and below the arch above it; the space enclosed by the mouldings of a pediment.

Utzon, Jørn (1918–): Danish architect and winner of the competition to design the Sydney Opera House, 1956–73.

van Alen, William (1883–1954): US architect who studied at the École des Beaux-Arts in Paris and designed high-rise commercial buildings. The best known, the Chrysler Building, New York, 1928–30, combines modern construction with art deco ornament based on automobile motifs.

Vanbrugh, Sir John (1664–1726): foremost English baroque architect and playwright whose buildings include Castle Howard, 1699–1726, and Blenheim Palace, 1705–24.

van der Rohe, Mies: see Mies van der Rohe, Ludwig.

Vasari, Giorgio (1511–74): Italian painter, author of the famous *The Lives of the Italian Architects, Painters and Sculptors*, 1550, and architect of the Uffizi, 1560–80s, in Florence. Vasari's admiration and promotion of the work of Michelangelo had an enormous influence on architectural taste.

vault: an arched roof or ceiling of brick, stone or concrete.

Venturi, Robert (1925–): American postmodern architect and theorist whose *Complexity and Contradiction in Architecture*, 1966, and *Learning from Las Vegas*, published with Denise Scott-Brown and Steven Izenour, 1972, provided a theoretical basis for postmodern architecture. Among his most recent buildings, in conjunction with the above partners, is the Sainsbury Wing at the National Gallery, London (1986–91).

vermiculated: shallow, wavy groove-like decoration similar to worm tracks.

vernacular architecture: local or regional, self- or community-built, secular and sacred architecture using local materials and style. Sometimes called folk, peasant, primitive or traditional architecture.

vernacular revival style: see domestic revival.

Viollet-le-Duc, Eugène-Emmanuel (1814–79): French architect, writer, scholar and restorer. His ideas on architecture and, in particular, gothic as a rational style were published in his ten-volume *Dictionaire raisonné de l'architecture française*, 1854–68, and his two-volume *Entretiens sur l'architecture*, 1863 and 1872. He influenced not only his contemporaries, but also the succeeding generation of architects, such as Victor Horta and Hector Guimard.

vista: a closely framed view or prospect, especially as seen through an avenue.

Vitruvius Pollio, Marcus (active 46–30 BC): Roman architect and theorist of enormous influence in the early renaissance, his ten-volume treatise on architecture, *De Architectura*, was the only one to survive from antiquity.

Voysey, Charles Francis Annesley (1857–1941): designer and architect who became a leading member of the arts and crafts movement in Britain. He designed fabrics, wallpaper, metalwork and furniture and built mainly houses including Broadleys, Lake Windermere, 1898, and his own house, The Orchard, Chorley Wood, 1899–1900.

wall plane: two-dimensional surface of a wall.

Wallis, Gilbert & Partners: Thomas Wallis (1872–1953); UK architectural practice that specialised in industrial buildings and initially collaborated with the American Trussed Concrete Steel Ltd. Well known for factories along the Great West Road in west London, such as the Firestone Tyre and Rubber Company, 1928, and Hoover Ltd, 1931–8; also the India Tyre and Rubber Company Factory and Offices, Inchinnan, Scotland, 1929.

Walpole, Horace (1717–97): a patron and promoter of the revived gothic style in the mid-eighteenth century. His own house, Strawberry Hill, Twickenham, from 1750, was designed in a fanciful gothick style.

weatherboarded: an external cladding of overlapping horizontal timber boards.

Webb, Philip (1831–1915): important architect of the English domestic revival and the arts and crafts movement. Best known for Red House, 1859–60, for William Morris and for his involvement with William Morris in the Society for the Protection of Ancient Buildings, 1877.

Winckelmann, Johann Joachim (1717–68): German scholar and art historian who worked as a librarian, mainly in Rome. He rose to fame mainly from promoting Greek works of art, although he never visited Greece.

Wood, John, elder and younger: John Wood (1704–54) and John Wood (1728–81), English architects. John Wood the elder's design for Prior Park, Bath, 1735–48, was Palladian in style, but it was his redesign of the town of Bath (Queen Square and the Circus) which was his major achievement. His son, who designed the Royal Crescent, carried on his work.

Wren, Sir Christopher (1632–1723): has been called England's greatest architect, for after the fire of London, 1666, he designed his masterpiece, St Paul's Cathedral, and 51 city churches. His secular works include Chelsea Hospital, 1682–92, Greenwich Hospital, from 1696, Tom Tower, Christchurch, Oxford, 1681–2, as well as many additions and alterations to major buildings.

Wright, Frank Lloyd (1869–1959): America's greatest architect, whose work over his long life continually explored new ideas, from the early Chicago suburban houses including the prairie houses after 1901 to mass-production houses and the low-density planning ideas of Broadacre City, 1931–5; from the Imperial Hotel, Tokyo, 1916–20, and the Johnson Wax Factory, Racine, 1936–9, to the Guggenheim Museum, New York, designed 1942, built 1960.

Notes

2 Architecture and building

1 Le Corbusier, *Towards a New Architecture*, London, Architectural Press, 1946, p. 31.
2 *Ecclesiologist*, vol. 41, 1851, p. 269.
3 Paul Oliver (ed.), *Encyclopaedia of Vernacular Architecture of the World, Vol. 1*, Cambridge, Cambridge University Press, 1997, pp. viii and xxii.
4 N. Pevsner, *A History of Building Types*, London, Thames & Hudson, 1976.
5 Christopher Wilson, *The Gothic Cathedral*, London, Thames & Hudson, 1990, pp. 11, 140–1.
6 Qinghua Guo, 'Yingzao Fashi: Twelfth-Century Chinese Building Manual', *Architectural History*, vol. 41, 1998, pp. 1–13.
7 Robert Hillenbrand, *Islamic Architecture*, Edinburgh University Press, 1994, pp. 26–8.
8 RIBA MSS, SP4/1, 15 June 1835.
9 *The Builder*, vol. 34, 1876, p. 10, quoted in J. Mordaunt Crook, 'Architecture and history', *Architectural History*, vol. 27, 1984, p. 556.
10 N. Pevsner (founding ed.), *The Buildings of England*, revised by B. Cherry, Harmondsworth, Penguin, 1951–.
11 Andrew Ballantyne, 'The Curse of Minerva', *Society of Architectural Historians' Newsletter*, no. 51, spring 1994, pp. 1–2.
12 Prince Charles, *A Vision of Britain*, London, Doubleday, 1989, p. 45.
13 R. Dixon and S. Muthesius, *Victorian Architecture*, Thames & Hudson, 1978, pp. 160–4.
14 C. Jencks, *The Language of Post-Modern Architecture*, London, Academy Editions, 5th edn, 1987.
15 His spiral extension to the Victoria and Albert Museum, London, remains on the drawing board at the time of writing.
16 P. Blundell Jones, 'In search of authenticity', *Architects' Journal*, 1991, 30 October, pp. 26–30; 6 November, pp. 32–6; 4 December, pp. 22–5; 1992, pp. 8–15 January, pp. 29–32.

3 Architectural history

1 Giorgio Vasari, *The Lives of the Artists*, translated by George Bull, Harmondsworth, Penguin, 1965, pp. 32, 38–9. First edition, 1550; Bull's translation largely used the second edition of 1568, Florence.
2 Lynne Walker, 'Women and architecture' in J. Rendell, B. Penner and I. Borden (eds), *Gender, Space, Architecture: An Interdisciplinary Introduction*, London, Routledge, 2000, pp. 244–57.
3 D. Watkin, *The Rise of Architectural History*, London, Architectural Press, 1980.

4 Ibid., Chapter 2.
5 Colin Cunningham, 'James Fergusson's *History of Indian Architecture*' in Catherine King, *Views of Difference: Different Views of Art*, New Haven and London, Yale University Press, 1999, pp. 43–66.
6 Sheila S. Blair and Jonathan A. Bloom, 'The mirage of Islamic art: reflection on the study of an unwieldly field', *Art Bulletin*, vol. 85, no. 1, March 2003.
7 John Summerson, 'What is the history of construction?' in *Construction History*, vol. 1, 1985, pp. 1–2.
8 Nicola Coldstream, 'The middle pointed revival: a medievalist's view' in Frank Salmon (ed.), *Gothic and the Gothic Revival*, Papers from the Symposium of the Society of Architectural Historians of Great Britain, 1997.
9 A. W. N. Pugin, *Contrasts*, Leicester University Press, 1973, p. 2.
10 D. Watkin, *Morality and Architecture*, Oxford, Clarendon Press, 1977.
11 See Dan Sperber, 'Claude Lévi-Strauss' in John Sturrock (ed.), *Structuralism and Since*, Oxford, Oxford University Press, 1979.
12 See: Paul Oliver, *Dwellings Across the World*, Oxford, Phaidon, 1987, p. 155; Peter Nabakov and Robert Easton, *Native American Architecture*, New York/Oxford, Oxford University Press, 1989, p. 330; Susan Kent, 'Navajo: Hogan Symbolism' in Paul Oliver, *Encyclopaedia of Vernacular Architecture of the World*, Cambridge, Cambridge University Press, 1997, vol. 3, pp. 1935–6.
13 Peter Nabakov and Robert Easton, *Native American Architecture*, New York/Oxford, Oxford University Press, 1989, p. 330.
14 Tom Turner, *City as Landscape, A Post Postmodern View of Design and Planning*, London, E. & F. Spon, 1996.
15 Regius Professor of History, Oxford, 1884, quoted in J. M. Crook, 'Architecture and history', *Architectural History*, vol. 27, 1984, p. 570.
16 M. Swenarton, 'The role of history in architectural education', *Architectural History*, vol. 30, 1987.
17 *Architects' Journal*, 12 June, 1991, p. 14.

4 Space and function

1 George Michell, *The Penguin Guide to the Monuments of India*, vol. 1, Harmondsworth, Penguin Books, 1989, pp. 65–6.
2 A. Vidler, *Claude-Nicholas Ledoux*, Cambridge, Mass., MIT Press, 1990, p. 314.
3 Anthony Quiney, *The Traditional Buildings of England*, London, Thames & Hudson, 1990, pp. 60–92.
4 Lucy Caffyn, *Workers' Housing in West Yorkshire 1750–1920*, London, HMSO, 1986; Jack Reynolds, *The Great Paternalist: Titus Salt*, London, Maurice Temple Smith and St Martin's Press, 1983, pp. 267–9.
5 D. Hayden, *The Grand Domestic Revolution*, Cambridge, Mass., MIT Press, 1981, pp. 108–10.
6 Rowan Roenisch, 'Mental maps and shifting settlements: the invisible boundaries of the Shona and Tonga home' in *Traditional Dwellings and Settlements Working Papers Series: Politics of Cartography*, University of California at Berkeley, vol. 144, 2003, pp. 17–54.
7 Dariush Zandi, 'Bahrain (Gulf)' in Paul Oliver, *Encyclopaedia of Vernacular Architecture of the World*, vol. 2, Cambridge, Cambridge University Press, 1997, pp. 1449–5.
8 Robert Tavernor, *Palladio and Palladianism*, London, Thames & Hudson, 1991, p. 41.
9 George Michell, *The Penguin Guide to the Monuments of India: Buddhist, Jain, Hindu*, Harmondsworth, Penguin, 1989, pp. 63–4.

10 J. J. Coulton, *Greek Architects at Work*, London, Granada, 1982, pp. 59–65.
11 Rhys Carpenter, *The Architects of the Parthenon*, Harmondsworth, Penguin, 1970, p. 113.
12 J. J. Coulton, *Greek Architects at Work*, London, Granada, 1982, pp. 108ff.
13 Vitruvius, *De Architectura Books I–IV*, London, Heinemann/Cambridge, Mass., Harvard University Press, 1970, pp. 207–9.
14 R. Wittkower, *Architectural Principles in the Age of Humanism*, London, Tiranti, 1962, pp. 109–10.
15 Le Corbusier, *The Modular*, London, Faber & Faber, 1967.
16 R. Wittkower, *Architectural Principles in the Age of Humanism*, London, Tiranti, 1962, p. 7.
17 Robert Hillenbrand, *Islamic Architecture*, Edinburgh University Press, 1994, p. 455.
18 T. Benton and C. Benton, *The International Style*, Milton Keynes, The Open University, 1975, p. 37.
19 *The Architects' Journal*, 1997, 29 May, pp. 23–9.
20 John Norton, 'Cooling' in Paul Oliver, *Encyclopaedia of Vernacular Architecture of the World*, Cambridge, Cambridge University Press, 1997, vol. 1, p. 461.
21 Bernard Rudofsky, *Architecture Without Architects*, London, Academy Editions, 1973, figs 114 and 115.

5 Drawings and models

1 A. D. King, *The Bungalow*, London, Routledge & Kegan Paul, 1984.
2 Jill Franklin, *The Gentleman's Country House and Its Plan 1835–1914*, London, Routledge & Kegan Paul, 1981, p. 130.
3 Laurence G. Lui, *Chinese Architecture*, London, Academy Editions, 1989; David Lung, *Chinese Traditional Vernacular Architecture*, Hong Kong, Regional Council, 1994.
4 David Lung, *Chinese Traditional and Vernacular Architecture*, Regional Council, Hong Kong, 1994, illustration 3, p. 23.
5 Andrew Boyd, *Chinese Architecture and Town Planning 1500 BC–AD 1911*, London, Tiranti, 1962, p. 69.
6 J. Summerson, *The Classical Language of Architecture*, London, Thames & Hudson, 1985.
7 Malcolm Quantrill, *Alvar Aalto*, London, Secker & Warburg, 1983.
8 J. Wilton-Ely, 'The architectural model', *Architectural Review*, vol. 142, 1967, pp. 27–32.
9 M. Richardson, 'Model architecture', *Country Life*, vol. 183, no. 38, 21 September 1989, pp. 224–7.
10 J. Physick and M. Darby, 'The architectural model during the Victorian period', *Marble Halls*, Exhibition Catalogue, London, Victoria and Albert Museum, 1973, pp. 13–16.
11 B. Fortier and P. Prost, *Casabella*, vol. 51, no. 533, March 1987, pp. 44–53.
12 A. Bussell, *Progressive Architecture*, vol. 70, no. 7, July 1989, p. 21.
13 C. van Bruggen, *Frank O. Gehry, Guggenheim Museum, Bilbao*, New York, The Solomon R. Guggenheim Foundation, 1997.

6 Materials and construction

1 D. Hey, *Packmen, Carriers and Packhorse Roads*, Leicester, Leicester University Press, 1980, p. 122.
2 A. Welby Pugin, *The True Principles of Pointed or Christian Architecture*, London, Academy Editions, 1973, pp. 33–4.
3 W. H. Pierson, Jr, *American Buildings and Their Architects: the Colonial and Neo-Classical Styles*, New York, Anchor Books, 1976, p. 461.

4 Peter Collins, *Concrete*, London, Faber, 1959.

5 R. Ettinghausen and O. Grabar, *The Art and Architecture of Islam 650–1250*, Pelican History of Art, Harmondsworth, Penguin, 1987, pp. 217–18.

6 Further information can be found in J. E. Gordon, *Structures: or Why Things Don't Fall Down*, Harmondsworth, Penguin, 1983, and Mario Salvadori, *Why Buildings Stand Up*, New York, W. W. Norton, 1990.

7 C. W. Condit, *The Chicago School of Architecture*, Chicago, University of Chicago Press, 1975, p. 23.

8 P. Blake, *Frank Lloyd Wright: Architecture and Space*, Harmondsworth, Penguin, 1963, p. 69.

9 Michael Ball, *Rebuilding Construction*, London, Routledge, 1988, p. 8.

10 For the many varieties of arch and vault, see J. Fleming, H. Honour and N. Pevsner, *The Penguin Dictionary of Architecture and Landscape Architecture*, Harmondsworth, Penguin, fifth edition, 1999, or J. S. Curl, *Oxford Dictionary of Architecture*, Oxford, Oxford University Press, 1999.

11 J. E. Gordon, *Structures: or Why Things Don't Fall Down*, Harmondsworth, Penguin, 1983, p. 216.

12 L. G. Liu, *Chinese Architecture*, London, Academy Editions, 1989, p. 93.

7 The exterior

1 George Michell, *The Penguin Guide to the Monuments of India*, vol. 1, Harmondsworth, Penguin, 1990, p. 668.

2 N. Pevsner, *An Outline of European Architecture*, Harmondsworth, Penguin, 1968, p. 238.

3 *Chambers Twentieth Century Dictionary*, Edinburgh, Chambers, 1987, p. 100.

4 Robert and James Adam, *The Works in Architecture of Robert and James Adam (1773)*, London, John Tiranti and Company, 1931, vol. 1, p. v.

5 A. Ballantyne, 'Downton Castle: function and meaning', *Architectural History*, vol. 32, 1989.

6 See also Mendelssohn and Chermayeff, House at Chalfont St Giles, Buckinghamshire, 1935.

7 J. Summerson, *The Classical Language of Architecture*, London, Thames & Hudson, 1985, p. 26.

8 R. Wittkower, *Architectural Principles in the Age of Humanism*, London, Tiranti, 1962, pp. 45–7.

9 Le Corbusier, *Towards a New Architecture (Vers une Architecture, 1923)*, London, Architectural Press, 1970, p. 23.

10 R. Bofill, *Architectural Design*, 5/6, 1980.

8 Styles and periods

1 W. H. Pierson, Jr, *American Buildings and their Architects: The Colonial and Neoclassical Styles*, New York, Anchor Books, 1976, pp. 417–18.

2 T. R. Metcalf, *An Imperial Vision: Indian Architecture and Britain's Raj*, London, Faber & Faber, 1989, pp. 55ff. and 92–4.

3 C. Tadgell, *The History of Indian Architecture*, London, Phaidon, 1990, p. 246.

4 Dr Crispin Branfoot kindly suggested this example.

5 C. F. A.Voysey, *Individuality*, London, Chapman & Hall, 1915.

6 Quoted in D. Watkin, *The English Vision*, London, John Murray, 1982, p. 51.

7 A. Hauser, *The Social History of Art*, London, Routledge Kegan Paul, 1962, p. 30.

8 J. M. Crook, *The British Museum*, Harmondsworth, Penguin, 1973, p. 19.

9 Daniel Bluestone, *Constructing Chicago*, New Haven and London, Yale University Press, 1991.

9 Site and place

1 T. Smollett, *Humphrey Clinker*, London, Everyman, 1968, p. 34; first published 1760.
2 L. G. Liu, *Chinese Architecture*, London, Academy Editions, 1989.
3 A. Jackson, *Semi-detached London*, London, Allen & Unwin, 1973.
4 Jane Jacobs, *The Death and Life of Great American Cities*, London, Penguin, 1965.
5 E. Lip, *Chinese Geomancy*, Singapore, Times Books International, 1979.
6 This was a play on the phrase 'met his Waterloo' where Napoleon was defeated in 1815.
7 Stephen Daniels, *Landscape Gardening and the Geography of Georgian England*, London and New York, Yale University Press, 1999.
8 Ray Desmond, *Kew: the History of the Royal Botanic Gardens*, London, Harvill Press, 1995.
9 Ludwig Trauzettle, 'Wörlitz: England in Germany', *Garden History*, vol. 24, no. 1, 1996, pp. 221–36.
10 Maggie Keswick, *The Chinese Garden*, London, Academy Editions, 1986.
11 Ji Cheng, *The Craft of Gardens*, 1631, translated by Alison Hardie, London and New Haven, Yale University Press, 1988.
12 Jane Jacobs, *The Death and Life of Great American Cities*, London, Penguin, 1965.
13 O. Newman, *Defensible Space, People and Design in the Violent City*, London, Architectural Press, 1973.
14 A. Coleman, *Utopia on Trial: Vision and Reality in Planned Housing*, London, Hilary Shipman, 1985.
15 A. L. Marshall, 'Tribal borders and their exclusion of sacred landscapes', *Traditional Dwellings and Settlements Working Papers Series*, IASTE, University of California, Berkeley, vol. 144, 2002, pp. 6–9.

10 Sources

1 R. Hillenbrand, 'Studying Islamic Architecture', *Architectural History*, vol. 46, 2003, pp. 5–6.
2 J. J. Coulton, *Greek Architects at Work*, London, Granada Publishing, 1977, pp. 52–3.
3 J. J. Coulton, *Greek Architects at Work*, London, Granada Publishing, 1977, p. 15; M. Wheeler, *Roman Art and Architecture*, London, Thames & Hudson, 1964, p. 9.
4 William Bell Dinsmoor, *The Architecture of Ancient Greece*, New York, W. W. Norton & Co., 1975, p. xviii.
5 R. Hillenbrand, *Islamic Architecture*, Edinburgh, Edinburgh University Press, 2000, pp. 26–30.
6 H. M. Colvin, *A Guide to the Sources of English Architectural History*, Oakhill, The Oakhill Press, 1967.
7 R. Hillenbrand, 'Studying Islamic Architecture', *Architectural History*, vol. 46, 2003, pp. 7 and 16.
8 V. Sachdev and G. Tillotson, *Building Jaipur: The Making of an Indian City*, London, Reaktion Books, 2002, p. 179.
9 W. H. Pierson, Jr, *American Buildings and their Architects: the Colonial and Classical Styles*, New York, Anchor Books, 1976, p. 464.
10 G. H. R. Tillotson, *The Tradition of Indian Architecture*, Yale University Press, 1989, pp. 33–4.
11 H. R. Hitchcock, *Architecture Nineteenth and Twentieth Centuries*, Harmondsworth, Penguin, 1990, pp. 121, 598.
12 T. O. Elias, *The Nature of African Customary Law*, Manchester, Manchester University Press, 1956, p. 162.
13 Peter Jackson, *Historic Buildings of Harare*, Harare, Quest Publishing, 1986, pp. 8–9.

14 S. Martin Gaskell, *Building Control: National Legislation and the Introduction of Local Bye-Laws in Victorian England*, London, Bedford Square Press, 1983.
15 A. Smart, *Making Room: Squatter Clearance in Hong Kong*, Hong Kong, University of Hong Kong, 1992, p. 25.
16 N. Aldridge (ed.), *The Hearth Tax, Hull*, School of Humanities and Community Education, Humberside College of Higher Education, 1983.

Index

(Page numbers for illustrations are in **bold**)